*The Genesis of Modernism*

SVEN LOEVGREN

# The Genesis of Modernism

SEURAT, GAUGUIN, VAN GOGH,

& FRENCH SYMBOLISM

IN THE 1880's

REVISED EDITION

 *Indiana University Press*

BLOOMINGTON / LONDON

Published in Canada by Fitzhenry & Whiteside Limited, Don Mills, Ontario

Library of Congress catalog card number: 76-135009

ISBN: 253-32560-9

Manufactured in the United States of America

# ❦ / CONTENTS

## ❦ / ILLUSTRATIONS

# ❦ / PREFACE

IN THE JANUARY 1890 ISSUE OF THE NEWLY ESTABLISHED *Mercure de France*, Albert Aurier, a young art critic, published an enthusiastic article dealing with Vincent van Gogh's paintings. In an exalted prose, which sparkled like fireworks and shone like Bengal lights, he described van Gogh's expressive landscapes. In van Gogh Aurier found a worthy successor to the great seventeenth-century painters of the Netherlands. Van Gogh was similar to them in his humility vis-à-vis nature, his artistic resolution, and his demands for truth. Nevertheless there was an enormous chasm between this modern artist and the old Dutch masters. They had created a scrupulously honest, very Protestant, and very republican art, painted with warm feet and tankards full of ale. Vincent van Gogh's work, on the other hand, was the direct outflow of his artistic and human personality.

He has, Aurier went on, a violent fever in his drawing and colors. He goes to orgiastic extremes in everything he paints. He is a volcano, and discharges his lava into all the ravines of art, irresistible, a terrifying and distracted genius. He is often sublime, at times grotesque, and he is always bordering on the pathological. His painting is the fruit of hyperaestheticism of abnormal, intolerable intensity.

Attraction towards the inherent reality of things is not enough to explain this profound and complex art. He is certainly very conscious of the beauty of colors, but he regards them primarily as a fantastic language, a means of interpreting and visualizing Ideas. In almost everything he does he is a symbolist. If one denies his idealism, his art becomes largely unintelligible. His painting *The Sower,* for example, is not only what it seems to be. It is also a symbol of the artist-Messiah sowing the seed of truth, which will heal the frailties of our polluted industrialized community.

Thus van Gogh is not merely a great painter, but also a dreamer, a devoted believer, a man consumed by longing for beautiful utopias. He

dreams of going south to happier spots, and he wishes to create an art for simple people. Some of his work reminds one of oleographs from Epinal.

In this artist, Aurier concluded, material, method, and temperament are in complete harmony. Vincent van Gogh is at one and the same time too naive and too subtle for our current bourgeois taste. He will never be completely understood save by his brothers, the real artists . . . and by the very, very few happy, simple people who have been fortunate enough to escape the eager educational activities of society.

Aurier's essay was topical, apropos the great exhibition that the *avant-garde* association of artists, *Les XX,* was to open the following month in its elegant galleries in Brussels. Vincent van Gogh was one of those invited, and it was his first important appearance in public. The artist himself was still convalescing at Saint-Rémy after the nervous crises and attacks of epilepsy he had suffered during the previous year.

The artist and the critic had never met personally. Aurier's only knowledge of van Gogh had been gained from their mutual friend, Emile Bernard, and gleaned from Vincent's paintings at the Goupil gallery, managed by Théo van Gogh, and at Père Tanguy's paint shop.

Vincent van Gogh reacted to the article immediately. It made a deep impression on his sensitive nature. He commented on the article in letters to his mother and his sister Will, but first and foremost to his brother Théo. He was fully aware of its great significance in art circles, and he knew that it would be discussed immediately in the Belgian cultural periodical, *L'Art Moderne,* the mouthpiece of *Les XX.* He would suddenly be torn from his isolated but sheltered retreat and thrust into the limelight. On the very first day thousands of visitors to the exhibition would critically scrutinize his work.

It is true that he felt both touched and encouraged by the enthusiastic tone of Aurier's article, but he was also terrified by the shameless journalistic exposure of his mental state. To his relatives he wrote that the article expressed rather what he in his art *ought to be,* not what he *was.* In his letter to Théo he stressed that he would have felt more encouraged if he dared to renounce reality and surrender himself to a coloristic musical language. But in spite of everything, he preferred "to be a cobbler rather than a musician" with his colors.

This, however, was not enough; he also sent a long, well-reasoned letter to Aurier. It seems as if he wished to mobilize his whole intellectual capacity to characterize as false the critic's picture of him as a half-

mad genius intoxicated with violent sensations. The letter began with an art-historical exposé intended to cut the foundations from under the solipsistic picture Aurier had drawn. Van Gogh admitted his great debt to Delacroix, Millet, Monticelli, and Gauguin, and did not hesitate to defend even Meissonnier, the thorn in the flesh of every ambitious *avant-garde* critic.

The central problem in his reasoning was, however, formulated as follows: "And then I should like to ask you something else. Let us say that the two canvases of sunflowers which are presently exhibited with *Les XX* have certain qualities of color, and also that they express an idea symbolizing 'gratitude'. Is that so different from all the other paintings of flowers [by other artists] painted with greater skill and which are not yet sufficiently appreciated . . . ? You see, it seems to me so difficult to make a distinction between impressionism and other things; I do not see the necessity for so much sectarian spirit as we have seen in these last years; *in fact I fear its absurdity.*"

It seems reasonable from this to draw the conclusion that Vincent van Gogh and his critics had radically different conceptions of the essential content of the artist's work. While Aurier found in original pictures thoughts and ideas that were symbols of a higher reality, van Gogh stubbornly declared his respect for nature and his obligation to artistic tradition. If the artist's letter is fitted into a wider context, it will be found, however, that his attitude was by no means as uniform as it may seem at first sight.

As a matter of fact, van Gogh was well acquainted with the aesthetic problem raised in Aurier's article. For more than two years he had discussed with his colleagues Paul Gauguin and Emile Bernard, as well as with his brother—by letter and orally—the possibility of art visualizing a higher reality, to give expression to emotions and experiences outside workaday incidents. What is more, the passage from his letter quoted above was sandwiched between descriptions of two pictures—*Gauguin's Chair,* which later became so famous, and *The Cypress Tree,* which he intended to present to Aurier—which were devoted exclusively to the symbolic values of the pictures.

But Vincent van Gogh had good reason for his critical attitude. He was right in thinking that Aurier in his youthful enthusiasm—he was twenty-four years old at the time—had been beguiled into making exaggerated and one-sided declarations. Above all, however, he put his finger on the sore spot in *avant-garde* art criticism. He pointed out the difficulties—not to mention the inability of the critics—to describe

lucidly the artistic nature of the symbols that critics found, or believed themselves to have found in the new art. It was a burning question for Vincent van Gogh. The previous autumn he had disagreed with Bernard and Gauguin in regard to the interpretation of these symbols. In addition, in letter after letter in recent months, his brother had exhorted him to "keep to nature." For Théo van Gogh this viewpoint was dictated as much by his own aesthetic principles as by concern for his brother's health; and Théo was the last person in the world Vincent wished to offend. Therefore, for tactical reasons, he assumed a more moderate and traditional attitude than his painting really entitled him to adopt. Fundamentally his art was very closely related to the aesthetic theories that the young critic had advocated.

However one judges the course of events outlined above, it is obvious that one is face to face with a new and remarkable situation in the history of art. Ten years earlier it would have been inconceivable. It is true that there had existed friendships and possibly fruitful exchanges of ideas between artists and critics, but one will search in vain for a discussion between two such well-matched figures as van Gogh and Aurier on such a high intellectual level.

During the latter half of the 1880's, however, a sweeping change took place. The radical artists began to show far greater theoretical consciousness than their immediate forerunners had. Their discussions were not confined to their own circles; they often took to the pen and spread their aesthetic speculations in print. They associated with poets and art critics, and entered into debate with them. The problems they had to solve were common to all branches of aesthetics.

It was the cultural crisis during the years around the middle of the decade that caused this change in the relations between the exponents of different branches of art. The crisis had its roots in social, economic, and political changes, but first and foremost it was the consequence of new and foreign philosophies that began to gain ground in the cultural life of France. New aesthetic and philosophic doctrines undermined the very foundations of traditional conceptions of reality. When these new views had been assimilated by art and literature they often led to confusion and a feeling of impotence. Artists, who for decades had struggled with an unappreciative public, but had still never doubted the righteousness of their task, suddenly felt the ground falling from beneath their feet.

Without any warning, their earlier objectives seemed quite meaningless.

In other cases, and particularly among the younger generation, the crisis led to hectic artistic and literary activities. Broadly speaking, the period was distinguished by the establishment of aggressive, rapidly changing groups, a lively aesthetic debate in ephemeral cultural periodicals, and an increased number of exhibitions. It may be tempting to describe this period as a violent torrent of disparate manifestations, like a choir of strident voices, to let the documents—works of art, poems, novels, criticisms, debates—speak for themselves. The method was applied in an inimitable way in John Rewald's *Post-Impressionism.*

The present work follows other lines. In the firm conviction that no historical account can be given without valuations, I have devoted the following studies to analyses of three well-known masterpieces from the period, and the circumstances attendant upon and leading up to their execution. The three paintings, by Seurat, Gauguin, and van Gogh, occupy an indisputable key position both in the works of the respective artists and in the artistic sphere with which we are here concerned. However, to give a really true picture of the nature of the revolutionary character of the part played by the three pioneers, it is necessary to give, in Chapter 1, a rather detailed account of the cultural crisis in the middle of the eighties, and interpret its significance.

Anyone who has applied himself to this period in the history of art must have experienced the difficulty of treating material belonging to the sphere of pictorial art without touching on other branches of aesthetics at the same time. The activities of the radical artists and writers overlapped one another so intimately that it is usually impossible to separate the two means of aesthetic expression. Nevertheless, in art histories, literature and art criticism have mainly been given the role of a more or less subordinate accompaniment.

In the following chapters, one of the principal tasks has been an attempt to unravel the tangled web of relations that existed between the various representatives of art and literature. This has not been done to show, at all costs, possible "influences." I have tried to penetrate somewhat deeper into the problem, and it has been my ambition to determine on what level and at what points of intersection artists and poets were able to understand each other. This objective has led, among other things, to a rather more detailed interpretation of the literature and criticism of the period than is the rule in art histories. In one case this way of approaching the subject has led to a comparative analysis of the structure and content of a painting and a poem.

The three chapters on Seurat's, Gauguin's, and van Gogh's art dovetail into each other, but in their conception they are not uniform. The section on Seurat treats the creation of a single painting and the ideological surroundings in which it was executed. The second chapter traces the evolution of a new artistic structure, and analyzes the theoretical development of this pictorial representation. The third chapter, finally, discusses some paintings by van Gogh, which are deeply inspired by his favorite reading, and which also reflect his position in the aesthetic field with which we are concerned. A letter from Gauguin to a colleague, Jens Ferdinand Willumsen, written at Pont-Aven in 1890, is given in an appendix. The letter has, it is true, been published before, but in a periodical of so difficult an access that I thought it justifiable to reproduce it in its original form. It is one of Gauguin's most ambitious letters, and summarizes his objectives during the years 1885–90.

It may seem a grave shortcoming that the fourth great pioneer of the art of the 1880's, Paul Cézanne, is only mentioned in passing. No doubt his influence on Gauguin and Bernard, and possibly even on van Gogh, was considerable, but his development was wholly outside the currents dealt with here. The only critic who commented on his work during the eighties was Huysmans, in *Certains,* 1887. His articles betray an almost complete lack of understanding of Cézanne's genius. It was only near the end of the nineties that attention was attracted to his work. Maurice Denis' famous painting, *Hommage à Cézanne,* is dated 1900.

In view of the title I have chosen for my book, attention should perhaps be drawn to the—in itself truistic—fact that the conception "modernism" did not have the same wide meaning in the eighties as it has now.[1] It implied, of course, a clear opposition to traditionalism as an expression of a positive belief in progress, the conception of naturalism in art and literature and Parnassus poetry, and at the same time gave scope for symbolic theories of a modified kind. With that artists and authors were given certain possibilities of carrying their Penates relatively unharmed from burning Troy.

In spite of this distinction, perhaps little has been said, seeing that the conception "symbolism" can also be interpreted in many ways. Even though one is unwilling to agree with the assertion that the word symbolism is "nothing but a convenient epithet," it must be admitted that it is unsuitable as a definition of a specific artistic or literary style. It denotes rather a series of attitudes that became decisive for the artistic outlook of a particular period.

To give outline to the conception symbolism I have endeavored to give it as adequate a historical content as possible. It will be seen that well-known facts often appear in a new and unexpected light, and that to less well-known circumstances far greater significance should be allotted than one has felt inclined to allow them. Facts arrange themselves in a tangible pattern, a pattern showing that the fundamental problems of art as represented in the works of Seurat, Gauguin, and van Gogh are with us, even today.

In this new edition some changes have been made in the text of Chapter 2. In the other chapters minor errors have been corrected and a few paragraphs rephrased. Where English translations of quoted material have been introduced, the text in its original language appears in the footnotes. Some illustrations have been replaced, and the bibliography has been completed and brought up to date.

*The Genesis of Modernism*

# *1 / In Search of a Style*

THE OFFICIAL DATE OF THE FOUNDATION OF THE BELGIAN ASSO-
ciation of artists, *Les XX,* is 4 January 1884. The general pro-
gram, however, was drawn up at a meeting in a café during the
autumn of 1883. A prominent citizen with marked literary and ar-
tistic interests, Octave Maus, a lawyer at the Court of Appeal in
Brussels, became secretary of the group. As its name implies, *Les XX*
consisted of twenty artists, most of whom enjoyed a good reputation
in official Belgian art circles. One may therefore wonder why it was
that they broke away at all. The immediate reason, or perhaps, ex-
cuse was a petty difference of opinion in the official Salon jury con-
cerning some of the more independent candidates for the Salon of
1883.[1]

*Les XX* had no consistent aesthetic program.[2] This was due to
the fact that the rupture was simply a last-minute movement to-
wards freedom under the motto of impressionism, and was therefore
less hostile than the impressionist struggle in France. *Les XX* as-
sured its members full freedom to realize their personal artistic aspi-
rations. Judging by the regulations, however, it was apparently just
as important to guarantee financial and legal support in case of
eventual brushes with the law. It was probably the practical lawyer,
Octave Maus, who was responsible for these regulations.

The practical and modest character which distinguished *Les XX*
did not lead to the repudiation of the group by the official institu-
tions. The galleries of the Palace des Beaux-Arts were made availa-
ble for the exhibitions, which according to the rules, were to be held
annually. In addition to the members of *Les XX,* twenty foreign art-
ists from different countries were invited to these exhibitions.
During the early years a very cautious policy was pursued, and as a

rule only artists whose work was above discussion were invited. Among those invited in 1884 were Gervex, Rodin, Whistler, Liebermann, Sargent, Israëls, Maris, and Mauve.[3]

Since right from the beginning *Lex XX* occupied a much disputed but sanctioned position, the group's diplomatic exhibition policy enabled it to act as a real pioneer in the world of art. In particular it began to function early as a loophole and a support for the young, struggling French art. With the help of suitable galleries, the Belgian group was able as early as 1884 to reform the accepted exhibition technique radically. The compact hanging of pictures in several rows above each other was avoided, and the works of the different participants were clearly arranged together in separate groups. The traditional brown walls were enlivened with Ferdinand Khnopff's monogram of *Les XX,* specially designed for the occasion. The exhibition program included a series of lectures at which Edmond Picard lectured on *L'Art jeune,* and Catulles Mendès on *Richard Wagner,* and two promenade concerts of music by young Belgian composers were given in the galleries.

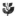

DURING THE SAME SPRING, 1884, the foundations were laid for an association of artists of a structure essentially different from that of *Les XX.* Nevertheless, during subsequent years the two groups were to have frequent contacts with each other. The Salon jury in Paris had been unusually strict and conservative that year, and the exhibition was completely dominated by the official Salon painters in the Avenue de Villiers and the Boulevard Malesherbes. The most popular picture was the work of a military artist, Armand-Dumaresq's *La Lecture de l'Annuaire de la Cavalerie.*

That year the official Salon was—for reasons to which we will return later—the only chance an artist had to get his works hung. Some of the artists who had been refused therefore issued an appeal for an independent exhibition. The prime mover was Albert Dubois-Pillet, painter and captain in the Republican Guard. It was undoubtedly his good relations with the town that made it at all possible to obtain premises for an exhibition.

At the end of April a few simple posters were to be seen on the walls of houses in Montmartre and Montparnasse with the text: "Salon des Artistes Indépendants 1884 autorisé par le ministre des Beaux-Arts de la Ville de Paris. Baraquement B, Cour des Tuileries du 15 mai au 1er juillet." The idea of the exhibition was an immediate success among Parisian artists, for no one would be rejected. Each participant had the right to submit two works. No fewer than four hundred and two artists answered the call. The varnishing day, however, was rather confused. Two antagonistic groups had emerged, and each had its own entrance for visitors, in spite of the fact that all the works were exhibited in the same hall. One group called itself *Les Indépendants,* the other *Groupe des Indépendants.* The latter had a sign over its part of the exhibition with the words *Exposition des Impressionnistes,* although none of the recognized impressionists were represented, which further increased the confusion.

Among the artists in the latter group, which was to take the lead, were Odilon Redon with sketches and pastel drawings, Dubois-Pillet with the oil painting *L'Enfant Mort* (which was to occupy a prominent place in the art debate), and Charles Angrand, Henri-Edmond Cross, and Paul Signac, all with landscapes. Signac's canvases were, in the artist's own words, "painted only with the colors of the prism, placed on the canvas in little comma-strokes, following the Impressionist mode and under the influence of his chosen masters: Claude Monet and Guillaumin, whom he was not to know until later, but always without mixing the pigments on the palette." *

The most remarkable painting was Georges Seurat's large canvas, *Une Baignade, Asnières* (Fig. 1). Neither Seurat nor the other artists, however, aroused much interest. Signac described Seurat's painting as follows: *"A Bathing Beach (Asnières),* by Georges Seurat (100, Boulevard Magenta), was done with large strokes, one swept on top of another, issued from a palette composed, as in Dela-

* "peints avec les seules couleurs du prisme, posées sur la toile en petites touches virgulaires, selon le mode impressionniste et sous l'influence des maîtres qu'il avait élus: Claude Monet et Guillaumin et qu'il ne devait connaître que plus tard, mais toutefois sans mélange de pigments sur la palette." [Tr. MacGarrell.]

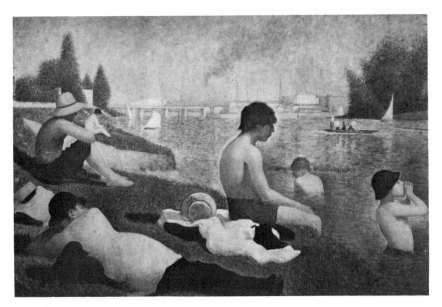

FIG. 1   Georges Seurat, *Une Baignade Asnières,* 1884, National Gallery, London.

croix, of sonorous and ochreous colors. The contours are drowned in elements (light, shadow, local color, the fleck of the brushstroke. Observation of the laws of contrast, methodical separation of reactions)." *

The press criticisms of the painting were adverse or indifferent. One notice, however, is worth quoting. In *Le Cri du Peuple* an article signed Trublot said: "This is a fake Puvis de Chavannes. Such funny bathing beauties! Such droll gentleman swimmers! But the painting itself is so self-convinced that it is almost touching and I dare not joke about it any more." **

Trublot was the pseudonym of the writer Paul Alexis, a friend of Zola's and Cézanne's. His criticism shows that he had not really

* *"Une Baignade (Asnières)* de Georges Seurat (100, boulevard Magenta) était à grandes touches balayées les une sur les autres et issue d'une palette composée, comme de Delacroix, de couleur sonore et d'ocre. Les contours étaient noyés des éléments (lumière, ombre, couleur locale, dans la tache. Observation des lois du contraste, séparation méthodisée des réactions).⁴

** "Ceci c'est un faux Puvis de Chavannes. Les drôles de baigneurs et de baigneuses! Mais c'est tellement convaincu que c'en est presque touchant et que je n'ose plus blaguer." ⁵

studied Seurat's work, but had paid more attention to the comments of the group. The radical attitude of this sworn naturalist is in its way remarkable. It was no less remarkable that a short time later he opened the columns of *Le Cri du Peuple* to Paul Signac,[6] who, as early as 1882, had dealt ironically with Zola's work, with the story "La Trouvaille" in *Le Chat Noir*.[7]

As a matter of fact, Paul Alexis' "appreciative" criticism of Seurat's work was one of the very first signs in the contemporary art debate that something new was taking place in French painting. In contrast to the brief mention made of *Une Baignade* in, for example, *L'Intransigeant* and *Le Voltaire,* Alexis did not regard the painting as part of the impressionist movement, but associated it with classical forerunners, especially Puvis de Chavannes.

With *Une Baignade* Seurat had found a milieu—the banks of the Seine at Pont Courbevoie—that was to hold him artistically captivated for years to come. He began work on the painting in the spring of 1883, and progressed in the methodical way that was to become so typical of his work. A great many drawings and sketches in oil preceded, or were made side by side with the indoor work on the final version. Recent exhibitions have shown clearly that Seurat's impulses for *Une Baignade,* for example, have little in common with impressionism, with which, by the way, he did not get in touch until a late phase in the painting of the picture.[8]

The small sketches on wood and canvas may at first glance look like impressionist studies, but a close scrutiny reveals that with their cross-wise or broadly parallel brush strokes, they serve quite a different purpose. While the impressionists with their comma-like strokes created sensuous values that were their artistic aims, Seurat's wood panels were purely preparatory studies which served partly to make a note of the subject and the principal lines of the composition, and partly to verify the laws of color that he believed he had discovered while studying the works of Charles Blanc, Delacroix, Chevreul, and Rood.

The formative process and the integration of the contents of the sketches occurred mostly in the drawings, and were then embodied in the final composition. This artistic method gives to *Une Baignade* an entirely different feeling than the impressionist pictures—

despite the fact that it describes the same kind of leisurely atmosphere as Renoir and Monet, for example, had exploited earlier.[9] The constructive elements of Seurat's picture emerge clearly. The diagonal strip of the bank is balanced by the horizontal lines of the bridge. The figures are grouped in a repetitive pattern that gives the composition a static character. The boy in the water waiting for an echo from the island La Grande Jatte, opposite, gives to the picture an air of expectancy which stresses its fundamental character. The atmosphere of unreality that dominates the picture is emphasized by the lack of contact between the persons and nature. Technically this is brought out by several of the figures being marked by a narrow halo-like outline which isolates them from the surrounding reality and underlines the introverted, somewhat melancholy character of the work.[10]

As early as 1882 profound differences of opinion between the members of the old, once so firmly united group of impressionists became noticeable. At the beginning of the year the modest Gustave Caillebotte failed completely in his attempts to rally his friends for a common exhibition. He passed on the task to Durand-Ruel, who had to use all his diplomacy to organize a collective exhibition at all. He was also compelled to exclude Edgar Degas, who by his intrigues, his protection of the socialist genre painter Raffaëlli, and his then growing misanthropy, had contributed largely to the rupture.[11]

It is probable that Degas' exclusion from the circle was inevitable. He had never been an impressionist in the same meaning of the term as, for example, Monet. Tactical considerations rather than common aesthetic doctrines attached him to the group in the seventies. From the beginning of the eighties his art began to differ more and more from that of his contemporaries. His choice of subject was mainly restricted to two principal themes: the ballet and female nudes. The perspective in his works became less deep, the angle of vision more daring, and the aspiration towards firm decorative contours more and more marked.

The development was accompanied in Degas by literary experiments. He began to study poetry systematically, bought a rhyming dictionary, and wrote sonnets about the ballet.[12] A source of inspiration for his attempts at versifying was undoubtedly his circle of ac-

FIG. 2    Pierre-Auguste Renoir, *Le Déjeuner des Canotiers,* 1881, The Phillips Collection, Washington, D.C.

quaintances in the world of opera. Ludovic Halévy, who wrote the libretto to Offenbach's *La Belle Hélène,* was one of his most intimate friends. But he did not hesitate to discuss his poems with Stéphane Mallarmé. He obviously regarded them as a kind of exercise in form, a means of fixing his artistic aspirations. He felt somewhat uncertain, however, of the justification of his ambitions, and his letters reveal several examples of his lack of self-reliance. In August 1884 he wrote to his friend Henry Lerolle:

> If you were single, 50 years of age (for the last month) you would know similar moments when a door shuts inside one and not only on one's friends. One suppresses everything around one and once all alone one finally kills oneself, out of disgust. I have made too many plans, here I am blocked, impotent. And then I have lost the thread of things. I thought there would always be enough time. Whatever I was doing, whatever I was prevented from doing, in the midst of all my enemies and in spite of my infirmity of sight, I never despaired of getting down to it some day.

I stored up all my plans in a cupboard and always carried the key on me. I have lost that key. In a word I am incapable of throwing off the state of coma into which I have fallen. I shall keep busy, as people say who do nothing, and that is all.*

In the first place the words seem to express purely personal problems, but the curious state of mind in which he was at the time, the causes of which he was evidently incapable of analyzing, influenced—as shown by another letter written at the same time —all his artistic activities in a fateful way.

Ah! where are the times when I thought myself strong. When I was full of logic, full of plans. I am sliding rapidly down the slope and rolling I know not where, wrapped in many bad pastels, as if they were packing paper.**

This feeling of alienation vis-à-vis his former artist colleagues, the sensation that the ground was falling from beneath his feet, led Degas to seek contacts with a younger generation. Thus he became one of the few of his age to view with sympathy the manifestation of the *Groupe des Indépendants* in the Tuilerie Barracks during the spring of 1884. He was later to be a powerful supporter of the younger painters.

But Degas was not the only problem the impressionist group had to face. In reply to Durand-Ruel's inquiry regarding participation in the proposed exhibition, Claude Monet wrote from Dieppe on 10 February 1882:

* Si vous étiez célibataire et âgé de 50 ans (depuis un mois) vous auriez de ces moments-là, où on se ferme comme une porte, et non pas seulement sur ses amis. On supprime tout autour de soi, et une fois tout seul, on s'annihile, on se tue enfin, par dégoût. J'ai trop fait de projets, me voici bloqué, impuissant. Et puis j'ai perdu le fil. Je pensais avoir toujours le temps; ce que je ne faisais, ce qu'on m'empêchait de faire, au milieu de tous mes ennuis et malgré mon infirmité de vue, je ne désesperais jamais de m'y mettre un beau matin.

J'entassais tous mes plans dans une armoire dont je portais toujours la clef sur moi, et j'ai perdu cette clef. Enfin, je sens que l'état comateux où je suis, je ne pourrai le soulever. Je m'occuperai, comme disent les gens qui ne font rien, et voila tout.[13]

** Ah! Où est-il le temps où je me croyais fort, où j'étais plein de logique, plein de projets? Je vais descendre bien vite la pente et rouler je ne sais où, enveloppé dans beaucoup de mauvais pastels, comme dans du papier d'emballage.[14]

Now for this exhibition, I must tell you that my ideas on the subject are very definite. At the point where we are now, an exhibition must either be extremely well done or not take place at all, and it is totally necessary that we be *among ourselves,* that no stain be allowed to compromise our success. Is it possible to hold such an exhibition this year? I know that it is not possible, since certain persons are already involved; thus, to my great regret, I absolutely refuse to take part under these conditions.*

Who these undesirable *certaines personnes* were is evident from some temperamental letters written in February by Renoir, who was confined to bed with a cold at Éstaque, to Durand-Ruel:

This morning I addressed to you a telegram as follows: Those paintings of mine which you have are your property; I cannot prevent you from disposing of them, but I will not be the one who exhibits them.

These few words are the complete expression of my thought.

It should be understood, then, that in no fashion do I adhere to the Pissarro-Gauguin combination, and that I do not for a single minute accept being included in the group called the Independents.

The first reason is that I exhibit in the Salon, which hardly fits in with the rest.

So I refuse and I still refuse.**

Renoir's irritation over the new constellation Pissarro-Gauguin was even more clearly expressed in the draft of the letter quoted above. Social and political antagonisms within *avant-garde* artistic circles are revealed in it:

* Maintenant pour cette exposition, je vous dirai que mes idées sont très arrêtées à ce sujet. Au point où nous sommes il faut qu'une exposition soit très bien faite ou n'en pas faire et il est de toute nécessité que nous soyons *entre nous,* et il ne faut pas qu'une tache vienne compromettre notre succès. Est-il possible de faire un telle exposition cette année? Je sais que non, puisque c'est engagé avec certaines personnes, donc, à mon grand regret, je refuse absolument d'en faire partie dans ces conditions.[15]

** Je vous ai adressé ce matin un télégramme ainsi conçu: Les tableaux que vous avez de moi sont votre propriété, je ne puis vous empêcher d'en disposer, mais ce ne sera pas moi qui exposerai.

Il est donc bien entendu que je n'adhère en aucune façon à la combinaison Pissarro-Gauguin et que je n'accepte pas d'être compris une seule minute dans le groupe dit des Indépendants.

La première raison est que j'expose au Salon, ce qui ne s'accorde guère avec le reste.

Donc je refuse et je refuse encore.[16]

Unfortunately I have a goal in my life, and that is to show my pictures. The means I use is perhaps not good, but I like it. To exhibit with Pissarro, Gauguin, and Guillaumin would be like showing my work with some socialistic group. A little more and Pissarro would invite the Russian Lavrof or some other revolutionary. The public doesn't like what smells of revolution, and I have no wish, at my age, to be a revolutionary. To remain with the Jew Pissarro, that would be the revolution.*

The tone of Renoir's letter and draft is definitely antagonistic, and shows as clearly as might be wished how non-aesthetic considerations helped divide the champions of impressionism. It is immaterial that Renoir was right when he characterized Pissarro as an anarchist. The draft, however, also gives an unpleasant hint of the anti-Jewish campaign that was started a few years later, with, among others, Edouard Dumont's *La France juive* (1886).

The following year, 1883, Durand had entirely given up the idea of a common impressionist exhibition, and had applied his energies—with indifferent success—to separate exhibitions of Monet, Renoir, Pissarro, and Sisley. Although the critics were on the whole favorably inclined towards these front-rank impressionists, their financial situation still remained very precarious. The failure of the *Union Général des Banques* the previous year had caused a catastrophic decline in willingness to buy art. Not the least distressing was the fact that Durand-Ruel himself was hard hit by the crisis, and by the spring of 1884 he seems to have been practically bankrupt.[18]

But the critical situation was not restricted solely to financial matters and exhibition policies. Several of the impressionists seem to have begun to doubt seriously the fruitfulness of the aesthetic course they had chosen. In May 1884 Renoir informed Durand-Ruel that he intended to go to Paris to found a new group of artists, *La Société des Irrégularistes*. He enclosed a proposed prospectus for this in-

* Malheureusement j'ai un but dans ma vie, c'est de faire monter mes toiles. Le moyen que j'emploie n'est peut-être pas bon, mais il me plaît. Exposer avec Pissarro, Gauguin et Guillaumin, c'est comme si j'exposais avec une sociale quelconque. Un peu plus, Pissarro inviterait le Russe Lavrof ou autre révolutionnaire. Le public n'aime pas ce qui sent la politique et je ne veux pas moi, à mon âge, être révolutionnaire, Rester avec l'israélite Pissarro, c'est la révolution.[17]

tended group, which he thought should elevate architecture, art, and handicrafts.[19] The prospectus is diffuse to the point of incomprehensibility. It has been assumed that it would anticipate the doctrines of the Art Nouveau movement. If this were so, the theories had no influence on Renoir's own work. Apart from the fact that they are evidence of the limitations of the impressionists as theorists, they indicate the growing uneasiness and uncertainty regarding the stylistic means of expression. It is well known that Renoir's theoretic speculations were followed by a more distinct, firm, and classical formalism. The foremost expression of this new orientation is his painting *Les Grandes Baigneuses* (1885–87).

Claude Monet's situation was the same. In 1883 he informed his dealer that the autumn's work at Giverny had given very poor results, and in January 1884 he went to Bordighera in Italy, hoping that the change of surroundings might help him regain his self-confidence. But even the sojourn in Italy was, in the artist's opinion, a disappointment.[20]

In autumn of 1883 Camille Pissarro was painting in the neighborhood of Rouen. The many letters to his son Lucien, who was in London studying art, reveal the artist's situation. On 20 November he wrote:

> I have just concluded my series of paintings, I look at them constantly. I who made them often find them horrible. I understand them only at rare moments, when I have forgotten all about them, on days when I feel kindly disposed and indulgent to their poor maker. Sometimes I am horribly afraid to turn round canvases which I have piled against the wall; I am constantly afraid of finding monsters where I believed there were precious gems! *

Pissarro had then been painting for thirty years.

* Je viens de terminer ma série de peintures, je les regarde beaucoup. Moi-même, qui les ai faites, je les trouve parfois horribles. Je ne les comprends que par moments, longtemps après les avoir exécutées, quand je les ai perdues de vue, un jour que je suis bien disposé et assez indulgent pour le pauvre peintre. J'ai parfois des peurs horribles de retourner une toile. Je crains toujours de trouver un monstre à la place des précieux joyaux que je croyais avoir faits.[21]

THE GENERAL FEELING of uncertainty to which these ex-
tracts bear witness can hardly be explained satisfactorily by referring
only to the depressing economic situation or the lack of contact be-
tween the members of the impressionist group. The causes lay much
deeper. Some intimation is given in another letter from Camille Pis-
sarro to Lucien, written on one of the last days of 1883:

> I am sending you *Les Fleurs du Mal* and the book of Verlaine. I
> do not believe these works can be appreciated by anyone who comes
> to them with the prejudices of English, or what is more, bourgeois
> traditions. Not that I am completely in favor of the contents of these
> books; I am no more for them than for Zola, whom I find a bit too
> photographic, but I recognize their superiority as works of art, and
> from the standpoint of certain ideas of modern criticism, they have
> value to me. Besides it is clear that from now on the novel must be
> critical; sentiment, or rather sentimentality, cannot be tolerated with-
> out danger in a rotten society ready to fall apart.
>
> The discussion you had about naturalism is going on everywhere.
> Both sides exaggerate. It is clear that it is necessary to generalize and
> not lean on trivial details.—But as I see it, the most corrupt art is
> the sentimental, the art of orange blossoms which makes pale women
> swoon.*

Pissarro's letter leads to the heart of the crisis that was approach-
ing the French Parnassus, and which was also to be decisive for
French painting. It would be more than interesting to know what
"book" by Verlaine it was that Camille Pissarro sent to his son. It is
tempting to imagine that he was so conscious of literary merit that

---

* Je t'envoie les *Fleurs du Mal* et le livre de Verlaine. Je ne crois pas que ce
soit un livre appréciable par quelqu'un qui y apporte un parti pris de tradition
anglaise, et surtout bourgeoise. Ce n'est pas que je défende absolument le fond
de ces livres, pas plus que ceux de Zola que je trouve un peu trop photogra-
phiques, mais j'en reconnais la supériorité comme œuvre d'art; et au point de vue
de certaines idées de criticisme moderne, j'y retrouve encore mon compte. Du
reste, c'est entendu que le roman ne peut plus être que critique; le sentiment
ou plutôt la sentimentalité ne peut, sans danger, être de mise dans une so-
ciété pourrie et en voie de décomposition.

La discussion que tu a eue à propos du naturalisme se reproduit partout. Il y
a exagération de deux côtés. Il est évident qu'il faut généraliser et non
s'appesantir sur la petite bête.—Mais, selon moi, l'art le plus corrompu, c'est
l'art sentimental. L'art à la fleur d'oranger qui fait pâmer les femmes pâles.[22]

he chose Verlaine's latest book of poems, *Sagesse,* published in 1881. This collection gives eloquent evidence of the inner crisis that shook the poet during the latter half of the seventies, and which led him for a time to seek solace in the Church. Long passages of *Sagesse* consist of a contrite, naive confession of sins, expressed in a gentle language of great musical beauty. But for the few readers who found their way to the book (the edition was only 500 copies, most of which remained unsold) it was not simply a pious testimony, but also something of a poetic revelation. Its message, touched by mysticism, of the poet's duty to explore that which lay behind the visible world, seemed like a new and fresh aesthetic program.[23]

The association with *Fleurs du Mal,* however, suggests that Pissarro was referring to an early work by Verlaine, *Poèmes Saturniens,* which was greatly inspired by Baudelaire, Hugo, and Leconte de Lisle. Its natural lyrical content may possibly have been a source of inspiration to Pissarro as a landscape painter.[24] Whatever the "book" may have been that he sent to Lucien, the letter shows—and this is the most important point—that Pissarro reacted very early to the literary and aesthetic debate. It may seem astonishing that he so decidedly rejected Zola's naturalism in favor of the idealistic aestheticism proclaimed by Baudelaire and his disciple Verlaine, among others. But the choice was typical of the times. During the autumn of 1883, a number of young poets, the so-called Decadents, expressed their contempt for the traditional, polished Parnassus poetry in the *avant-garde* periodical *Lutèce.* Verlaine had had success in the periodical with a series of articles entitled *Les Poètes maudits* (published as a book in 1884), introducing Tristan Corbière, Arthur Rimbaud, and Stéphane Mallarmé. Shortly afterwards a wider circle of readers was to become conscious of what was happening in the field of literature.

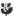

IN JUNE 1883, Zola's pupil, Joris-Karel Huysmans, wrote to his Belgian friend, the painter and poet Théodore Hannon, that he was working on ". . . a very strange novel, vaguely clerical, slightly pederast; . . . a novel with a single character! . . . It

will be curious, I think, all the more so that therein is the worn-out refinement of all things, of literature, of art, of a flower, of perfumes, of furniture, of precious stones, etc." *

The novel was published by Charpentier in March 1884 under the title *A Rebours*. The hero of the book, the decadent Duke Jean Floressas des Esseintes, surfeited with society life and dissipation, re-tires to an eccentrically furnished house in Fontenay-aux-Roses in order to devote himself exclusively to the study of literature and art. In chapter after chapter des Esseintes amuses himself in his complete isolation by delving deeply into literature dating from the time of the decline of Rome, and early religious works. He cultivates bizarre exotic plants, and creates symphonic scent and taste sensations by blending costly perfumes and precious wines.

Des Esseintes's curious tastes appeared most clearly in his asso-ciation with contemporary art and literature. He valued most highly his collection of Gustave Moreau and Odilon Redon, and he printed privately rare poems by Paul Verlaine, Tristan Corbière, Villiers de L'Isle-Adam, and Stéphane Mallarmé, and had them bound in ex-quisite private bindings.

Huysmans' book was an enormous success. "*A Rebours* fell like a meteorite onto the literary fairground," the author himself wrote, "and there was utter stupefaction and rage, the press went wild; never had it raved through so many articles." ** The success may seem a little puzzling to us. In its structural elements the novel fol-lowed conventional patterns. It is a rather stilted composition built up by the collection of facts according to the recipe of the Médan group. It is without tension and is of a pronounced episodal charac-ter. Emotionally it describes an even curve leading from hopes of radically renewed existence, through disappointment, to despair over inability to follow the plan of life laid down.

The uniform course of events is broken, however, by every chap-

---

* . . . un roman très estrange, clérical vaguement, pédéraste un peu; . . . un roman à un seul personnage! . . . Ça sera curieux, je crois, d'autant que là-dedans, il y a le raffinement épuisé de toute chose, de la litterature, de l'art de la fleur, de parfums, des ameublements, de pierreries, etc." 25

** "A Rebours tombait ainsi qu'un aérolithe dans le champ de foire litteraire et ce fut une stupeur et une colère, la presse se désordonna; jamais elle ne diva-gua en tant d'articles." [Tr. McGarrell.]

ter resolving itself into an independent quasi-scientific essay, the
main object of which is to deliver a philosophic, aesthetic, and liter-
ary message. As a matter of fact, these essays gave the interested
public the key to the cultural crisis that could be felt, but the impli-
cations of which were difficult to understand.

With des Esseintes Huysmans created a new literary type with
moral, philosophic, and aesthetic principles that must have shocked
the general public. A necessary condition for the eccentric way of
life that des Esseintes pursued was complete disbelief in the value of
every form of human companionship. This fundamental pessimism
was necessary for his appreciation of aloof artistic manifestations. By
being totally alone he was the ideal recipient of new aesthetic tid-
ings. But to realize his ideal of loneliness at all he needed a philoso-
phy of life. At certain moments he seemed to find one in his studies
of the history of religion.

Thus his tendency towards artifice, his need for eccentricity, were
they not, after all, the result of specious studies, of extraterrestrial re-
finements, of quasi-theological speculations; they were, at bottom,
transports, bursts towards an ideal, towards an unknown universe, to-
wards a distant beatitude, desirable as the ones the Scriptures promise
us.*

But just as often the dogma of the Church seemed to him vague,
powerless, and diluted, and at such times he sought new ways:

Schopenhauer was more exact; his doctrine and that of the
Church set off from a common point of view; he also based himself
on the iniquity and turpitude of the world, he also flung forth (with
*The Imitation of Our Lord*) the dreary clamor: "It is truly misery to
live on the earth!" . . . but he extolled to you no panacea, did not
lull or distract you as a remedy for inevitable ills.

. . . He pretended to heal nothing, offered the sufferer not the
slightest compensation, not the slightest hope; but his theory of Pessi-

---

* Ainsi ses tendances vers l'artifice, ses besoins d'excentricité, n'étaient-ils
pas, en somme, des résultats d'études spécieuses, de raffinements extraterrestres,
de spéculations quasi-théologiques; c'étaient au fond, des transports, des élans
vers un idéal, vers un univers inconnu, vers une béatitude lointaine, désirable
comme celle que nous promettent les Ecritures.[26]

mism was, in short, the great consoler of chosen intelligences, of higher souls.*

The illusory world that this intelligent, aristocratic, and eccentric des Esseintes created for himself was an incarnation of Schopenhauer's metaphysics. In *Die Welt als Wille und Vorstellung*, the German philosopher had drawn a sharp borderline between the phenomenal and the noumenal worlds: "What we know is not that there exist a sun and a world, but that we have eyes that see the sun and hands that feel the earth." The relative existence of objects makes them symbols, not independent entities. Our knowledge is only an object-subject relationship, in other words, an *idea*. What has for centuries been called common sense is nothing but a blind force. Schopenhauer called it, paradoxically enough, the *will*, but it has neither meaning nor aim. Existence in such circumstances is a continuous yearning for something undefinable. Such an existence must of necessity be malign. Neither suffering nor pleasure has any meaning. To a certain extent, however, existence may be sublimated. This is achieved by contemplation in the Platonic sense, by which the will is "objectivated." This process is carried out chiefly with the help of art. The artist-genius and the contemplation of his work may provide temporary liberation from suffering and passion. He releases things from the bonds of time, bursts the fetters of affections, and gives in intuitive vision a meaning to life, something that scientific knowledge can never do.[28]

Excellent examples of des Esseintes's application of this idealistic philosophy are his fictitious journeys, particularly the trip to England, which begins and ends in an English restaurant in Paris not far from the Gare Saint-Lazare, the Taverne Anglaise in the Rue d'Amsterdam. There all foreign objects, tastes, and smells become

---

* Schopenhauer était plus exact; sa doctrine et celle de l'Eglise partaient d'un point de vue commun; lui aussi se basait sur l'iniquité et sur la turpitude du monde, lui aussi jetait avec *l'Imitation de Notre-Seigneur,* cette clameur douloureuse: "C'est vraiment une misère de vivre sur la terre!" . . . mais il ne vous prônait aucune panacée, ne vous berçait, pour remédier à d'inévitables maux, par aucun leurre.

. . . Il ne prétendait rien guérir, n'offrait aux malades aucune compensation, aucun espoir; mais sa théorie du Pessimisme était en somme, la grande consolatrice des intelligences choisies, des âmes élevées.[27]

symbols of the journey abroad that the hero of the novel in his neurotic state of mind cannot decide to make.

In the private world that des Esseintes, with Schopenhauer's help, created parallel with his rational existence, there was room for the writers and artists who appealed to him. There Baudelaire's poetical milieu and way of life were cherished. His theories of the connection between different sensations were skilfully applied in the passages describing the blending of perfumes and wines. Details from Edmond de Goncourt's *La Maison d'un Artiste,* and stories about the Paris dandy, Count Robert de Montesquiou-Fezensac, had contributed towards des Esseintes's milieu. Huysmans had been helped considerably in this respect by Stéphane Mallarmé, who had given an account of a visit he had paid to the eccentric nobleman. He had discovered that the door bell was really a bell intended for use during church service. One room was built as a monk's cell, another as a ship's cabin. In a third room there was a sleigh on a polar bear skin. There was also a library of rare books in expensive bindings. And there were the remains of a tortoise in a gilt bowl, too.[29]

Huysmans had become acquainted with Mallarmé as early as the end of October 1882, when the novel was still in its initial stages.[30] The immediate reason was that he lacked material for his chapter on contemporary poetry, and asked therefore to be allowed to borrow, among other works, *Après-midi d'un Faune* and *Hérodiade* by Mallarmé. The friendship that arose between the two provided Huysmans with new aspects of his hero. Among other things he worked into *A Rebours* Mallarmé's admiration for the art of Odilon Redon, undoubtedly because it was in keeping with the Schopenhauerian inclinations of the book. Mallarmé's reaction to Redon's particularly artistic world is shown by the following quotation:

For two days I have been going through this extraordinary set of six lithographs without exhausting the effect of any of them—the sincerity of your vision goes so far, and is equaled by your power to evoke it in another! Indeed a mysterious sympathy made you portray in that delicious mad hermit the poor little man I long to be in the depths of my soul; and I am hanging that drawing by itself on some

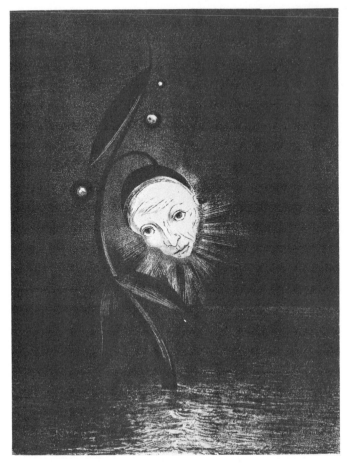

FIG. 3   Odilon Redon, *The Marsh Flower, A Sad Human Face,* 1885.
Plate 2 from *Homage à Goya,* Museum of Modern Art, New York.

wall of my memory, in order to judge the others in a more disinterested way. The head of Dream, that "swamp flower," illuminates, with a clarity that she alone knows, unspeakable, the whole tragic lantern of ordinary existence. . . . But my entire admiration goes to the great Magus, inconsolable, obstinate; seeker of a mystery which he knows does not exist and which he will pursue forever despite that, from within the deep mourning of his lucid despair, for *it should have been* the truth. . . .*

* Voilà deux jours que je feuillette cette suite extraordinaire de six litographies sans épuiser l'impression d'aucune, tant va loin votre sincerité dans la vi-

Mallarmé's letter to Odilon Redon is in exact correspondence with des Esseintes's sensations of the artist's visionary drawings.[32] With this and other stylistic methods Huysmans created in literary form a special collection of topical attitudes in relation to the idealistic philosophy and aesthetics. Thus *A Rebours* became one of the more important testimonies to the anti-naturalistic currents in both literature and painting at the beginning of the eighties.

❧

GENERALLY SPEAKING, the publication of *A Rebours,* written by one of Zola's most prominent disciples, has been regarded as a remarkable volte-face which at once placed Huysmans in uncompromising opposition to the naturalist school. This contention is considerably exaggerated and has given a false perspective to Zola's role in this connection. In reality the cultural crisis was so profound that it left its traces in the Médan master's own work. A comparative study of Huysmans' and Zola's work at this time reveals the critical situation in its full extent, and makes it possible to understand better the feeling of disaster prevalent among the impressionist painters.

Huysmans was engaged on *A Rebours* during the greater part of 1883, and the book was published in March 1884. At almost exactly the same time Zola was working on his *La Joie de Vivre.* This work was begun, after a number of preparatory studies, on 25 April 1883, and it was on sale in the bookshops in February 1884. *La Joie de Vivre* has been described as one of Zola's most personal works.[33] It is true that his mother's painful death on 17 October 1880 and the neurotic condition that overwhelmed the author afterwards played a decisive role in the shaping of the novel. Before Zola de-

---

sion, non moins que votre puissance à l'évoquer chez autrui! Une sympathie bien mystérieuse vous a fait portraiturer dans ce délicieux ermite fou le pauvre petit homme que du fond de mon âme j'aimerais être; et je suspends ce dessin à part à quelque mur de ma mémoire, pour juger les autres d'une façon plus désintéressée. La tête de Rêve, cette "fleur de marécage," illumine d'une clarté qu'elle connaît seule et qui ne sera pas dite, tout le tragique falot de l'existence ordinaire . . . Mais mon admiration tout entière va au grand Mage inconsolable et obstiné chercheur d'un mystère qu'il sait ne pas exister et qu'il poursuivra, à jamais pour cela, du deuill de son lucide désespoir, car *c'eût été* la verité. . . .[31]

cided on the ironic title *La Joie de Vivre* he had considered several other titles: *La Vallée des Larmes, La Sombre Mort, La Misère du Monde, Le Triste Monde,* and others.

The principal theme of the book is the agony of death, a fear of the kind that would be called heart-neurosis today. The character tortured by this paralyzing fear is the leading male figure, Lazare Chanteau.

As is often the case with Zola's novels, the author's draft and notes clearly explain the literary intentions:

> Lazare should make a mess of his life, do nothing, begin everything. *That's very good,* that is the modern character of the pessimist —enterprises that fall through, three or four of them, more and more unbalanced. . . . The notion of pessimism grows little by little, but in the depths, like a hidden explanation, the fear of death, not emphasizing the macabre but rather a secret torment. First of all a doctor (and musician).*

The highly gifted and scientifically trained Lazare is thus made to represent a topical cultural malady, and Zola gives further plastic graphicness to his character:

> For Lazare's philosophical sense, it might perhaps be that the fear of death was like a piercing insight which returned at every moment, growing with age, ever sharpening, ever more present, at the slightest fact, so as to poison the existence; but this thought should not be the only one. The important thing, the very basis of Lazare, is to make him into a pessimist, someone sick of our new science. It would be interesting to study the continual abortion that takes place in someone's nature; in an intelligent nature that knows something about our times, goes along with scientific discovery, has touched on experimental method, has read our literature, but denies it all by a kind of bewilderment, a slightly narrow outlook, and most of all by a great personal incapability—to show, in a word, an intelligent guy, involved

---

* Lazare doit manquer sa vie, ne rien faire, avec des commencements de tout. *Cela est très bon,* c'est la caractère moderne du pessimiste, des entreprises qui claquent, trois ou quatre, et de plus en plus détraqué. . . . Les idées du pessimisme augmentent peu à peu, mais au fond, comme explication cachée la peur de la mort, non pas tournée au macabre, mais au tourment secret. D'abord medécin (et musicien).[34]

in today's movements; and denying this moment, flinging himself into Schopenhauer.*

To judge by this quotation, *La Joie de Vivre* ought to have been an anti-positivist novel. But, as usual, Zola's positive powers took the upper hand. They are represented by the almost saint-like Pauline Quenu, who is continually sacrificing herself for her fellow creatures, and even succeeds in keeping her balance when she decides to surrender her betrothed, Lazare, to another woman.

The most important thing in this connection, however, is that with this novel of ideas the naturalist Zola showed that he was fully aware of the cultural situation and that he did not hesitate to make use of it in his literary work. His interpretation of the significance of the German idealistic philosophy for French theorizing was rather superficial, however, and Huysmans protested. In March 1884 he wrote to Zola thanking him for the novel, which he had read as a "salutary universal panacea" during the pauses while working on the proofs of *A Rebours*. In his opinion Lazare was skillfully conceived, but he could not agree with the theory of Schopenhauer. Instead he developed, starting from Bourdeau's *Schopenhauer, Pensées, Maximes et Fragments* (1880), his interpretation of the consoling theory of resignation in the same way as des Esseintes was to do it in *A Rebours*. He closed by maintaining that neither Pauline nor Lazare was a real follower of Schopenhauer.

It is not known what Zola replied to Huysmans' comments, but we do know how he reacted to similar criticism by the author Edouard Rod. Zola's defense was that he had never intended to make Lazare a metaphysicist, a servile disciple of Schopenhauer, for

---

* Pour le sens philosophique de Lazare, il faudrait peut-être que la peur de la mort fut comme une pensée lancinante qui revient à tout moment, grandissant avec l'âge, prenant de l'acuité, s'éveillant de plus en plus, et sur le moindre fait, de façon à empoisonner l'existence; mais cette pensée ne devait pas être seule. L'important, le fond même de Lazare est de faire de lui un pessimiste, un malade de nos sciences commençantes. Voilà qui est curieux à étudier: l'avortement continu dans une nature, et dans une nature intelligente, qui a connaissance, des temps nouveaux, qui va avec la science, qui a touché à la méthode expérimentale, qui a lu notre littérature, mais qui nie tout par une sorte d'éblouissement, un peu d'étroitesse de vue et surtout beaucoup d'impuissance personnelle. Montrer en un mot un garçon très intelligent, en plein dans le mouvement actuel, et niant ce moment, se jetant dans le Schopenhauer.[35]

no such thing existed in France. But he had wished to make him demonstrate the ideas of pessimism as developed in France.[36]

It is obvious that Zola did not allow German metaphysics to penetrate too deeply into his literary world. When he had read *A Rebours* he commented on it politely and cautiously, but there is no doubt that in his heart of hearts he believed that Huysmans had allied himself with the enemies of naturalism: "Des Esseintes has a communicant in Mallarmé, drolly enough. . . . What can one say about it? If they don't shut up they may well turn it into a devil's Sabbath, or throw it at your head, or ours, as the latest rottenness of our literature. There is an odor of asininity in the air." * When reading these lines one is reminded of Renoir's letter to Durand-Ruel.

Zola's criticism compelled the tactician Huysmans to forswear his work. In a letter of reply he stressed that the novel by no means reflected his own personal views, which were instead to be found expressed in his art criticism, collected in the work *L'Art Moderne*, 1883. "That much is clear—and my antipodal preferences permit me to express truly sick ideas and to sing Mallarmé's praises—it seems to be a pretty affable hoax." **

It was obvious, however Huysmans tried to play his cards, that there were fundamental differences between the philosophies of des Esseintes and Lazare-Pauline. In Zola's book the life-enhancing powers were victorious, in Huysmans' the anti-life aspects. With that he had revealed the hotbed of the new aesthetic doctrines. Even if he himself was resolved that *A Rebours* was to be a mere episode in his career as an author, his "innocent joke" was not to be buried in silence. Instead it was the signal for the beginning of a literary and artistic campaign that passed like a hurricane through the cultural life of Paris.

---

* "Des Esseintes communie très drôlement en Mallarmé. . . . Que va-t-on en dire? S'ils ne se taisent pas, ils pourraient très bien en mener un sabbat du diable, ou le jeter à la tête à vous, à nous, comme la pourriture dernière de notre littérature. Il me semble que je sens des âneries dans l'air." [Tr. McGarrell.]

** "Ça c'est clair—et cette antipode absolue de mes préférences m'a permis d'émettre des idées vraiment malades et de célébrer la gloire de Mallarmé ce qui m'a semblé être d'une assez affable blague!" [37]

❧

IT HAS ALREADY BEEN INTIMATED that the new system of values that was emerging in the middle of the eighties was fundamentally anti-positivist and anti-naturalist in character. It was anchored in older French and German idealism, and often given a personal interpretation. As a matter of fact the individualist leanings of the young exponents of literature and art were so manifest that it may seem futile to seek a common denominator for their efforts. The new ideas and their application were borne forward on a wave of literary periodicals, which often disappeared after a short period of passionate activity. Thus Schopenhauer's and Wagner's aestheticism was interpreted by Téodor de Wyzewa in *La Revue Wagnérienne* (1885–88). In *Lutèce* (1883–86), mentioned above, the poet Jean Moréas defined the word that was, more than any other, to stand as the title of the whole epoch—symbolism. *Les Taches d'Encre* (November 1884 to February 1885 [!]) was a one-man periodical in which all the articles were written by Maurice Barrès. In *La Pléiade* (1886) the poet René Ghil, with *Traité du Verbe,* gave his opinion of a new poetic form.

*Les petites revues* and the coteries grouped around them were naturally in the first place of importance to the development of literature. One is therefore justified in asking if it is of any use referring to these periodicals in a work that is concerned with the visual art of the time—particularly as it would require considerable space to penetrate deeply into the literary jungle.[38]

Nevertheless the fact remains that it was in close contact with this aesthetic milieu that the *avant-garde* painting of the eighties developed. It seems incredible that writers and painters could have associated at such close quarters without their ideas converging at some point. On the contrary the values that literary symbolism attempted to interpret were shared to a large extent by the exponents of the visual arts, and they, in their turn, had perhaps their only sincere supporters among the symbolist poets. This does not imply that the artists were always conversant with all the labyrinths of the new

poetry. It would, therefore, take us an unnecessarily roundabout way to give a complete exposé of the literary symbolism. The following account has been concentrated, as hitherto, around a more practical plan, which attempts to restrict itself to the points of intersection in the aesthetic field where there was an exchange of ideas and experience between the various classes of creative artists.

The campaign that was opened in the middle of the eighties in Paris was a purely urban phenomenon. In the main it was restricted geographically on the south by the Rue de Rivoli, on the north by the Boulevard de Clichy, on the west by the Rue d'Amsterdam, and on the east by the Rue Lafitte. Within this rather limited zone were to be found the exhibition galleries and art dealers of the impressionists. The new periodicals that grew up according to the principle "every man his own editor" had located their offices in the bookshop district of Quartier Latin and St. Germaine, but several of them moved over to the right bank rather early. There were two periodicals of particular significance for the progressive visual arts in the middle of the eighties, *La Revue Indépendante* and *La Vogue*. Associated with them are the names of three very young journalist-strategists—Félix Fénéon, Edouard Dujardin, and Gustave Kahn —barely twenty years old but possessed of unmistakable ambitions.

Fénéon, who in the daytime was employed at the War Office, had associated diligently with the young poets since his arrival in Paris. He came into contact with the independent painters during the exhibition in the Tuilerie Gardens and at the meetings held in the neighboring Café Marengo in the Rue de Rivoli. The rendezvous that most suited the tastes of the young authors, however, was the Brasserie Gambrinus, which was also frequented by artists. It was there that Félix Fénéon started *La Revue Indépendante* in May 1884. It was issued first from the Rue de Medici, but was soon moved to the Rue Blanche in Montmartre. Stéphane Mallarmé was living in the Rue de Rome, not far from *La Revue Indépendante,* and he also became one of the first contributors to the periodical. An extremely varied group of writers contributed to the first number, including such authors as Edmond de Goncourt, Zola (!), Huysmans, Verlaine, Moréas, Morice, and Tailhade.

After Manet's death Mallarmé had left the meeting place of the impressionists at the Café de la Nouvelle Athènes near Pigalle, where they had met since the last years of the seventies, and moved to the Café d'Orient in the Place Clichy. There he regularly met the energetic Gustave Kahn, who in 1885 had just returned from military service in Algiers, and who was determined to make a name for himself in literature. The following year Kahn took over the editorship of the weekly magazine founded by Léo d'Orfer, *La Vogue* (in the Rue des Ecoles), which soon became a platform for Verlaine, Rimbaud, Laforgue, Mallarmé, Moréas, Ghil, and other moderns. In spite of the fact that Félix Fénéon had his own periodical, he preferred to publish much of his advanced art criticism in *La Vogue*.

Another habitué of the Café d'Orient was the tall, distinguished Edouard Dujardin, whom his friends thought—unfortunately erroneously—had a considerable fortune, and was therefore willing to invest money in divers risky literary adventures. In any case, Dujardin was one of the most versatile of the cultural radicals. He was one of the instigators of Mallarmé's Tuesday receptions, and had, with Dukas and Debussy, passed through the Conservatoire; after a visit to Bayreuth he introduced Richard Wagner as a philosopher and aesthete, and with the support of rich music enthusiasts he founded *La Revue Wagnérienne* in 1885, in collaboration with a Pole, Téodor de Wyzewa.

But his interests covered other spheres, too. Through his friends, Henri de Toulouse-Lautrec, Jacques-Emile Blanche, and Louis Anquetin, he kept in touch with the new trends in the visual arts. Further, he began to turn his attention to *La Revue Indépendante,* which Fénéon was finding difficult to keep alive. In 1886 he succeeded in getting himself elected manager of the periodical, and he immediately appointed Wyzewa and the lawyer Ajalbert joint editors with Fénéon.

Dujardin was firmly resolved to make *La Revue Indépendante* the leading periodical of its kind in Paris. He rented fashionable offices in Chaussée d'Antin in the shadow of the Opera, contributors were paid for their work (which was very unusual for that kind of publication), and a luxury edition with illustrations by more or less

radical artists was published for the financiers of the periodical. In order to augment its reputation with the public further, the well-to-do society painter Jacques-Emile Blanche became a member of the editorial staff. Business did not prosper, however, and in 1889 Dujardin was compelled to give up; the periodical changed hands, and reverted to a more modest existence.[39]

Even from such a brief account as this it should be clear that the opportunities were very favorable for exchanges of ideas and influence within the strictly limited zone. It is reasonable to assume, for example, that the central figures of the independent exhibition of 1884 were on the whole well aware of what was happening in the literary world. The most immediate effect, however, was probably the reaction that was so clearly discernible in the correspondence of the older impressionists: an indefinite feeling that something was in the air, a confused echo of new signals that created feelings of uncertainty and discomfort regarding their own work.

If the literary debate was to be a generative influence it would have to extend beyond the narrow radical circles of poets and become the subject of public discussion. This occurred during the latter part of 1885 and the spring of 1886.

In May 1885 the radical publisher, Léon Vanier, who was also the printer of *Lutèce,* issued a small book, the full title of which was *Les Déliquescences. Poèmes décadents d'Adoré Floupette, avec sa Vie par Marius Tapora. Byzance chez Lion Vanné, 1885.* As the title indicates, the book was the biography of an imaginary poet, Adoré Floupette, written by "a friend of the poet's," Marius Tapora, a chemist. Floupette himself had contributed a short preface, after which followed a score or more of his poems.[40]

The twenty-five-year-old Adoré Floupette may be regarded as the prototype of the young generation of poets. His literary development had passed from the schoolboy's admiration for the classical Racine, by way of Lamartine, Hugo, Musset, Vigny, and Bizeux, to Zola's naturalism, with which he became acquainted when, in accordance with his parents' wishes, he moved to Paris to study law. From that moment onwards his dream was to create "a great modern poem in which the naturalistic evolution of the century would be summed up in a few hundred lines. A washerwoman's barge, a railway station, a

hospital interior, a slaughterhouse, a horsemeat butcher, all today's poetry was there and there alone." *

After a time the poet and his biographer met in Paris. Tapora interviewed Floupette on the literary situation, and in reply to his questions was told that Zola was *démodé,* Hugo a *burgrave,* François Coppée a *bourgeois,* and that *Parnasse* wrote a *poésie rustique—bonne pour les Félibres.* When Tapora asked in horror what then remained, Floupette replied gravely: *Il reste le Symbole.*

To demonstrate the validity of his announcement the poet introduced his friend to the clique at the café, "Panier Fleuri." There the guests spent their time analyzing poetic futilities, the morphine syringe was passed around, and disturbing paradoxes were bandied about; all of which taken together produced an atmosphere of extreme eccentricity and preciosity, a desire to exploit the world of dreams, to *exprimer l'inexprimable.* Bottomless pessimism, atheism, and depravity were important ingredients in their philosophy of life.

Late at night Tapora accompanied the poet to his dwelling place, which is described as follows:

> A few wrinkled unstretched canvases were pinned here and there on the wall, and reflected in the mirror was a drawing by the great artist Pancrace Buret: a huge and magnificent spider, which bore a bouquet of eucalyptus flowers at the extremity of each tentacle, and whose body consisted of an enormous eye, desperately musing, the very sight of which made one shiver.**

In these surroundings Floupette gave a lecture on the aesthetics of literary evolution. The words in earlier French poetry, he maintained, had been tortured to death. But words were not merely combinations of letters, they are living entities, they march onwards.

---

* "un grand poeme moderne où serait resumée en quelques centaines de vers l'évolution naturaliste du siècle. Un bateau de blanchisseuses, une gare de chemin de fer, un intérieur d'hôpital, un abattoir, une boucherie hippophagique, toute la poésie possible aujourd'hui était là et rien que là." [41]

** Quelques crépons étaient, ça et là, piqués au mur par des épingles, et dans la glace se réflétait un dessin du grand artiste Pancrace Buret: Une magnifique araignée gigantesque qui portait à l'extrémité de chacune de ses tentacles un bouquet de fleurs d'eucalyptus et dont le corps était constitué par un œil énorme, désespérément songeur, dont la vue seule vous faisait frissonner. [42]

One does not paint with words; they are paintings in themselves.
Not only that:

> The words sing, murmur, whisper, splash, coo, creak, tintinnabu-
> late, clarion forth; they are, in turn, the shiver of water over moss, the
> glaucous song of the sea, the basso profundo of the storm, the sinister
> ululation of wolves in the forest. . . .*

Tapora was given more views on the new problems of poetry
the following day, and he was introduced to Arsenal and Bleucoton,
"the two great initiators of the poetry of the future." Their conversa-
tion is not reported, however, but instead Floupette's own preface is
given. In half unintelligible slang it suggests "a very sweet and very
dear music of half-decomposed hearts" ** intended to imbue the
reader with a suitably poetic state of mind. For reasons that will be
discussed later one of the poems that follow, a satire on Mallarmé's
"Idylle Symbolique," is given here.

| Symbolic Idyll | Idylle Symbolique |
|---|---|
| The child abdicates her joy. | L'enfant abdique son extase. |
| And, already taught by roads, | Et, docte déjà par chemins, |
| She utters the word: Anastase! | Elle dit le mot: Anastase! |
| Born for Eternal parchments. | Né pour d'Éternels parchemins. |
| | |
| Before a Sepulcher may laugh | Avant qu'un Sépulcre ne rie |
| Beneath some sky, her ancestor | Sous aucun climat, son aïeul, |
| At bearing this name: Beauty | De porter ce nom: Pulchérie |
| Hidden by the overlarge Gladi-olus.[44] | Caché par le trop grand Glaïeul. |
| | Stéphane Mallarmé |
| | |
| Girls in love, hypnotized | Amoureuses Hypnotisées |
| By the indolence of hope, | Par l'Indolence des Espoirs, |
| Soft young men, darkly gleaming | Éphèbes doux, aux reflets noirs, |
| With bedewed immodesties, | Avec des impudeurs rosées, |
| | |
| In murmur of an Ave, | Par le murmure d'un Ave, |
| Disappeared! O strange miracle! | Disparus! O miracle Etrange! |

* Les mots chantent, murmurent, susurrent, clapotent, roucoulent, grincent,
tintinnabulent, claironnent; ils sont, tour à tour, le frisson de l'eau sur la mousse,
la chanson glauque de la mer, la basse profonde des orages, le hululement si-
nistre des loups dans les bois. . . .[43]
** une très douce et très chère musique des cœurs à demi-décomposés

| The Demon complements the Angel, | Le démon supplée par l'Ange, |
| Vile Hyperbole escaped! | Le vil Hyperbole sauvé! |
| | |
| They speak, with nuances, | Ils parlent, avec des nuances, |
| As, in the grassy heart of bowling greens, | Comme, au cœur vert des boulingrins, |
| Do Bengalis and canary birds | Les Bengalis et les serins, |
| And faithful bill collectors. | Et ceux qui portent des créances. |
| | |
| But they utter the word: Chouchou, | Mais ils disent le mot: Chouchou, |
| —Born for Holland paper,— | —Né pour du papier de Hollande,— |
| And behold them solitary on the moor, | Et les voilà seuls, dans la lande, |
| 'Neath the too-small raincoat! [45] | Sous le trop petit caoutchouc! |

Naturally *Les Déliquescences* was conceived as a biting satire on literary symbolism, and as such it was undoubtedly a great success. An edition of 1,500 copies was published, and sold out in a fortnight, which must be regarded as remarkable in comparison, for example, with the sales of Verlaine's poetry.

The reviews in *Gil Blas* on 17 May and in *La Justice* on 19 July applauded Floupette and pronounced an anathema against the new suspect literature. More significant, however, was the article published by Paul Bourde in *Le Temps* on 6 August. In it Adoré Floupette was compared to Verlaine and Mallarmé in their relationship to the Parnassus poetry. The writer went through the most important names and works of the new school and showed how extremely close to reality the book was. Neither the pursuit of preciosity and the exceptional by the young poets, nor their neurotic attitudes would have been worth wasting words on, he wrote, if it were not for the fact that they really had succeeded in renewing the rhythm and the language of poetry. Verlaine and Mallarmé had continued where Hugo and Baudelaire had left off, but for Bourde it was an open question whether they had allowed their vision to be obscured by a too one-sided desire for virtuosity.[46]

He closed his article sensationally by disclosing the names of

those behind the imaginary Adoré Floupette. He probably had his omniscient colleague at *Le Temps,* Jules Claretie, to thank for this information. Claretie had contributed to *Le Petit Journal,* and could report that the editor-in-chief, Henri Beauclaire, together with the somewhat older poet Gabriel Vicaire, had written *Les Déliquescences.* This meant that the book was the work of two people closely associated with the symbolists, and well acquainted with the milieu. It was not difficult for them to give the correct local color to the coterie at Le Panier Fleuri (the Brasserie Gambrinus), to Arsenal (Mallarmé), and to Bleucoton (Verlaine). Pancrace Buret's octopus in Floupette's den was supposed to be a drawing by Odilon Redon. Otherwise the idea was taken from *A Rebours.*[47] The poems were cleverly composed parodies on Mallarmé's manneristic play on words, Verlaine's erotic mysticism, Rimbaud's hallucinationist poems, and Laforgue's neurotic works.

At the bottom of their hearts the decadent poets were no doubt gratified by the attention paid to *Les Déliquescences,* but this did not prevent Jean Moréas from replying to the articles in the press, particularly that by Paul Bourde. A few days after the publication of Bourde's article, Moréas announced in *Le XIX<sup>e</sup> siècle* (11 August 1885) that only to a very small extent did the young poets draw nourishment from the pale lips of the Goddess Morphine, nor did they devour bleeding fetuses. They preferred to drink from ordinary glasses rather than from their grandmother's skulls; it was their habit to work in the dark winter evenings, not cultivate the acquaintance of the Devil in order to attend witches' sabbaths and mumble horrifying blasphemies, wag red tails, and shake foul heads of oxen, asses, swine, and horses. He claimed that the young poets were followers of Baudelaire, and that in their art they sought the pure idea and eternal symbol as defined by Edgar Allan Poe.

By referring to the influence of Poe's aesthetics, Moréas was touching on an essential point in the new doctrines. In Poe reason and emotion were combined in mystical speculations. In his *Philosophy of Composition* he had maintained that a poet ought to evolve with mathematical consistency. The emotion was of subordinate importance. The creation of poetic effect and rhythmic beauty was the only important thing. Treating an irrational theme rationally, he

thought, would increase the poetic effect.[48] The young French poets worked according to this mixture of idealism and rationalism when they strove to create an art "which would be vaguely poetry, painting, music, but not simply painting, or poetry,—something like a concert of colors, a painting of musical notes,—a willful fusion of genres, a Tenth Muse." *

It would be an exaggeration to claim that the artists—with the possible exception of Redon—need feel directly concerned in the debate, but it cannot be denied that it contributed towards making the antagonism between idealism and naturalism more clear. It became a point of honor for all engaged in art to choose their standpoint, to try to understand the significance of the associations contained in such words as *idea, dream, symbol.* In that respect radical art criticism was an invaluable link between the visual arts and literature. The young critics were all from the ranks of those singled out, and shared completely the aesthetic valuation of symbolism. Still the impressionist and independent painters might possibly, in spite of everything, have preferred to remain outside the struggle if they had not just then been made the victims of something they regarded as base treason. The attack did not, perhaps, come wholly by surprise, but the blow was none the less heavy, and cut into their artistic souls like the lash of a whip. The man who dealt the blow was Zola.

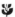

BOTH MONET AND RENOIR had had work accepted by the Salon in 1880, but their pictures were hung so indifferently that the two artists sent a letter of protest to the Minister of Culture. A copy of the letter was sent to Cézanne, who was asked to forward it to Zola with a request that he publish it with comments in the daily papers.[50] Cézanne did as his colleagues wished, and Zola, who had taken practically no part in debates on art since his commendable

---

* "qui serait vaguement des vers, de la peinture, de la musique, ni de la peinture, ni des vers,—quelque chose comme un concert fait avec des couleurs, comme un tableau fait avec des notes,—une fusion voulue des genres, une Dixième Muse." [49]

action for the impressionists in *L'Evènement* in the sixties, placed his services at their disposal.

Between 18 and 22 June he published three articles in *Le Voltaire* on the current Salon in connection with Monet's and Renoir's protest. His opinion of the contributions of the impressionists was, however, quite different from what the painters themselves had anticipated. He began by accusing them of isolationist tendencies. They had formed a clique instead of carrying on their struggle within the walls of the Salon, the only platform from which their efforts would gradually gain respect. The only one who had gained any advantage from these group exhibitions, he maintained, was Degas, whom he wished to distinguish stylistically from the impressionists proper.

After that he made a rapid survey of the advances these painters had made, and pointed out their significance to French art. But he closed:

> The great misfortune is that not one artist of this group has realized powerfully and definitively the new formula that they all bring, dispersed throughout their works. The formula is there, infinitely divided; but nowhere, not in any of them, does one find it applied by a master. . . . One may reproach them for their personal weaknesses, but they are nonetheless the veritable craftsmen of the century. . . . They leave gaps, they are too often sloppy, they are too easily satisfied with themselves, they show themselves to be unfinished, illogical, exaggerated, impotent. But it doesn't matter; working with contemporary naturalism is enough to put them at the head of a movement and to cause them to play a considerable role in our school of painting.*

* Le grand malheur, c'est que pas un artiste de ce groupe n'a réalisé puissamment et définitivement la formule nouvelle qu'ils apportent tous, éparse dans leurs œuvres. La formule est là, divisée à l'infini; mais nulle part, dans aucun d'eux, on ne la trouve appliquée par un maître. . . . On peut leur reprocher leur impuissance personnelle, ils n'en sont pas moins les véritables ouvriers du siècle. . . . Ils ont bien des trous, ils lâchent trop souvent leur facture, ils se satisfont trop aisément, ils se montrent incomplets, illogiques, exagérés, impuissants; n'importe, il leur suffit de travailler au naturalisme contemporain pour se mettre à la tête d'un mouvement et pour jouer un rôle considérable dans notre école de peinture.[51]

Thus Zola reproached his old friends for not having a *style*. They fell short of the demands he made on "naturalist" painting. Their inability to apply *la formule nouvelle* in order to present existence from all possible angles was a problem that was to occupy his thoughts during the following years. In 1882 Paul Alexis published a work on the Médan master—*Emile Zola, Notes d'un Ami*. In it he described the novels that Zola was then considering. One of them was about art, and the principal character was taken from one of his earlier books in the Rougon-Maquart series, *Le Ventre de Paris:*

> I know that he plans to sketch, in Claude Lantier, the horrible psychology of artistic impotence. Around the central man of genius, a sublime dreamer paralyzed in his production by a flaw, other artists, painters, sculptors, musicians, men of letters gravitate—a whole band of ambitious young people who have come to conquer Paris, some of them failing, the others more or less succeeding; all of them cases of the illness of art: *varieties of the great neurosis of today.**

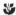

YEARS PASSED BY, but no novel of the kind announced by Alexis saw the light of day. Instead other parts of the great family chronicle appeared; the above-mentioned *La Joie de Vivre* (1884) and the mining novel, *Germinal* (1885). At the end of December 1885, however, *Gil Blas* began the serial publication of a new novel by Zola—*L'Œuvre*. On 22 February 1886 the author had completed the last page of the manuscript, and shortly afterwards the book was published by Charpentier.[53]

The story opens with the artist, Claude Lantier, walking late one night from the Halls to his studio. He is overtaken by a violent thunderstorm. Just as he is about to enter the house a flash of light-

---

* Je sais qu'il compte étudier, dans Claude Lantier, la psychologie épouvantable de l'impuissance artistique. Autour de l'homme de génie central, sublime rêveur paralysé dans la production par une fêlure, graviteront d'autres artistes, peintres, sculpteurs, musiciens, hommes de lettres, toute une bande de jeunes ambitieux également venus pour conquérir Paris: les uns ratant leur affaire, les autres réussissant plus ou moins; tous, des cas de la maladie de l'art; *des variétés de la grande névrose actuelle.*[52]

ning reveals a young woman pressed close to the wall. She tells him a barely credible story of how she has come to Paris for the first time. Her train was late and she was unable to meet the person who was to receive her at the station. She had taken a cab to her address in Plassy, but the driver had behaved improperly and she had been compelled to leave the cab. Now she knew neither where she was nor what to do. Lantier, who on principle distrusted women, was convinced that she was a streetwalker, but his kind heart overcame his distrust and he gave her shelter for the night. It proved, however, that the girl—Christine Hallegrin—had spoken the truth. Their odd meeting led to friendship and gradually to love.

The next chapter introduces two of Lantier's childhood friends from the south of France: the young author Pierre Sandoz, and the student of architecture Dubuche. Sandoz acts as a model for a large painting, *Plein-air,* that Claude is working on. It shows a number of naked women and a fully dressed man resting in the sunshine in a wood. In spite of the fact that the artist had been working on the picture until he was quite exhausted, it never became quite what he wanted:

—Too dark still, I'm damned if it isn't! Delacroix, that. Can't get away from him. And the hand there, look at it. That's Courbet, pure Courbet! . . . That's what's wrong with all of us, we're still wallowing in Romanticism. We dabbled in it too long when we were kids, and now we are in it up to the neck. What we need is a thorough scrubbing.*

Claude Lantier's sketches had begun to attract the attention of a number of art dealers who realized that in their bold treatment of color, they represented something new and sincere. But it was with the large canvas *Plein-air* that he wished to conquer the Salon, and thus prove the greatness of his genius, of which both he and his friends were convinced.

The naked figure in the foreground was particularly difficult. Fi-

* —Nom d'un chien, c'est encore noir! J'ai ce sacré Delacroix dans l'œil. Et ça, tiens! cette main-là, c'est du Courbet. . . . Ah! nous y trempons tous, dans la sauce romantique. Notre jeunesse y a trop barboté, nous en sommes barbouillés jusqu'au mention. Il nous faudra une fameuse lavisse.[54]

nally he succeeded in persuading Christine to act as model. The picture was completed and he sent it to the Salon. It was not accepted, but was hung at the *Salon des Refusés,* where it was a *succès de scandale.* His friends were all the more convinced of his unique genius, and his gifted and nimble-fingered colleague, Fagerolles, resolved to remember the lessons of the painting.

Claude Lantier himself, however, was deeply hurt by the reaction of the public. He severed his connections with his friends and isolated himself with Christine in the country, to the west of Paris. Four seemingly happy years passed by during which Lantier applied himself to open-air painting. Finally the isolation became too depressing; his longing for his old friends was too strong, and the family—now increased by a baby boy—returned to Paris.

They found many changes. Some of Claude's artist friends, Fagerolles, for example, had won fame by the cautious application of Claude's bold naturalism. Others had sunk into apathy as a consequence of inhuman privation. Sandoz had begun to win fame as an author and, by virtue of his Thursday meetings, he was still the fixed point in the circle of friends. Claude Lantier found himself almost forgotten.

Nevertheless he was firmly resolved to create a new name for himself in the art market. Several attempts to gain a new entry into the official Salon with open-air paintings were unsuccessful, however, and he became a victim of depression. Finally he pulled himself together to carry out a monumental project, a mighty apotheosis of Paris. He already had the scene clear in his head, and he described it to Christine:

"Look!" he said. "It's what we saw yesterday. . . . A superb sight! I spent three hours there to-day, and now I've got it. Just what I want. Amazing! A knock-out, if ever there was one! . . . Look, this is it. I stand under the bridge, with the Port Saint-Nicolas, the crane and the barges with all the porters busy unloading them, in the foreground, see? That's Paris at work, understand: hefty labourers, with bare arms and chests and plenty of muscle! . . . Now on the other side, there's the swimming-bath, Paris at play this time. There'll be an odd boat or something there, to fill the centre, but I'm not too sure about that. I shall have to

work it out a bit first. . . . There'll be the Seine, of course, between the two, a good broad stretch. . . ." *

For months he studied by the Seine, all hours of the day and in all sorts of weather. He hired an old drying room that had belonged to a dyer, forty feet long and thirty wide. Here he made a sketch on cardboard and then began to transfer it to an enormous canvas he had stretched across one wall. Being unaccustomed to the gigantic format he continually got entangled in contradictory problems of perspective, but he worked tenaciously, as if in a trance. In the evenings he staggered home completely exhausted. His heroic work resulted in a magnificent "sketch," a blaze of uncoordinated colors. The friends who saw the work were delighted. Sandoz invited the whole company to a celebration dinner.

Then inspiration seemed to flag. For three years Lantier struggled with details that would never come right. At last he was ready to give up, but after a period of apathy he began a new study of the same subject, this time somewhat smaller. To balance the composition, he placed a naked woman in the Seine boat in the center of the sketch, and he was so pleased with the effect that he began working on the large canvas again. The whole family moved into the studio barracks, for Lantier's small fortune had dwindled to almost nothing. Christine helped her husband in all kinds of ways, and at last she posed again.

The naked woman in the center of the picture had become a fixed idea with Claude Lantier. She was to symbolize Paris, indeed life itself. She became the dominant feature of the monumental painting, but Lantier was never satisfied with his work. Christine was compelled to pose until she collapsed from exhaustion, and at the same time she felt that she had become less interesting as a

---

* Tiens! C'est ce que nous avons vu hier. . . . Oh! superbe! J'y ai passé trois heures aujourd'hui, je tiens mon affaire, oh!, quelque chose d'étonnant, un coup à tout démolir. . . . Regarde! Je me plante sous le pont, j'ai pour premier plan le port Saint-Nicolas, avec sa grue, ses péniches qu'on décharge, son peuple de débardeurs. Hein? Tu comprends, c'est Paris qui travaille ça! Des gaillards solides, étalant le nu de leur poitrine et de leurs bras . . . Puis de l'autre côté, j'ai le bain froid, Paris qui s'amuse, et une barque sans doute, là, pour occuper le centre de la composition; mais ça je ne sais pas bien encore, il faut que je cherche. . . . Naturellement, la Seine au milieu, large, immense. . . .[55]

human being in her husband's eyes. The woman he loved so passionately was the woman in the "masterpiece" on the wall. The more Claude became enthralled by the painting, the more Christine hated it. In reply to her increasingly earnest prayers to him to give up his mad idea he replied stubbornly: "I'm going on with it, and it will kill me, and it will kill my wife, my child, the whole mess, but it will be a masterpiece, God damn it!" *

One morning Claude and Christine found their weakling son dead. The artist at once began painting a portrait of the dead child. For five hours he worked without a break. When Sandoz came on a visit a day or two later he stood before the picture in melancholy admiration. In it he recognized Lantier's former fine touch. It was a masterpiece of luminous intensity and color. Claude decided to send the portrait to the Salon. His old painter colleague, Fagerolles, was now a member of the jury. By availing himself of the so-call *charité* right (every member of the jury had the right to approve one painting on his own responsibility) he managed to get the picture accepted. *L'Enfant Mort,* being badly hung, aroused no interest at all, and Lantier was seized with despair.

One night Christine found her husband standing on a ladder in the studio painting by the light of a candle. He was working on the Naked Woman, heedless of the melted wax that ran down over his left hand.

> Yes, there he was with the other woman, painting her legs and body like some infatuated visionary driven by the torments of the real to the exaltation of the unreal, making her legs the gilded columns of a temple and her body a blaze of red and yellow, a star, magnificent, unearthly. Nudity thus enshrined and set in precious stones, demanding to be worshipped, was more than Christine could tolerate. She had gone through too much already; she would put an end to this betrayal.**

---

* "Je vais m'y remettre, et il me tuera, et il tuera ma femme, mon enfant, toute la baraque, mais ce sera un chef-d'œuvre, nom de Dieu!"

** Oui, il était bien avec l'autre, il peignait le ventre et les cuisses en visionnaire affolé, que le tourment du vrai jetait à l'exaltation de l'irréel; et ces cuisses se doraient en colonnes de tabernacle, ce ventre devenait un astre, éclatant de jaune et de rouge purs, splendide et hors de la vie. Une si étrange nudité d'ostensoir, où des pierreries semblaient luire, pour quelque adoration religieuse, acheva de la fâcher.[56]

Inspired by a sudden strange power Christine began to persuade Claude for the last time to desist from the wild abortive undertaking. She finally succeeded in convincing him that he was living in an illusory world, and that he must return to life. By mobilizing all her feminine resources she managed to induce him to forswear the picture and return to her. When Christine awoke she was alone. An awful feeling of disaster overcame her when she went out into the studio to look for Claude.

> And there he hung, in his shirt, barefooted, an agonizing sight, his tongue blackened and his eyes bloodshot and starting from their sockets, stiff, motionless, looking taller than ever. His face was turned towards the picture and quite close to the Woman whose sex blossomed as a mystic rose, as if his soul had passed into her with his last dying breath and he was still gazing on her with his fixed and lifeless eyes.*

IN HIS COMMENTS on the plans of *L'Œuvre* Paul Alexis had also written that Zola was compelled to take advantage of his friends, and to include their most typical features in his works. If I were to find myself represented there in an unflattering way, he wrote, I would still not begin to quarrel with him.[58]

This complaisance, however, was by no means shared by the artists. They regarded *L'Œuvre* as a *roman à clef*. It could, they thought, only injure them in the eyes of the public. Monet's letter of thanks to Zola, dated Giverny, 5 April 1886, gives a good indication of the reactions of the artists:

> My dear Zola,
> You were good enough to send me *L'Œuvre*. I am very grateful to you for it. I have always enjoyed reading your books, and this one was doubly interesting to me because it raises questions about art for which we have been fighting so long. I have just read it and I am worried and upset, I admit.

---

* En chemise, les pieds nus, atroce avec sa langue noir et ses yeux sanglants sortis des orbites, il pendait là, grandi affreusement dans sa raideur immobile, la face tournée vers le tableau, tout près de la Femme au sexe fleuri d'une rose mystique, comme s'il lui eût souffé son âme à son dernier râle, et qu'il l'eût regardée encore, des ses prunelles fixes.[57]

You were purposely careful to have none of your characters resemble any one of us, but, in spite of that, I am afraid lest our enemies amongst the public and the press identify Manet or ourselves with failures, which is not what you have in mind, I cannot believe it.

Forgive me for telling you this. It is not a criticism; I have read *L'Œuvre* with great pleasure, finding memories on every page. Moreover you are aware of my fanatical admiration for your talent. No; but I have been struggling for a long time and I am afraid that, just as we are about to meet with success, our enemies may make use of your book to overwhelm us.

Excuse this long letter. Remember me to Madam Zola, and thank you again.

<div style="text-align: right;">

Devotedly yours,
CLAUDE MONET *

</div>

Who then was the prototype of Zola's character, Claude Lantier? It is obvious that he borrowed features from Manet, Monet, and Renoir. Art history research is probably unanimous in the view that in the first place it was Zola's childhood friend, Paul Cézanne, who had been the model for Claude Lantier.[60] This view is based on three circumstances: Cézanne's abrupt break with Zola after receiving a copy of *L'Œuvre*,[61] Emile Bernard's notes of Cézanne's statements about Zola,[62] and Ambroise Vollard's supposed interview with Zola at Médan in 1898.[63] From this circumstantial evidence it

* Mon cher Zola,

Vous avez eu l'obligeance de m'envoyer *L'Œuvre*. Je vous en suis trés reconnaissant. J'ai toujours un grand plaisir à lire vos livres et celui-ci m'intéressait doublement puisqu'il soulève des questions d'art pour lesquelles nous combattons depuis si longtemps. Je viens de le lire et je reste troublé, inquiet, je vous l'avoue.

Vous avez pris soin, avec intention, que pas un seul de vos personnages ne ressemble à l'un de nous, mais malgré cela, j'ai peur que dans la presse et le public nos ennemis ne prononcent les noms de Manet ou tout au moins les nôtres pour en faire des ratés, ce qui n'est pas dans votre esprit, je ne veux pas le croire.

Excusez-moi de vous dire cela. Ce n'est pas une critique; j'ai lu *L'Œuvre* avec un très grand plaisir, retrouvant des souvenirs à chaque page. Vous savez du reste mon admiration fanatique pour votre talent. Non: mais je lutte depuis un assez longtemps et j'ai des craintes qu'au moment d'arriver, les ennemis ne se servent de votre livre pour nous assommer.

Excusez cette trop longue lettre, rappelez-moi au souvenir de M$^{me}$ Zola, et merci encore.

<div style="text-align: right;">

Votre tout dévoué,
CLAUDE MONET [59]

</div>

may be inferred that Zola in *L'Œuvre* had created an extremely un-just picture of Cézanne, and that he was also totally ignorant of the current trends in art.

Some attempts have been made by literary historians to rehabili-tate Zola. It has been pointed out quite correctly that the statements of Bernard and Vollard are very imaginative and partial, and should be used with great caution. It has further been stressed that Zola's intention was not to write a history of impressionism, but to illus-trate, in the form of a novel, the rupture between romanticism and naturalism. *L'Œuvre,* it has been said, is also an expansion of Bal-zac's *Le Chef-d'œuvre inconnu.* Finally it has been emphasized that not only Sandoz, but Claude Lantier, too, are to a great extent Zola himself, or rather the irrational, "Mallarméan" side of Zola.[64]

All this may be true, but it does not explain Monet's attitude; nor does it explain the reaction that can be traced, for example, in Camille Pissarro's letter to Lucien, written in March 1886:

> I went to dinner with the impressionists. This time a great many came: Duret brought Burty, an influential critic, Moore, the English novelist, the poet Mallarmé, Huysmans, M. Deudon, and M. Bérard; it was a real gathering. Monet had been in Holland,—he arrived from The Hague at eight o'clock, just in time for dinner.—I had a long discussion with Huysmans, he is very conversant with the new art and is anxious to break a lance for us. We spoke of the novel *His Masterpiece.* He is decidedly of my opinion. It seems that he had a quarrel with Zola, who is very worried. Guillemet, who is furious about the book, also wrote to Zola, but only to complain that *Fage-rolles* is too easily identifiable. They are telling a charming anecdote in connection with the book: Guillemet, who worships Zola, and with good reason, wanted his name to appear on this work, which he was certain would add to Zola's renown. He wrote Zola, requesting that the book be dedicated to him. Zola, very embarrassed, as you can imagine, by this expression of admiration, replied that he was reserv-ing all dedications until the whole *Rougon-Macquart* series appeared. But since *His Masterpiece* was published, Guillemet's ardor has melted like butter in the sun; he wrote Zola a long letter of com-plaint. Zola assured him that it was Gervex he had described. Guil-lemet calmed down, completely content with this explanation.—As

for Gervex, he takes a different attitude. He has his friends call him "Fagerolles." At X's marriage he paraded this name.

What I have written you should not be repeated.*

The letter provides additional proof that Zola's novel was regarded as a contribution to the current art debate, and not as a kind of historical work. Paul Alexis in his advance notes had also stressed that Zola would describe "des variétés de la grande névrose actuelle." In other words the book had a message. The difficulties of interpreting Zola's intentions are mainly due, however, to the fact that the novel had several dimensions of time. At the beginning of *L'Œuvre* Claude Lantier is working on a picture reminiscent of Manet's *Déjeuner sur l'herbe*. What is more, it is said in the book that Lantier's picture was hung in the first *Salon des Refusés* (1863), at which Manet's painting was the great attraction. But Lantier's style was wilder, less restrained than Manet's was in reality. Cézannes's early works were probably the closest equivalent. When one studies any of these works—*La Moderne Olympia* (Fig. 4), for example —one is convinced that Claude Lantier would have painted in this manner if he had been flesh and blood.

The women he hustled out of his studio he adored in his pictures. He caressed them, outraged them even, and shed tears of despair over his

* J'ai dîné avec les impressionistes. On était nombreux cette fois: Duret avait amené Burty, critique influent, Moore, le naturaliste anglais, Mallarmé, le poète, et Huysmans, M. Deudon, M. Bérard, c'était un vrai banquet. Monet était en Hollande—arrivait de La Haye à huit heures, juste pour se mettre à table. —J'ai beaucoup parlé: avec Huysmans. Il est très au courant de l'art nouveau, très désireux de rompre des lances en notre faveur.—Nous avons parlé de *L'Œuvre*. Il est absolument de mon avis. Il a, paraît-il, eu un attrapage avec Zola qui est très inquiet. Guillemet, furieux, lui a écrit aussi, mais pour se plaindre de la transparence du rôle de Fagerolles. Il a eu, à propos de ce livre, une petite anecdote charmante: Guillemet, enthousiasmé de Zola, et pour cause, désirant beaucoup figurer en nom sur cette œuvre qui devait illustrer son auteur, avait écrit à Zola pour avoir la faveur de la dédicace. Zola, comme bien tu penses, fort embarrassé de cette ardeur, lui écrivit qu'il ne mettrait de dédicaces que lorsque tous ses romans serait publiés en série. Mais depuis que *L'Œuvre* a paru, l'enthousiasme de Guillemet s'est fondu comme beurre au soleil; il a écrit une longue lettre de plaintes. Zola lui a assuré que c'est Gervex qu'il a voulu mettre en scène. Guillemet, plus calme, s'est parfaitement contenté de cette explication.—Quant à Gervex, c'est tout le contraire. Il se fait appeler par tous ses amis "Fagerolles". Au mariage de X., il s'était tout le temps paré de ce nom triomphal.

C'est entre nous, ce que je t'écris.[65]

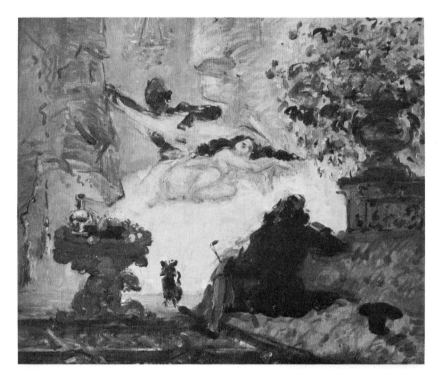

FIG. 4 Paul Cézanne, *La Moderne Olympia*, 1872, Le Louvre, Paris.

failures to make them either sufficiently beautiful or sufficiently alive.*

In the strongly emotional *La Moderne Olympia* the object-subject relationship between the work and its creator has been erased. Cézanne is literally and in spirit in his picture. Two worlds meet in the Olympia in dramatic conflict. The dismal foreground figure contrasts with a scene of beauty bathed in light. The conventional prospective is dissolved, and the figures become in their peculiar isolation incarnations of Baudelairean satanism. Cézanne painted, as did Claude Lantier, with a romantic irony no less demonic than that of Goya and Daumier.

This was by no means the artistic problem of the impressionists,

* Ces filles qu'il chassait de son atelier, il les adorait dans ses tableaux, il les caressait et les violentait, désespéré jusqu'aux larmes de ne pouvoir les faire assez belles, assez vivantes.[66]

and Claude Lantier's evolution as a painter had not much in common with the art of the seventies. It is true that he spent four years at Bennecourt as an open-air painter, but his work executed during that period is very vaguely and roughly outlined by the author.[67] The references to the impressionists are mostly superficial, as, for example, in the account of Claude Lantier's relations with the official Salon. In this connection Zola had an opportunity to follow exactly the same line of thought as in his criticism of the Salon in 1880.[68] As has been shown by Monet's and Renoir's action in this question, they had drifted so far from Zola that they were constrained to enlist the services of Cézanne as a go-between.

Nor does Claude Lantier's masterpiece, the apotheosis of Paris, remind one in the first place of impressionism, but is described as a "social-realistic" monumental painting, into which a stylistically contradictory element is gradually introduced:

The background, the embankment, the Seine, with the prow of the Cité rising triumphantly out of it, were merely sketched in, but sketched in by a masterly hand, as if the painter had been afraid of spoiling his dream Paris by an excess of detail. To the left there was one excellent group, porters unloading sacks of plaster, which was beautifully and powerfully finished. But the boat with the female figures in it simply broke the canvas with a violent burst of flesh tints which were completely out of place. The big nude figure in particular, which had clearly been painted at fever-heat and had the glow and the strange larger-than-life quality of an hallucination, struck a disturbing and discordant note amid all the realism of the rest of the picture.*

This account of the Masterpiece is no longer, as at the beginning of the novel, concerned with the question of a rupture between ro-

---

* Les fonds, les quais, la Seine, d'où montait la pointe triomphale de la Cité, demeuraient à l'état d'ébauche, mais d'ébauche magistrale, comme si le peintre avait eu peur de gâter le Paris de son rêve, en le finissant davantage. A gauche se trouvait aussi un groupe excellent, les débardeurs qui déchargaient les sacs de plâtre, des morceaux très travaillés ceux-là, d'une belle puissance de facture. Seulement, la barque des femmes, au milieu, trouait le tableau d'un flamboiement de chairs qui n'étaient pas à leur place; et la grande figure nue surtout, peinte dans la fièvre, avait un éclat, un grandissement d'hallucination d'une fausseté étrange et déconcertante au milieu des réalités voisines.[69]

manticism and realism, but between naturalism and symbolism. The descriptions of the symbolic naked woman that appear here and there in the book, parts of which have been given above, draw one's thoughts to work by Gustave Moreau, whose post-romantic art was used with good effect in Huysmans' *A Rebours*. But as a whole, Zola's "painting" has nothing in common with Moreau's style, of which the author, in his criticism of *A Rebours,* wrote: "Personelle- ment, je n'ai que de la curiosité pour Gustave Moreau." [70]

In the light of this, one is inclined to assign Lantier's painting to the category of literary constructions, created with the intention of il- lustrating a crisis in literature rather than in art. There are, however, certain facts that point in another direction. An important feature of the novel is the story of how Claude paints the portrait of his dead child, and then gets the work hung in the Salon. The episode is based on an actual event. After many years of fruitless attempts to gain admission to the Salon, Cézanne, with the help of a friend in the Médan circle who was a member of the jury—the Antoine Guillemet of the Pissarro letter—succeeded in getting a picture accepted. It is improbable, however, that the *motif* was the same as that described by Zola. On the other hand, Félix Fénéon stated, as early as 1886, that the painting *L'Enfant Mort* by Albert Dubois- Pillet was the same picture as described by Zola in *L'Œuvre.*[71]

This throws new light on Zola's book. It has already been men- tioned that Dubois-Pillet's painting was hung in the independent ex- hibition in the Tuilerie Gardens in May–June 1884. The artist was, it will be remembered, an army officer. Towards the end of the eighties he was given a command at Le Puy, where he died suddenly in 1890. For that reason *L'Enfant Mort* (Fig. 5) hangs in Musée Crozatier at Le Puy-en-Velay. Judging by the title, *Cécile Louise 20 Xber 1881,* the portrait was executed in 1881. Its treatment is un- sentimental and realistic, with a pronounced emphasis on the mate- rial, like a still life by Manet. Perhaps that is what makes it so mov- ing. It is easy to understand that the work could arouse Zola's fantasy and, to a certain extent, satisfy his demand for epic natural- ism.

It is highly probable that Zola had visited and carefully studied the 1884 independent exhibition. If this is so, one has every reason

FIG. 5 Albert Dubois-Pillet, *L'Enfant Mort,* 1881, Musée Crozatier, Le Puy-en-Velay.

to assume that he also kept in touch with other current trends in art in Paris.

There were probably no difficulties in the way of Zola's obtaining information on the new tendencies in art. He could have gotten it from Henri Gervex, who had begun as a successful Salon painter, but who had been expelled in 1878 on account of his "immoral" nude scene from Musset's novel *Rolla.* In the eighties he became a highly appreciated *vie en redingote* artist among the respectable middle class. His special background made him an initiated recorder of trends within the art world. (He was, too, Georges Seurat's teacher for a time, and was, as we have seen, invited to participate in the first exhibition arranged by *Les XX.*)

It has been shown above that Zola was one of the early contributors to *La Revue Indépendante,* which may have increased his knowledge of *avant-garde* circles. It is important in this connection to stress that there were no watertight compartments between the

champions of different aesthetic ideals. Thus Mallarmé and Zola, for example, kept up a correspondence for many years, which shows, among other things, that Mallarmé could appreciate the traits in Zola that reflected a mystically inclined pantheism, and admire the architectural construction of his novels.[72]

But above all, Zola was very friendly with Paul Alexis in the *Cri du Peuple*. Alexis appears in *L'Œuvre* lightly disguised as the journalist Paul Jory. Zola's draft of this character resolves itself into a sketch of the prevailing cultural life as reflected in the small periodicals, which has many parallels in the quarters surrounding L'Opéra, described earlier in this chapter.[73] Thus there is reason to seek a real prototype of Claude Lantier's paintings, particularly in his apotheosis of Paris, outside the ranks of the original impressionists.

In his biography of Louis Anquetin, Emile Bernard described the enthusiastic triumvirate of young painters—Bernard, Anquetin, and Toulouse-Lautrec—established in 1884 at the Boulevard de Clichy.[74] They were all more or less *frondeurs* from Académie Cormon. It is true that they frequented the Durand-Ruel Gallery in order to study the impressionist palette, but they had other stylistic ambitions and were also regular visitors to the Louvre. At first Anquetin seems to have been the most advanced of the three painters. Partly under the influence of the popular Japanese woodcuts he had developed a decorative, strongly outlined, and grand style. Anquetin's great project at that time was an *Intérieur de Chez Bruant,* a genre picture from Aristide Braunt's cabaret in Montmartre. In the course of the work the trio of young painters became acquainted with Edouard Dujardin, the energetic manager of *La Revue Wagnérienne.* Dujardin induced Anquetin to introduce a symbolic figure into his painting. The result of this experiment, however, was that Anquetin never succeeded in reconciling the realistic and symbolic elements in his great painting. Finally he cut up the cartoons and put aside the many sketches. The episode, which it cannot be denied was in conformity with an actual event, is remarkably similar to the story in *L'Œuvre.*

Zola's description of Lantier's masterpiece mentioned other in-

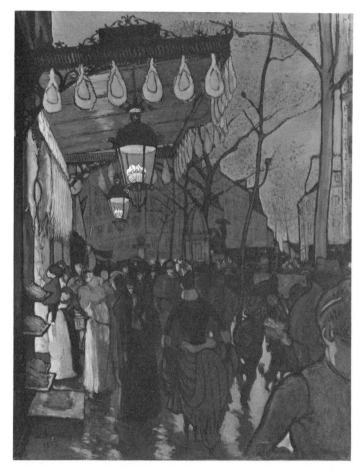

FIG. 6  Louis Anquetin, *Avenue de Clichy, le soir, variante des bleus,* 1887, Wadsworth Atheneum, Hartford, Conn.

teresting singularities that cannot be brought into direct agreement with the speculations of the Cormon students:

. . . he indulged in all kinds of mysterious practices when it came to applying his colours. He concocted his own recipes and changed them at least once a month, believing that he had suddenly discovered the best method of painting when he spurned the old, flowing style and proceeded by a series of strokes of raw colour juxtaposed until he obtained the exact tone-value he desired. It had long been a mania of

his to paint from right to left; he never said so, but he was sure it was lucky.

His latest terrible misfortune had been to be led astray by his fast-developing theory of complementary colours. He had heard of it first from Gagnière, who also had a weakness for technical experiments. Then, with characteristic over-indulgence, he had begun to exaggerate the scientific principle which deduces from the three primary colours, yellow, red and blue, the three secondary colours, orange, green and violet and from them a whole series of similar complementary colours obtained by mathematical combination. In that way science gained a foothold in painting and a method was created for logical observation. It meant that, by taking the dominant colour of a picture and establishing its complementary or cognate colours, it was possible to establish by experimental means all the other possible variations of colour, red changing to yellow next to blue, for example, or even a whole landscape changing its tone-values through reflexion or decomposition of light due to the passing of the clouds in the sky. From this true conclusion he argued that things have no fixed colour, but that their colour depends upon circumstances and environment.*

In spite of the conscious "literary" interpretation, it is clear that this theoretic argument goes far beyond the intuitive color speculations of the impressionists. Instead it reflects a newly awakened interest in the scientific analysis of the optical and coloristic experi-

---

* . . . il se permettait toutes sortes de pratiques mystérieuses dans l'application du ton, il se forgeait des recettes, en changeait chaque mois, croyait brusquement avoir découvert la bonne peinture, parce que, répudiant le flot d'huile, la coulée ancienne, il procédait par touches successives, béjoitées,[75] jusqu'à ce qu'il fût arrivé à la valeur exacte. Une de ses manies avait longtemps été de peindre de droite à gauche: sans le dire il était convaincu que cela lui portait bonheur. Et le cas terrible, l'aventure où il s'était détraqué encore, venait d'être sa théorie envahissante des couleurs complémentaires. Gagnière, le premier, lui en avait parlé, très enclin également aux spéculations techniques. Après quoi, lui-même, par la continuelle outrance de sa passion, s'était mis à exagérer ce principe scientifique qui fait découler des trois couleurs primaires, le jaune, le rouge, le bleu, les trois couleurs secondaires, l'orange, le vert, le violet, puis tout une série de couleurs complémentaires et similaires, dont les composés s'obtiennent mathématiquement les uns des autres. Ainsi, la science entrait dans la peinture, une méthode était créée pour l'observation logique, il n'y avait qu'à prendre la dominante d'un tableau, à en établir la complémentaire ou la similaire, pour arriver d'une façon expérimentale aux variations qui se produisent, un rouge se transformant en un jaune près d'un bleu, par exemple, tout un paysage changeant de ton, et par les reflets, et par la décomposition même de la lumière, selon les nuages qui passent.[76]

ences of former generations of artists. As a matter of fact, Zola in his comments on color touched on the vital points in the current aesthetic theories. His description presumes knowledge of:

(1) A technical application of color that differs from the spontaneous intuition of the impressionists.

(2) The emotional values of lines according to modern experimental psychology, made known in France by, above all, Charles Henry's lectures at the Sorbonne in 1884, and by his "Théorie des directions" and "Introduction à une esthétique scientifique," both printed in *La Revue Contemporaine,* 25 August 1885.

(3) The significance of complementary colors as analyzed in David Sutter's series of articles "Les phénomènes de la vision" in *L'Art,* 1880 (this in its turn was based on Ogden N. Rood's *Modern Chromatics* [New York, 1879; French translation, 1881]).

(4) The function of simultaneous contrasts according to M. E. Chevreul's *La Loi du Contraste Simultané des Couleurs,* 1839.

This technical knowledge in Zola may be most closely compared with Signac's and Seurat's program of studies during the years 1882–85.[77] It is obvious that these studies had repercussions far beyond the small circle of sympathizers that had formed during the independent exhibition in 1884. Thus Emile Bernard tells how he and Anquetin visited Paul Signac "pour avoir le dernier mot sur les recherches chromatiques des théoriciens de l'optique." Their studies culminated in a large colored woodcut, *Le Bateau,*[78] which in strength of color surpassed anything seen before. The work was hung in the offices of *La Revue Indépendante.* The two artists drifted farther and farther away from impressionism, and tried, under the motto *Voir le style et non point l'objet* (Observe the style and not the subject), to replace naturalism with an art of ideas and fantasy.[79] Again we meet with something that really happened, which seems to have been taken straight from the pages of *L'Œuvre.*

One might think that it would have been in the interests of the naturalist Zola to make positive use of Claude Lantier's theories of color. His scientific inclinations should, in accordance with a positivist turn of mind, have helped him to come into closer contact with nature, to reveal to art some of nature's own secrets. It is evidence of Zola's intimate knowledge of the prevailing cultural situation that

he does not interpret the scientific speculations on color as a continuation and enrichment of the methods of the impressionists, but as a condition for the creation of a transcendental, idealist picture—in other words, a symbolic painting. Speculations on color became a fundamental element in a mystic artistic grammar. For Zola this way of thinking was of negative value, but for the progressive aesthetes of the eighties it had positive implications.

The psycho-physical research that France had taken over from Germany and the United States (Helmholtz, Maxwell, Rood) did not, paradoxically enough, give rise to a positivist aestheticism. On the contrary it was considered, at least in the circles with which we are most concerned here, that these investigations attracted attention from the object-nature to the subject-ego. With that they had an individualistic concentration which could easily be combined with the current idealistic views; for example, Schopenhauer's popular thesis on the relative existence of objects. It was therefore quite in order to make the *symbolist* Claude Lantier the mouthpiece of experimental psychological theories of color.

In the review of Zola's novel in *La Justice* of 12 May 1886, the young critic Gustave Geffroy stressed, quite rightly, that the author had mixed current events with what he remembered of the period around 1870, when he was planning the first parts of the Rougon-Maquart chronicle.[80] There is no doubt that this double perspective was adopted with the definite aim of increasing the effect of the propaganda in the book. From the beginning Claude Lantier was conceived so that he would be able to illustrate the main trends of the book—the struggle between a natural way of life and the artistic ideal. But as the story progressed the artist was given traits that made him an incarnation of the current situation in art. While he gradually lost his human plasticity he appeared more clearly as a general symbol of a tragically fateful cultural situation. Zola's literary figure derived his impact from being almost exclusively the bearer of aesthetic doctrines. In that way he gained an almost demonic intensity. It was tempting for every young artist to identify himself with essential aspects of Lantier, not the least because the actual background was easily recognizable.

For Zola the aim of art was to reproduce reality, but an intensi-

fied reality. This intensity could be achieved by a pantheistic absorption in nature, whereby a mystic unity between all created things was established. The impressionists had failed to achieve this because they had not delved sufficiently deep into universal problems. They had been content to depict the sensual surface of life. Claude Lantier's ambitions had exceeded those of the impressionists, but he, too, had failed because he had lost the "human scale" in his art. With the help of science and philosophy he had endeavored to create a unique, individual reality. But this modern Icarus was doomed to fall. He had transgressed nature's own laws.

Thus *L'Œuvre* developed into a dismal prophesy, full of forebodings of catastrophe. It could not but make a deep and disturbing impression on all concerned. The importance that literary symbolism in fact attached to the novel is shown by the vicious attack made by Léo Trézenick, the editor-in-chief of *Lutèce,* in his review of the work: *"L'Œuvre,* this drivelling, harping description of the 'flow of the Seine,' rejuvenated only by pitiful ravings about art." *

How far Zola's pessimistic cultural analysis was justified was to be practically illustrated shortly after the publication of *L'Œuvre.*

IN THE INTRODUCTION TO THIS CHAPTER, the creation of the group of Belgian artists, *Les XX,* and its attempts to make a breach in the exhibition traditions were touched on. The leader of the group, Octave Maus, was eager to establish contacts with French *avant-garde* artists, but in spite of all, the first attempts gave only modest results. Connections with Paris were not lacking, however. Above all Huysmans acted as art reporter to the group's periodical, *L'Art Moderne.* But he seemed to lack the ability to establish suitable contacts for the Belgians. The Brussels Exhibition of 1885 is evidence of this. There J. F. Raffaëlli appeared as the representative of the French impressionists and gave a speech, which was little appreciated, on *Le laid dans l'art.* By his and Constantin Meunier's appearance, the exhibition was given a certain social-realistic bias.[82]

* "L'Œuvre, cette description radoteuse cent fois rabachée de la 'coulée de la Seine', rajeunie seulement par les divagations apitoyantes sur l'Art." [81]

A natural step forward towards a radical Belgian art policy would have been an attempt to ally the leading French impressionists with *Les XX*. This occurred, too, at the 1886 exhibition, when Monet and Renoir were among those invited. Their appearance clearly aroused no great interest, and was passed over, curiously enough, without comment even by the inner circles of *Les XX*. The circumstance seems mysterious and demands an explanation.

This lack of interest in French impressionism was partly due to the fact that several of the most influential of the members of the group, Willy Finch, Théo van Rysselberghe, and James Ensor, for example, were much influenced by English painting, above all by Turner and Whistler. But more important was the fact that the interest of the large Parisian colony of Belgian authors and critics intimately associated with Octave Maus, *L'Art Moderne,* and *Les XX* were not orientated in the direction of impressionism and literary naturalism.

Thus the circle around Mallarmé was extremely Franco-Belgian. Further, the editorial staff of the periodical *La Pléiade,* mentioned above, consisted largely of Belgians, among others the two poets Maeterlinck and Ch. van Lerberghe. This periodical, which had a rather brief existence, had a direct offshoot in *La Wallonie,* founded in 1886, and edited by the Paris trained Albert Mockel. Emile Verhaeren, Edmond Picard, and André Fontainas were to be found early among Octave Maus's reporters in Paris. In 1886 all of them had distinct leanings towards symbolism. The 1887 exhibition in Brussels was to demonstrate clearly what this meant for *Les XX.*

ON ACCOUNT OF ITS ORIGINAL HETEROGENEOUS COMPOsition, *La Société des Artistes Indépendants,* which made its debut in the Tuilerie Barracks in the spring of 1884, had great difficulty in creating an effective organization. On 24 June 1884, however, Albert Dubois-Pillet and his friends finally drew up the rules of the society. It was resolved that annual exhibitions were to be held in Paris, and as far as possible in French provincial towns and abroad. The exhibitions were to embrace all branches of art, and would have

no juries whatsoever. The semi-annual membership fee amounted to the modest sum of 1.25 francs. A further exhibition fee not exceeding 10 francs would be paid by members who had belonged to the organization for less than two years. The business of the society was administered by a board of twenty, elected for two years. Every third year a third of the eventual income was to be divided among all the members.[83] Thus right from the beginning the society was conceived as a cooperative effort. It indicates an art trend and an organizational development that was very advanced for its time, intended to break the monopolistic position of the State and the private art dealers. During subsequent decades the organization was to be extremely successful.

The first board elected as its president the insignificant painter Guinard, who was supported by the two vice presidents, Albert Dubois-Pillet and Odilon Redon. It has always been a source of wonder that these two so stylistically different artists could, side by side, hold key positions in the independent organization. As will be shown in the next chapter, their different means of expression need not necessarily imply serious ideological rivalry between them.

By 10 December the same year the new association was ready to open its first official exhibition in *Pavillon de la Ville de Paris* in Champs-Elysées. Among the one hundred and thirty-eight participants were Bastien-Lepage, Angrand, Cross, Dubois-Pillet, Guillaumin, Redon, Schuffenecker, Seurat, and Signac. The exhibition was a complete public and financial failure. It was such a serious reverse that the group could not see its way clear to arrange further exhibitions during all of the following year.

This failure was all the more regrettable because the art market had become extremely unstable. The financial difficulties of Durand-Ruel and the impressionists have already been touched on in this chapter. The crisis probably culminated in 1885 and during the early months of 1886, when Durand-Ruel was constrained to make desperate attempts to capture the Anglo-American market.

The most vivid and dependable sources of information on the art situation in Paris, particularly during 1886, are Pissarro's letters to his son Lucien. Purely personal circumstances contributed to making him a central figure in the critical events at that time. Like most

of the other impressionists, he preferred to work in the country, but within easy reach of Paris so as not to lose touch with his dealers. During 1885 his possibilities of obtaining even the most modest sale for his work were reduced so catastrophically that he was compelled to spend most of his time in Paris (while his family was in Osny or Eragny), living on the hospitality of his relatives. He was literally running the gauntlet of the different art dealers trying to sell drawings, gouaches, decorated fans, and other trifles. These circumstances gave Pissarro an unusually good insight into the prevailing situation.

Apart from that, he had acquired through Lucien an interest in his son's colleagues that was unusual for his generation. As early as 1885 he had met Signac at Guillaumin's studio, and shortly afterwards he became acquainted with Seurat. Pissarro, influenced by his new friends, began to take a critical view of his own generation, and regarded Monet and Renoir as "romantics" in comparison with the young "scientific impressionists" or *primitifs modernes,* as he also called them. At the same time, on account of his age and experience, he had great possibilities of overcoming the rivalry between the generations. His gifts were later to be urgently required.

Pissarro's plan, as outlined in a letter to Monet dated 7 December 1885, was to try to unite the two generations in a common exhibition.[84] The only connecting link between such divergent painters as Degas and his circle, Monet, Renoir, and Seurat with his supporters, however, was the fact that they all had been more or less accepted by Durand-Ruel. (Durand-Ruel intended to include Seurat and Signac in his American exhibition.) [85] Pissarro therefore stressed *l'élément Durand* as the fundamental idea. The undertaking was complicated, however, by the fact that because of his growing lack of confidence in Durand-Ruel, Monet had gone over to his rival, Georges Petit, and participated in the latter's *Exposition Internationale de Peinture.* At the same time he had bound himself not to take part in any impressionist group exhibitions.[86]

The estrangement of Degas and Monet made the situation even worse, if possible, since the participation of the Degas group was an essential condition for the financing of the exhibition. Finally Pissarro was compelled to allow the initiative to pass to Berthe Morisot

and her husband, Eugène Manet, but with that the difficulty of getting Seurat and his friends accepted increased, which meant that the scope of the original exhibition had to be abandoned. In March 1886 Pissarro could report to Lucien in the letter in which he discussed the reaction to Zola's *L'Œuvre:*

> Schuffenecker has been to see Monsieur and Madame Manet. The latter went to see his Work and accepted it. What do you think of that? After his letter which was so dignified!—I have just seen a still life of his, and it's truly terrible.*

Monet and Renoir, and with them Caillebotte and Raffaëlli, faced by the new "suspect" constellation, withdrew completely. When the exhibition was finally opened on 15 May in the old headquarters of the impressionists, Maison Doré, 1, Rue Lafitte, the following artists were represented: Degas, Berthe Morisot, Gauguin, Guillaumin, Zandomeneghi, Forain, Mary Cassat, Odilon Redon, Seurat, Signac, Camille and Lucien Pissarro, Marie Bracquemond, Charles Tillot, Henri Rouart, Vignon, Emile Schuffenecker, la comtesse de Rambure, and David Estoppey (the last two *hors de catalogue*).

Nothing remained for the critics and the public but to acknowledge with Maurice Hamel of *La France Libre,* that these impressionists, intentionists, illuminists, and independents would no longer accept a common designation, for their endeavors—macabre fancies, gifted puerilities, paradoxes that surpass but embrace reality, unreasoning efforts side by side with learned experiments——were quite different.[88]

It is more interesting to study the Belgian reaction. The anonymous Paris correspondent of *L'Art Moderne* (who in this case was most probably Octave Maus, who had gone especially to cover the exhibition) headed his report *Les vingtistes parisiens.* He regarded the exhibition as salt in the bourgeois wound; announced with satisfaction that the hanging, like that of the Vingtistes, paid attention to the individual style of each participant; gave a detailed

---

* *Schuffenecker a été voir Monsieur et Madame Manet.* Ces derniers ont été voir ce qu'il fait et *l'ont accepté!* Qu'en dis-tu? Après sa lettre si remplie de dignité.—Je viens de voir une nature morte de lui, oh! diable! c'est terrible.[87]

account of Degas's contribution; and expressed his admiration of Seurat's work, which, however, he suspected would lead to fits of madness if it were to be shown in Brussels.[89] The article shows that French and Belgian *avant-gardism* were practically unanimous at that moment.

The "orthodox" impressionists, however, had left the motley crowd at the Rue Lafitte. They were to be found between 15 June and 15 July at the fifth *Exposition Internationale* in Georges Petit's elegant galleries near the Madeleine Church. A study of some of Monet's, Renoir's, and Raffaëlli's exhibition colleagues—Besnard, J.-E. Blanche, Gervex, Edelfeldt, Liebermann—makes one inclined to agree with Camille Pissarro in his view that the impressionism of the seventies had acquired a new social standing.[90] Georges Petit's appearance in the arena was one of the first indications that impressionism was on its way towards being accepted by the French middle class.

This circumstance naturally aggravated the ideological rivalry. The younger generation did not find even the Rue Lafitte exhibition sufficiently forceful, and the Seurat group resolved, within the scope of *La Société des Artistes Indépendants,* which seemed to have gained new strength, to make a new assault on the critics and public at the end of August.

COMPARED WITH PREVIOUS YEARS, Félix Fénéon had an extremely lively exhibition season to look back on when, in the autumn of 1886, he collected his art reviews from *La Vogue* in a small book entitled *Les Impressionnistes en 1886*. In the rather profuse flora of critical articles dealing with the current exhibitions— which had really roused the interest of the young symbolist poets; they had gone in force, and several of them had given their views in the press [91]—Fénéon's contribution is by far the most important and is worthy, therefore, of special notice.

It should perhaps be pointed out that art research has shown a certain disinclination to delve deeply into Fénéon's criticism, in spite of the fact that his contemporaries accepted it with both admiration

and respect. Some of the reasons for this may be revealed most easily with the help of the following quotation from Fénéon's review of Degas's crayon drawings at the exhibition in the Rue Lafitte.

The crouching, gourd-like women fill the bathtub as a pupa: with her chin on her breast, one is scratching the back of her head; another, her arm stuck to her back, and twisted a half circle is rubbing her behind with a dripping sponge. An angular backbone is stretched; fore-arms—which press forward breasts as ripe as Virgoulée pears—fall vertically between legs to dip a washing-clout in the water where the feet are. The hair falling down over the shoulders, the breasts over the hips, the belly over the thighs, the limbs over their joints, make this ugly woman— seen from above lying on her bed with her hands pressed to her hams—look like a series of rather swollen cylinders joined together. A woman seen from the front, on her knees is drying herself, with her thighs wide open and her head sunk over the loose flesh of her torso. And it is in disreputable furnished rooms, in the vilest retreats that these richly patinized bodies, ravaged by childbirths and illness expose or stretch themselves.*

In this description Félix Fénéon, who was generally regarded as one of the most daring word virtuosos by his symbolist colleagues,[93] poured out a cascade of words by no means inferior to Zola's description of Claude Lantier's masterpiece. But at the same time he approaches the demonic in the descriptions of women in *A Rebours*. Clearly affected by a style of painting that seemed to him original, he endeavored by bold neologisms and archaisms to create a language of art criticism that combined calm observation, not to say in-

---

* Des femmes emplissent de leur accroupissement cucurbitant la coque des tubs: l'une, le menton à la poitrine, se râpe la nuque; l'autre, en une torsion qui la fait virante, le bras collé au dos, d'une éponge qui mousse se travaille les régions coccygiennes. Une anguleuse échine se tend; des avant-bras, dégageant des seins en virgouleuses, plongent verticalement entre des jambes pour mouiller une débarbouilloire dans l'eau d'ùn tub où des pieds trempent. S'abattent une chevelure sur des épaules, un buste sur des hanches, un ventre sur des cuisses, des membres sur leurs jointures, et cette maritorne, vue du plafond, debout sur son lit, mains plaquées aux fesses, semble une série de cylindres, renflés un peu, qui s'emboîtent. De front, agenouillée, les cuisses disjointes, la tête inclinée sur la flaccidité du torse, une fille s'essuie. Et c'est dans d'obscures chambres d'hôtel meublé, dans d'étroits réduits que ces corps aux riches patines, ces corps talés par les noces, les couches et les maladies, se décortiquent ou s'étirent.[92]

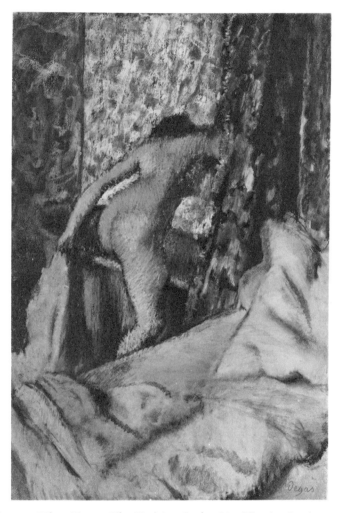

FIG. 7    Edgar Degas, *The Morning Bath*, 1883, The Art Institute of
Chicago.

difference, with the pregnant magic of words. The intention seems
to have been to capture the fundamental misanthropy of Degas's art.
The quotation reveals that Fénéon took many of his expressions
(*coccygien, virgouleuse, décortiquer,* etc.) from Emile Littré's well-
known *Dictionnaire de la Langue Française,* the source from
which his friend Stéphane Mallarmé enriched his poetic language.[94]

It is equally important to study Fénéon's opinion of the art of his
day. His interest in the impressionists Renoir and Monet was re-

markably cool. He found that Renoir (who had not yet shown his great *Baigneuses*) had nothing new to give, but had remained "that radiant painter of the Parisian epidermis and of sea-green eyes, that gay colorist, that skillful arranger of couples moving in yellowish light" *—an opinion that he clearly shared with Zola. He gave short but pertinent descriptions of Monet's *Etrétat* landscapes, and summed up by saying that the paintings were "impressions of nature fixed in their transience by a painter whose eye instantly apprehends all the motifs of a spectacle and spontaneously separates the tones." **

He was, however, as has been hinted, eager to exclude Degas's latest work from that of the impressionist group (Fig. 7). The description of the pastel suite of the women bathing seems to contain a curious contradiction which is perceptible in the lines quoted above. It is true that Fénéon regarded Degas as the bold, cruel observer *par préférence,* but his design was of a special kind. Not only did his female figures seem to be built up of a "series of cylinders," they were not derived from direct observations of nature, but constituted a *synthesis* of observations of form, movement, and expression. With that Degas had, according to Fénéon, broken away from impressionist naturalism and was moving towards a new style.

But above all the twenty-five-year-old art critic expressed his admiration of Seurat, with whose work he had first become acquainted about two years earlier. But this time it was no longer a question of the unknown painter who, at the beginning of the chapter, had appeared before the public with *Une Baignade,* but a young, exceptionally purposeful artist who had made a name in Parisian *avant-garde* circles, and whose intentions seemed to them to be intimately related to the problems of des Esseintes, Claude Lantier, and the symbolist poets. At a time when firmly established artists were seized with confusion and despair, when literary ideologies and styles were struggling for supremacy, when the Wagnerian *Gesamtkunstwerk* was discernible in the distance like a mirage, he found that Seurat, and perhaps Seurat alone, had prospered in his search for a "style."

* ce radieux peintre de l'epiderme parisien et des yeux pers, ce gai coloriste, cet ordonnateur habile de couples se mouvant dans des lumières flavescentes
** des impressions de nature fixées dans leur fugacité par un peintre dont l'œil apprécie instantanément toutes les données d'un spectacle et décompose spontanément les tons.

# 2 / L'Ile des Iridées

A WALK ALONG THE BOULEVARD BINEAU TOWARDS NEUILLY leads straight to the island of La Grande Jatte in the Seine. The island, as its name implies, has a bowl-like depression in the middle. It is surrounded by a low, but rather steep beach. Today most of the island is covered with ugly heaps of coal and blackened stumps of trees. In the 1880's, however, it was a pastoral, idyllic place and a popular recreation spot within easy reach of Paris.

In the middle of the eighties one of Georges Seurat's friends, Maurice Beaubourg, kept his canoe on the island. For some time canoeing had been a popular sport, as is shown by a large number of impressionist paintings. Beaubourg relates that Sundays on La Grande Jatte were very lively. Vociferous canoeists and soldiers congregated there to drink beer and eat waffles, which were made on portable stoves. The island seems also to have served as a modern Cythera, a rendezvous for the burghers of Paris and the city *co-cottes*.[1]

This was the milieu that Georges Seurat chose to describe in his picture *Un dimanche après-midi à l'île de la Grande Jatte* (Fig. 8). He commenced work on the painting in the autumn of 1884, and continued until March 1885. Then followed a break during which Seurat was painting at the seaside, at Grandcamp. On his return to Paris in October he resumed work on the picture, which was completed in time for the last "Impressionist Exhibition" at the Maison Doré.

A large number of drawings and sketches in oil[2]—executed on the spot—preceded and were made side by side with the picture, which was wholly composed and completed in the studio. The preliminary work was executed according to the same principles as

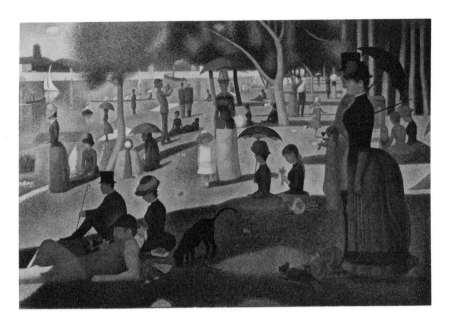

FIG. 8   Georges Seurat, *Un dimanche après-midi a l'île de La Grande Jatte,* 1884–86, The Art Institute of Chicago.

those applied during the painting of *Une Baignade.* Details of color and form, studies of light and shade were collected painstakingly to be finally brought together in a composition with the greatest possible expressive power. The monumental painting is executed in *béjoité,* the pointillist technique that made the work such a *succès de scandale* with the general public. With rigorous consistency Seurat applied the findings of experimental psychology in regard to the significance of complementary colors in the creation of the maximum intensity of light.

Discussion of the technical novelties in *La Grande Jatte* has gone on ever since the work was first exhibited, right up to the present time,[3] with such intensity and wealth of detail that the structural elements of the work, which are no less important, have been neglected. The composition presented by Seurat is in its entirety extremely individual.

The preliminary studies consist of about a score of drawings, some of them obviously made on the spot, others in the studio. To these must be added almost thirty paintings, most of them small,

FIG. 9  Georges Seurat, Study for *La Grande Jatte,* present whereabouts unknown.

painted rapidly on the spot. A few larger, more thoroughly worked out sketches were executed in the studio. This method of work, which was opposed to that of the impressionists, naturally imposed its special character on the final composition. It is impossible today to give the exact chronological order of these studies.[4] It is easy, however, to see that the oil sketches contain color data and variations, and only touch lightly on the preliminary problems of composition. The drawings, on the other hand, are mainly devoted to studies of form and details of composition. When a problem was finally solved in black and white the artist did not lose sight of it, but combined it with the results of the coloristic experiments of the oil sketches. Thus the large sketches, and above all the final painting, were a kind of aggregate of the detail studies.

The forms created by Seurat in his charcoal drawings for *La Grande Jatte* have an extremely individual stamp. Seurat does not define forms with the help of distinct lines (in contrast to Ingres, whom he admired), but by rich contrasts of light and shade. One should not, however, assume therefore that the drawings—with

FIG. 10   Georges Seurat, *L'Ile de La Grande Jatte,* 1884, Collection Mr. and Mrs. John Hay Whitney, New York.

certain exceptions—are influenced by impressionism. On the contrary the distinction between figures and background is usually clearly stressed. This is attained by making the figures and the background equivalent in their capacities as contrasts; they have an analogous technical structure.

Seurat's drawings are strongly reminiscent of photographic negatives. It is uncertain whether the artist was influenced by photography, but it seems not unlikely.[5] There is no doubt that by his style of drawing Seurat endeavored to attain a carefully calculated effect. The drawings give a strong feeling of dream and illusion, a feeling that is augmented by the tranquility and firm stability that characterize the figures. Here Seurat gives a view of the world in which the objective realities are changed to a strongly subjective, contemplative picture with marked aesthetic aims.

The attitude becomes the standard for the whole of the composi-

FIG. 11  Georges Seurat, Study for *La Grand Jatte,*
1884–86, Collection Mrs. John D. Rockefeller, Jr.

tion of *La Grande Jatte.* The "topographic" sketch—made in the
studio, probably at a late phase in the work—shows a seemingly
very deep "stage" with perspective lines that meet on the high hori-
zon. But since the sky is almost obscured by the crowns of the trees
with their indefinite positions in space, the illusion of depth appears
to be dissolved.

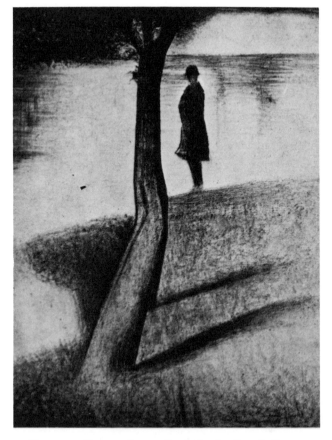

FIG.  12    Georges Seurat, Study for *La Grande Jatte*.

The shadows are deserving of special attention. The cause of the heavy shadow in the foreground is not shown in the picture, but it is probably a group of trees. Farther in the picture, to the left, a curious double shadow falls diagonally, while the shadows of the other trees are horizontal.

It has been suggested that this double shadow is due to the slope of the ground in that part of the island. This theory seems attractive, but lacks foundation. On the one hand it is possible by visiting the island to convince oneself that *La Grande Jatte* has no such beach slopes, and on the other, even if it had they could only influence the direction of the shadows very slightly. Finally—and this is the decisive point—the careful detail study (Fig. 12) shows that Seurat

applied a non-naturalistic style without rational foundation. It was used in order to attain a certain aesthetic effect, a fascinating rhythm of form.[6] Once this idea was clear in his head it was transferred unaltered to the large composition.

The final version of *La Grande Jatte,* therefore, works simultaneously with several viewpoints, in both vertical and horizontal directions. The foreground is seen partly from a very high viewpoint, while the middle distance and the background are seen mainly from eye level. The effect of this compositional method, which is without parallel since before the Renaissance, is an aggregate of the space elements with indefinite and invisible, but for the spectator clearly apprehensible limits. The disparate features are brought together without synchronization in order to visualize a discontinuous reality.

Into this irrational scene Seurat introduced a large number of decorative and artificially arranged groups of persons, animals, and articles. He gives iconographically a true picture of the somewhat frivolous milieu described by Beaubourg. In the foreground there is a Parisian burgher with his *cocotte.* It is not surprising that Seurat's contemporaries were shocked by the subject matter of the painting. The artist had taken the liberty of providing the woman with a monkey on a leash—for centuries a symbol of vice and profligacy.[7] A quiet flirtation is going on deeper in the picture, a girl is playing with a hoop, two St Cyr cavalrymen can be seen near the shore, a tall, lanky man is playing a trumpet, and to the far right a small group is sitting expectantly before a waffle range.

All the figures are strictly conceived as silhouettes. They have no psychical contact with each other. This effect has been achieved by, among other things, the fact that the artist has exaggerated the coincident contrasts between the figures and the background; he has created a narrow band of colorless light around the outlines. According to the conventional central perspective the figures are not in proportion to each other. Further they seem to be indefinitely placed. The positions of the figures give no indication of the depth of the perspective. The people seem to be either totally contemplative, or they are engaged in indolent pursuits which are not directed towards any particular objective, but which seem limited to the sphere of ex-

pressive movement. It may be maintained that this account of a group of people is characteristic of the situation the artist desired to visualize. The curious thing, however, is that he has recapitulated it with such frenetic pregnance. Notice, for example, the curiously restrained movements—the rowers captured in a moment of rest between the strokes, and the smoke from the two steamboats. They are incompatible with the way the sailing boat is moving. All these are details that lead one's thoughts to the principles of composition which were not to become accepted aesthetic norms until decades later.

It has been pointed out in analyses of *La Grande Jatte* how firm and consistent the diagonal composition of the picture is. The method of composition contributes naturally to the feeling of abstract construction one gets when faced with the painting. There still remain, however, a couple of even more important elements to analyze.

The painting comprises two principal zones—one in the foreground with mainly cold tones (emerald, ultramarine, violet), and a more distant zone dominated by bright, warm colors (greenish yellow, vermilion, and so on). The cold foreground is bounded on the top by a line sloping downwards from right to left. That it is experienced in this way is due to the size range of the figures and the direction of their gaze. The warm zone is bounded by the shore line sloping upwards from left to right. This effect is augmented by the gradations in the size of the figures, which produces a deep perspective, and by the direction of the double shadow of the tree mentioned earlier.

These two zones, and the directions of the movements which run together abruptly, form two fundamental elements in the artistic structure of Seurat's work. They are essential ingredients of the picture, and communicate a mysterious atmosphere—a feeling of approaching disquietude, a brittle harmony that may be shattered at any moment.

With this composition Seurat created tension of great artistic effect, between the phenomenal and the noumenal, between the observed and the imagined. All technical methods were applied to reach this end. The picture is dematerialized by the abolition of

every tendency towards tactile values. As far as the colors are concerned, the painting is monotonously uniform. The aim of the artist is no longer, in the style of the impressionists, to record the perceptive sphere. Instead he attempts to capture the emotional experiences according to definite aesthetic formulas. His endeavors to delve deeply into the disparate elements of existence in order to create a new synthesis with intuitive clarity were to him—as to many of his contemporaries—an agonizing pilgrimage toward the illusive autonomous work of art, towards a unique world of symbols in which the artist, by virtue of his knowledge and poetic power, is the supreme ruler.

AT THIS POINT it is not out of place to consider whether this analysis has historical relevance. It might be assumed that Seurat's painting has been credited in the analysis with aesthetic values that were quite foreign to contemporary art enthusiasts. The painting was, as has been pointed out, a great sensation. The comments of the conservative papers were, however, indifferent, and on the whole the general attitude towards the exhibition was negative. For the *avant-garde* circles described in Chapter 1, on the other hand, the exhibition, and especially Seurat's work, was a great event, and it is within this sphere that the historical situation and contemporary evaluations that culminated in *La Grande Jatte* must be viewed.

As mentioned earlier, the group associated with the periodical *L'Art Moderne* reacted quickly to the exhibition in the Rue Lafitte. As early as 27 June 1886 the Paris correspondent published his views on Seurat's picture:

> Finally, to end the parade, an original about which, in this uncompromising exhibition, the intransigeants themselves are fighting, some boundlessly exalting it, others criticizing it ruthlessly. This messiah of a new art, or this calculating rascal, is M. Georges Seurat. A personality, assuredly, but what kind? Judging him only by the immense canvas which he calls *A Sunday at the Grande Jatte in 1884*—which shows the banks of the Seine under the verdure of the trees, encumbered by an infinity of life-size personages, sitting,

standing, walking, talking, sleeping, playing the horn, fishing—he cannot be taken seriously. The figures are naively sculpted, like the little wooden soldiers that come to us from Germany in splintery pine boxes with a good smell of resin, and which we maneuver with an ingenious arrangement of tiny laths and pegs, painted red.

The composition has a geometric aspect. Painted from one end to the other with little brush strokes of equal dimension, a sort of miniscule stippling, one might believe that it was embroidered on canvas with colored wools, or woven like a tapestry. At Brussels *La Grande Jatte* would create a scandal. If it were exhibited there, there would be sudden cases of mental breakdown and overwhelming apopleptic seizures.† And yet, even in this disconcerting work, what depth, what exactitude of atmosphere, what radiance of light!

A hoax? We do not think so. A few landscapes, painted by the same technique—*Le Fort Samson, Le Bec du Hoc, La Rade de Grand-Camp,* where a white flight of yachts passes on an azure sea, and *La Seine at Courbevoie*—reveal an artistic nature singularly gifted at isolating the elements of phenomena in order to express in them, by a simple but brilliant combination of means, the most complicated and intense effects. We accept M. Georges Seurat as a sincere, reflective, observant painter whom the future will classify.

† So, my dear Maus, it must be shown at the XX next year. *Proofreader's note* [Edmond Picard].*

* Enfin, pour terminer le défilé, un original autour duquel, en cette exposition intransigeante, les intransigeants eux-mêmes livrent bataille, les un exaltant outre mesure, les autres critiquant sans ménagement. Ce messie d'un art nouveau, ou ce mystificateur à froid, c'est M. Georges Seurat. Une personnalité, assurément, mais de quelle sorte? A ne le juger que par l'immense toile qu'il intitule: *Un dimanche à la Grande Jatte en 1884,* montrant, sous la verdure des arbres, les berges de la Seine encombrées d'une infinité de personnages de grandeur naturelle, assis, debout, se promenant, causant, dormant, jouant du cor, pêchant à la ligne, on pourrait ne pas le prendre au sérieux. Les figures sont en bois naïvement sculptées au tour comme les petits soldats qui nous viennent d'Allemagne en des boîtes d'esquilles de sapin qui sentent bon la résine, et qu'on fait manœuvrer sur un appareil de lattes peintes en rouge, ingénieusement chevillées.

La composition a un aspect géométrique. Peinte d'un bout à l'autre à petits coups de pinceaux d'égale dimension, sorte de pointillé minuscule, on la croirait brodée sur canevas moyen de laines de couleurs, ou tissée ainsi qu'une toile de haute-lice. A Bruxelles, *La Grande Jatte* ferait scandale. Il y aurait, si elle était exposée, des cas subits d'aliénation mentale et des apoplexies foudroyantes.† Et pourtant, même dans cette toile déconcertante, quelle profondeur, quelles exactitudes d'atmosphère, quel rayonnement de lumière!

Une mystification? Nous ne le pensons pas. Quelques paysages, peints au

This rather comprehensive description has been given in its entirety because it illustrates clearly the situation at the time. The title of the article itself emphasizes the circumstances in art policies. The writer, who was possibly Octave Maus, did not call it *Les Impressionnistes à la Maison Doré* or anything like that, but *Les Vingtistes Parisiens*. This stresses the fact that the Parisian exhibitors were in sympathy with the Belgian *Les XX*, artists who shared their artistic values. The reviewer described Seurat's painting as *new art* and the artist himself as a chilly mystic. The intellectual features were underlined. He observed the static "tin-soldier-like" attitudes of the figures, and noted the artificial scenic arrangement. The new pointillist technique was also mentioned, as was the marked geometric composition. But at the same time as the writer described the intellectual side of the composition he admitted that it also reflected the phenomenal world: "What depth, what exactitude in the atmosphere, what brilliant light!"

Perhaps the writer would not have been able to produce such an excellent characteristic of *La Grande Jatte* if he had not—as there is reason to assume—been acquainted with the articles on the exhibition published in *La Vogue* by Félix Fénéon between 13 May and 20 June 1886, and which some months later were collected in the booklet *Les Impressionnistes en 1886*.

We have already read the analysis that Fénéon gave there of Degas's, Renoir's, and Monet's painting (pp. 59). The greater part of the contents, however, was devoted to Seurat and his circle, and a detailed analysis of *La Grande Jatte* was also given. In it Fénéon makes a great effort to explain the pointillist technique of the painting, and the significance of the so-called optic blending of color.

If you consider a few square inches of uniform tone in Monsieur Seurat's *Grande Jatte,* you will find on each inch of its surface, in a

moyen du même procédé, *Le Fort Samson, Le Bec du Hoc, La Rade de Grand-Camp,* où passe sur une mer d'azur une blanche envolée de yachts, et *La Seine à Courbevoie,* révèlent une nature artistique singulièrement apte à décomposer les phénomènes à en exprimer, par des moyens simples mais savamment combinés, les effets les plus compliqués et les plus intenses. Nous prenons M. Georges Seurat pour un peintre sincère, réfléchi, observateur, que l'avenir classera.[8]
† Donc, mon cher Maus, il faut l'exposer aux XX, l'an prochain. *Note du correcteur* [Edmond Picard].

whirling host of tiny spots, all the elements which make up the tone. Take this grass plot in the shadow: most of the strokes render the local value of the grass; others, orange tinted and thinly scattered, express the scarcely felt action of the sun; bits of purple introduce the complement to green; a cyanic blue, provoked by the proximity of a plot of grass in the sunlight, accumulates its siftings toward the line of demarcation, and beyond that point progressively rarefies them. . . .

These colors, isolated on the canvas, recombine on the retina: we have, therefore, not a mixture of material colors (pigments), but a mixture of differently colored rays of light.*

For further study of these problems Fénéon recommends Maxwell's color wheels and O. N. Rood's *Théorie scientifique des couleurs; ses applications à l'art et à l'industrie,* 1881. His analysis culminates in the following summary:

Monsieur Seurat is the first to present a complete and systematic paradigm of this new technique. His immense canvas, *La Grande Jatte,* whatever part of it you examine, unrolls, a monotonous and patient tapestry: here in truth the accidents of the brush are futile, trickery is impossible; there is no place for bravura—let the hand be numb, but let the eye be agile, perspicacious, cunning. Whether it be on an ostrich plume, a bunch of straw, a wave, or a rock, the handling of the brush remains the same. And if it is possible to uphold the advantages of "virtuoso painting," scumbled and rubbed, for rough grasses, moving branches, fluffy fur, in any case "la peinture au point" imposes itself for the execution of smooth surfaces, and, above all, of the nude, to which it has still not been applied.**

---

* Si, dans *La Grande Jatte* de M. Seurat, l'on considère, par exemple, un décimètre carré couvert d'un ton uniforme, on trouvera sur chacun des centimètres de cette superficie, en une tourbillonnante cohue de menues macules, tous les éléments constitutifs du ton. Cette pelouse dans l'ombre: des touches, en majorité donnent la valeur locale de l'herbe; d'autres, orangées, se clairsèment, exprimant la peu sensible action solaire; d'autres, de pourpre, font intervenir la complémentaire du vert; un bleu cyané, provoqué par la proximité d'une nappe d'herbe au soleil, accumule ses criblures vers la ligne de démarcation et les rarifie progressivement en deçà. . . .

Ces couleurs, isolées sur la toile, se recomposent sur la rétine: on a donc non un mélange de couleurs-matières (pigments), mais un mélange de couleurs-lumières. . . .[9]

** M. Georges Seurat, le premier, a présenté un paradigme complet et systématique de cette nouvelle peinture. Son immense tableau, *La Grande Jatte,* en quelque partie qu'on l'examine, s'étale monotone et patiente tavelure, tapis-

Fénéon rounds off his analysis of *La Grande Jatte* with a description and characterization of the *motif* of the painting:

The subject: beneath a canicular sky, at four o'clock, the island, boats flowing by at its side, stirring with a dominical and fortuitous population enjoying the fresh air among the trees; and these forty-odd people are caught in a hieratic and summarizing drawing style, rigorously handled, either from the back or full-face or in profile, some seated at right angles, others stretched out horizontally, others standing rigidly; as though by a modernizing Puvis.

The atmosphere is transparent and singularly vibrant; the surface seems to flicker. Perhaps this sensation, which is also experienced in front of other such paintings in the room, can be explained by the theory of Dove: [11] the retina, expecting distinct groups of light rays to act upon it, perceives in very rapid alternation both the disassociated colored elements and their resultant color.*

Félix Fénéon, in his first article on Seurat, had the same opinion as art critics have had ever since then: Pointillism may be considered as a kind of scientific systematization of the technique of impressionism. At the end of his article, however, one can read between the lines that he had begun to suspect the radicalism of Seurat, and that he sought tentatively to express this idea in adequate language. He seems to have become aware of the dematerialization of matter, he looked upon Seurat as a modern Puvis de Chavannes, and thus he

serie: ici, en effet, la patte est inutile, le truquage impossible; nulle place pour les morceaux de bravoure; que la main soit gourde, mais que l'œil soit agile, perspicace et savant; sur une autruche, une botte de paille, une vague ou un roc la manœuvre du pinceau reste la même. Et si se peuvent soutenir les avantages de la "belle facture" sabrée et torchonnée pour le rendu, j'imagine, d'herbes rêches, de ramures mobiles, de pelages bourrus, du moins la "peinture au point" s'impose-t-elle pour l'exécution des surfaces lisses, et, notamment, du nu, à quoi on ne l'a pas encore appliquée.[10]

* Le sujet: par un ciel caniculaire, à quatre heures, l'île, de filantes barques au flanc, mouvante d'une dominicale et fortuite population en joie de grand air, parmi des arbres; et ces quelque quarante personnages sont investis d'un dessin hiératique et sommaire, traités rigoureusement ou de dos ou de face ou de profil, assis à angle droit, allongés horizontalement, dressés rigides: comme d'un Puvis modernisant. 'atmosphère est transparente et vibrante singulièrement; la surface semble vaciller. Peut-être cette sensation, qu'on éprouve aussi devant tels autres tableaux de la même salle, s'expliquerait-elle par la théorie de Dove: la rétine, prévenue que de faisceaux lumineux distincts agissent sur elle, perçoit, par très rapides alternats, et les éléments colorés dissociés et leur résultante.[12]

placed *La Grande Jatte* in a different category from impressionist paintings.[13] He saw in Seurat a backward glance at French classical tradition.

During the summer of 1886 Félix Fénéon was given the task (probably as a consequence of Octave Maus's assumed visit to Paris) of replacing Huysmans as the Paris correspondent of *L'Art Moderne*. His first article for the periodical was published on 19 September 1886 under the title *L'Impressionnisme aux Tuileries*. Consequently it was about the autumn exhibition of *La Société des Artistes Indépendants* (cf. pp. 54 f.). About three hundred and fifty artists took part in the exhibition, but Fénéon found it worthwhile to review only the little *avant-garde* group around Seurat. He gave short but apt reviews of pictures by Camille and Lucien Pissarro, Paul Signac, and Albert Dubois-Pillet.

In its general descriptive passages the article has much in common with the train of thought in *Les Impressionnistes en 1886,* but a new aspect emerges. He finds that the group deviates now and again from the strictly scientific methods he had believed them to pursue: "And, for example, the stroller in the foreground of *La Grande Jatte* is standing in the grass without the slightest trace of green contributing to the tone of her dress." *

It is clear that Fénéon had begun to consider seriously the aim of this new art, and had found that the application of scientific theories of color was not an end in itself, for he closed the article with the following important passage:

> There is an abundance of inoffensive arguments against the reform promulgated by the three or four painters whom these notes concern. "The uniformity, the impersonality of material execution deprives their pictures of all distinctive style." This is a confusion of calligraphy with style. These paintings will differ because the temperaments of their authors differ.—"A recent Pissarro, a Seurat, a Signac, all look alike," proclaim the critics. Critics have always uttered the stupidest opinions with pride. —Finally, these painters are accused of subordinating art to science. They are simply using scientific dis-

---

* Et pour prendre un exemple, la promeneuse du premier plan dans *Un Dimanche à La Grande Jatte* est debout dans l'herbe sans que la moindre tache verte concoure à la formation du ton de sa robe." [14]

coveries to indicate and perfect the education of their eye and to control the exactitude of their vision. Professor N. O. (!) Rood has given them some precious findings. Soon M. Charles Henry's general theory of contrast, rhythm, and measure will equip them with new and sure information. M. Z. can read treatises on optics through eternity, but he will never paint *La Grande Jatte*. Between his courses at Columbia College, M. Rood—whose perspicacity and artistic vision seem to be nonexistent—paints: it must be awful. The truth is that the neo-impressionist method exacts an exceptional delicacy of eye: let them flee in terror from this dangerous loyalty, all those skillful hacks who use their digital niceties to hide their visual incapacity. This painting is only accessible to *painters:* the jugglers of studio tricks should bend their efforts towards a simpler game, like cup-and-ball.*

The passage is sensational. Not only was the concept "neo-impressionism" used for the first time in the history of art, but Fénéon also stressed the individual features of each member of the group, and underlined sharply the fact that the scientific methods were only a means of obtaining an artistically profound vision of reality. Fénéon also mentions Charles Henry, whose scientific works were touched on in the first chapter in my discussion on Claude Lantier's art. Charles Henry and his remarkable contribution to the art of the period will be dealt with shortly.

* Contre la réforme promulguée par les trois ou quatre peintres que concernent ces notes, les arguments affluent, inoffensifs. "L'uniformité, l'impersonnalité de l'exécution matérielle privera leurs tableaux de toute allure distinctive." C'est confondre la calligraphie et le style. Ils différeront, ces tableaux, parce que le tempérament de leurs auteurs différera.—"Un Pissarro récent, un Seurat, un Signac ne sauraient se distinguer," proclament les critiques. Toujours les critiques ont fait avec orgueil les plus pénibles aveux.—On accuse enfin ces peintres de subordonner l'art à la science. Ils se servent seulement des données scientifiques pour diriger et parfaire l'éducation de leur oeil et pour contrôler l'exactitude de leur vision. Le professeur N. O. (!) Rood leur a fourni de précieuses constatations. Bientôt la théorie générale du contraste, du rythme et de la mesure, de M. Ch. Henry, les munira de nouveaux et sûrs renseignements. Mais M. Z. peut lire des traités d'optique pendant l'éternité, il ne fera jamais *La Grande Jatte*. Entre ses cours au Colombia-College, M. Rood—dont la perspicacité et l'érudition artistiques nous semblent d'ailleurs absolument nulles—peint: ce doit être piètre. La vérité est que la méthode néo-impressionniste exige une exceptionelle délicatesse d'œil: fuiront éffarés de sa loyauté dangereuse tous les habiles qui dissimulent par des gentillesses digitales leur incapacité visuelle. Cette peinture n'est accessible qu'aux *peintres:* les jongleurs des ateliers devront tourner leurs efforts vers le bonneteau ou le bilboquet.[15]

It would be an exaggeration to claim that the independent exhibition in September at the Tuileries, except for the symbolist group, aroused any considerable interest in Parisian art circles. The exhibition, however, contributed largely towards the consolidation of the neo-impressionist group. At the same time, together with Fénéon's article, it supported the Belgians in the view already advanced by Edmond Picard, that Seurat should be invited to *Les XX*. This was done, and Seurat agreed to participate in the 1887 exhibition. It was, however, in keeping with the cautious and liberal policy of *Les XX* that for the time being no attempt was made to introduce the new movement on a broad front. Seurat and Camille Pissarro, who in his later years had become a neo-impressionist but who still enjoyed a good reputation as an artist, were the only two hung. The other invitations were clearly intended to pour oil on troubled waters: Among those invited were Marie Cazin, Berthe Morisot, Walter Sickert, the English painter, and Fritz-Taulow, a Norwegian.[16]

All the same, the Brussels exhibition of 1887 is recorded in the annals of *Les XX* as *L'année de la Grande Jatte*. Seurat's painting aroused enormous interest. During the opening day, for example, there were fifteen hundred visitors. The critics in the conservative press were furious with the new style of painting, and characterized it as a national danger. The event had powerful repercussions in Paris, and many art enthusiasts went to Brussels to see the exhibition. Among them was J.-K. Huysmans, who curiously enough had not taken the trouble to see the neo-impressionst art in Paris.

The preface in the exhibition catalogue was signed Octave Maus, and dealt with *Le Pittoresque*. It was hardly on the same level as the advanced neo-impressionist theories (he was to write such a preface for the following year's exhibition),[17] but it attacked the style and subjects of the official painters, and pleaded for the "aesthetics of ugliness" in order to *épater la bourgeoisie*.

The events show clearly how extremely important *Les XX* was for French *avant-garde* painting during the latter part of the eighties. It was not only the Belgian symbolist writers who were rapidly drawn into the magic circle of the neo-impressionists. Several of the young Belgian painters, above all Willy Finch, Théo van Ryssel-

berghe, and Henry van de Velde, adopted the new art theories without hesitation. But in addition the French painters found, for the first time, the way to a large and enthusiastic public who did not always share their views, but still took them seriously. An important role in the formation of doctrines, and in the art debate was played by *L'Art Moderne,* which was supported faithfully by the cultural elite of Liège, where Albert Mockel had, as mentioned above, been publishing *La Wallonie* [18] since 1886. Nor should it be forgotten that the anarchist-inclined circles around *La Revue Indépendante* sought and found a welcome asylum in Belgium during periods when the French police was particularly zealous.

To return to Félix Fénéon, a couple of months were to elapse before he was prepared to formulate in print his final view of the new art. This was done in the article *Le Néo-Impressionnisme,* also published in *L'Art Moderne,* 1 May 1887. The primary reason for this article was the third exhibition of the *Société des Artistes Indépendants,* which was held this time in Pavillon de la Ville de Paris, but he was also referring to the *Les XX* exhibition.

The Fénéon was no longer undecided. He rapidly summarized the impressionist exhibitions during the years 1884–85, after which he continued with a short analysis of the neo-impressionist technique and its prospects. Then followed the most vital passage:

> The spectacle of the sky, of water, of greenery varies from instant to instant, according to the original Impressionists. To seize one of these fugitive appearances on the canvas was their goal. Thus the necessity arose of capturing a landscape in a single sitting, and a propensity for making nature grimace to prove that the moment was indeed unique and would never be seen again.
>
> To synthesize the landscape in a definitive aspect which perpetuates the sensation [it produces]—this is what the Neo-Impressionists try to do. (Furthermore, their manner of working is not suited to hastiness and requires painting in the studio.)
>
> In their scenes with figures, there is the same aversion to the accidental and transitory. Thus the critics in love with anecdote whine: they are depicting dummies, not men. These critics are not tired of the Bulgarian's portraits, which seem to ask: guess what I am thinking! It doesn't bother them at all to see on their wall a gentleman

whose waggishness is eternalized in a wicked wink, or some flash of lightning *en route* for years.

The same critics, always perspicacious, compare the Neo-Impressionist paintings to tapestry, to mosaic, and condemn [them]. If it were true, this argument would be of meager value, but it is illusory; step back a bit, and all these varicolored spots melt into undulating, luminous masses; the brushwork vanishes, so to speak; the eye is no longer solicited by anything but the essence of the painting.

Is it necessary to mention that this uniform and almost abstract execution leaves the originality of the artist intact, and even helps it? Actually, it is idiotic to confuse Camille Pissarro, Dubois-Pillet, Signac, and Seurat. Each of them imperiously betrays his disparity—if it be only through his unique interpretation of the emotional sense of colors or by the degree of sensitivity of his optic nerves to such and such a stimulus—but never through the use of facile gimmicks.

Among the throng of mechanical copyists of externals, these four or five artists produce the very effect of life; this is because to them objective reality is simply a theme for the creation of a superior, sublimated reality in which their personality is transformed.*

---

\* Le spectacle du ciel, de l'eau, des verdures varie d'instant en instant professaient les premiers impressionnistes. Empreindre une de ces fugitives apparences sur le subjectile, c'est le but.—De là résultaient la nécessité d'enlever un paysage en une séance et une propension à faire grimacer la nature pour bien prouver que la minute était unique et qu'on ne la reverrait jamais plus.

Synthétiser le paysage dans un aspect définitif qui en perpétue la sensation, à cela tâchent les néo-impressionnistes. (Au surplus, leur faire ne s'accommode point des hâtes et comporte un travail à l'atelier.)

Dans leurs scènes à personnages, même éloignement de l'accidentel et du transitoire. Aussi des critiques épris d'anecdotes geignent: on nous montre des mannequins, non des hommes. Ces critiques ne sont pas las des portraits du Bulgare qui semblent questionner: Devinez ce que je pense! Ils ne s'affligent point de voir sur leur mur un monsieur dont la dicacité s'éternise en un malin clignement d'œil, ou quelque éclair depuis des années en route.

Les mêmes, perspicaces, toujours comparent les tableaux néo-impressionnistes à de la tapisserie, à de la mosaïque, et condamnent. Exact, cet argument serait de piètre valeur; mais il est illusoire: un recul de deux pas,—et toutes ces versicolores gouttes se fondent en ondulantes masses lumineuses; la facture, on peut dire, s'évanouit: l'œil n'est plus sollicité que par ce qui est essentiellement la peinture.

Que cette exécution uniforme et comme abstraite laisse intacte l'originalité de l'artiste, la serve même,—est il besoin de le noter? En fait, confondre Camille Pissarro, Dubois-Pillet, Signac, Seurat . . . serait imbécile. Chacun d'eux impérieusement accuse sa disparité,—ne serait-ce que par son interprétation propre du sens émotionnel des couleurs, par le degré de sensibilité de ses nerfs

In this article Fénéon succeeded in giving an exhaustive review of the neo-impressionist style in the widest significance of the term. It should be pointed out, however, that his analysis was made chiefly in view of Seurat's painting. In Seurat's work, Fénéon recognized all the structural features that should be typical of a perfect neo-impressionist painting. He regarded his picture as the antithesis of impressionist painting, and made a clear line of demarcation between its casual sauntering character and the efforts of neo-impressionism to create a definite and permanent *synthesis* of existence. He further stressed its attempts to dematerialize and spiritualize the facture. He interpreted the new technique not as a goal but as a means to make reality abstract. After apostrophizing the ability of the neo-impressionists to give to colors definite sensuous values on the basis of experimental psychology, he finally lifted the discussion up to an idealistic-philosophical level, and defined what he calls the "life-enhancement" of the new painting—a gift granted to these artists, by the complete mobilization of all their individual resources, to convert an everyday objective world to a higher, sublimated reality. In other words, Fénéon characterized in unusually "modern" terms the art of Seurat and his associates as symbolic.

IT IS UNDOUBTEDLY TEMPTING to study the experiences that may have led the young art critic to this remarkable clarity of vision. His opinion of neo-impressionism had far from the same crystal-clear contours when he wrote his essay on Seurat in *Les Impressionnistes en 1886.* Let us for a moment return to *avant-gardisme* in Paris around the middle of the eighties. In an article entitled *Le Symbolisme* in *La Cravache* of 16 June 1888, Jules Christophe vividly described the radical coterie so cruelly satirized in the description of Adoré Floupette's favorite café, Le Panier Fleuri:

optiques à telle ou telle stimulation,—mais jamais par le monopole d'agiles trucs.

Parmi la cohue des machinaux copistes des extériorités, ils imposent, ces quatre ou cinq artistes, la sensation même de la vie: c'est que la réalité objective leur est simple thème à la création d'une réalité supérieure et sublimée où leur personnalité se transfuse.[19]

At number five of that sweet and Odéonesque Avenue de Medicis, carved right into the Luxembourg Gardens, is the unknown, elm-shaded Brasserie Gambrinus. There, from 1884 to the autumn of 1886, . . . one would see, every night, this "budding" literature: Messieurs Gustave Kahn, finely Semitic; Papadiamantopoulos, blue-bearded Athenian (pseudonym, Jean Moréas); Joseph Caraguel, a red-bearded Narbonnais; Félix Fénéon, a Burgundian with Yankee manners, born at Turin; Charles Vignier, the elegant Swiss; Paul Adam, the Parisian with the extremely white and stiff collars; and others, more transitory: Edouard Dujardin, creator of *La Revue Wagnérienne;* Fédor Fédorowitch de Wyzewa, the "Oblomovist of Montmartre"; Marius Pouget, brilliantly metallized into d'Orfer (Leo); Jean Ajalbert, the glabrous modernist verse writer; Mathias Morhardt, the Swiss critic; Charles Morice, Verlainesque poet; Jules Laforgue, the lunar Gerson, who unfortunately died last August 20; Charles Henry, the dynamist of art, future author of a "mathematical and experimental aesthetic"; Gaston Dubreuil, who expressed ideas about music in the newspapers; Maurice Barrès, the Boulangist prose writer. There were also those Parisian painters of an independent style: Dubois-Pillet, Georges Seurat, Paul Signac, with Alexis Boudrot and David Estoppey, simply Impressionist "painter-drawers"; Maurice Raymond, of polychrome statuary; and Barbavara, an Italian doctor, a student of Charcot.*

Here pass in review most of the eccentric, but in spite of their modest standards of life, basically aristocratic figures introduced in

* Au numéro cinq de cette douce et odéonesque avenue de Médicis, taillée en plein jardin du Luxembourg s'ouvre l'ignorée brasserie *Gambrinus,* ombragée d'ormes. Là, de 1884 à l'automne 1886, . . . voyait-on, chaque soir, cette littérature *budding:* MM. Gustave Kahn, fin sémite, Papadiamantopoulos, Athénien à barbe bleue (pseudonymmement dit Jean Moréas), Joseph Caraguel, Narbonnais à barbe rouge, Félix Fénéon, burgonde d'allure yankee, né à Torino, Charles Vignier, Suisse élégant, Paul Adam, Parisien aux cols spécialement candides et rigides, et plus transitoires: Edouard Dujardin, créateur de *La Revue Wagnérienne,* Fédor Fédorowitch de Wyzewa "oblomoviste montmartrois," Marius Pouget, métallisé brillament en d'Orfer (Léo), Jean Ajalbert, glabre versificateur moderniste, Mathias Morhardt, critique suisse, Charles Morice, poète verlainien, Jules Laforgue, Gerson lunaire, tristement décédé le 20 août dernier, Charles Henry, dynamiste d'art, futur auteur d'une "esthétique mathématique et expérimentale," Gaston Dubreuil, qui exprime des idées sur la Musique dans des feuilles publiques, Maurice Barrès, prosateur boulangiste; étaient aussi ces peintres parisiens de la touche indépendante: Dubois-Pillet, Georges Seurat, Paul Signac, avec Alexis Boudrot et David Estoppey, *painter-drawers* simplement impressionnistes, Maurice Raymond, statuaire polychromiste, et Barbavara, médécin italien, élève de Charcot.[20]

Chapter 1. It is, however, of value to obtain further confirmation of how intimate relations were between the representatives of the various artistic, philosophic, and psychological views. It was there that the aesthetic ideologies of modernism were formulated, and there Félix Fénéon occupied a prominent position. Of course he was influenced by the various representatives of radical ideas. It seems quite natural to assume that he was kept informed by Barbavara of Professor Charcot's most recent lectures on the problems of hysteria and hypnosis. But above all it was with his closest friends, Gustave Kahn, Jules Laforgue, and Charles Henry, that he had the most lively exchange of ideas.

Gustave Kahn, who with Léo d'Orfer founded *La Vogue* at the beginning of 1886, seems to have had rather more radical aesthetic views than Fénéon from the very beginning, and probably exerted great influence on Fénéon's opinions. That was no doubt one of the reasons that Fénéon published *Les Impressionnistes en 1886* in Kahn's periodical and not in *La Revue Indépendante*. One is not surprised to find the belligerent Kahn also engaged in the literary feud that followed the publication of *Les Déliquescences d'Adoré Floupette,* and which culminated in Moréas' noble and diffuse symbolic manifestation in *Le Figaro Littéraire* on 18 September 1886. Kahn's contribution, published in *L'Evénément,* was not without point, but was only to a very small extent emotional. It was rather characterized by a desire to elucidate the intentions of the symbolist movement.

He referred to Moréas' article and regretted that its wording was more likely to increase than disperse the speculations about symbolism. Further he stated that great ignorance of what should be designated symbolic poetry and literature was rife among reviewers. For that reason he gave the names of the leading members of the movement and their principal works. He stressed Stéphane Mallarmé's prominent position, and also mentioned Félix Fénéon as a member of the group, and as the creator of a new style of art criticism.

The general characteristic of these books, which unifies their tendencies, is the ancient and monochordic technique of the line, the desire to break up the rhythm, to evoke in the graphic nature of a strophe the schema of a sensation. With the evolution of intelligence,

the sensations become more complicated; they must have terms more appropriate to them, not yet worn out by an identical use over the last twenty years. Furthermore there is the normal enlarging of a language by the inevitable neologisms and by the setting up of an ancient vocabulary, which is necessitated by the return of the imagination to the epic or the supernatural.

The principal point at which we separate ourselves from all similar attempts is when we set down as a fundamental principle that the perpetual flexion of the line or strophe declare itself the only unity.

Banal prose is the tool of conversation. We claim for the novel the right of rhythmic phrasing, of accentuating declamation; the tendency is towards a mobile poem in prose, with differing rhythms following the styles, the oscillations, the contortions, and the simplicity of the idea.

In his article, M. Deschaumes seems to believe that we are borrowing the techniques of Ronsard. This opinion is erroneous. Ronsard, first of all, fettered verse by a uniform arrangement.

The attempt today consists in our amplifying and liberating it far beyond the very techniques of the Gothic writers.

For the subject matter of the works, weary of the quotidian, of the elbowing and necessity of the contemporary, we want to be able to place the development of the symbol in any epoch or even in dreamland (*the dream being indistinguishable from life*). We want to substitute for the battle of individuals, the battle of sensations and ideas; and in place of re-examining the decor of city squares and streets, examine all or part of the brain. The essential goal of our art is to objectify the subjective (the exteriorization of the Idea) instead of subjectifying the objective (nature seen through a temperament). Analogous reflections have created the polyphonic tone of Wagner and the latest technique of the Impressionists.[21] This is a literary adherence to scientific theories constructed by induction and controlled by the experiments of M. Charles Henry, expressed in an introduction to the principles of mathematical and aesthetic theory. These theories are founded on the purely idealistic philosophical principle that causes us to reject the utter reality of matter and only admit the existence of the world of representation.

Thus let us push the analysis of the *self* to the extreme; let us make the multiplicity and interlacing of rhythms accord with the measure of the Idea; let us constitute a literary fairyland by annulling

the mode of a forced and intellectual modernism; let us compose a personal vocabulary throughout the whole range of the work and try to escape the banality of the ready-made.*

In a condensed form Gustave Kahn gave in these words a declaration of the theory and practice of symbolism. He was not satisfied to define just the objectives of the new literature, but attempted to

---

* La caractéristique générale de ces livres, ce qui unifie la tendance, c'est la négation de l'ancienne et monocorde technique du vers, le désir de diviser le rythme, de donner dans le graphique d'une strophe le schéma d'une sensation. Avec l'évolution des esprits, les sensations se compliquent; il leur faut des termes mieux appropriés, non usés par un emploi identique de vingt ans. De plus, l'élargissement normal d'une langue par les néologismes inévitables et une instauration de l'ancien vocabulaire nécessité par un retour des imaginations vers l'épique et le merveilleux.

Le point principal où nous nous séparons de toute tentative similaire, c'est que nous posons en principe fondamental la flexion perpétuelle du vers ou mieux de la strophe déclarée seule unité.

La prose banale est l'outil de la conversation. Nous revendiquons pour le roman le droit de rythmer la phrase, d'en accentuer la déclamation; la tendance est vers un poème en prose très mobile et rythmé différemment suivant les allures, les oscillations, les contournements et les simplicités de l'Idée.

Dans son article, M. Deschaumes semble croire que nous empruntons les procédés de Ronsard. Cette opinion est erronée. Ronsard, le premier, entrava les vers par une uniformité d'ordonnance.

La tentative actuelle consiste à l'amplifier et à la libérer au delà des procédés mêmes des gothiques.

Pour la matière des œuvres, las du quotidien, du coudoyé et de l'obligatoire contemporain, nous voulons pouvoir placer en quelque époque ou même en plein rêve (le rêve étant indistinct de la vie) le développement du symbole. Nous voulons substituer à la lutte des individualités la lutte des sensations et des idées et pour milieu d'action, au lieu de ressasser décor de carrefours et de rues, totalité ou partie d'un cerveau. Le but essentiel de notre art est d'objectiver le subjectif (l'extériorisation de l'Idée) au lieu de subjectiver l'objectif (la nature vue à travers un tempérament). Des reflexions analogues ont créé le ton multitonique de Wagner et la dernière technique des impressionnistes.[21] C'est une adhésion de la litterature aux théories scientifiques construites par inductions et contrôlées par l'expérimentation de M. Charles Henry, énoncées dans une introduction aux principes d'esthétiques mathématiques et expérimentales. Ces théories sont fondées sur ce principe philosophique purement idéaliste qui nous fait repousser toute réalité de la matière et n'admet l'existence du monde que comme représentation.

Donc, pousser l'analyse du moi à l'extrême, faire concorder la multiplicité et l'entrelacement des rhythmes avec la mesure de l'Idée, constituer la féerie littéraire en annulant la mode d'un modernisme forcé et spirituel, composer un vocabulaire personnel sur toutes les gammes de l'œuvre et chercher à sortir de la banalité des moules reçus.[22]

describe the philosophic and aesthetic principles that were common to literature, art, and music. He stated that poetry did not merely strive to create a new metaphorical language. It broke down the traditional form of poetry and shattered it to be reassembled into a mosaic according to principles that Kahn, in another connection, called "the theory of discontinuity." [23] A few months later he was to give a practical demonstration of his aesthetics in a collection of poems called *Les Palais Nomades*. In it he introduced free verse seriously for the first time, probably influenced by Laforgue, and developed an interchange, full of tension, between the conscious and the subconscious, between rational thinking and dreamlike visions.

Gustave Kahn states clearly in his article that the neo-impressionists *mutatis mutandis* worked according to the same fundamental principles as the literary symbolists. His conception of art was decidedly anti-impressionist. He had no time to waste on Zola's famous proposition that art is a corner of nature seen by temperament. On the contrary the emotional experiences should be schematized and subordinated in a definite formula. To reach the *Idea* of existence, however, a thorough analysis of one's own ego was necessary. Only thus could the artist create adequate symbols for his experience of the universe.

Kahn's reasoning reads like an echo of Schopenhauer, as summarized in Chapter 1 (cf. pp. 17 f.). As had already been indicated, he was by no means alone in his application of German idealism. His friend Jules Laforgue had been engaged during the years 1881–86 as the Empress Augusta's reader in Berlin, and had, during that time, acquired a profound knowledge of German philosophy. In his philosophic speculations he seems to have been inspired not by Schopenhauer but by Hartmann's *Philosophie des Unbewussten*.[24] However, from the angle of French symbolism, the difference between Hartmann's "transcendental realism" and Schopenhauer's "idealistic pessimism" must have been illusory. Hartmann was undoubtedly regarded as a "disciple" of Schopenhauer, and both were considered to be inspired by the same views. Laforgue's studies of the aesthetics of the subconscious (which he did not publish himself, but which were collected and printed after his premature death in

1887 by Edouard Dujardin and Félix Fénéon) gave to his nervous and fitfully conceived poetry a singular "surrealist" character which made a deep impression on Gustave Kahn, among others.

What is perhaps at first most shocking in Kahn's *Réponse des Symbolistes* is his claim that the symbolic transcendental theory of art could be verified and confirmed by Charles Henry's *esthétique scientifique,* which in its turn was derived from mathematical formulas and experimental psychology experience. From the modern point of view Kahn seems to have fallen between idealist and positivist opinions. The study of Zola's *L'Œuvre* in Chapter 1, however, showed that the cultural circles with which we are concerned here by no means saw the question in the same light. On the contrary, mathematics, by virtue of its abstractness and experimental psychology, by its analysis of the reactions of the individual, were regarded as valuable "auxiliary sciences" when there arose a question of arriving at knowledge of *la réalité supérieure*—the Idea.[25]

One of the most flagrant examples of the effect of such an attitude is to be seen in certain aspects of the work of Odilon Redon. In an excellent study Sven Sandström has shown that in his series of lithographs, *Les Origines* (1883), Redon was inspired by Darwin's *Origin of Species.* With this theory of evolution as his starting point, he created a new enigmatic and "surrealistic" iconography which was regarded by contemporary representatives of literary symbolism—Huysmans, Mallarmé, Hennequin, and others—as being wholly in conformity with their own poetic metaphoric language.[26] It must be stressed, however, that Redon's style was far too bound up in the romantic manner of his generation to create a new school. The ideological principle common to symbolists of various shades explains why the eccentric Odilon Redon not only participated in the last impressionist exhibition, but was also elected vice president of the newly-founded *Société des Artistes Indépendants.* In spite of the differences of style he felt that he belonged to the group, that he was one of the "initiates." It was certainly not by chance that when he published his memoirs, he chose the title *A soi-même,* reminiscent of Schopenhauer.

During his sojourn in Berlin, Jules Laforgue kept up a lively correspondence with a young Paris scientist whom he had met

through Kahn in 1879. Not only did they exchange letters, but La-
forgue regularly sent poems for criticism, too, and now and then he
attempted to persuade his Parisian friend to desert science for *belles
lettres*. The letters were addressed to M. Charles Henry.

Charles Henry was born in Alsace in 1859, and moved to Paris
in 1875, where he pursued intensive university studies for a number
of years. In 1881 he was appointed librarian at the Sorbonne, and
later published a doctor's thesis that attempted to prove how biologi-
cal functions could be demonstrated by mathematical curves. During
the nineties he was engaged as a university tutor, but was regarded
with suspicion by his colleagues. Henry was an all-round genius—
perhaps somewhat eccentric. In his investigations of the simple
numbers 1, 2, 3, 4, . . . and their combinations he is considered
to have anticipated Planck's quantum theory.[27] He published cal-
culations of the mathematical possibilities of winning at rouge et
noir, and in his investigations and calculations regarding cosmic
radiation he was decades ahead of his time.[28] He ended his days
worn out by chemical experiments and mathematical calculations
trying to discover a reagent capable of converting water into gaso-
line.

It may be asked what such a person had to give to the poet Jules
Laforgue. The answer is given partly in the obituary of Charles
Henry published by Kahn.[29] Kahn became acquainted with Henry
in 1879 outside the Bibliothèque Nationale, where Henry was stud-
ying the history of literature. He had specialized in the eighteenth
century and had, among other things, succeeded in bringing to light
the small biography of Watteau by Caylus, which the brothers Gon-
court had overlooked. He was further engaged in editing a number
of unpublished letters written by Mlle. Lespinasse, the patroness of
the encyclopedists, and was also working privately on a book enti-
tled *La Vérité du Marquis de Sade*. At the same time he was study-
ing Rameau's theory of harmony, and had just begun to take an in-
terest in Wronski's scientific remains. Kahn's account, in its fantastic
colorfulness, reads as though it were taken straight from the pages of
*Les Déliquescences d'Adoré Floupette*. Of particular interest is the
information about Henry's studies of Wronski. This singular Polish
mathematician and philosopher strove to prove the existence of God

and the immortality of the human soul by mathematical formulas. In his messianism he had endeavored to reconcile faith and knowledge. Here Henry found the same metaphysical problems that were to be the great fundamental questions in the symbolist speculations.

It was, however, from other points of view that Charles Henry came into contact with *avant-garde* painting. In 1884 he began a series of lectures at the Sorbonne on the emotional values of colors and lines. It was a rather popular evening course attended by all kinds of people. Henry seems to have been a gifted teacher. It is said that he had two dolls, one dark and the other fair, which he dressed in clothes of the same color cloth in order to demonstrate how relative the color perception of the audience was. Henry's starting point was the psychology of the senses, including Fechner's investigations. But all the time he tried to express experimental psychology experience in universal mathematic formulas to create a synthetic *esthétique scientifique*. With this instrument an artist would be able to break through the veil of empiricism into a crystal-clear world of absolute beauty. This theory of aesthetics was to be given its final form in *Le rapporteur esthétique* (1888) and *Le cercle chromatique* (1888–89), but the main lines of thought were in his lectures in 1884 and in the two works he published the following years—*Théorie des directions* and *Introduction à une esthétique scientifique*.[30] Félix Fénéon, who reviewed the first two works in *La Cravache*, dwelt preferentially on the fundamental psychological and aesthetic theories that were of special interest to the practicing artist.

> The characteristics of continuity or increase in the vital functions, or of discontinuity or more or less rapid arrest of these functions, which are appropriate, following the definitions of the physiologists, to dynamogeny and inhibition, are also appropriate to pleasure and pain. This remark permits M. Charles Henry to establish a rich and fertile solidarity between aesthetic and physiological problems, and to express them in a single symbolic form.*

* Les caractéristiques de continuité ou d'accroissement des fonctions vitales, de discontinuité ou d'arrêt plus ou moins rapide de ces fonctions, qui conviennent, d'après les définitions des physiologistes, à la dynamogénie et à l'inhibition, conviennent aussi au plaisir et à la douleur; cette remarque permet à M. Charles Henry d'établir entre le problème esthétique et le physiologique une solidarité féconde, et de les poser sous une même forme symbolique.[31]

Fénéon also propounded the question as to which directions of lines express dynamogeny or pleasure, and which express inhibition or pain. Henry replied, on the authority of his own and his precursors' investigations:

> We will thus symbolize agreeable or dynamogenic excitations by the directions low to high and left to right; disagreeable or inhibitory ones, by the directions high to low and right to left.*

But colors, too have definite expressive values which correspond to the form values:

> But colors are dynamogenic to a greater or lesser degree (muscular effort of hysterics, perception of differences in clarity, growth curves of vegetables, etc.). Let us project them on the compass rose, making pink and yellow, which are relatively dynamogenic, correspond to the dynamogenic directions; and green, violet, and blue, which are relatively inhibitory, correspond with the inhibitory directions. Thus we obtain the first sketch of a chromatic circle; it will next be necessary to determine rigorously its linear elements with reference to each band of the spectrum.**

To prove the validity of his contention Charles Henry had experimented with special spectacles in warm and cold colors; with their help one could study how in one case the horizontals, in the other the verticals appeared most clearly. In his review Fénéon contributed another example which was more directly associated with the practice of art. In two impressions of a Japanese woodcut in different colors the form elements did not appear identical to the eye.

With complicated mathematical and physical reasoning Henry considered that he could further show that all movement was dependent on the magnetism of the earth and followed the compass.

---

* Nous symboliserons donc les excitations agréables ou dynamogènes par les directions de bas en haut et de gauche à droite; les désagréables ou inhibitoires, par les directions de haut en bas et de droite à gauche.[32]

** Mais les couleurs sont dynamogènes plus ou moins (effort musculaire des hystériques, perception des différences de clarté, courbes de croissance des végétaux, etc.). Projetons-les sur la rose de directions en faisant correspondre le rouge, le jaune, qui sont relativement dynamogènes, aux directions dynamogènes; le vert, le violet, le bleu, qui sont relativement inhibitoires, aux directions inhibitoires; nous obtenons ainsi la première esquisse d'un cercle chromatique dont il faudra ensuite déterminer rigoureusement les éléments linéaires repérés avec chaque raie du spectre.[33]

Thus also emotional values of lines, color, and rhythm could be expressed in mathematical formulas. In other words he had created an *esthétique scientifique*.[34]

Naturally these experiments and theories were very attractive to the young generation of painters. When Henry published his first studies on the subject in 1885, both Signac and Seurat had been studying the colors of Delacroix and the impressionists and the optical theories of Rood and Sutter for three years. Their experiences were confirmed by Charles Henry, and in addition he gave aesthetic meaning to their theories by his doctrine of expression. It has been said that Signac attended Henry's lectures from the beginning, and it seems incredible that he did not immediately share his newly acquired knowledge with his intimate friend and colleague, Georges Seurat. According to Rewald, Seurat was first personally introduced to Henry by Gustave Kahn in 1886, which may be correct, and it was only in his later pictures—*La Parade* (1887–88), *Le Chahut* (1889–90) etc.—that he applied Henry's theories.[35] This is not, however, quite in accordance with the facts. Gustave Kahn's articles "De l'esthetique du verre polychrome" and "Réponse des Symbolistes" [36] show (see pp. 84–86 of this book) that there was a clear connection between Henry's aesthetic theories and the neo-impressionist experiments during the years 1884–85.[37] Further the analysis of *La Grande Jatte* (p. 70) reveals that Seurat would not have achieved the specific structure required for the painting without knowledge of Henry's antithetic expression symbols "dynamogeny" and "inhibition."

It must again be pointed out in this connection that the various members of the Seurat circle were very different in their ability to make use of Charles Henry's teachings. Fénéon's friend, Georges Lecomte—from 1888 editor of *La Cravache*—who took part in Henry's séances, related that Camille Pissarro did not understand anything of Henry's diagrams and equations on the blackboard, and that Seurat later tried to explain to him what they meant.[38] The meagre and unoriginal neo-impressionist manifesto that Pissarro sent in a letter to Durand-Ruel confirms Lecomte's statement.[39] The same verdict may to a certain extent be pronounced on Signac, in spite of the fact that he was credited with having "discovered"

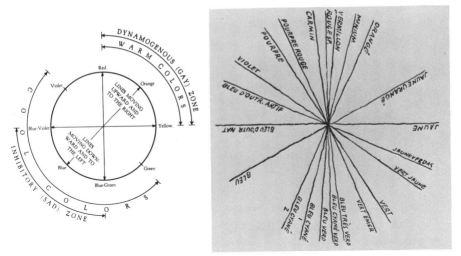

FIG. 13  Left: Diagram illustrating Charles Henry's theories of the expressive values of directions and colors. From W. J. Homer, *Seurat and the Science of Painting*. Right: Seurat's Color Wheel, copied from O. N. Rood, Collection Ginette Cachin-Signac, Paris.

Henry, and Henry engaged him to illustrate certain of his aesthetic writings. Signac's own writings and paintings show that he had, to a certain extent, become entangled in color-technical problems and occasionally found it difficult to follow Henry on this way towards "absolute beauty."

Not so Georges Seurat, of whom Lecomte said that he could listen to Henry indefinitely, and that he was firmly resolved on the basis of these theories to create "more gorgeous harmonies, feasts of more nuanced colors." * The color wheel, which both Seurat and Henry borrowed from Rood and used for their own aesthetic purposes, clearly shows the affinity between the two. The wheel was by no means constructed in the same mechanical way as, for example, would have resulted by following David Sutter's instructions on the primary and secondary distribution of the complementary colors.[40] Seurat's color wheel is instead oriented around the center point, with the color register arranged so that the warm colors fall within the "dynamogenic" zone, and the cold within the "inhibitant" zone.

* des harmonies plus fasteuses, des fêtes de couleurs plus nuancées

In opposition to this it may be maintained that although there is nothing to show definitely that Seurat's color wheel was not used until the final phase of his artistic activities, it could—since it is not dated—have been made in 1890, for example.[41] There exists, however, indirect, but none the less reliable evidence that the color wheel was made during an early period in the history of neo-impressionism. Félix Fénéon closed his article on neo-impressionism in *L'Art Moderne* with a short account of the work of the different members of the group. He wrote, among other things:

> M. GEORGES SEURAT.—A study of a nude, *Model,* which would glorify the greatest museum. Marine studies of Honfleur, and the marvel of infinite skies. The predominance of horizontal lines contributes to their serene character. The dynamogeny of the glorious landscapes of M. Paul Signac is arranged quite differently.*

By his choice of words (*dynamogénie*) and his way of writing, Fénéon reveals that Charles Henry's theories were well known at that time both to him and to the neo-impressionists. They would certainly never have reached this point if they had not, right from the beginning, accepted the values of the *avant-garde* symbolists.

GUSTAVE KAHN, in his article in *L'Evénément,* had pointed out that there was intimate connection between neo-impressionist painting, symbolic poetry, and some modernist music. The program of the exhibition *Les XX* shows most clearly that he was not alone in this. It included readings by the leading symbolist poets and music by young French and Belgian composers—Vincent d'Indy, Gabriel Fauré, Cesar Franck, and others.[43] Octave Maus and his associates had, as a matter of fact, quickly outdistanced their colleagues in Paris when the problem of combining different branches of modernist art into a kind of *Gesamtkunstwerk* arose. In Paris

---

* M. GEORGES SEURAT.—Une étude de nu, *Poseuse,* qui glorifierait les plus altiers musées. Des marines d'Honfleur, et la merveille de ces ciels infinis. A fixer leur caractère de sérénité, concourt la prédominance des lignes horizontales. Tout autrement se distribue la dynamogénie des glorieux paysages de M. Paul Signac.[42]

Richard Wagner was still regarded as the prime representative of obscure, symbolistic music. The Belgian *avant-garde* had passed this stage at the beginning of the eighties after repeated visits to Bayreuth.

All the same it is not at all difficult to find parallel manifestations in French symbolist poetry and neo-impressionist painting. They are evident in Jules Laforgue's *Dernier Vers;* they are obvious in the suite, *Les Voix au Parc,* included in Gustave Kahn's *Les Palais Nomades;* and they are to be found in several other representatives of the younger generation of poets.[44] But just as often, these poets felt closely related to such artists as Odilon Redon and the macabre but banal Félicien Rops, who, it is true, excelled in peculiar, symbolist-inclined iconography, but who depended pictorially on the heritage from romantic art.

It is therefore important to consider whether the relationship between literary symbolism and the most consistent and gifted representative of the neo-impressionists, Georges Seurat, was confined only to similar impressions due to common aesthetic ideologies, or whether there really existed a deeper relationship between the structure of symbolist poems and neo-impressionist paintings. If this difficult task—difficult because the comparison concerns two widely divergent mediums—is to be meaningful, the objects investigated must satisfy two requirements: They must be of artistically high quality within their own class, and have been executed about the same time.

As far as painting is concerned, *La Grande Jatte* is naturally the obvious choice, but the poetic equivalent that also satisfies the condition of having been executed at the same times is not so obvious. In the previous chapter, however, a poet has appeared continually in most of the important connections. First he appeared as the friend of the impressionists, and as the one who taught Degas to write sonnets. He gave Huysmans valuable material for *A Rebours* and at the same time became acquainted with Odilon Redon. He kept up a correspondence with Zola for many years. During the eighties he occupied a more and more influential position in literary *avant-gardisme,* and he contributed with poems in many of *Les petites revues.* In 1885 he was duly ridiculed in *Les Déliquescences d'Adoré Flou-*

*pette,* but his admirers increased steadily in number, also among young Belgian poets.

There is no doubt that in the middle of the decade Stéphane Mallarmé was the central figure of literary symbolism in Paris. When in 1871 he moved from Avignon to Paris he was practically unknown as a poet. A few Paris poets, among them Verlaine, welcomed him, but considered his poems abstruse. This view was confirmed in 1873 when he published *Toast Funèbre* in memory of Théophile Gautier. During the whole of the seventies Mallarmé led a retired life, and close contact was not established with the young Parnassus until 1880. But Gustave Kahn managed to win the confidence of the shy poet, and took the initiative to *Les mardis,* the Tuesday evenings when the *avant-garde* Paris met in Mallarmé's flat in the Rue de Rome to listen to the expositions of the master on the nature of art.[45]

It was not, however, until the year 1884 that Mallarmé's name became well known in literary circles in Paris, when Verlaine published his collection of essays, *Les Poètes maudits,* and Huysmans his novel, *A Rebours.* In other respects, too, that year marked the emergence of Mallarmé from his isolation. He joined the editorial staff of *La Revue Indépendante,* where he became acquainted with Seurat and his painter colleagues. It was there he met Charles Henry. It is hardly likely that Mallarmé appreciated the new artistic ideas in the beginning. For several years he had been a great admirer of the art of Manet and Degas. In the new situation, however, Félix Fénéon played an important role as an intermediary between the neo-impressionists and Mallarmé's literary symbolism. As already mentioned, he himself was greatly influenced by the poet's masterly use of words. Whether Mallarmé and Seurat ever really understood and appreciated each other's aims is a question that will probably always remain unanswered. On the other hand it seems obvious that as artistic types they were very similar to each other. One finds in both of them the same retired way of life and a *noli me tangere* attitude. Both had a pronounced intellectual approach to their art; their work was the result of prolonged and methodical efforts, and art was the essential thing in their lives. It is therefore reasonable, when seeking

a poetic parallel to *La Grande Jatte,* to turn to the works of Mallarmé.

In January 1885 Félix Fénéon published a poem by Mallarmé entitled *Prose pour des Esseintes* in *La Revue Indépendante.* The poem was written as a token of gratitude to Huysmans, who had referred to Mallarmé's poetry in his novel. But the poem might also be regarded as a veiled, but none the less malicious criticism of Huysmans.[46] It is true that Huysmans had, in his account of Mallarmé, thrown light on new and essential features of his work:

> These precious, interwoven ideas he knotted together with an adhesive style, a unique, hermetic language, full of contracted phrases, eliptical constructions, audacious tropes.
>
> Sensitive to the remotest affinities, he would often use a term that by analogy suggested at once form, scent, colour, quality, and brilliance, to indicate a creature or thing to which he would have had to attach a host of different epithets in order to bring out all its various aspects and qualities, if it had merely been referred to by its technical name. By this means he managed to do away with the formal statement of a comparison that the reader's mind made by itself as soon as it had understood the symbol, and he avoided dispersing the reader's attention over all the several qualities that a row of adjectives would have presented one by one, concentrating it instead on a single word, a single entity, producing, as in the case of a picture, a unique and comprehensive impression, an overall view.*

But in his analysis of the individual poems he undeniably showed a certain bias and superficiality. He stressed *Hérodiade* be-

---

\* Ces idées nattées et précieuses, il les nouait avec une langue adhésive, solitaire et secrète, pleine de rétractions de phrases, de tournures elliptiques, d'audacieuses tropes.

Percevant les analogies les plus lointaines, il désignait souvent d'un terme donnant à la fois, par un effet de similitude, la forme, le parfum, la couleur, la qualité, l'éclat, l'objet ou l'être auquel il eût fallu accoler de nombreuses et de différentes épithètes pour en dégager toutes les faces, toutes les nuances, s'il avait été simplement indiqué par son nom technique. Il parvenait ainsi à abolir l'énoncé de la comparaison qui s'établissait, toute seule, dans l'esprit du lecteur, par l'analogie, dès qu'il avait pénétré le symbole, et il se dispensait d'éparpiller l'attention sur chacune des qualités qu'auraient pu présenter, un à un, les adjectifs placés à la queue leu-leu, la concentrait sur un seul mot, sur un tout, produisant, comme pour un tableau par exemple, un aspect unique et complet, un ensemble.[47]

cause it was a parallel to des Esseintes's favorite painting, *Salomé* by Gustave Moreau, and in *L'Après-midi d'un Faune* he was most attracted by the way the erotic contents were formally visualized. When Mallarmé suggested by the title of his new, subtle poem that it was to be regarded as suitable reading for des Esseintes, he transformed Huysmans' hero into a considerably more refined connoisseur of poetry than the author himself had been able to make him. In this lay the ambiguity of Mallarmé's "complimentary poem."

*Prose pour des Esseintes,* referring as it was to a then very popular character in a novel, was a great sensation in literary circles. It was characterized as being both extremely abstruse and indecent. The first opinion has survived many decades, during which the poem has emerged more and more clearly as one of Mallarmé's masterpieces. It has naturally been the subject of literary research, and many attempts at interpretation have been made.[48] In fundamentals these interpretations show rather close agreement. When they diverge in individual points, it is not on account of the degree of incomprehensibility in *Prose,* but because of its complexity. It satisfies different demands which together are likely to stress the depth and strength of Mallarmé's poetic vision. Because of the relative degree of difficulty in *Prose,* it may be more suitable to consider first another of Mallarmé's poems, written a few months later, but closely related to *Prose* in sentiment and content.

The prose poem *Le Nénuphar Blanc* [49] was written in 1885 at Valvin, where the poet had had a summer cottage since 1874. In this pastoral setting by the Seine he relaxed from his tiring and tedious work as a teacher in Paris, devoted himself to open-air life and meditation, and occasionally entertained his most intimate friends. On account of its somewhat less complicated structure, *Le Nénuphar Blanc* forms a suitable introduction to *Prose,* and at the same time makes possible a general survey of Mallarmé's poetic style.

In this apotheosis of summer the poet discards his faun or Hamlet mask and appears openly in the poem, which begins with an impression of nature, full of joyful intoxication. In gently flowing lines Mallarmé tells how he was rowing about on the river on a sun-saturated summer's day with no other aim than to enjoy the overwhelm-

ing beauty of nature with all his senses. He was so wrapped up in dreams and sensations that he did not return to full consciousness until his tiny boat was stranded on a marshy, reedy island in the middle of the river.

Then he suddenly remembered that he had really had a definite goal for his trip. He had been on his way to gather a few water lilies before paying a visit to a "lady friend's lady friend" who was said to be living by the river. But where was he now?

Upon closer examination, I discovered that this tuft of green tapering off above the stream concealed the single arch of a bridge which was extended on land by a hedge on either side surrounding a series of lawns. Then it dawned on me: this was simply the estate belonging to the unknown lady to whom I had come to pay my respects.

It was an attractive place for this time of year, I thought, and I could only sympathize with anyone who had chosen a retreat so watery and impenetrable. Doubtless she had made of this crystal surface an inner mirror to protect herself from the brilliant indiscretion of the afternoons. Now, I imagined, she must be approaching it; the silvery mist chilling the willow trees has just become her limpid glance, which is familiar with every leaf.

I conjured her up in her perfection and her purity.*

Motionless, crouching in the boat, the poet listened for the being his imagination had called forth. He looked down at his feet, which were strapped to the bottom of the boat, and smiled at the erotic spell that captivated his senses. But on the mysterious island there was only calm and silence.

"Probably just somebody . . ." I was about to say.

Then, suddenly, the tiniest sound made me wonder whether the

---

* L'inspection détaillée m'apprit que cet obstacle de verdure en pointe sur le courant, masquait l'arche unique d'un point prolongé, à terre, d'ici et de là, par une haie clôturant des pelouses. Je me rendis compte. Simplement le parc de Madame . . . , l'inconnue à saluer.

Un joli voisinage, pendant la saison, la nature d'une personne qui s'est choisi une retraite aussi humidement impénétrable ne pouvant être que conforme à mon goût. Sûr, elle avait fait de ce cristal son miroir intérieur à l'abri de l'indiscrétion éclatante des après-midi; elle y venait et la buée d'argent glaçant des saules ne fut bientôt que la limpidité de son regard habitué à chaque feuille.

Toute je l'évoquais lustrale.[50]

dweller on this bank was hovering about me—perhaps by the river!—while I lingered there.

The walking stopped. Why? *

The poet brooded over the strange phantoms roused by the sound of steps. Why had she stopped, had she really heard him, or had she had a presentiment of the presence of a stranger? Yes, that must be it. And suddenly he saw clearly that if he tried to penetrate more deeply into the mystery, the spell would be broken and he would become a cloddish trespasser.

With a glance I shall gather up the virginal absence scattered through this solitude and steal away with it; just as, in memory of a special site, we pick one of those magical, still unopened water-lilies which suddenly spring up there and enclose, in their deep white, a nameless nothingness made of unbroken reveries, of happiness never to be—made of my breathing, now, as it stops for fear that she may show herself. Steal silently away, rowing bit by bit, so that the illusion may not be shattered by the stroke of oars, nor the splashing of the visible foam, unwinding behind me as I flee, reach the feet of any chance walker on the bank, nor bring with it the transparent resemblance of the theft I made of the flower of my mind.**

Fearing to disturb the dreamlike silence and by his movements attract the lady of the island—"the Thoughtful, the Noble, the Timorous, the Gay"—the poet retreated noiselessly from the spot. However, he took his sensations with him, as one picks a water lily, which when it opens, reveals "a lovely nothingness full of innocent dreams, of bliss that never existed."

---

* "—Aussi bien une quelconque . . ." allais-je terminer.

Quand un imperceptible bruit me fit douter si l'habitante du bord hantait mon loisir, ou inespérément le bassin.

Le pas cessa, pourquoi? [51]

** Résumer d'un regard la vierge absence éparse en cette solitude et, comme on cueille, en mémoire d'un site, l'un de ces magiques nénuphars clos qui y surgissent tout à coup, enveloppant de leur creuse blancheur un rien, fait de songes intacts, du bonheur qui n'aura pas lieu et de mon souffle ici retenu dans la peur d'une apparition, partir avec: tacitement, en démarrant peu à peu sans du heurt briser l'illusion ni que le clapotis de la bulle visible d'écume enroulée à ma fuite ne jette aux pieds survenus de personne la ressemblance transparente du rapt de mon idéale fleur.[52]

❦

MANY OF THE TYPICAL FEATURES of Mallarmé's aesthetics and poetry are present in the beautiful prose poem *Le Nénuphar Blanc.* It is constructed on a series of continually changing and astonishing poetic metaphors. The perspective of the "subject" undergoes a number of transformations that give the poem a rich articulation. On the surface it is markedly sensual; symbols of nature and erotic allusions are blended unceasingly. The poem reaches its emotional climax in the episode of the fading sounds of footsteps. A rapid change takes place in the structure. A chilly breath of wind passes over the picture, the language becomes more arid, more argumentative. The poet begins to analyze his feelings; he reflects on the singular fluctuation between dream and reality.

With this the poem is given a new dimension. Its principal aim is no longer to describe a sensual experience, but to endeavor to capture "absolute beauty" in striking, pregnant metaphors. But the poem ends in impotence and defeat. Those who try to delve deeply into the nature of poetry must always run the risk of breaking the spell. The poet never reaches his goal.

It cannot be denied that Mallarmé's aesthetic theories are strongly reminiscent of Schopenhauer, but his pessimism is less gloomy. For him effort expended in making poetry is never wasted. The reflections around the poetic dream-world ultimately give a form of *insight.* They create a "third aspect"—an aesthetic alternative to the experiences of the phenomenal and noumenal worlds: a completely new artistic structure.[53]

In 1886, when Mallarmé was asked by Gustave Kahn to give his definition of poetry to the readers of *La Vogue,* the poet answered: "Poetry is the expression, in human language brought back to its essential rhythm, of the mysterious sense of existence: thus it endows our existence with authenticity and constitutes the sole spiritual task." *

* "La Poésie est l'expression, par le language humain ramené à son rythme essentiel, du sens mystérieux de l'existence: elle doue ainsi d'authenticité notre séjour et constitue la seule tâche spirituelle." [54]

This uncompromising attitude to art, this emphatic insistence on the supreme significance of poetry give to Mallarmé's aesthetics a sublime grandeur. In the strength of his belief the poet is not satisfied only to discover and absorb the beauty of the surrounding reality (*esthétique de l'inspiration*); he tries unceasingly to penetrate beyond the contingencies and absurdities of existence, to create a more dignified world—a world of appreciation (*esthétique de la construction ou création*).[55] In this act of creation—*la poésie scientifique*—every little cog wheel is cut with the greatest precision so that it will be able to perform its function efficiently in the complicated machinery of poetry. *Prose pour des Esseintes* is a sonorous example of Mallarmé's great demands on the art of poetry. It is a monumental approach to his poetry of the eighties, at the same time as it marks his final victory over a ten-year period of poetic impotence. Compared to *Prose,* the somewhat later *Le Nénuphar Blanc,* in spite of its beauty, is a kind of echo.

The circumstances around the creation of *Prose* have been briefly described. It will be remembered that it was conceived and published at a time when Georges Seurat was struggling most intensively with the problems of *La Grande Jatte,* when the circle around *La Revue Indépendante* was fused into a group with common interests and values. The poem consists of fourteen stanzas, each containing four octosyllabic verses with regular rhymes according to the pattern a, b, a, b.[56]

<table>
<tr><td>

PROSE [57]

*pour des Esseintes*

HYPERBOLE! from my memory
triumphant can you not arise,
today from a book bound with
    iron
as cabalistic gramaries:

because by knowledge I induct
the hymn of all hearts spirituel
to this labor of my patience,
atlas, herbal, ritual.

</td><td>

PROSE

*pour des Esseintes*

HYPERBOLE! de ma mémoire
Triomphalement ne sais-tu
Te lever, aujourd'hui grimoire
Dans un livre de fer vêtu:

Car j'installe, par la science,
L'hymne des cœurs spirituels
En l'œuvre de ma patience,
Atlas, herbiers et rituels.

</td></tr>
</table>

We would turn our visages
(I maintain that we were two),
O sister, to the landscape's
    charms,
always comparing them with
    you.

The era of authority
is troubled when, with no motifs,
they say of this southland our
    double
mind's subconsciousness perceives

that, hundred-iris bed, its site,
they know if really it existed,
does not bear a name the gold
of the Summer's trumpet cited.

Yes, on an island charged by air
not with visions but with sight
every flower showed off, freer,
though we never spoke of it.

Such, immense, that every one
usually adorned itself
with a lucid edge, lacuna
which from the gardens set it off.

Glory of long desire, Ideas
all in me with great elation
saw the family Irides
arise to this new consecration,

but this sensible fond sister
went no further than to spare
a smile and, to understand her,
I attend my ancient care.

Nous promenions notre visage
(Nous fûmes deux, je le main-
    tiens)
Sur maints charmes de paysage,
O sœur, y comparant les tiens.

L'ère d'autorité se trouble
Lorsque, sans nul motif, on dit
De ce midi que notre double
Inconscience approfondit

Que, sol des cent iris, son site,
Ils savent s'il a bien été,
Ne porte pas de nom que cite
L'or de la trompette d'Eté.

Oui, dans une île que l'air charge
De vue et non de visions
Toute fleur s'étalait plus large
Sans que nous en devisions.

Telles, immenses, que chacune
Ordinairement se para
D'un lucide contour, lacune
Qui des jardins la sépara.

Gloire du long désir, Idées
Tout en moi s'exaltait de voir
La famille des iridées
Surgir à ce nouveau devoir.

Mais cette sœur sensée et tendre
Ne porta son regard plus loin
Que sourire et, comme à
    l'entendre
J'occupe mon antique soin.

| | |
|---|---|
| O Spirit of contention! know | Oh! sache l'Esprit de litige, |
| at this hour when we are still, | A cette heure où nous nous tai- |
| that too tall for reason grows | sons, |
| the stalk of multiple asphodels | Que de lis multiples la tige |
| | Grandissait trop pour nos raisons |
| | |
| and not as the shore weeps, | Et non comme pleure la rive, |
| when its monotonous frolic lies | Quand son jeu monotone ment |
| to wish an amplitude would | A vouloir que l'ampleur arrive |
| come | Parmi mon jeune étonnement |
| into my juvenile surprise | |
| | |
| at hearing all the sky and map | D'ouïr tout le ciel et la carte |
| always in my steps attested, | Sans fin attestés sur mes pas, |
| by the wave even that ebbs away, | Par le flot même qui s'écarte, |
| that this country never existed. | Que ce pays n'exista pas. |
| | |
| Already lessoned by the roads | L'enfant abdique son extase |
| the child resigns her ecstasy | Et docte déjà par chemins |
| and says it: Anastasius! born | Elle dit le mot: Anastase! |
| for parchments of eternity, | Né pour d'éternels parchemins, |
| | |
| before a sepulcher could laugh | Avant qu'un sépulcre ne rie |
| in any clime, her ancestor, | Sous aucun climat, son aïeul, |
| to bear the name: Pulcheria! | De porter ce nom: Pulchérie! |
| hidden by the too great lily's | Caché par le trop grand glaïeul. |
| flower. | |

The title of the poem may seem both puzzling and ironic, in view of the artistically interwoven lines. Undoubtedly the author had good reasons for his choice of title. On the one hand he wished to stress the view that des Esseintes and people like him would be able to appreciate the ornate form and the enigmatic contents as easily as ordinary people understand workaday prose. On the other the title indicated that the poem was related to the old Latin form of hymn that was sung in church on special occasions. This aspect will be dealt with later.

The two introductory stanzas differ noticeably from the rest of the poem. They form a learned introduction in which the poet con-

jures up a mighty vision from the world of memory. Mallarmé draws on all of his cabbalistic poetic arsenal, housed symbolically in an ironbound book of black magic. Even atlases, herbals, and rituals help him relate to his sympathizers (*des cœurs spirituels*), in poetic form, a fabulous experience he has had. With vivid scenic graphicness the poet tells—as in *Le Nénuphar Blanc*—of a strange lovers' meeting on a luxurious paradisial island. The exalted atmosphere is suggested in a rising crescendo of ostentatious flower symbolism. The rendezvous gradually emerges as an alluring, exotic place. Affected allusions with occult leanings intensify the sensation of the unique, the unprecedented in the situation.[58] The sensual metaphoric language reaches its climax in the seventh and eighth stanzas, and reappears in the last two lines of the tenth, like a violently expanding echo,[59] which, however, fades away just as quickly. In the eleventh stanza the relation has a completely new emotional character, and the poem seems to end in pessimism and resignation. The poet's Cythera, which in the moment of desire had seemed so physically manifest (*Oui, dans une île que l'air charge / De vue et non de visions*), proved at last to be only a dream.

In this interpretation *Prose* becomes one of the long list of erotic complimentary poems dedicated to Méry Laurent, who was Mallarmé's muse and intimate associate during all of the eighties.[60] Mme. Laurent had begun her career as a naked dancer at the Châtelet theatre, but she "seemed to have had more success in what she did after, rather than during the dance." She posed regularly for Manet, and it was in his studio that she became acquainted with Mallarmé.

A wealthy and tolerant American dentist, Dr. Evans, raised her to the rank and dignity of a *demi-monde*. Having a certain degree of *esprit* and talent she acted as a literary and artistically interested "Olympia." Her circle embraced the leading representatives of *avant-garde* literature, and she was the only female element in the symposiums of the editorial staff of *La Revue Indépendante*. For four years Méry Laurent was a neighbor of Mallarmé's in the Rue de Rome, and they seem to have been most intimately acquainted during the years immediately after the death of Manet in 1883. There

is no doubt that the association was a source of poetic inspiration to Mallarmé, but the unavoidable secrecy and the fundamentally untenable situation led to mental strain, and gave to the acquaintanceship a melancholy, muted tone.

In order to visualize the erotic experience poetically, Mallarmé uses in *Prose* an ascending series of word paintings, in sensually warm colors. This rising sequence, which may be designated the *dynamogenic* part of the poem, is balanced by the falling curve of contractile, chilly intellectual metaphors in the last four stanzas—the *inhibitant* section of the poem. But within the framework of this continuity great tension is established between disparate and ambiguous pictorial elements that collide abruptly. The title of the poem alludes to the Latin hymn sung between the epistle and the gospel at certain masses. The poem is without meter, but keeps rigorously to eight syllables in every line and the final rhyming words. This gives the poem a monotonously pulsating rhythm that contributes largely towards making the contents abstract, and to suppressing the plastic obviousness of the individual metaphors. The reader's attention is drawn to the carefully chosen artistic and affected rhymes which elucidate and intensify each other. One seems to find in the syntactical arrangement of the various elements of the poem a parallel to the painstaking pointillism and exact application of the laws of color of the neo-impressionists. For example, the expression "D'un lucid contour, lacune," in stanza VII seems directly connected with the formal device in Seurat's *Une Baignade* and *La Grande Jatte.*

The erotic content of *Prose* is not in itself sufficient to explain the complex structure of the poem. It is not, however, necessary to bind oneself by a definite interpretation of individual words such as *nous*—the poet and the ideal reader (Thibaudet), the poet and his Muse (Soula), the poet and his patience (Mme Noulet), the androgynal nature of the poet (Wais, Fowlie)—to understand that *Prose* is fundamentally *ars poetica.* It is an artistic manifestation opposed to the conventional aestheticism of the Parnassus poetry— *l'ère d'autorité* and *l'esprit de litige*—that threatens continually to destroy the paradise the poet has created for himself.

The childishness of literature until now has been in the belief, for example, that to choose a certain number of precious stones and write their names on paper was to *make* precious stones. Ah well, no! Since poetry consists in *creating,* one must find in the human soul states, flashes of a purity so absolute that, well sung, properly illuminated, it constitutes in effect man's jewels: there is symbol, there is creation, and here the word poetry has meaning: it is, in short, the only possible human creation.*

But in this ideal world, too, there exist violent oscillations between hope and despair, between ecstatic visions of beauty and a numbing feeling of impotence to describe them adequately (stanzas 8, 9, 10). It is true that the poet has carefully planned his aesthetic approach with full consciousness of all the pitfalls in his way.

To name an object is to suppress three-fourths of the delight of a poem which consists of divining, little by little; to *suggest* it, that is the dream. It is the perfect use of this mystery which constitutes the symbol: to evoke an object little by little in order to show a mental state, or, inversely, to choose an object and bring forth from it a state of soul by a series of decipherings.**

But what was dream, and what reality? What metaphors could reflect absolute beauty? Perhaps the poet's efforts were doomed eternally to be esoteric wizardry, unintelligible to most people. It is possible that the dizzying play on words, the complicated analogies, were but the intangible results of an abortive seeking for the incomprehensible.

This undertone of anxiety transforms *Prose pour des Esseintes*

---

* L'enfantillage de la littérature jusqu'ici a été de croire, par exemple, que de choisir un certain nombre de pierres précieuses et en mettre les noms sur le papier, même très bien, c'était *faire* des pierres précieuses. Eh bien! non! La poésie consistant à *créer,* il faut prendre dans l'âme humaine des états, des lueurs d'une pureté si absolue que bien chanté et bien mis en lumière, cela constitue en effet les joyaux de l'homme: là il y a symbole, il y a création, et le mot poésie a ici son sens: c'est, en somme, la seule création humaine possible.[61]

** *Nommer* un objet, c'est supprimer les trois-quarts de la jouissance du poème qui est faite de deviner peu à peu: le *suggérer,* voilà le rêve. C'est le parfait usage de ce mystère qui constitue le symbole: évoquer petit à petit un objet pour montrer un état d'âme, ou, inversement choisir un objet et en dégager un état d'âme, par une série de déchiffrements.[62]

into a magic land of poetry. There the coulisses of reality are thrust into the visions of fantasy; there is created a nervously tense struggle between emotion and thought. The tension reaches its climax in the eighth stanza.

> Gloire du long désir, Idées
> Tout en moi s'exaltait de voir
> La famille des iridées
> Surgir à ce nouveau devoir.

The antithesis *désir-idée* is absorbed in the synthesis *iridées* in which the world of ideas is the dominant. Captured in a single concentrated symbol is the poetic dream-land where every gaudy hot-house lily, like the figures in Seurat's painting, "is clad in a lucid contour, lacuna, which separates her from the gardens." * But this artificial world, built on a frail equilibrium between discontinuous principles of form, threatens continually to slip through the poet's fingers. With infinite care he has endeavored, by means of archaisms, grammatical subtleties which place the reader in perplexing dilemmas, and synecdoches and syllepses, to give form to his hyperbolical visions, and in the last two stanzas he is urged (Anastase!) to immortalize his sensations on "eternal parchment" at once, so that beauty (Pulchérie) shall not be for ever inaccessible on the mysterious isle of irises.[63]

Like a melancholy note there runs through the poem the conviction of the existence of pure beauty coupled with the inability to describe its nature. The poet was, like Odilon Redon's magician, an "inconsolable seeker of a mystery which he knows does not exist and which he will pursue forever, all the same, from the deep mourning of his lucid despair, for *it should have been* the truth . . ." **

In all its artistry *Prose* has a clearly didactic character. Throughout the poem runs an impassioned dialogue about the problems of the ascendancy of form over the poetic inspiration, of the sublime and the mystic ideas that threaten to destroy the form of the poem.

---

* se para d'un lucide contour, lacune, qui des jardins la sépara.

** inconsolable chercheur d'un mystère qu'il ne sait pas exister et qu'il poursuivra, à jamais pour cela, du deuil de son lucide désespoir, car *c'eût été* la vérité.

The relationship between the form as the expression of emotion and the form as the bearer of ideas called forth in Mallarmé, as in the champions of neo-impressionism, a new artistic structure—*discontinuity*. It was for both parts the essential means of expressing aesthetic experiences of hitherto unparalleled complexity.

"If you knew," wrote Stéphane Mallarmé to his friend Dr. Cazalis, "how many nights of despair, and days spent in dreams one must go through to create an original poem—I have not yet created one, however,—a poem which in its innermost secret places can delight the soul of a poet. How carefully one must study the tone and colour of the words, the musical and the picturesque, so that one's thoughts shall inspire the poem, so beautiful that it must be called poetry." *

*L'Ile des Iridées*—the enchanted isle—became for both Mallarmé and Seurat the lists for a joust between artistic principles, between the sensual, life-enhancing world, and the world of abstract ideas. "The flashes of absolute purity" ** that thereby emerged, however, dazzled the artists' contemporaries with its chilly lustre. In the main their intentions were interpreted as a strange, aimless wandering in the treacherous outlands of aesthetics. Their work was, to quote Félix Fénéon, "an art for artists alone."

IT IS ONLY NATURAL that the closed circle at the Brasserie Gambrinus and *La Revue Indépendante* should do their best to try to understand and interpret in writing Mallarmé's aesthetic program. Let us look for a moment, however, at *Prose pour des Esseintes* through the eyes of the jester, Adoré Floupette.

*Les Déliquescences* appeared in May 1885, only a few months after the publication of Mallarmé's poem. Thus Adoré Floupette's travesties were highly topical. Starting from the two enigmatic final

---

* Mais si tu savais que de nuits désespérées et de jours de rêverie il faut sacrifier pour arriver à faire des vers originaux (ce que je n'avais jamais fait jusqu'ici) et dignes, dans leurs suprêmes mystères, de réjouir l'âme d'un poète! Quelle étude du son et de la couleur des mots, musique et peinture par lesquelles devra passer ta pensée, tant belle soit-elle, pour être poétique.[64]

** Les lueurs d'une pureté absolue.

stanzas of *Prose,* Beauclaire and Vicaire constructed a nonsense poem, which in rhyme, sentence construction, and metaphor did all that could be done to tear to pieces the sentiments of its prototype (see p. 30). Adoré Floupette's poem would not have been a parody if it had not at the same time made use of the essential emotional values in Mallarmé's poem. Well aware of the erotic content of *Prose,* the two authors took full advantage of the possibilities of playing on the violent changes between sensual tension and Platonic idealism. Mallarmé's pregnant metaphors were transformed by Floupette into pretentious, banal and equivocal doggerel.[65]

But the purpose of the poem was not merely to poke fun at a single theme of *avant-garde* poetry. It must not be forgotten that the title of the book was "Deliquescences, Decadent Poems by Adored Weather-vane." The intention of Beauclaire and Vicaire was to show that symbolic poetry was fundamentally lacking in originality. Adoré Floupette's development as a poet, as related by Marius Tapora, undeniably confirmed this claim. His poems were the fruits of learning culled from the works of the masters of classicism, romanticism, and naturalism. The remarkable symbols that Floupette defended so warmly proved on closer scrutiny to be derived from old stereotype phrases and everyday experiences. In what, then, did symbolic poetry differ from its forerunners? Its originality and force, claimed the critics, depended almost wholly on the formal and emotional character of the symbols. If they were not given a sufficiently pregnant structure, the whole poem ran the risk of becoming a conventional allegory or emblem.

It should be remembered that the press debate which followed in the wake of *Les Déliquescences* was more concerned with the contribution of the commentators rather than with the parody itself. This was probably due to the fact that the distance between Beauclaire's and Vicaire's book and symbolic poetry was too small. If the amusing turns of speech are ignored, Adoré Floupette's attempts to define the symbolic world of the new poetry coincide with the aesthetic problems of the symbolists.

Shortly before the publication of *Prose,* one of the members of the Brasserie Gambrinus coterie—Maurice Barrès—made an earnest attempt to analyze Mallarmé's poetry. In his one-man peri-

odical *Les Taches d'Encre,* he dealt, characteristically enough, with
the problem in a series of articles under the title "la sensation, le
sentiment, l'idée en littérature." After apostrophizing the poet's abil-
ity to synthesize a complicated experience in a striking figure, he
went on:

> . . . Let us follow, in fact, his process of composition: he mathemati-
> cally refines the initial idea, with its already singular complication,
> then, to realize it, having chosen some rare and *adequate* comparison,
> he suddenly drops everything and keeps only the comparison itself
> —whence he sets forth, without further explanation, towards new
> and distant analogies. Again, to bind it all together, he eliminates all
> transitions; and most often he moves, not from idea to idea, but from
> emotion to emotion. There is an art of sensations here, but always
> controlled, thoughtful, developing an intellectual conception. He
> writes for himself alone, and some blasé readers savor him.*

Maurice Barrès' lucid characterization of the unique nature of
Mallarméan poetry, made as early as December 1884, is evidence of
the rapid communication of ideas within symbolist circles. But not
even he succeeded fundamentally in interpreting Mallarmé's figura-
tive language, although he noticed the violent tension between the
different moods and the fluctuations between emotional metaphors
and content. There emerged an uneasy assumption that only the
poet himself was in a position to understand the new poetry.

The greatest efforts to bridge the gulf between symbolic poetry
and the reading public were made by Mallarmé's young critic friend
Emile Hennequin. Around the middle of the decade he published a
series of essays in *La Revue Indépéndante* and *La Revue Contempo-
raine;* in 1888 they were collected in an ambitious aesthetic and
art-critical work, *La Critique Scientifique.* Hennequin began from

---

* . . . Suivons, en effet, son procédé de composition: sur l'idée initiale d'une
complication déjà singulière, il raffine mathématiquement, puis, pour la réaliser,
ayant fait choix de quelque comparaison rare et *adéquate,* il lâche tout soudain
et ne conserve plus que la comparaison même, d'où il s'élance, sans autre expli-
cation, à de nouvelles et lointaines analogies. Encore, pour resserrer le tout, sup-
prime-t-il les transitions; et le plus souvent il procède, non point d'idée à idée,
mais d'émotion à émotion. C'est bien là de l'art sensationniste, mais toujours
voulu, médité, et développant quelque conception intellectuelle. Il écrit pour lui
seul, et quelques blasés le savourent.[66]

the standpoint of the milieu theories of positivism, but was gradually compelled to renounce them. Instead he created something he called *esthopsychologie,* a three-sided method of criticism which led from form analysis over to an interpretation of the expressive value of form (with reference to Charles Henry, among others), and finally to a "sociological analysis." Henry was concerned exclusively with the study of the poems as symbols of their writers, and of the ideal milieu created by the admirers and sympathizers of the poet.[67] Hennequin stressed emphatically that aesthetic feelings were of a different nature than actual emotions. They were fictitious, delusive, and "unproductive." He maintained further that the efforts of symbolism to create the "pure idea" were equivalent to shaping adequate symbols for aesthetic feelings. The logical conclusion of this was that "a work of art only moves those whose emblem it is," and it "will have an aesthetic effect only on those persons who believe they possess a mental organization both similar and inferior to the organization that created the work and that can be deduced from it." * With that Hennequin had in reality reduced the sphere of symbolic poetry almost as much as his critic colleagues.

The mighty net of interpretations with which the critics encircled the new symbolic art emphasized the strictly individual nature of its mystical aestheticism. Nevertheless, the idea that the individual nuances reflected a common inner mechanism was never really abandoned. Thus Mallarmé's and Seurat's conception of the "isle of irises" were, for the initiated circles around the two artists, analogous and at the same time terrifying and alluring examples of an ideal art. They inspired imitation, but kindled in a few a burning desire to develop the main thoughts of the pioneers on purely personal lines.

---

* "une œuvre d'art n'émeut que ceux dont elle est le signe"; "n'aura d'effet esthétique que sur les personnes qui se trouvent posséder une organisation mentale analogue et inférieure à celle qui a servi à créer l'œuvre et qui peut en être déduite." [68]

# 3 / La Lutte et le Rêve

IN THE FIRST CHAPTER I MENTIONED THE ECONOMIC CRISIS THAT coincided with the aesthetic revolution in art and literature around the middle of the eighties. Those who suffered most in the rigorous economic climate during those years were the artists who had already made a name for themselves—Pissarro, Renoir, Monet—who immediately before the crisis had enjoyed a slow but steady rise in the prices of their works. Pissarro's letters suggest that the situation on the art market had suddenly become catastrophic.

In such circumstances it seems extremely puzzling that at the turn of the year 1883–84, in the middle of the crisis, the banker Paul Gauguin left a very lucrative post as a stockbroker to devote himself solely to art. A careful study of the situation, however, shows that this drastic step was by no means the consequence of a rash impulse, but rather the realization of a long-cherished plan. When Gauguin became a professional artist he was by no means a beginner. His work had been accepted by the Salon as early as 1876, and during the period 1880–83 he had been privileged to take part in the impressionist exhibitions, in spite of Monet's disapproval. His *Étude de nu,* hung in 1881, had been the subject of a favorable review by Huysmans. Thus he could devote himself entirely to painting with a certain degree of self-confidence.

All the same it is highly probable that the crash in the Union Générale des Banques gave the immediate impulse to Gauguin's choosing to go over definitively to art. The crisis was felt throughout the financial life of the country, and caused reductions in the staff of Gauguin's firm, Bertin & Cie. Gauguin's friend Schuffenecker was dismissed, and compelled to earn his living as a teacher of drawing. Gauguin, it is true, held a more important post, but the senior part-

ner, Gustave Arosa, who had been his guardian and protector, had died in 1878. It is quite possible that Gauguin's position at Bertin's had become less secure after Arosa's death, and that he had good reason to fear that his fate would be the same as that of Shuffenecker.[1]

Paul Gauguin was clearly of the opinion that the prospects of the impressionists' dominating the art market were good, and he seems to have regarded the unwillingness to buy art in the years 1883–84 as a temporary phenomenon. On the whole he was right, even if the recovery took longer than he had anticipated. During the nineties Monet, Renoir, and even Pissarro received astonishingly high prices for their work. A contributory cause of Gauguin's decision to devote himself wholly to art was undoubtedly the life of his friend and teacher, Camille Pissarro. As far as can be judged, Pissarro had no difficulty in supporting his large family before the years 1883–84. Gauguin followed Pissarro's example and settled in the country, in Rouen, where living was cheap.[2] Unfortunately this stay in Rouen coincided with the acute crisis in the art market during the spring of 1884. Durand-Ruel, as we have seen, was on the verge of bankruptcy. It was impossible for Gauguin to sell either his own works or any part of his large collection of impressionist pictures, which included works by Manet, Jongkind, Renoir, Monet, Pissarro, Guillaumin, Cézanne, Sisley, and others.

The situation was really very grave. After much hesitation, the Gauguin family decided in December 1884 to move to Copenhagen, the former home of Mette Gad, Gauguin's wife. This decision was undoubtedly made with full knowledge of the fact that the French franc was hard currency in Scandinavia. By selling his life insurance policy Gauguin had managed to scrape together enough money so that the family did not arrive in Denmark as beggars. In contrast to what the popular biographies usually claim, they did not live on the Gads after their arrival in Copenhagen. They rented an eight-room flat in Gammel Kongevej rather cheaply—for about 150 francs a month. Further Paul Gauguin had obtained a post as the Danish agent for a French tarpaulin firm, Dillies & Co. of Roubaix. With recommendations from his wife's influential friends in Denmark and Norway, he hoped to make a good income from his agency, which would also allow him plenty of time for painting.

Paul Gauguin's actions during this period provide a revealing insight into the dominant features of his character. He underestimated considerably the language difficulties that were to be so fateful for his business activities. At the same time he had too high an opinion of the cultural standard in Denmark. It is possible that he was deceived in this by his brother-in-law, Fritz Taulow, who had given him to understand that French impressionism had already begun its triumphal march through Scandinavia.

Reality was quite different. The correspondence with Dillies & Co. clearly reflects Gauguin's failure as a businessman in Denmark. Everywhere he seems to have been met with mistrust, probably because he was inexperienced in the branch and did not understand Danish, in addition to being profoundly uninterested in tarpaulins.

His endeavors to conquer the Danish art public ended just as ignominiously. If he had had any expectations that his culturally radical relations, Georg and Edvard Brandes, were favorably inclined towards French *avant-garde* art, he was no doubt very disappointed. An exhibition at the Society of the Friends of Art in Copenhagen May 1885 did not cause the slightest repercussion in the Copenhagen press, and must be regarded as a complete fiasco.[3]

In a letter to Schuffenecker Gauguin himself attributed his failure to organized sabotage by the Danish Academy of Art. After five days the exhibition had been closed; he felt like a Rochefort of art.[4] Eighteen years later, on the island of Hiva-Oa, he returned to the subject when he wrote *Avant et Après*. Then the episode had swelled out to gigantic proportions. The exhibition was said to have been closed before it was even opened, "on orders from above." [5] As a matter of fact, a week was the normal exhibition period in the artistic life of Copenhagen. The circumstance, however, sets off Gauguin's personality and situation in sharp relief. His stay in Denmark had been built up on a foundation of optimism that was totally unjustified. It also shows the adventurous and haphazard features of his character.

Very soon, therefore, he found conditions in Copenhagen almost unbearable. This feeling was augmented by a lively exchange of correspondence with Schuffenecker and Pissarro,[6] which confirmed him in his view that a profound change was taking place in the artistic

life of Paris. Confined to Copenhagen he would be left outside the important events.

Gauguin's letters clearly show that he was kept in touch with the cultural situation in Paris during the spring of 1885. As early as 14 January he sent a very remarkable letter from Copenhagen, in which he defended himself against the proposal that he become a member of *La Société des Indépendants.* His argument was the same as that of the doctrinary impressionist art policy. To his mind the society would rapidly be augmented by a number of mediocre painters and become completely commercialized in a very short time. He kept rigidly to this opinion as long as he lived.

Most of the letter, however, dealt with theoretical problems of art. He pondered over how intimations of the supernatural could be interpreted through the medium of art; he delved deeply into the magic import of the relationship of simple numbers and measures; and discussed the part played by color, line, and form as symbols of sensations. On the basis of the collection of pictures that he had taken to Copenhagen, he analyzed Cézanne's artistic achievement. He regarded him as an "oriental mystic," whose paintings had a parabolic content. They reflected the inner reality that the artist had created in his imagination. The letter ended:

Work *freely and passionately,* you will make progress and sooner or later if you have any worth they will recognize it. Above all don't sweat over a canvas; a great emotion can be translated instantly, dream about it and seek for it the simplest form.

The equilateral triangle is the most solid and perfect form of a triangle. An elongated triangle is more elegant. In pure truth, sides don't exist; according to our feelings, lines to the right advance and those to the left recede. The right hand strikes, the left is in defense. A long neck is graceful but heads sunk on the shoulders are more pensive. A duck with its eye turned upward listens; I know, I tell you a bunch of idiotic things; your friend Courtois is more sensible but his painting is so stupid. Why are the willows with hanging branches called "weeping"? Is it because descending lines are sad? Is the sycamore sad because it is put in cemeteries; no, it is the color that is sad.*

---

* Travaillez *librement et follement,* vous ferez des progrès et tôt ou tard on saura reconnaître votre valeur si vous en avez. Surtout ne transpirez pas sur un

This letter gives important information about Gauguin's artistic development at that time. The partly advanced art theories can hardly be assumed to have emerged unless Gauguin had been aware in one way or another of the aesthetic debate that had begun in Paris shortly after his departure from France. His speculations on the emotional values of lines and colors are like an echo of Charles Henry's lectures on experimental psychology. There was nothing to prevent the artist, though living in Rouen, from visiting the first independent exhibition, and perhaps even becoming acquainted with Signac and Seurat.

Over and above that, the lines about Cézanne give a glimpse of Gauguin's attraction to "exotic" art, a partiality that was to be decisive for the future development of his style. As a matter of fact, the Copenhagen letter outlines—albeit vaguely—a symbolic artistic program. To realize this program Gauguin felt compelled to return to Paris, and in June, or possibly July, 1885 he left Denmark.

ANYONE WHO ENDEAVORS TO DRAW a true picture of the artist's activities during the following months runs up against almost insurmountable obstacles. His letters to his wife dealt predominantly with the struggle for existence. The situation was complicated by the fact that he had taken his little son Clovis with him to Paris.

It is known, however, that on his arrival in France he immediately renewed his association with Schuffenecker. He spent part of the autumn in the neighborhood of Dieppe, where he met Degas. He also seems to have had a violent quarrel with his older col-

tableau; un grand sentiment peut être traduit immédiatement, rêvez dessus et cherchez en la forme la plus simple.

Le triangle équilatéral est la forme la plus solide et la plus parfaite d'un triangle. Un triangle long est plus élégant. Dans la pure vérité il n'existe pas de côté; à notre sentiment il y a les lignes à droite qui vont de l'avant celles à gauche reculent. La main droite frappe celle de gauche est en défense. Un cou long est gracieux mais les têtes dans les épaules sont plus pensives. Un canard qui a l'œil en l'air écoute, que sais-je, je vous raconte un tas d'idiotismes; votre ami Courtoi est plus raisonnable mais sa peinture est si stupide. Pourquoi les saules dont les branches pendent sont-ils appelés pleureurs? Est-ce parce que les lignes baissantes sont tristes? Et le sycomore est-il triste parce qu'on le met dans les cimetières, non c'est la couleur qui est triste.[7]

league. At an early stage he probably improved his acquaintanceship with Signac and Seurat. In this he by no means played the part of the passive receiver of others' views, but he was able to contribute to the aesthetic debate. He lent Seurat an eighteenth century Turkish "manuscript" that consisted partly of a tract on painting.[8]

The following extract is taken from Seurat's copy:

Let everything about you breathe the calm and peace of the soul. Also avoid motion in a pose. Each of your figures ought to be in a static position. When Oumra represented the death of Ocraï, he did not raise the saber of the executioner, or give the Khakhan a threatening gesture, or twist the culprit's mother in convulsions. The sultan, seated on his throne, wrinkles his brow in a frown of anger; the executioner, standing, looks at Ocraï as on a victim who inspires him with pity; the mother, leaning against a pillar, reveals her hopeless grief in this giving way of her strength and her body. One can therefore without weariness spend an hour before this scene, so much more tragic in its calm than if, after the first moment had passed, attitudes impossible to maintain had made us smile with an amused scorn.

Study the silhouette of every object; distinctness of outline is the attribute of the hand that is not enfeebled by any hesitation of the will.

Why embellish things gratuitously and of set purpose? By this means the true flavor of each person, flower, man, or tree disappears; everything is effaced in the same note of prettiness that nauseates the connoisseur. This does not mean that you must banish the graceful subject, but that it is preferable to render it just as you see it rather than to pour your color and your design into the mold of a theory prepared in advance in your brain.*

---

* Que chez vous tout respire le calme et la paix de l'âme. Ainsi évitez la *pose en mouvement.* Chacun de vos personnages doit être à l'état *statique.*

Quand Oumra a représenté le supplice d'Ocraï, il n'a point levé le sabre du bourreau, prêté au Khakhan un geste de menace et tordu dans des convulsions la mère du patient. Le sultan, assis sur son trône, plisse sur son front la ride de la colère. Le bourreau, debout, regarde Ocraï comme une proie qui lui inspire pitié. La mère, appuyée sur un pilier, témoigne de sa douleur sans espoir par l'affaissement de ses forces et de son corps. Aussi *une heure se passe-t-elle sans fatigue devant cette scène plus tragique dans son calme* que si, la première minute passée, l'attitude impossible à garder eût fait sourire de dédain.

Appliquez-vous à la *silhouette* de chaque objet. La netteté du contour est l'apanage de la main qu'aucune hésitation de volonté n'affadit.

Pourquoi embellir à plaisir, et de propos délibéré? Ainsi la vérité, l'odeur de

There is no doubt that the text is surprisingly similar to Seurat's artistic program, and it is difficult to dismiss the thought that the episode was a result of discussions of *La Grande Jatte* by the two painters. Gauguin seems to have been one of the few who recognized early the essential features of Seurat's work. The Copenhagen letter mentioned above, which may partly have been inspired by the Turkish tract, shows that Gauguin was theoretically capable of appreciating Seurat's painting. This does not necessarily imply that, like his former teacher, Pissarro, he felt constrained to surrender unconditionally to the neo-impressionist technique. On the contrary, he tried many ways, as before, in the hopes that he would suddenly achieve something completely new and original. His undecided attitude was marked by, among other things, a leaning toward certain aspects of Redon's mysticism which corresponded to his own exotic inclinations.

In his customary vivid way Gustave Kahn described Gauguin in 1886 as an artist who endeavored by all available means to regain a position in the heterogeneous impressionist milieu. As far as his hopeless financial position permitted he frequented the cafés where artists met. He is also said to have organized the celebration feast on the occasion of the opening of the last impressionist exhibition in the Maison Doré. Gauguin chose an inn at the Lac Saint-Fargeau in the Bellville hills. The young symbolist critics were invited, and the whole party went to the feast by omnibus from Arts et Métiers. In springlike, romantic surroundings, usually frequented by wedding parties, the radical artists and critics could, for the moment at least, abandon themselves to the illusion that they had conquered the cultural life of Paris.[10]

In spite of financial difficulties, Gauguin participated in the exhibition in the Rue Lafitte with no fewer than nineteen works. Several of the paintings were from the Rouen and Copenhagen periods, but there were also later works painted on the west coast of France. Félix Fénéon, in his reviews in *La Vogue,* therefore had to give his

chaque personne, fleur, homme, arbre, disparaît. Tout s'efface dans une même note de joli qui soulève le cœur du connaisseur. Ce n'est point à dire qu'il faille bannir le sujet gracieux, mais il est préférable de rendre comme et tel que vous voyez, que de couler votre couleur et votre dessin dans le moule d'une théorie préparée à l'avance dans votre cerveau.[9]

opinion of an impressionist of a very complex type, an artist who reflected stylistic characteristics reminiscent of Pissarro, Cézanne, and Degas, and who was also sufficiently original to occupy himself with sculpture. Fénéon divided his criticism of the exhibition into three sections. The principle figure in the first section was Degas (cf. p. 61), in the second Gauguin, and in the third Seurat. The review of Gauguin's work ran as follows:

> The tones used by M. Paul Gauguin are only very slightly removed from each other: hence, in his paintings, that dull harmony. Dense trees burst out of the fat ground, lush and humid, overflowing the frame, excluding the sky. The air is heavy. A glimpse of bricks suggests a nearby house; limp dresses, muzzles poking through a thicket—cows. These russets of roof and beasts—the painter constantly opposes them to his greens and reflects them in the water flowing between the tree trunks, clogged with long grasses. He also has Norman beaches, cliffs, a still life, and finally a wooden sculpture dated 1882.*

Thus Fénéon was the first to recognize and describe the uniqueness of Gauguin's art. He pointed out the muted harmonies, the close canopy of trees "which overflowed the frames and excluded the sky." By this he probably wished to give a hint of Gauguin's endeavors to reduce the depth of the composition. He further emphasized the originality of the iconography and the colors of the pictures.[12] Fénéon persevered in this opinion throughout the eighties, and it was to have no little influence on the attitude of literary symbolism towards Gauguin's art.

Of decisive significance for Gauguin's relations towards Seurat and Signac, with whom he was clearly in sympathy at that time,[13] was a long journey to Les Andelys that Signac began at the begin-

---

* Les tons de M. Paul Gauguin sont très peu distants les uns des autres: de là, en ses tableaux, cette harmonie sourde. Des arbres denses jaillissent de terrains gras, plantureux et humides, envahissent le cadre, proscrivent le ciel. Un air lourd. Des briques entrevues indiquent une maison proche; des robes gisent, des mufles écartent des fourrés,—vaches. Ces roux de toiture et de bêtes, ce peintre les oppose constamment à ses verts et les double dans des eaux coulantes entre les fûts et encombrées d'herbes longues. De lui encore, des plages normandes, des falaises, une nature-morte et, enfin, une sculpture sur bois datée de 1882.[11]

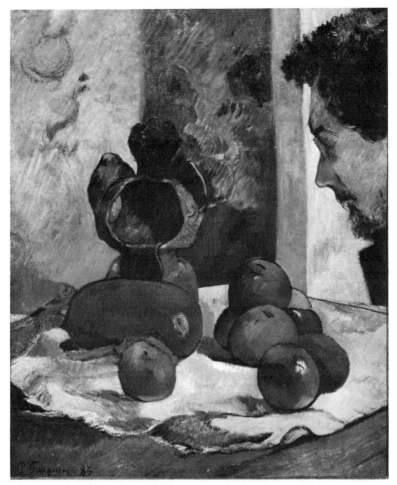

FIG. 14    Paul Gauguin, *Nature morte avec portrait de Charles Laval*, 1886,
Collection Mr. and Mrs. Walter B. Ford II, Grosse Pointe, Michigan.

ning of June 1886. During his absence he had promised Gauguin
the use of his studio. Seurat, having no knowledge of this agreement,
closed the studio on his own responsibility. The episode caused a bit-
ter feud between Gauguin and the neo-impressionists, which placed
Gauguin in opposition to the coterie around *La Revue Indépendante*
and estranged him from Fénéon.[14] Instead he was more drawn to
Degas, but otherwise he isolated himself during the late summer
and autumn of 1886 at Pont-Aven on the coast of Brittany.[15]

His still life with a portrait of his newly acquired painter friend
from Pont-Aven, Charles Laval (Fig. 14), shows the weakness and

the strength of Gauguin's painting at that time. The picture is reminiscent of both Cézanne and Degas. The facture is in part plainly impressionistic. The painting, however, as a consequence of the marked contours, strongly stresses the form values. The scene is confined to a small space, which presses the subject towards the surface. The oblique light gives the picture a passive, meditative character. In contrast to this feeling is the combination of the curious earthenware vessel (one of Gauguin's experiments in sculpture with Chaplet) and the boldly cropped profile that together create a conscious enigmatical play of contrasts. In comparison to Degas's pastels shown at the last impressionist exhibition (Fig. 7), however, Gauguin's painting seems the least progressive.

The winter of 1886–87 was no less financially embarrassing than the previous one. When spring came Gauguin could no longer endure Paris, and with his friend Laval, he set out for the West Indies. The badly planned journey was extremely fatiguing, and there was little to show artistically for the six-months' sojourn in Panama and on the island of Martinique. The two artists returned to Paris completely worn out, and it was only thanks to the unselfish help of Schuffenecker, Brouillon, and others that Gauguin recovered.[16]

The turn of the year, however, brought with it some respite. Gauguin's original pottery aroused a certain interest among collectors.[17] His journey had increased the novelty value of his art, and Parisian dealers were not wholly indifferent. The situation in the art market had changed somewhat since Durand-Ruel had begun to specialize in exports to the United States. This phenomenon was regarded not without uneasiness by the impressionists and their younger colleagues. They began to attach themselves more and more to Théo van Gogh at the Goupil Gallery.[18] At the beginning of December 1887 Gauguin wrote to Mette:

> You know the gallery of Goupil, the editor and art dealer; at the moment his gallery has become the center for the Impressionists. Little by little he is going to make his clientele swallow us; here is yet another hope and I am sure that in a short time I will be launched. Send me the Manet so that I can try to sell it.*

* Tu connais la maison Goupil éditeur et marchand de tableaux; aujourd'hui cette maison est devenue le centre des impressionnistes. Petit à petit il va nous

Gauguin's expectations were not frustrated. In January 1888 Théo hung a suite of Gauguin's paintings, among which were about a dozen canvases from Martinique. Pottery made during the winter of 1886 was also included in the collection. It is true that it was not an individual exhibition; works by Guillaumin and Pissarro were also shown.[20] But still it was a great move forward. The tactful Théo had clearly been able to arrange a truce between the "scientific" and the "romantic" schools, besides which he himself had the final right of deciding whose works should be hung in the gallery.

Many years later Gustave Kahn wrote that as far as Gauguin was concerned the exhibition was a fiasco, and even the few earlier admirers of Gauguin found his palette too heavy and discordant. The pictures were neither impressionist nor neo-impressionist.[21] This is not entirely correct, however, for Gauguin was able to inform Mette that he had sold three pictures for the not inconsiderable sum of 900 francs, and that interest in his pottery was growing steadily. The fact that Fénéon, as early as 15 January, had reviewed his work in *La Revue Indépendante* was no less important:

> In addition to the *Bathers* (1885), number 53 of the Eighth Impressionist Exhibition, and the *Little Bathers* (1886), M. Paul Gauguin, is showing a large Breton landscape. His style, without becoming clearer or lighter, is acquiring a virile eloquence of line. The modelling of the breast-like forms gives play to his habitual sculptural qualities; the canvas, like certain Corots, bears a double signature and two dates (1885, 1886). From a voyage to the Antilles (1887), he has brought a Martinique landscape which—with its pink copse, its shaggy central tree beneath which women drowse, its ochre road with two blacks carrying baskets—evokes old engraved illustrations of the Isles; between the heavy greens, the red clamor of a roof, as in all authentic Gauguins. Of a barbarous, atrabilious character, only slightly atmospheric, colored with diagonal strokes which shower from right to left, these proud pictures would sum up the work of M. Paul Gauguin if this intractable artist were not chiefly a potter. He loves the lowly *grès* earthenware, baneful and hard: haggard, long-jowled faces, with minimal, limited eyes, with graveyard

faire avaler par sa clientèle; voilà encore un espoir de plus et je suis persuadé que d'ici peu de temps je marcherai. Envoies-moi le Manet que je m'occupe de le vendre.[19]

noses—two vases; a third: of an ancient ruler, some dispossessed Atahualpa, the mouth torn apart into a whirlpool; two others of an abnormal, swollen geometry.*

The neo-impressionist-inclined Fénéon's criticism of Gauguin was, it cannot be denied, a little equivocal, but on the whole it must be regarded as positive. Fénéon was again the only one of the critics to recognize Gauguin's peculiar genius. He stressed the coloristic effect and the marked lucid and rhythmical lines. He found, however, a strong hint of dissonance in the artist's intentions, but considered that this emotional strain was at least beneficial to his work in ceramic.

Curiously enough it was not until Gauguin had arrived at Pont-Aven, whither he had gone around 1 March, that he read the article. This shows, perhaps, how isolated he was from the neo-impressionist phalanx. He had, however, gained some compensation during his stay in Paris. At Père Tanguy's paint shop, the rendezvous of all admirers of Cézanne, he had become acquainted with Vincent van Gogh and the twenty-year-old Emile Bernard. Both were to be of the greatest significance to Gauguin's work during the year 1888.

In a letter to Schuffenecker, Gauguin commented on Fénéon's criticism. He was displeased with the critic's designation of his work as "barbarous and hypochondriac," but it is also clear that he was not insensible to the propaganda value of the article.[23] By February he had hinted to his wife that he had been invited to show his

* Outre les *Baigneuses* (1885), n° 53 de la VIIIᵉ exposition impressionniste, et les *Petits baigneurs* (1886), M. Paul Gauguin, dont le style sans s'éclaircir ni s'alléger acquiert une virile éloquence de lignes, montre un ample paysage breton. A en modeler la configuration mamelue s'évertuèrent ses habituelles qualités de sculpteur; la toile, comme certains Corots, porte double signature et deux millésimes (1885, 1886). D'un voyage aux Antilles (1887), il ramène un paysage martiniquais qui,—avec son taillis rose, son touffu arbre médian sous lequel s'assoupissent des femmes, son chemin ocre aux deux noirs portant des mannes, —suscite les anciennes gravures d'illustration sur les îles; entre les verdures pesantes, la clameur rouge d'un toit, comme en tout Gauguin authentique. De caractère barbare et atrabilaire, peu atmosphérique, coloriés par touches diagonales tombant en averse de droite à gauche, ces fiers tableaux sommeraient l'œuvre de M. Paul Gauguin si ce grièche artiste n'était surtout un potier. Le grès honni, néfaste et dur, il l'aime: faces hagardes aux larges glabelles, aux minimes yeux bridés, aux nez camards,—deux vases; un troisième: tête de royale macrobe, quelque Atahualpa qu'on dépossède, la bouche déchirée en gouffre; deux autres d'une géométrie anormale et gobine.[22]

work in Brussels. It seems not improbable that Fénéon, in his capacity of the Paris correspondent of *L'Art Moderne,* had influenced this choice. At the exhibition of 1888, as earlier, *Les XX,* had applied the principle of allowing French modernism of a style other than neo-impressionism to be represented. Thus Louis Anquetin and Toulouse-Lautrec and others had been invited. It was also during this exhibition period that "symbolist" music was energetically brought to the notice of the public.

Gauguin's statement concerning the invitation to Brussels was slightly premature. It was not until the autumn of 1888 that the invitation finally arrived, but he had been right in principle. Serious notice was being taken of his work; his years of apprenticeship were ended; his style and technique were gliding away from impressionism. The time seemed ripe for a radical change in the structure of Gauguin's art. This was confirmed in the month of September at Pont-Aven, where he completed the program by painting *La Lutte de Jacob avec l'Ange.*

❦

As the title implies, *La Lutte de Jacob avec l'Ange* (or *La Vision du Sermon* as the painting was also called) is a religious subject. The *motif* was conceived and the picture executed in a way that leads the thoughts to popular naive art.

> And Jacob was left alone; and there wrestled a man with him until the breaking of the day. And when he saw that he prevailed not against him, he touched the hollow of his thigh; and the hollow of Jacob's thigh was out of joint, as he wrestled with him. And he said, Let me go, for the day breaketh. And he said, I will not let thee go, except thou bless me. And he said unto him, What is thy name? And he said, Jacob. And he said, Thy name shall be called no more Jacob, but Israel: for as a prince hast thou power with God and with men, and hast prevailed.
> Genesis xxxii. 24–28

The simple women of Brittany have fallen in contemplation before the dramatic scene that the village priest has evoked. In their

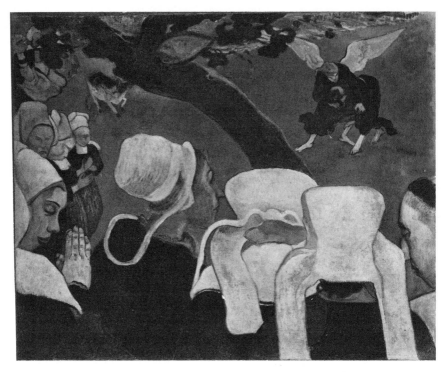

FIG. 15  Paul Gauguin, *La lutte de Jacob avec l'Ange,* 1888, National Gallery of Scotland, Edinburgh.

naive imagination they experience the struggle as if it were real. The distance to the large figures in the foreground is so short that the onlooker himself seems to belong to the congregation.

The formal lay-out is extremely interesting. All the elements of the picture are conceived as planes, but there is at least a hint of shading in the foreground figures, and with it plastic modeling. The circle of onlookers is artistically grouped. The profiles of the priest and the young girl flank the picture like figures in a medieval triptych. The other women are presented in a definite order, seen from behind, the side, and obliquely from the front. The plan serves to create, among other things, links between the different zones of the picture. The figures are marked by gently flowing contours. The situation of the persons in the picture is indicated only by the overlapping of the silhouettes. Fluctuating lines run in a pleasing rhythm

through the typical headdresses and costumes. Thus the onlookers are bound together in a homogeneous group, in spite of the fact that the figures in the upper left are reproduced on an unnaturally reduced scale.

The diagonally situated tree plays an important role in the balance of the picture. Its function is, among other things, to isolate the principal theme—the struggle between Jacob and the angel—from the other elements of the picture, which have a marked tendency to create plane-geometrical forms. Gently rounded planes dominate in the foreground. The combatants, on the other hand, are enclosed in a triangle which in itself is a sharp-cornered aggressive figure.

The dawn—the break of day in the Bible story—falls obliquely from the right and bathes the headdresses and faces of the onlookers in a chilly shimmer, but gilds the upper contours of the tree trunk and the angel's wings. The pale light is too weak to throw shadows. The direction of the light emphasizes the curious perspective, which consists of a marked foreground plane imposed abruptly on a background. The saturated colors in the foreground form a cold, broken scale of black mixed with prussian blue (according to Emile Bernard), dove blue, olive green, and ivory white. The background is dominated entirely by the vermillion ground plane. This color is of an expansive nature and seems to protrude from the picture, while the cold colors have a contrary tendency.

If one pauses for a moment on the earth colored tree trunk, the effect of Gauguin's organization of the colors is clearly seen. The red zone bounded by the lower contours of the tree is conceived as lying in front of the tree, while the upper red triangle, because of the influence of the cadmium yellow contour of the tree, remains attached to the background. The struggling figures are perhaps conceived as being "stuck" to the red triangle, but at the same time the angel's intensive ultramarine blue mantle makes a "hole" in it.

With such coloristic and plastic means Gauguin succeeded in creating a new and peculiar structure of space. His ambition was to paint a devotional picture the like of which had never been seen in the history of art. (The picture was offered to the small church of Nizon, but the priest declined to accept it.) In his endeavors to unite

two diametrical emotional sensations—the pious worship of the congregation and the violent struggle of the Bible story—the artist was driven to make a series of bold strokes in the composition. The foreground figures are seen from a very high level, and are only to a very small extent visualized as individuals. By the rhythmical repetition of similar plastic elements and the prevailing cold color scale, they merge into a united visual symbol for the conception "pious group." In contrast to this are the active colors and the aggressive lines of the background. The struggle between Jacob and the angel is enacted in a "no man's land" that is practically devoid of depth and space, and whose foreground boundary is indefinite and ambiguous. In this intangible space the movements of the combatants have stagnated in a heraldic pose. But with that the content of the picture has changed. The moods and the emotions aroused by the unprecedented vision remain as a hardly perceptible overtone, but in the center of interest problems of the mutual relationship of color and form emerge inexorably.[24] *La Lutte de Jacob* was a definite step forwards on the way towards the autonomous picture.

> I did a painting for a church, naturally it was refused, also I have sent it back to Van Gogh. Useless to describe it to you, you will see it.
> This year I have sacrificed everything—execution, color—for style, wishing to impose on myself something other than what I already know how to do. I think this is a transformation which has not yet borne fruit, but will.*

Thus did Gauguin summarize his activities in a letter to Schuffenecker from Quimperlé on 8 October 1888. He was not wrong in his prophecy. The painting was of decisive significance not only for Gauguin himself, but also for several of his colleagues. As mentioned in the letter, it was hung at Théo's gallery, where it aroused well deserved attention. Gauguin described the picture in a letter to Vincent van Gogh, who was greatly influenced by the new artistic program. In February 1889 the picture was given a prominent place

---

* J'ai fait pour une église un tableau, naturellement il a été refusé, aussi je le renvoie à Van Gogh. Inutile de vous le décrire, vous le verrez.

J'ai cette année, tout sacrifié, l'exécution, la couleur, pour le style, voulant m'imposer autre chose que ce que je sais faire. C'est je crois une transformation qui n'a pas porté ses fruits mais qui les portera.[25]

in the *Les XX* exhibition in Brussels, and Octave Maus reviewed it enthusiastically in *La Cravache*.[26] Finally it became the core and an illustration of the artistic doctrines that the young art critic, Albert Aurier, built up around the new style at the beginning of the nineties.

But *La Lutte de Jacob* was also the root of *synthetism,* as Gauguin himself called his new compositional style.[27] The question as to who was the first to practice synthetic painting is a purely academic one—at least if the conception is meant to imply a complete artistic structure, and is not merely used as a term for a technical-stylistic manner. Nevertheless, the problem has been eagerly discussed in art-historical research from Charles Chassé in the 1920's to Mark Roskill most recently.[28]

From the viewpoint of Gauguin's relation to literary symbolism the question is naturally of interest, and it will therefore be discussed briefly here. It was Emile Bernard, who, at an early stage, sowed the seed of contention. His version of the birth of the new art is roughly as follows: In August 1888, Bernard moved to Pont-Aven, where Gauguin had been working since March. Bernard himself had spent the spring farther north, at Saint Briac, a little coastal village immediately to the west of Saint-Malo. There he completed a picture of Brittany women and children in a field. He took the canvas with him to Pont-Aven, and Gauguin, after studying the picture, painted *La Lutte de Jacob.* The two canvases are, by the way, almost exactly the same size. The striking stylistic features of Bernard's painting were a result of studying Japanese woodcuts together with Anquetin. This was as early as 1884, and led to the creation of so-called cloisonism (cf. p. 48). Bernard has also correctly pointed out that Gauguin copied the combatants in *La Lutte de Jacob* from an album of Japanese woodcuts. Bernard adhered all his life to this opinion of Gauguin.[29]

Even a superficial glance at Bernard's picture, *Les Bretonnes dans la prairie,* will show that the work is completely devoid of the rich and complex structure that characterizes Gauguin's painting, Bernard's canvas rather gives the impression of a series of robust figure studies on a sketchbook sheet. The picture has no emotional amplitude; all the interest is centered around the folklore. Vincent van

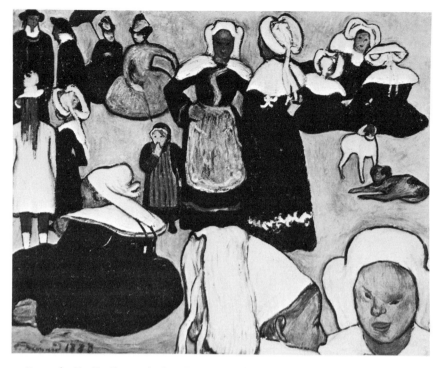

Fig. 16  Emile Bernard, *Les Bretonnes dans la prairie,* 1888, Collection Mlle. B. Denis, Saint-Germain-en-Laye, France.

Gogh copied the picture in water colors and gouache the same autumn, and could not resist the temptation to "improve" it. In other words he gave his copy a coloristic and psychological center of interest around which the other figures were spontaneously grouped. Without renouncing the superficial decorativeness of the original he succeeded in suggesting a field of action in which emotions and attitudes could be visualized. Van Gogh's version, therefore, is more deserving than the original of the title, *Marché en Bretagne,* by which Bernard's picture is also known.

If one adds to that the fact that when the new pictorial structure became the subject of more penetrating art criticism and doctrinal theories a few years later it was so unanimously connected with Gauguin and not with any of his younger colleagues and admirers, then it may perhaps be agreed that the controversy around the origin of synthetism is of little interest.

Still it is with eager expectation that one follows Gauguin's and Bernard's development during that fateful year. It is obvious that Gauguin was much inspired by Bernard's appearance at Pont-Aven, and that he found something of value in *Marché en Bretagne.* But this was neither the only nor the essential reason that his mature style emerged just at that time.[30]

Apart from important technical divergences *La Lutte de Jacob* has been shown to have a distinct relationship with Seurat's fundamental principles of pictorial representation. Gauguin, too, created discontinuous space to give expression to an event outside the sphere of everyday life. He contrasted inhibitant and dynamogenic color tones to suggest specific emotional situations. Time and again during the scrutiny of *La Lutte* one is reminded of Gauguin's letters written in Copenhagen to Schuffenecker, and the Turkish "manuscript" that Seurat studied so eagerly. But Gauguin was less of a scientific doctrinarian, more intuitive in his work than Seurat. He avoided, therefore, the hard and fast rules of complementary colors and the patience-trying pointillistic technique. Instead the melody of flowing lines and ringing accords of color were his distinguishing features. But the goal remained: to create an equivalent to post-impressionist symbolism.

It is quite correct that Jacob and the angel were taken from a wrestling scene in Katsushika Hokusai's *Mangwa.*[31] In his "Japonism" Gauguin had a rich tradition at his disposal. Interest in Japanese art and culture had been awakened in France in the 1860's by *La Société Japonaise du Jin-glar,* the Oriental goods shop of Desoy in Paris, and was further stimulated when Edmond de Goncourt published *La Maison d'un artiste* in 1881. Such artists as Manet, Fantin-Latour, Whistler, and Degas introduced Japanese elements into their works, and allowed themselves to be more or less influenced by the stylistic mannerisms of Hokusai and Hiroshiga.[32]

Gauguin's interest in Japanese woodcuts was probably aroused during the seventies by Félix Bracquemond. It was nourished by intercourse with Vincent van Gogh during the winter 1887–88. Van Gogh's letters to his brother are full of references to the significance of Japanese woodcuts to current French painting, and they also give some indication of the differences in attitude towards "Ja-

ponism" between the older impressionists and their successors. Van
Gogh and Gauguin, for example, identified themselves much more
intimately with the idealized picture of the artistic life of the Far
East than their older colleagues did. They endeavored as well as
they could, by reading such books as were available—Pierre
Loti's *Madame Chrysanthème,* and unsophisticated travel stories—
to penetrate into an exotic world that seemed far superior both
morally and aesthetically to the decadent western civilization. Thus
Japanese woodcuts were credited with far stronger aesthetic and
emotional values by the pioneers of modernism than by the impres-
sionists.

But Gauguin's exoticism had a wider sphere. He was a regular
visitor to the Musée Guimet after its reorganization in Paris, and he
was interested in the sculpture of Egypt and the Near East. A great
exhibition of Indo-Persian art in Paris in 1878 opened wider vistas
on Oriental culture. It is said that there had been a large collection
of exotic articles in the home of Gauguin's parents.[33]

However, like Seurat and the symbolists, Gauguin greatly ad-
mired Puvis de Chavannes's monumental painting.[34] A copy of Pu-
vis's *L'Espoir,* made by Gauguin himself, was seldom out of his
sight. He was attracted mainly by the pure lines and the striking
simplicity of the older master's compositions. Later he emphatically
stressed the impassable gulf between the structure of his own primi-
tivist work and the middle-class idealism of Puvis de Chavannes.[35]

While Gauguin delved deeper and deeper into the primitive fea-
tues of the ancient culture of Brittany, his impressionist leanings
were extruded and replaced by artistic experiences of a foreign exotic
lustre. At a favorable opportunity these experiences might be welded
together into a completely new artistic style. This occurred when
Emile Bernard arrived at Pont-Aven.[36]

As mentioned above, during an early phase of their studies, An-
quetin and Bernard had been captivated by the art of the Far East.
By the complementary study of medieval stained glass windows they
had developed a simplified style of painting dominated by strongly
marked contours. In the spring of 1888, when Anquetin was invited
to participate in the *Les XX* exhibition, his contribution was re-

viewed by his friend Edouard Dujardin, who called his style *cloison-isme* in an article in *La Revue Indépendante*.[37]

The article has unmistakable signs of being a "writing-desk product." Art criticism was not Dujardin's province. The essay however, has a special background. Usually Octave Maus acted as a reporter in *La Revue Indépendante,* where he enthusiastically chronicled the exhibitions of *Les XX*. But this time for some reason he was not able to write, and Emile Verhaeren was casually substituted. Verhaeren, who was strongly engaged in the neo-impressionist coterie, wrote about Louis Anquetin:

> Among the invited artists there is one who has never exhibited in Paris: M. Anquetin. His painting is offered to the public for the first time and the public is upset about it.
> His gaudy effects of light horrify. He sports his enraged vision: be it of a blue night that hurls itself towards the hour when streetlights are lit; be it of a watery landscape, a rower parting the rivery branches; be it of the burning fields of July, during scorching heat. All these canvases seem uniquely decorative; they are done in flat smooth tones.*

Obviously Dujardin found the appreciation too cool and insignificant. He decided to strike a blow for his old friend Anquetin (see p. 48), all the more as he would also show his paintings at the end of the month at the Independents in Paris. Thereby he greatly exaggerated the importance of Anquetin (and Bernard). A glance at Anquetin's paintings from the period reveals that the artist was still confined within the bounds of naturalism, but that he obscured his naturalism behind a lattice of contours and artificial coloring. But in Dujardin's exegesis the paintings were elevated to remarkable intellectual constructions and symbolic configurations, whose aim was to interpret, with the simplest possible means, the inner essence of

---

* Parmi les invités un seul n'a jamais exposé à Paris: M. Anquetin. Sa peinture s'offre pour la première fois au public et le public s'acharne après elle.

Ses criards effets de lumière épouvantent. Il arbore sa vision exaspérée: soit d'une nuit bleue qui se fonce à l'heure des réverbères s'allumant, soit d'un paysage d'eau, qu'un canotier raie à travers les branches riveraines, soit de la brûlure des champs en Juillet, pendant les torridités. Toutes ces toiles semblent uniquement décoratives; elles sont faites à tons plats et lisses.[38]

things. That had been the primary objective of primitive art, and therefore cloisonism was also based on Japanese art and popular *images d'Epinal:*

> At first glance these works give the idea of a wholly decorative painting—a traced outline, a violent and limited coloration, inevitably recalling popular imagery and Japanese art; then, beneath the general hieratic character of the drawing and the color, one perceives a sensational truth emerging from the passion, the romanticism; and beyond all else, little by little, it is the voluntary, the reasoned, the intellectual and systematic construction, which requires analysis. The point of departure is a symbolic conception of art. . . .
>
> The painter, neglecting all photography, retouched or not, only seeks to define, in the smallest possible number of lines and characteristic colors, the intimate reality, the essence of the object he imposes on himself.
>
> Primitive art and popular art, which is the contemporary continuation of primitive art, are symbolic in this fashion. The Epinal pictures exist through their tracing of contours. In their perfection of craft, the ancient painters had this technique. And Japanese art is still like that. . . .
>
> And the work of the painter will be something like a painting *by compartments,* analogous to cloisonné work, and his technique will be a kind of *cloisonisme.**

In April of the same year Emile Bernard went to Brittany. The month before he had begun a correspondence with Vincent van

---

* Au premier aspect, ces œuvres donnent l'idée d'une peinture décorative, un tracé en dehors, une coloration violente et arrêtée, rappelant inévitablement l'imagerie et le japonisme; puis, sous le caractère général hiératique du dessin et de la couleur, on perçoit une vérité sensationnelle se dégageant du romantisme de la fougue; et, par dessus tout, peu à peu, c'est le voulu, le raisonné, la construction intellectuelle et systématique, qui requiert l'analyse. Le point de départ est une conception symbolique de l'art. . . .

Le peintre, négligeant toute photographie avec ou sans retouche, ne cherchera qu'à fixer, en le moindre nombre possible de lignes et de couleurs caractéristiques, la réalité intime, l'essence de l'objet qu'il s'impose.

L'art primitif et l'art populaire qui est la continuité de l'art primitif dans le contemporain, sont symboliques de cette façon. L'imagerie d'Epinal procède par le tracé des contours. Dans leur perfection de métier, les peintres anciens avaient cette technique. Et tel est encore l'art japonais. . . .

Et le travail du peintre sera quelque chose comme une peinture *par compartiments,* analogue au cloisonné, et sa technique consistera en une sorte de *cloisonisme.*[39]

Gogh, who had moved to Arles at the beginning of 1888. The exchange of letters continued with varying regularity through most of the year. Van Gogh's letters to Bernard are perhaps the best gauge of the reliability of Bernard's later history of the genesis of synthetism. In these primary sources we meet a young enthusiast, intellectually alert and exceedingly susceptible to the influence of friends and colleagues.

Letters written by Vincent during the latter part of April relate that Bernard had arrived at Saint Briac, and there met the poet Albert Aurier, three years his senior. Aurier had made his debut a year or two earlier in *Le Décadent* with ironic and melancholy poems of a kind reminiscent of Verlaine and Flaubert. He had recently become editor-in-chief of the symbolist periodical *Le Moderniste*. Right from the very beginning, Aurier seems to have made a deep impression on Bernard, who himself began to write sonnets, which he sent to Vincent van Gogh for criticism. To put it mildly, the poems, published in 1906 as *Les Cendres de gloire* under the pseudonym Jean Dorsal, were strongly influenced by Aurier.[40]

In return Bernard could give the symbolist poet—who earlier had only casually applied himself to art criticism—initiated information about *avant-garde* painting. Bernard gave Aurier a fascinating picture of Vincent van Gogh's artistic fate, and described the unique paintings that Gauguin had brought with him from Martinique, and which had recently been hung in the Goupil Gallery. The painter and the poet were united in a common cultural pessimism and melancholy that seemed to give echo in the lonely and primitive milieu in which they lived. The discussions between Bernard and Aurier are reflected faithfully in Vincent van Gogh's letters. In May he wrote:

> I have just received your last letter. You are quite right to see that these negresses were heart-rending; and quite right too not to believe it was innocent.
>
> I have just read a book—not good and not well written either —about the Marquesas Islands, but very moving in its account of the extermination of a whole native tribe, admittedly a man-eating tribe inasmuch as let us say about once a month somebody got eaten —and what's that? . . .

You are quite right to think of Gauguin. There's great poetry in his pictures of negresses: everything he does has something gentle, heart-rending, astonishing. People don't understand him yet; and he's very upset he doesn't sell, like other real poets.*

The letter reveals that the dream of an ideal artistic existence in a primitive exotic milieu was vivid even in Saint Briac. It shows, too, that Emile Bernard had made a careful study of Gauguin's Martinique paintings in the Goupil Gallery, and that he had found in them a kind of confirmation of his own problems. He has completely ignored this phase in the development of synthetism in his own history.

A remarkable feature of Vincent van Gogh's correspondence with Emile Bernard during the spring and summer of 1888 is that it reflects general art theories to such a high degree. It also often wanders away into quasi-philosophical and religious speculations, but later in the autumn, when Bernard had joined Gauguin at Pont-Aven, the contents of the letters undergo a radical change. Van Gogh's plans to establish a colony of artists at Arles begin to materialize. The common current problems of art come into the foreground. A continuous stream of information reaches Vincent, who reacts strongly to the mixture of doctrines at Pont-Aven:

In spite of their colour, which was perfect, I had ruthlessly to destroy an important canvas—*Christ with the Angel in Gethsemane* and another of the *Poet against a Starry Sky,* because the form had not been studied from the model first, an absolute necessity in such cases. If you don't like the study I am sending you in exchange, look at it a little longer. I had the devil of a job doing it with the *mistral* raging (like the red and green study too). And although it is not as fluently painted as the *Old Mill,* it is finer and more intimate. It's got

---

* Je viens de recevoir ta dernière lettre. Tu as bien raison de voir que ces négresses étaient navrantes. Tu as bien raison de ne pas trouver cela innocent.

Je viens de lire un livre—pas beau et pas bien écrit d'ailleurs—sur les îles Marquises, mais bien navrant lorsqu'il raconte l'extermination de tout une tribu d'indigènes—antropophage dans ce sens que, disons une fois par mois on mangeait un individu—qu'est-ce que ça fait! . . .

Ah! tu fais rudement bien de penser à Gauguin. C'est de la haute poésie ses négresses, et tout ce que fait sa main a un caractère doux, navré, étonnant. On ne le comprend pas encore, et lui souffre beaucoup de ne pas vendre, comme d'autres vrais poètes.[41]

nothing to do with Impressionism, but what does that matter anyway. What I do is the result of abandoning myself to nature, without thinking of this or that. . . .

I'm not saying I don't turn my back on nature completely when I'm working a sketch up into a picture, arranging the colours, enlarging or simplifying: but as far as the forms are concerned I'm terrified of getting away from the possible, of not being accurate.*

The extract is, of course, an indirect reply to Gauguin's comments on *La Lutte de Jacob,* and his aesthetic aims in general. He had attempted to explain to van Gogh the magic and supernatural aspects of the picture, and he had stressed that they constituted the new ideas in the pictorial composition.[43] In a series of paintings, chiefly self-portraits, he was to give new interpretations of this specific pictorial method during the coming months.

If Gauguin's own artistic experience was too great to allow him to be influenced by Bernard's cloisonism, the arrival of his younger colleague at Pont-Aven in August 1888 was of decisive importance in several other respects. Gauguin's correspondence with his wife and Schuffenecker during the spring show that he felt completely isolated in Brittany. His art had begun to attract attention, and he could send his paintings to Théo van Gogh's gallery. But he lacked appreciative criticism, an exegesis of his work. In spite of their positive features, Fénéon's reviews seemed to him lacking in warmth.

When, therefore, Bernard came to him and told him enthusiastically about his contacts with Vincent van Gogh and of Albert Aurier's newly awakened interest in *avant-garde* painting, Gauguin

---

* Une toile importante—un Christ avec l'ange au Getsemani—une autre représentant le poète avec un ciel étoilé, malgré la couleur, qui était juste, je les ai, sans miséricorde, détruites, parce que la forme n'en était étudiée préalablement sur le modèle, nécessaire dans ces cas-là. L'étude que t'envoie en échange, si elle ne te va pas, tu n'as qu'à la regarder un peu plus longtemps. J'ai eu un mal du diable pour la faire avec un mistral agaçant (comme l'étude en rouge et vert aussi). Eh bien, malgré qu'elle ne soit pas aussi couramment peinte que le Vieux Moulin, elle est plus fine et plus intime. Tu vois que tout cela n'est pas du tout impressionniste; ma foi, tant pis. Je fais ce que je fais avec un abandon à la nature, sans songer à ceci ou cela. . . .

Je ne dis pas que je ne tourne carrément le dos à la nature pour transformer une étude en tableau, en arrangeant la couleur, en agrandissant, en simplifiant; mais j'ai tant peur de m'écarter du possible et du juste en tant que quant à la forme.[42]

must have felt very encouraged. It is possible that he saw in Aurier a critic who would appreciate his intentions. In any case he quickly formed a new iconography which was deeply rooted in the primitive pious life of his surroundings, and which reflected his own situation.

When one examines *La Lutte de Jacob,* one cannot avoid feeling strongly that Jacob's struggle is symbolic of Gauguin's own private problems. The new artistic program led directly into literary symbolism, and it can also be traced out of these circles. Although Gauguin's painting cannot be subjected to such close structural comparison as, for example, between Seurat and Mallarmé, it may still be claimed that its atmosphere is related to that found in Verlaine's confessional poems in *Sagesse.*

| | |
|---|---|
| O my God, you have wounded me with love | O mon Dieu, vous m'avez blessé d'amour |
| And the wound is pulsing still, | Et la blessure est encore vibrante, |
| O my God, you have wounded me with love. | O mon Dieu, vouz m'avez blessé d'amour. |
| O my God, your fear has struck me down | O mon Dieu, votre crainte m'a frappé |
| That burn, a thunderous bell, | Et la brûlure est encore là qui tonne, |
| O my God, your fear has struck me down. | O mon Dieu, votre crainte m'a frappé. |
| O my God, I saw that all is vile | O mon Dieu, j'ai connu que tout est vil |
| And your glory is displayed in me, | Et votre gloire en moi s'est installée, |
| O my God, I saw that all is vile. | O mon Dieu, j'ai connu que tout est vil.[44] |

In seemingly naive language Verlaine created a poem of great musical beauty. Its aesthetic tension was the result of the fluctuations between the extremities of sin and the certainty of the miracle of salvation. It must have been Albert Aurier who made Gauguin conscious of Verlaine's symbolic language, and it was undoubtedly through the medium of Emile Bernard. It was not until the following year that Gauguin and Aurier met.

Albert Aurier's name was not included among the members of the symbolist circles mentioned in the first chapter. This is mainly because his influence was not felt until the end of the eighties. Nevertheless, his literary career, perhaps more than that of his colleagues, is a living illustration of the fictitious Adoré Floupette.

Aurier was born at Châteauroux in 1865. He moved to Paris when he was twenty years of age to study law, but with poor success. Most of his time was spent visiting museums and exhibitions. He soon joined the circle of Decadents around Verlaine, and he contributed poems to *Le Décadent*. To a certain degree he was outside the coterie at the Brasserie Gambrinus and he had little sympathy with pointillist ideas because, among other things, of his firmly rooted admiration of Italian proto-Renaissance painting.[45]

Like most of the symbolist poets he was ambitious to collect his ideas into one single comprehensive work on definite logical principles, "a synthesis of all the general ideas perceived by a given ego." * For a long time he worked on a grammar of poetry which was to have the title "Notes for the Introduction to My Book of Verse." ** He presumed that in contemporary society the modern poet could be understood only by a few "exclusive idiots." It was necessary to create for their benefit a language that expressed the "inner generalization of the ego." This consisted of three strata of consciousness: centripetal, psychological, and centrifugal. A poem that included all three strata might in truth be called perfect! [46]

In part this imposing theory was a farcical mystification, but at the same time it reflected faithfully the idealist doctrines of the young symbolists, taken from Schopenhauer, Baudelaire, and Poe. When Emile Bernard and Aurier met at Saint Briac in the spring of 1888 (they had probably been acquainted earlier in Paris), Aurier was working on a collection of poems which he published the following year under the title *L'Œuvre Maudit*. The title clearly indicates the source of inspiration, but Aurier was original insofar as he also discussed the problems and situation of modern artists.

Furthermore the opening poem, which gave the book its title,

* une synthèse de toutes les idées générales perçues par un moi donné.
** Notes pour la préface de mon volume de vers.

was dedicated to Caravaggio. He represented artists who broke away from wornout norms:

| | |
|---|---|
| We are the Accursed, the Excommunicated,<br>Dragging the ball and chain of our denied masterpieces! | Nous sommes les Maudits, les Excommuniés,<br>Traînant, comme un boulet, nos chefs-d'œuvre niés! |
| We disdained the honey of Purgatories<br>And vomited our blasphemous cries towards Heaven! | Nous avons dédaigné le miel des Purgatoires<br>Et vomi vers le Ciel nos cris blasphématoires! . . . |
| We said: Let's flee from banal processions,<br>Let's wander by night, alone, without lamp or candle! | Nous avons dit: Fuyons les cortèges banaux,<br>Errons par les nuits, seuls, sans cierges ne fanaux! |
| Let's be no longer the vain River that unrolls,<br>But run, flags flying, where the crowd does not go! | Ne soyons plus le Fleuve vain qui se déroule,<br>Courons, drapeaux dressés, où ne va pas la Foule . . .[47] |

Bernard and Gauguin naturally responded to Aurier's cultural pessimism and strongly individualistic artist ideal. But at the same time he provided them with symbolic themes that suited their situation. Several of his poems were allegories of the position of modern artists in society. In *La Montagne de Doute,* for example, the poet is visualized as a Gethsemane figure who must be crucified for giving "the heavenly wine" to the people.

These poems of ideas provided the artists at Pont-Aven with a suggestive iconographic alphabet, and with moods which they did not hesitate to exploit. Above all they found expression in works of a confessional character. It was Vincent van Gogh, who by his untiring entreaties for an exchange of self-portraits ("as Japanese artists used to do"), was the prime mover in this genre.[48]

In Gauguin's self-portrait the artist's face and shoulders have been modeled vigorously in red, blue, and olive green. The integrity and determination of the figure are to a certain extent neutralized by the form of the face, which seems to be rendered both *en face* and

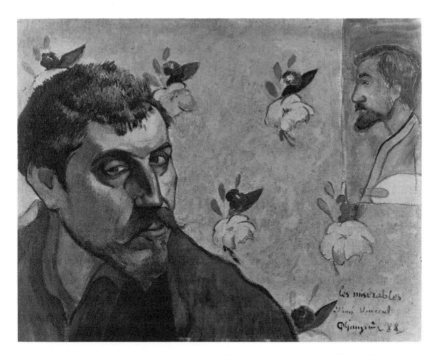

FIG. 17    Paul Gauguin, *Portrait de l'artiste, Les Misérables,* 1888, Stedelijk Museum, Amsterdam.

in profile. But above all the ambivalence of the picture consists in the lack of space. The subject is projected on a smooth background consisting of chrome yellow wallpaper with pink flowers and a profile of Emile Bernard in pale green tones. It balances the composition at the same time as it stresses its meditative nature. The portrait is, as can be seen, conceived on the same principles as *La Lutte.* It is dominated by a latent tension which gives a feeling of arrested activity, and is borne up by an atmosphere that one is tempted to call "sublimated fear." On the portrait Gauguin wrote "les misérables, à l'ami Vincent."

I made a portrait of myself for Vincent, who asked me for it. It is, I think, one of my best things: absolutely incomprehensible (for example), it is so abstract. At first glance a bandit's face, a Jean Valjean (*Les Misérables*), personifying also a discredited Impressionist painter, still wearing chains for the world. The drawing is totally special, complete abstraction. The eyes, the mouth, the nose, are like forms in

a Persian rug, personifying the symbolic side as well. The color is a color far from nature; imagine a vague memory of pottery twisted by the hottest fire! All the reds, the violets, striped by flashes of fire like a furnace glowing in the eyes, the battlefield of the painter's thought. The whole against a chrome yellow background sprinkled with child-ish bouquets. The room of a pure young girl. The impressionist is pure, too, as yet unsullied by the putrid kiss of the Beaux-Arts (School).*

It was thus that Gauguin described his portrait in a letter to Schuffenecker written on 8 October 1888, and in a similar way he introduced the painting to the recipient, but added, apropos the choice of Jean Valjean as prototype: "By painting him in my own likeness, you have an image of myself as well as a portrait of all of us, poor victims of society, who retaliate only by doing good." [50]

The formulation is remarkably similar to Aurier's poems of ideas, but it must be borne in mind that at that time Gauguin did not see himself against a Golgotha background. Instead he chose as his and his colleagues' *alter ego* Victor Hugo's hero, who, by contin-ually striving towards rehabilitation, was gradually transformed into a kind of Messiah, who washed away all the sins of the world, and was at the same time an incarnation of the primitive but fundamen-tally genuine emotional life of the common people. Jean Valjean was one of Vincent van Gogh's favorite literary figures,[51] and one should not, perhaps, dismiss the possibility that the picture was in-tended to prepare the way for future collaboration at Arles.

As a matter of fact, Gauguin's painting is an adequate expression of the problematic, but for the moment relatively hopeful situation of the artist. He thought he had found a unique means of expression

---

* J'ai fait un portrait de moi pour Vincent qui me l'avait demandé. C'est je crois une de mes meilleurs choses: absolument incompréhensible (par exemple) tellement il est abstrait. Tête de bandit au premier abord, un Jean Valjean (les Misérables), personnifiant aussi un peintre impressionniste déconsidéré et por-tant toujours une chaîne pour le monde. Le dessin en est tout à fait spécial, ab-straction complète. Les yeux, la bouche, le nez sont comme de tapis persan per-sonnifiant aussi le côté symbolique. La couleur est une couleur loin de la nature; figurez-vous un vague souvenir de la poterie tordue par le grand feu! Tous les rouges, les violets, rayés par les éclats de feu comme une fournaise rayonnant aux yeux, siège des luttes de la pensée du peintre. Le tout sur un fond chrome par-semé de bouquets enfantins. Chambre de jeune fille pure. L'impressionniste est un pur, non souillé encore par le baiser putride des Beaux-Arts (Ecole).[49]

that suited his genius. He had hopes of an individual exhibition at
Théo van Gogh's gallery after he had sent his *magnum opus,* the
struggle of Jacob. He had reason to believe that Octave Maus would
invite him to *Les XX* salon the following spring. Bernard had urged
Aurier to study Gauguin's paintings at the Goupil Gallery. Vincent's
invitation to Arles would give him peace to work through the win-
ter. At Bois d'Amour outside Pont-Aven, he had successfully demon-
strated his abstract conception of art for a young Parisian painter,
Paul Sérusier, from the Academy Julian. He summarized his ambi-
tions and hopes for Emile Schuffenecker:

> How you talk about my *frightful* mysticism! Be an Impressionist
> to the end and nothing will frighten you! Obviously this attractive
> path is full of obstacles, and as yet I have barely set foot on it, but it
> is deep in my nature and one must always follow his temperament. I
> know that I will be *less and less* understood. What does it matter if I
> stay away from others, for the great mass I will be a puzzle, for a few
> I will be a poet, and sooner or later the good makes itself known.
>
> What does it matter—whatever they may be, I tell you that
> someday I will do *first-rate things;* I know it and we shall see. You
> know very well that I am always right, fundamentally, about art. Pay
> strict attention, there is a favorable wind strongly circulating among
> the *artists,* and it is for me; I know it from a few indiscreet remarks;
> and don't worry, no matter how much van Gogh loves me, he
> wouldn't leap into supporting me in Provence just because of my
> pretty face. He has studied the terrain with Dutch coolness and in-
> tends to push the thing as far as possible, and exclusively. I asked him
> to lower my prices to try and tempt buyers; he replied that on the
> contrary he intends to raise them. Optimistic though I may be, this
> time I am on solid ground.*

---

* Que me parlez-vous de mon mysticisme *terrible.* Soyez impressionniste jus-
qu'au bout et ne vous effrayez de rien! Evidemment cette voie sympathique est
pleine d'écueils, et je n'y ai mis encore que le bout du pied, mais elle est au
fond dans ma nature et il faut toujours suivre son tempérament. Je sais bien que
l'on me comprendra de *moins en moins.* Qu'importe si je m'éloigne des autres,
pour la masse je serai un rébus, pour quelques uns je serai un poète, et tôt ou
tard le bon prend sa place.
    Qu'importe, quoi qu'il en soit, je vous dis que j'arriverai à faire *des choses
de I<sup>er</sup> ordre,* je le sais et nous verrons. Vous savez bien qu'en art, j'ai toujours
raison dans le fond. Faites-y bien attention, il circule en ce moment parmi *les
artistes* un vent favorable très pronouncé *pour moi;* je le sais par quelques indis-

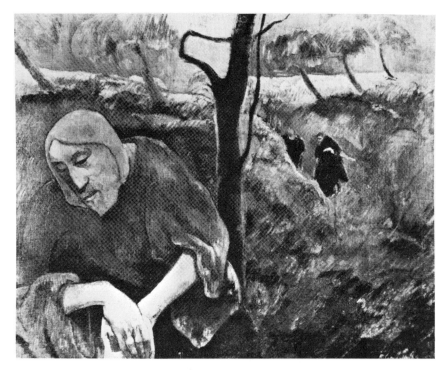

Fig. 18  Paul Gauguin, *Christ au Jardin des Oliviers,* 1889, Norton Gallery of Art, West Palm Beach, Florida.

If one studies the self-portrait that Gauguin painted about a year later, *Christ au Jardin des Oliviers,* it will be found that it is similar in several ways to the paintings analyzed earlier. The symbol of Christ, inspired by Aurier's poems, is visualized unequivocally. From the point of view of composition the painting is reminiscent of *La Lutte* and *Les Misérables* in that a dominant foreground has been superimposed on a background that piles up into the surface of the picture. A tree conceived as a silhouette, as sharp in contour as a crown of thorns, divides the picture into two balanced halves.

But there the similarities cease. New and astonishing features

crétions et soyez tranquille, tout amoureux de moi que soit Van Gogh, il ne se lancerait pas à me nourrir dans le Midi pour mes beaux yeux. Il a étudié le terrain en froid hollandais et a l'intention de pousser la chose autant que possible et exclusivement. Je lui ai demandé de baisser les prix pour tenter l'acheteur, il m'a répondu que son intention était au contraire de les hausser. Tout optimiste que je sois, cette fois-ci c'est sur un terrain solide que je marche.[52]

emerge. The facture is more orthodoxly "impressionistic" than formerly, or rather, the artist has applied Cézanne's technique, with diagonal showers of brush strokes descending from the right. In details, however, they are interrupted by uniform zones of color, or vertical brush strokes.

One of the most interesting features is the curious lighting. It is quite illogical. Christ-Gauguin, like certain parts of the landscape, absorbs light, while the tree trunk, so important to the composition, seems to exude light emanating from inside the picture. The painting is saturated in a flood of transcendental light that issues through the crowns of the trees, causing their trunks to sag, and weighing heavily on the figure of Christ. This composition, while so clearly expressing suffering inclined towards ecstasy, contains many surprising contradictions. The emotional tone is disturbed by the little Judas image in the right background, showing, with fawning gestures, the soldiers the way to Christ. This detail, which is naturally quite justified iconographically, breaks the mood of the painting and gives it a poisonous undercurrent.[53]

Gauguin's Gethsemane picture is representative of essentially different circumstances than those prevailing during the execution of *Les Misérables*. The year 1889 was for the artist largely a year of baffled anticipations. The collaboration with Vincent van Gogh at Arles during the previous autumn had ended in tragedy. The great hopes that he had entertained of the Goupil Gallery had proved abortive. Participation in the spring salon of *Les XX*, apart from Octave Maus's generous article in *La Cravache*, had not aroused the attention in the press that he had expected. The great group manifestation of "impressionists and synthetists" at the World's Fair in Paris had not been a success. All the critics were touchingly unanimous in their opinions that the commonplace interior decoration and humdrum amusements of the Café Volpini hardly provided worthy surroundings for *avant-garde* art. The reviews were, as might be expected, confused like Jules Antoine's, or disjointed like Aurier's.[54] There was, however, one exception. Félix Fénéon—naturally, one is tempted to add—published an excellent report of the exhibition in *La Cravache*. One really tragic feature of Gauguin's life was his inability to accept and benefit by Fénéon's dignified and penetrat-

ing intellect. The problem has been touched upon earlier. Now, however, the crisis had become acute. Gauguin was firmly convinced that Fénéon was the elected champion of the neo-impressionists, and *ipso facto* his implacable enemy. In a way this is understandable, since Fénéon's article is totally free of glamour. It swept away practically all the literary superstructure, and laid bare the skeleton of Gauguin's work.

Their mysterious, hostile, and rough aspect isolated the ambiance of the works of M. Paul Gauguin, a painter and sculptor of the Impressionist exhibitions of 1880, 1881, 1882, and 1886; many details of execution, and the fact that he carved bas-reliefs in wood and colored them was a sign of a tendency towards archaicism; the form of his earthenware vases bore witness to an exotic taste: all characteristics which attain their degree of saturation in his recent canvases.

The means of the *tachistes* [impressionists], so appropriate to the representation of brief visions, were abandoned about 1886 by several painters concerned about an art of synthesis and premeditation. While M. Seurat, M. Signac, M. Pissarro, M. Dubois-Pillet realized their conception of this art in paintings in which the episodes were abolished in a general docile orchestration conforming to the code of optical physics, and in which the personality of the author remains latent, like that of a Flaubert in his books, *M. Paul Gauguin was working towards an analogous goal, but by other means.* Reality for him was only the pretext for a far distant creation: he rearranges the materials reality furnishes; disdains trompe-l'œil, be it the trompe-l'œil of the very atmosphere; uses prominent lines, limits their number, hieraticizes them; and within each of the spacious cantons formed by their interlacings, an opulent and heavy color sits in bleak glory without attempting to meet its neighboring colors, unclouded. . . .

M. Louis Anquetin speculates on the hypothesis posed by Humboldt about the gentleman brusquely transferred from Senegal to Siberia. . . . It is probable that M. Anquetin's style, with its intractable contours, flat and intense colors, had some slight influence on M. Paul Gauguin: but only a formal influence, for it does not seem that the least feeling flows through these knowing and decorative works.

M. Emile Bernard is showing Breton landscapes and scenes; M. Charles Laval, scenes and landscapes of Brittany and Martinique— M. Gauguin's favorite territories. Both of them will free themselves

from the stamp of this painter, whose work is arbitrary, or at least is the result of a too special state of mind for newcomers to be able to use it as their point of departure.*

Fénéon's article, in all its seeming abruptness, is one of the most significant art-critical contributions to the contemporary debate. He had recognized similarities in the structural features of Seurat's and Gauguin's art. In terms reminiscent of Maurice Barrès' discussions of Mallarmé's poetry, Fénéon pointed out the discontinuity of Gauguin's color and form. He maintained that it had been applied with a view to creating a subjective, strongly emotional, but also abstractly clarified and definitive iconography. He considered that Anquetin, Bernard, and Laval were striving towards the same synthetic painting, but stressed that their results were unsatisfactory because their composition did not express unique emotional experiences.

* Leur aspect mystérieux, hostile et fruste isolait de l'ambiance les œuvres de M. Paul Gauguin, peintre et sculpteur aux expositions impressionnistes de 1880, 1881, 1882 et 1886; maints détails de facture, et ce fait qu'il taillait dans le bois ses bas-reliefs et les coloriait marquaient bien une tendance à l'archaïsme; la forme de ses vases de grès témoignait d'un goût exotique: tous caractères qui atteignent leur degré de saturation dans ses toiles récentes.
Les moyens des tachistes, si propres à figurer des visions disparaissantes, furent, vers 1886, abandonnés par plusieurs peintres soucieux d'un art de synthèse et de préméditation. Tandis que M. Seurat, M. Signac, M. Pissarro, M. Dubois-Pillet réalisaient leur conception de cet art en des tableaux où les épisodes s'abolissent dans une orchestration générale docile au code de la physique optique et où la personnalité de l'auteur reste latente comme celle d'un Flaubert dans ses livres, *M. Paul Gauguin tâchait vers un but analogue, mais par d'autres pratiques.* La réalité ne lui fut qu'un prétexte à créations lointaines: il réordonne les matériaux qu'elle lui fournit, dédaigne le trompe-l'œil, fût-ce le trompe-l'œil de l'atmosphère, accuse des lignes, restreint leur nombre, les hiératise; et dans chacun des spacieux cantons que forment leurs entrelacs, une couleur opulente et lourde s'enorgueillit mornement sans attenter aux couleurs voisines, sans se nuer elle-même. . . .
M. Louis Anquetin spécule sur l'hypothèse posée par Humboldt du monsieur brusquement transféré du Sénégal en Sibérie. . . . Il est probable que la manière de M. Anquetin, contours infranchissables, teintes plates et intenses, n'a pas été sans influencer un peu M. Paul Gauguin: influence seulement formelle, car il ne semble pas que la moindre sensation circule dans ces œuvres savantes et décoratives.
M. Emile Bernard expose des paysages et des scènes de Bretagne; M. Charles Laval, des scènes et des paysages de Bretagne et de la Martinique,—les territoires de prédilection de M. Gauguin. Tous deux s'affranchiront de l'estampille de ce peintre dont l'œuvre est arbitraire ou du moins résulte d'un trop spécial état d'esprit pour que les mouveaux venus y puissent utilement prendre leur point de départ.[55]

Gauguin was deeply offended by this criticism. His reaction to Fénéon's article was, however, natural and understandable. The last thing he wished to hear was that he was tending towards "an analogous goal" with Seurat and his circle. Instead of considering the marked positive features of the article, he occupied himself with insignificant details.[56] He had expected to be hailed as a new Messiah, but the critics certainly did not strew palm branches in his way. The unkindest cut of all was the fact that Albert Aurier, who, by way of Bernard, had supplied him with new pictorial themes and tactical arguments, hesitated to follow up Gauguin's efforts in his reviews. Gauguin, who lived at Pont-Aven during the greater part of 1889, kept Aurier constantly informed of his work.[57] He himself contributed to *Le Moderniste* with articles on art,[58] and tried, through Bernard, to induce Aurier to take up a definite position. But instead, in the early part of 1890 Aurier wrote the article on Vincent van Gogh, the main features of which have been given in the preface of this book, and then a study of Pissarro's painting.[59] Gauguin, who was now living to a large extent on Meyer de Haan and other new admirers at Le Pouldu, grew more and more irritated. In June 1890 he wrote to Bernard: "Aurier *hasn't answered* my 2 letters, just like dog shit along a wall. *Le Moderniste* hasn't come and I haven't been able to read 'le Maudit'." * Gauguin's chances of selling his work seemed less than ever before, and the idea of leaving France grew stronger.

It may be asked what could have caused the changed situation. There were many reasons. The Boulanger crisis in the spring of 1889 had led to an economic situation not unlike that prevailing during the years 1883–84. It caused a slump in the art market and in general had a discouraging effect on cultural activities. The already ephemeral existence of *avant-garde* literary periodicals became even more precarious. Edouard Dujardin was compelled to surrender to others his ambitiously conceived periodical *La Revue Indépendante*. It was no coincidence that Fénéon published his article, *Autre Groupe Impressionniste,* on the Volpini exhibition in *La Cravache.* Gustave Kahn's *La Vogue* was also on the verge of bank-

* A 2 lettres Aurier ne *m'a pas répondu* telle une merde de chien le long d'un mur. Le *Moderniste* n'est pas venu et je n'ai pu lire "le Maudit." [60]

ruptcy. Albert Aurier's *Le Moderniste* was rapidly losing ground, and he decided instead to devote part of his journalistic work to a newly established publishing enterprise that was to prove successful. During the autumn of 1889 the old organ of the symbolists, *La Pléiade,* was reorganized under the name *Mercure de France,* and at the beginning of 1890 Aurier joined the editorial staff and became its art critic.

It was naturally difficult for Gauguin, relatively isolated as he was in Brittany, to follow the course of events in detail. For him Aurier's silence was a Judas betrayal, which made him feel utterly rejected.[61] A study of Gauguin's work during the years 1889–90 gives one the impression that in some respect his pictures lacked a firm ideological foundation. They oscillated in style between conventional folklore-influenced pictures from Brittany, possibly intended for sale at Théo van Gogh's gallery, and pregnant compositions conceived to impress symbolist circles in Paris. *La Perte de Pucelage,* the self-portrait with the halo and the portrait of Meyer de Haan (Fig. 19) are so like caricatures that one is tempted to believe that Brittany had ceased to be a source of inspiration to Gauguin.

To a large extent these literary inclined pictures are samples from the aesthetic "nursery" established by Gauguin at Le Pouldu while waiting for something to turn up in Paris. Gathered around him were a number of young, completely "traditionless" artists, that is to say artists not handicapped by impressionist doctrines, who desired nothing better than to theorize over the master's views of art. Marie Henry's inn became a kind of substitute for a Paris hostile to art. It was decorated from floor to ceiling with very self-revealing paintings, which were intended primarily to stimulate their creators to debate.[62]

The discussions were, however, rather fruitless. Paul Sérusier, who had once imbibed Gauguin's wisdom at Bois d'Amour and afterwards inspired his colleagues to form an *avant-garde* artists club, *Les Nabis,* belonged to the group at Le Pouldu. His reports to his friends in Paris, chiefly Maurice Denis, clearly show that aesthetic speculations on the coast of Brittany had been caught in a kind of whirlpool.[63] The leader himself, Paul Gauguin, had given his best in his variations on the Gethsemane theme. His portrait of Meyer de

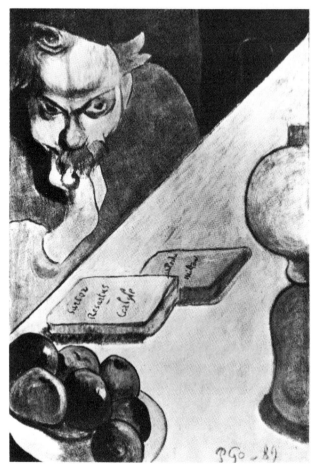

FIG. 19  Paul Gauguin, *Jacob Meyer de Haan*, 1889,
Collection Q. A. Shaw McKean, Boston.

Haan is like an angular coping stone, the close of a long period of
building. The discontinuous structure is roughly and forcibly ap-
plied, and the literary accessories—in a way borrowed from Vin-
cent van Gogh—seem intrusive.

Both Carlyle's *Sartor Resartus* and Milton's *Paradise Lost,* lying
like instructions for use before Meyer de Haan's uncanny dwarf-like
figure, belonged to the sacrosanct symbolist literature. The principal
themes of the books were easy to apply to the cultural pessimism of

the closing years of the century, with its demands on artistic self-realization and its Utopian dreams.

Pictures like this show that Gauguin was beginning to glide into a new aesthetic milieu. The propaganda of the Nabists, not the least that of Maurice Denis' obscure artistic maxims in *Art et Critique,*[64] conceived under the great influence of Gaugin and Sérusier, and Bernard's purposeful handling of Aurier [65] could not fail to have effect in the long run.

When, therefore, Gauguin returned to Paris in the late autumn of 1890, the ground had been prepared. With the establishment of *Mercure de France,* there occurred the most important literary amalgamation since the great days of *La Revue Indépendante.* The editorial office was in the Rue de l'Eschaudé in the shadow of the Saint-Germain church. At the Café Voltaire in the neighborhood, Gauguin was introduced to the young writers, with Verlaine as their aesthetic lodestar. Some of them, Charles Morice, Jean Dolent, and Julien Leclerq, were to be of decisive significance to Gauguin's artistic development during the coming years.

Gauguin, however, had not moved to Paris to absorb symbolistic theories. His relations with the new circle were almost wholly dictated by tactical considerations. He was naturally eager for his art to be given an ideological superstructure which would show clearly, for himself and for others, just where he stood, but it should be done preferably in forceful articles which enjoyed the greatest possible circulation. The proposed journey to the South Sea, which for two years had been the subject of deliberations with Bernard, Meyer de Haan, Schuffenecker, Redon, and others, had become a kind of fixed idea with Gauguin. It was necessary at all costs to obtain money, and the chances of selling his pictures, after the death of Vincent van Gogh and Théo's illness, were more uncertain than ever.

The letter sent by Gauguin to the Danish painter Jens Ferdinand Willumsen from Le Pouldu in the autumn of 1890 (see Appendix, p. 192), shows that by that time he was rather clear as to the path he should follow. From comments on old masters he admired, Rembrandt, Velazquez, Ingres, he could give an indirect characterization of his own artistic objectives. He strove to achieve the simplest

possible means of expression, to suppress *la belle matière* to appear more abstract, to give the lines an intensity and harmony that would interpret an "inner life," in short a symbolic and synthetic artistic program.

No less interesting were his reasons for his unwavering decision to leave France. The picture he painted of his future work in Tahiti was not limited to vague dreams. He drew up a complete Utopian program with the following main items: In the South he would escape from the culture-smothering materialism of the approaching golden age of the western world. He would not suffer from economic troubles there. There he would find his ideal artistic milieu. He would be freed from physical pain, and find peace to work. In these surroundings free love abounded, primitive and innocent. He would escape from the competiton and jealousy of other artists. And he would not be disturbed by having to pay consideration to the critics and the public.

With such a clear program to follow it was not difficult to keep the symbolist critics provided with material, when they had finally been convinced of the necessity of publicizing Gauguin. In face of the united assaults of Charles Morice, Mallarmé, and Pissarro (!),[66] Octave Mirbeau capitulated in February 1891 and published his article on the artist in *L'Echo de Paris*. Somewhat later it was also printed in *L'Art Moderne*. The article, which resolved itself into a semi-biographical sketch, was remarkably well written. It touched on the dramatic aspects of Gauguin's life and made use of all the suggestive vocabulary of symbolism. There is no doubt that it contributed largely to the growth of the myth surrounding the artist. Since it has often been quoted and reported, it will not be treated in detail here. One passage, however, is of particular interest. After a general account of Gauguin's gradual liberation from impressionist realism, Mirbeau devotes a number of lines to a description of the painting *Le Christ jaune,* which he considered was typical of the artist's symbolism:

In a yellow countryside, an agonizing yellow, at the top of a Breton hillock sadly yellowed by the end of autumn, under the open sky, a wayside cross rears up, an ill-made wooden cross, rotting, disjointed,

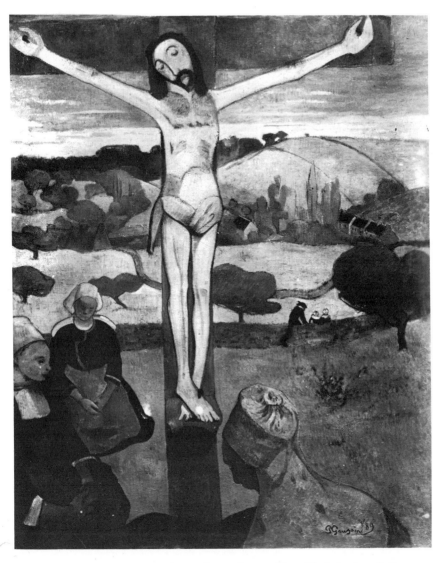

Fig. 20  Paul Gauguin, *The Yellow Christ,* 1889, Albright Art Gallery, Boston.

reaching its clumsy arms across the air. The Christ, like a Papuan divinity, laconically carved from a tree trunk by a local artist, the piteous and barbarous Christ is daubed with yellow paint. At the foot of the cross some peasant women are kneeling. Indifferent, their bodies sagging heavily on the ground, they have come there because it is the

custom to come there on a day of Pardon. But their eyes and lips are empty of prayer. Not a thought, not a look do they have for the image of Him who died of loving them. Already, climbing over hedges, scurrying under the red apple trees, other peasants are hastening towards their sties, happy at having finished their devotions. And the melancholy of this wooden Christ is unspeakable. His face is hideously sad; his meager flesh might sorrow for an ancient torture, and he seems to say, seeing at his feet this miserable humanity which understands nothing: "And yet, if my agony were useless?" *

The description is undoubtedly very suggestive, and is intended naturally to illustrate the transcendental nature of the painting. But like most of his literary symbolist colleagues, Mirbeau failed to characterize the structure of the new artistic style, the aesthetic nature of the symbolic values he thought he had found. His description was rather a pathetic allegory built on observations of mimetic details of the picture. Mirbeau could always excuse himself by claiming that the article had been written with another aim in view than to give profound aesthetic evaluations. Instead it was vouchsafed to Albert Aurier to delve into the problems of symbolism in Gauguin's painting.

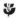

AURIER'S ARTICLE *Le Symbolisme en peinture. Paul Gauguin* was finally published in the March 1891 issue of *Mer-*

---

* Dans la campagne toute jaune, d'un jaune agonisant, en haut du coteau breton qu'une fin d'automne tristement jaunit, en plein ciel, un calvaire s'élève, un calvaire de bois mal équarri, pourri, disjoint, qui étend dans l'air ses bras gauchis. Le Christ, telle une divinité papoue, sommairement taillé dans un tronc d'arbre, par un artiste local, le Christ piteux et barbare, est peinturluré de jaune. Au pied du calvaire, des paysannes se sont agenouillées. Indifférentes, le corps affaissé pesamment sur la terre, elles sont venues là parce que c'est la coutume de venir là, un jour de Pardon. Mais leurs yeux et leurs lèvres sont vides de prières. Elles n'ont pas une pensée, pas un regard pour l'image de Celui qui mourut de les aimer. Déjà, enjambant des haies, et fuyant sous les pommiers rouges, d'autres paysannes se hâtent vers leur bauge, heureuses d'avoir fini leurs dévotions. Et la mélancolie de ce Christ de bois est indicible. Sa tête a d'affreuses tristesses; sa chair maigre a comme des regrets de la torture ancienne, et il semble se dire, en voyant à ses pieds cette humanité misérable et qui ne comprend pas: "Et pourtant, si mon martyre avait été inutile?" [67]

*cure de France.* As hinted previously, it was partly newspaper policy that had delayed his article for such a long time. But the delay was also certainly due to the fact that he had taken his task so seriously, not the least because he wished the article to fit naturally into the comprehensive *œuvre totale* that he was planning.

He opened with a detailed description of *La Lutte de Jacob avec l'Ange,* in which he stressed strongly the visionary and dreamlike features of the composition. He further emphasized that this painting had nothing to do with impressionism. Impressionism was merely a form of realism; its aim was to record sense data, but this new art was something else; it strove to express ideas pictorially. He called it *idéisme* to distinguish it from traditional idealization and classic salon painting.

There was nothing fundamentally new in Aurier's reasoning. Fénéon's articles on neo-impressionism and synthetism had followed the same lines. But Aurier approached the theoretic conceptions with unwonted vigor. To describe to his readers what *idéisme* really was he used very lucid and modern pedagogical examples. He assumed that for most people an object is just an object. That is, their conception of it is dictated by their "consumption needs." Things are arranged in what might be called a "need structure." This attitude, unfortunately, accompanied many people into the exhibition galleries, and made them experience works of art in a way that was foreign to the situation. As a result they were guilty of a physiognomic mistake; in art they wished to see *la vérité concrète, l'illusionnisme, le trompe-l'œil.*

But idéistic art did not tempt them to make such fatal mistakes. It created the right aesthetic attitude in the onlookers. It made them understand that things, in the hands of the artists, became *symbols* of his conception of beauty. The idéistic, symbolic, or synthetic art —whatever name one gives it—was, therefore, above all *décorative.*

Aurier's conclusion sounds like an anticlimax, but he used the word *décorative* in a definite psychological significance. By it he meant the easily comprehended, the "good figure," which was also of great aesthetic value. But, asked Aurier, was that enough to create art?

Isn't this man rather an ingenious scholar, a supreme formulator who knows how to write down Ideas like a mathematician? Isn't he in some ways an algebraist of Ideas, and isn't his work a miraculous equation, or rather a page of ideographic writing reminding us of the hieroglyphic texts of the obelisks of ancient Egypt? *

The artist must also possess other qualities. His symbols must be of such a nature as to awaken feelings to life. Still it was not the task of the artist to reproduce human passions. He should endeavor to find an *émotivité transcendantale,* to arouse a kind of "shudder of the soul" in the presence of beauty. Thought and emotion should be united in an aesthetic entirety.

Among the works by Gauguin that Aurier thought satisfied these demands were *La Lutte, Le Christ jaune,* the self-portrait, *Christ au Jardin des Oliviers,* and the two polychrome wood reliefs, *Soyez amoureuses* and *Soyez mystérieuses.*

Naturally, Aurier's carefully considered criticism was not a flash in the pan. It was part of comprehensive studies of aesthetics. Side by side with the Gauguin article he had been working on a *Préface pour un livre de critique d'art.*[68] It was an ambitious work, but was never finished. The author died suddenly on 5 October 1892. The article is worth bringing to light again on account of its passionate opposition to Taine's positivism and deterministic conception of history. In contrast to Taine's theories of environment, he vigorously maintained the autonomy of individual artists and individual works of art. It is obvious from the essay that he had studied Hennequin's *esthopsychologie.* There is no doubt that Aurier's grasp of the nature of aesthetic experience was the fruit of these studies.

Before his death, Aurier had time to support his views of Gauguin's synthetic symbolism in a long and richly illustrated article entitled *Les Symbolistes,* commissioned by *La Revue Encyclopédique,* and published in April 1892. As a motto Aurier chose the following passage: "We attach ourselves to the exterior of things, not knowing

---

* N'est-il [l'artiste idéiste] pas plutôt un génial savant, un suprême formuleur qui sait écrire les Idées à la façon d'un mathématicien? N'est-il pas en quelque sorte un algébriste des Idées et son œuvre n'est-elle point une merveilleuse équation, ou plutôt une page d'écriture idéographique rappelant les textes hiéroglyphiques des obélisques de l'antique Egypte? [Tr. Chipp, p. 93].

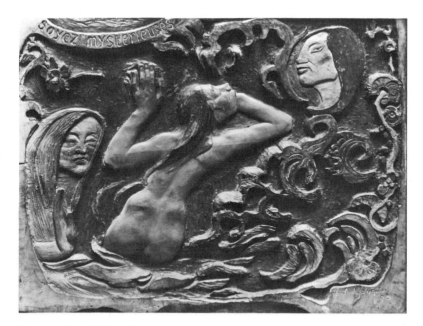

FIG. 21 Paul Gauguin, *Soyez Mystérieuses,* 1890, present whereabouts unknown.

that hidden within them is what moves us. (Plotinus, Ennead V, 3.) " * The text is also leavened with neo-Platonic ideas. Aurier began by describing in dark colors the false picture of existence that the positivist sciences had painted, and stressed how difficult it was for the new art to win recognition in such conditions.

These circumstances had, however, compelled artists to react, discuss, and explain to a far greater extent than formerly. They had become both painters and theorists. Aurier was determined once and for all to make a clean sweep of naturalist aesthetics. He declined to consider the most vulgar forms of the theory of imitation, and instead took up for discussion the famous thesis that art is "the imitation of material reality, as that reality is perceived through the diverse temperaments of artists, supposedly infinitely diverse," ** propounded first by Zola.

* Nous nous attachons à l'extérieur des choses, ignorant que c'est au dedans d'elles que se cache ce qui nous émeut.
** l'imitation de la réalité matérielle, telle que cette réalité est perçue par les divers tempéraments d'artistes, présupposés divers a l'infini

This definition assumed indirectly, he maintained, that some form of symbolism was necessary if a work of art was to be created, for "nature deformed by a temperament" was in fact nothing but *un signe visible,* a symbol of this temperament. But for naturalistic aesthetics this implied an absurd contradiction, since it did not recognize any connection between the soul and the "objective reality" to which works of art also should rightfully belong.

As an alternative to this theory Aurier developed a subtle, idealistic argument about the relative existence of things, which was a direct paraphrase of Schopenhauer's metaphysics. His conclusion was: "In nature, each object is, in short, only an Idea signified." * For the idealistic artist, therefore, the surrounding world was transformed into a mystic, but remarkably expressive combination of lines, planes, shades, and colors, with the help of which he could depict ideas, dreams, and thoughts.

Aurier's argumentation may seem diffuse, abstract, and barren, but his contemporaries did not think so. He tried vigorously to prove the aesthetic value of *avant-garde* art. Since cloisonism as well as pointillism must seem pure caricatures of reality to old aesthetic conceptions, it was necessary to undermine the very foundations of these norms. He did it in more or less the same way as his symbolist forerunners, but his vigor and devotion to the cause, and his pedagogical gifts made him the foremost champion of the new art. He defined its contours, and drew the historic borderline of modernism more clearly than anyone before him.

Albert Aurier summarized the program of the modern artist and aesthete in the following words:

> The work of art is the translation, into a special and natural language, of a spiritual gift of variable value; at the least it is a fragment of the artist's spirituality, at most, his entire spirituality plus the spiritual essence of various objective beings. The complete work of art is thus *a new being;* one may actually say *a living thing,* since there is a soul to animate it, which is even the synthesis of two souls, the soul of the artist and the soul of nature—I almost wrote the paternal and maternal souls. This new being, nearly divine, for it is immutable and

* Dans la nature, tout objet n'est en somme, qu'une Idée signifiée.

immortal, should be deemed capable of inspiring, in one who communicates with it in certain conditions, emotions, ideas, special feelings, proportionate to the purity and depth of his soul. It is this influx, this sympathetic enlightenment felt at the sight of a masterpiece, which we call the love of the beautiful, the aesthetic emotion; and the nature of this emotion thus explained by the communion of two souls —one inferior and passive, the human soul; the other superior and active, the soul of the work—will probably appear to the earnest seeker to be highly analogous to what is called Love: more truly Love than human love which is always maculate with muddy sexuality. To understand a work of art is to love it as a lover, definitively, to penetrate it, may I say at the risk of easy witticism, with incorporeal kisses.*

He had no hesitation in declaring that the foremost representative of this new art was Paul Gauguin, and he approved wholeheartedly of his decision to seek primitive surroundings where the gift of "conversing with the soul of things" had not yet been lost. Gauguin, who had left Paris for Tahiti a year earlier, wrote when he heard of the publication of the article:

I know Aurier and I think that in his article he gives me some little due. This movement in painting was created by me and many young painters are profiting from it—not that they are *without tal-*

---

* L'œuvre d'art est la traduction, en une langue spéciale et naturelle, d'une donnée spirituelle, de valeur variable, au reste, laquelle est comme minimum un fragment de la spiritualité de l'artiste, comme maximum cette entière spiritualité de l'artiste plus la spiritualité essentielle des divers êtres objectifs. L'œuvre d'art complète est donc *un être nouveau,* on peut dire absolument *vivant,* puisqu'il a pour l'animer une âme, qui est même la synthèse de deux âmes, l'âme de l'artiste et l'âme de la nature, j'écrirais presque l'âme paternelle et l'âme maternelle. Cet être nouveau, quasiment divin, car il est immuable et immortel, doit être estimé susceptible d'inspirer à qui communie avec lui dans certaines conditions, des émotions, des idées, des sentiments spéciaux, proportionnés à la pureté et à la profondeur de son âme. C'est cet influx, ce rayonnement sympathique ressentis à la vue d'un chef-d'œuvre, que l'on nomme le sentiment du beau, l'émotion esthétique, et le sentiment de cette émotion, ainsi expliqués par la communion de deux âmes l'une inférieure et passive, l'âme humaine, l'autre supérieure et active, l'âme de l'œuvre, apparaîtra sans doute, à qui voudra de bonne foi approfondir, très analogue à ce qu'on nomme: l'Amour, plus vraiment même l'Amour que l'Amour humain toujours maculé de boueuse sexualité. Comprendre une œuvre d'art, c'est en définitive l'aimer d'amour, la pénétrer, dirai-je au risque de faciles railleries, d'immatériels baisers.[69]

*ent,* but once more, I am the one who formed them. And nothing they have comes out of them, it comes from me.*

The passage may seem an exaggeration. But if one retrospectively surveys the aesthetic battlefield on which Paul Gauguin had fought bitterly for years for recognition, it must be admitted that he succeeded in realizing most of the dreams and hopes that he had outlined in his letter to Emile Schuffenecker in the early days of 1885. The campaign had been fought with many diversions and with different weapons, but without the ideological bastions and rallying points which literary symbolism had established in the heart of Paris during the eighties, the battle would have been lost at the outset.

---

* Je connais Aurier et je pense que dans cet article il me donne une petite part. Ce mouvement je l'ai créé en peinture et beaucoup de jeunes gens en profitent non pas *sans talent* mais encore une fois c'est moi qui les ai formés. Et rien en eux ne vient d'eux, cela vient de moi.[70]

# 4 / *La Nuit Etoilée*

GEORGES SEURAT, REFERRING TO THE ENTHUSIASTIC RECEPTION his literary friends gave to his paintings, is said to have remarked: "You see poetry in them; I only apply my method." As a matter of fact we know hardly anything about Seurat's reading habits or of his opinion about the literature of his time that he may be assumed to have read. On the other hand, we do know of his long and intimate association with symbolist poets and novelists, and an analysis of their works and Seurat's art has shown that they overlapped to some degree.

There is therefore no reason to question Gustave Kahn's good faith when he wrote of Seurat:

> He was silent in larger groups of people; with a few or with proven friends he spoke freely of his art, about his aims, about technical volitions. The emotion which penetrated him then was hinted at by a light redness along his jaws; he spoke very literarily and breathlessly, seeking to compare the progress of his art with those of the sonic arts, very preoccupied with finding a fundamental unity in his efforts and those of poets or musicians.*

Thus connections were established first on the strictly theoretic plane, and it is not until after an interpretation of the structure of Seurat's paintings that their emotional trend towards symbolist literature becomes obvious.

* Silencieux dans les groupes un peu nombreux, entre peu et amis plus éprouvés il parlait fort de son art en tant que visées, en tant que volitions techniques. L'émotion qui le pénétrait alors se notifiait par de légères rougeurs aux maxillaires; il parlait alors très littérairement et d'haleine, cherchant à comparer les progrès de son art avec ceux des arts sonores, très préoccupé de trouver une unité dans le fond de ses efforts et ceux des poètes ou musiciens.[1]

Paul Gauguin's attitude towards the symbolists was more robust and primitive. From the autumn of 1888 his paintings had a far more pronounced "literary" approach than Seurat ever allowed himself. I have tried to show how at an early stage he was influenced by Aurier's and Bernard's "private-religious" iconography, and how he repeatedly took subjects from popular symbolist literature. It was by no means an empty gesture that the benefit performance given at the Théâtre d'Art [2] immediately before his departure for Tahiti was also in honor of Paul Verlaine. The group at the Café Voltaire found common points of expression in the works of the poet and the painter. During the 1890's the influence of literature on Gauguin grew stronger. He established close collaboration with Charles Morice for *Noa-Noa;* his exotic paintings are full of poetic allusions; and the leading figures of symbolism appear in *Avant et Après.* All this, however, is beyond the scope of this work.

Vincent van Gogh's attitude towards literary symbolism was quite different, and was, perhaps, the most complicated of the three. Compared with Seurat and Gauguin, van Gogh was by far the most familiar with literature. From his first letters to Théo from London right up to his last letter to his sister Will, he discussed literary problems of the most diverse kinds. He seems to have had an almost insatiable appetite for contemporary literature. He had read an impressive number of English and French books. He was well versed in Balzac, Baudelaire, Carlyle, Coppée, Daudet, Dickens, George Eliot, Flaubert, the brothers Goncourt, Hugo, Huysmans, Keats, Loti, Maupassant, Jean Paul, Poe, Richepin, George Sand, Harriet Beecher Stowe, Taine, Thackeray, Whitman, and Zola, to give only a selection of the authors he read. His knowledge of literature also stretched from Petrarch to Shakespeare, from Goethe to Turgenev. His studies of religious and philosophic literature were at times very intensive. On the other hand, one seeks in vain for references to such writers as Mallarmé, Verlaine, and Rimbaud.

Vincent van Gogh's way of reading and his enthusiasm reveal essential features of his character. He was hardly actuated by a desire to increase his knowledge, nor does he ever seem to have used his erudition to impress others. He seems rather to have had recourse to books to obtain an evaluation of himself, a deeper insight into his

own personality.[3] The energy he expended on his moral rearmament by way of literature is fundamentally evidence of his isolation from his fellow creatures. His reading program was, therefore, sometimes almost touchingly sentimental.

All the same, his reading was not merely compensation. Often his comments on literature are extended beyond his personal problems to a discussion of the position of modern man in the universe. He shared his rootlessness with the cultural elite of France, and like them he at times sought a foothold in a romantically conceived past. Thus he did not read Victor Hugo's *Quatre-vingt-treize* and *Les Misérables* primarily to augment his knowledge of history, but rather to find an anchorage in the philosophy of his forefathers.[4]

It is only natural that Vincent van Gogh's literary tastes should influence his art. They were manifested in several ways, at various levels of integration and abstraction. Some of the main trends will be followed here.

Carl Nordenfalk, in an excellent study of van Gogh's relations to literature, has analyzed the artist's earliest still life with books,[5] painted in 1885. It shows a table with an open family Bible, a candlestick with a short piece of candle, and a French novel in the famous yellow covers. The painting was sent to Théo in Paris. There is nothing in the letter that Vincent sent with the picture to suggest that the still life was anything but the solution of a purely artistic problem.[6] This attitude was very typical. Sometimes his descriptions of his pictures to his art-dealer brother betray an obvious aversion to discuss the more or less manifest symbolic content of his works. He was far more communicative in his letters to his colleagues and his sister Will.

As Nordenfalk pointed out, the still life was composed in such a way that one is justified in calling it a modern allegory. The Bible is open at the Book of Isaiah, at chapters 52 and 53, which describe the sufferings and glorification of the servants of the Lord. Thus van Gogh gives an allusion of his own situation. But Zola's *La Joie de Vivre* is also included in the picture. The book had been published the previous year, and the artist's copy is read almost to shreds. By including Zola's novel of ideas he extended the symbolism to embrace the homelessness of modern man in existence—pessimism

and disgust with life.[7] Isaiah's prophesies are also full of forebodings of doom, and thus the two books together emphasize the symbolic content of the painting. Finally, however, it is associated with the artist. He himself was a kind of Lazare, full of good intentions, but for various reasons incapable of carrying them out. Still it was hardly his fault; he was a victim of the "evil times," and in the open Bible can be read the words:

> He is despised and rejected of men; a man of sorrows, and acquainted with grief. . . . Surely he hath borne our griefs and carried our sorrows. . . .
>
> Isaiah liii. 3–4.

It is extremely interesting to see how Vincent van Gogh in a veiled way anticipated the Gethsemane and salvation symbolism that Gauguin was to express more openly in his self-portraits a few years later.

The problem outlined here dogged the artist throughout his life, however much his style might change. He returned to the *motif* in March 1886 when he arrived in Paris. Several of his works are pure form and color studies, but in one of them (now in the Kröller-Müller Museum, Otterlo) the symbolic values emerge clearly. The still life, whose style is reminiscent of Cézanne, represents Maupassant's *Bel Ami* and the Goncourts' *Germinie Lacerteux*. The two novels lie between a cut rose and a statuette of a female torso. The books are characterized by crude psychological descriptions, and are lavish in seduction scenes. The attributes—the cut rose and the marked sexual features of the mutilated female body—underline the contents of the books. To some extent this picture may also be regarded as an expression of the artist's relations to the surrounding world, in this case women. At any rate, we know that he would very much have liked to be a "Bel Ami," if only his personal qualifications and his "marriage" to art had not prevented him.[8] The light, impressionist color scale rather complements than disturbs the ambivalent moods suggested by the two novels.

While living in Antwerp, van Gogh had already read a number of the works of Edmond and Jules de Goncourt, particularly their art-historical works. This reading was a kind of orientation prepara-

tory to his moving to Paris, and they gave body and color to such unusual conceptions as *japonerie, fin de siècle, l'art pour l'art.* But *Germinie Lacerteux* was his lifelong companion. He discussed it with Théo and Will from Paris to Saint-Rémy, and in his last portraits, two versions of the portrait of Dr. Gachet of Auvers, it appears again.

It is lying on the table in front of Dr. Gachet, with the Goncourts' novel on artists' lives, *Manette Salomon.* There is a glass containing foxglove in front of the doctor. Superficially these accessories are added as attributes of the subject of the portrait. The books symbolize his friendship with the Goncourt brothers, the heart medicine his profession. But the objects are integrated in the picture in such a way that they are given a more profound and wider significance. This has been attained by the special structure that distinguishes the painting. The lack of perspective lifts the figure out of a historical course and instead expresses a melancholy contemplative mood without beginning or end. Nevertheless the picture is not without tension. It is noticeable in the play of the complementary colors, but above all in the rhythm of undulating lines which run through the whole composition. The showers of brushstrokes are arranged in a magnetic field. Yet the most remarkable feature of the painting is the violent contrast between the strong tactile values in the clothes of the subject, and the diffuse, disintegrative form of the traditional expressive portions—the face and the hands. In this way the mimetic features of the picture are toned down, and the dominant emotional values are in the form alone.

In this aesthetically full-toned painting the accessories are elevated to the rank and dignity of universal symbols of the uneasiness of heart that was the constant companion of modern people. Vincent van Gogh regarded his friend the doctor as his spiritual brother, and was of the opinion that they both suffered from the same "ailment." He therefore identified himself intimately with the moods inherent in the picture. He was anxious to emphasize that the painting was complementary to the self-portrait (now in the Louvre) that he had painted just before he left the hospital at Saint-Rémy. Both were pictorial representations of "la grande névrose actuelle," to use the words of Paul Alexis about Zola's *L'Œuvre.*

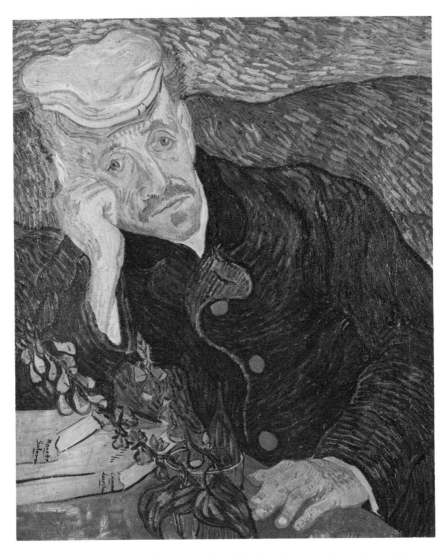

FIG. 22   Vincent van Gogh, *Dr. Paul Gachet,* Auvers, June 1890, collection the late Siegfried Kramarsky and Mrs. Kramarsky, New York.

Vincent van Gogh assigned to the portrait of Dr. Gachet a central position among his paintings. He described it in no fewer than three letters; one to Théo, one to Will, and one—unfinished and never sent—to Paul Gauguin. The first, typically enough, is restricted to an account of the colors and iconographic details. The second states in plain terms that the painting is an attempt to realize

the dream of the "modern portrait." The emotional values of the colors are discussed, and van Gogh even points out the structurally important effect of the disintegratively conceived face.

What impassions me most—much, much more than all the rest of my métier—is the portrait, the modern portrait. I seek it in color, and surely I am not the only one to seek it in this direction. I *should like*—mind you, far be it from me to say that I shall be able to do it, although this is what I am aiming at—I *should like* to paint portraits which would appear after a century to the people living then as apparitions. By which I mean that I do not endeavor to achieve this by a photographic resemblance, but by means of our impassioned expressions—that is to say, using our knowledge of and our modern taste for color as a means of arriving at the expression and the intensification of the character. So the portrait of Dr. Gachet shows you a face the color of an overheated brick, and scorched by the sun, with reddish hair and a white cap, surrounded by a rustic scenery with a background of blue hills; his clothes are ultramarine—this brings out the face and makes it paler, notwithstanding the fact that it is brick-colored. His hands, the hands of an obstetrician, are paler than the face. Before him, lying on a red garden table, are yellow novels and a foxglove flower of a somber purple hue.

My self-portrait is done in nearly the same way; the blue is the blue color of the sky in the late afternoon, and the clothes are a bright lilac.*

* Ce qui me passionne le plus, beaucoup, beaucoup d'avantage que tout le reste dans mon métier—c'est le portrait, le portrait moderne. Je le cherche par la couleur et ne suis certes pas seul à le chercher dans cette voie. Je *voudrais,* tu vois, je suis loin de dire que je puisse faire tout cela mais enfin j'y tends, je *voudrais* faire des portraits qui un siècle plus tard aux gens d'alors apparussent comme des apparitions. Donc je ne cherche pas à faire cela par la ressemblance photographique mais par nos expressions passionnées, employant comme moyen d'expression et d'exaltation du caractère notre science et goût moderne de la couleur. Ainsi le portrait du Dr. Gachet vous montre un visage couleur d'une brique surchauffée et hâlé de soleil, avec la chevelure rousse, une casquette blanche dans un entourage de paysage fond de collines bleu, son vêtement est bleu d'outremer—cela fait ressortir le visage et le pâlit malgré qu'il soit couleur brique. Les mains, des mains d'accoucheur, sont plus pâles que le visage. Devant lui sur une table de jardin rouge, des romans jaunes et une fleur de digitale pourpre sombre. Mon portrait à moi est presqu'aussi ainsi le bleu est un bleu fin du midi et le vêtement est lilas clair.[9]

The third letter is no less interesting. It was written in connection with a picture that van Gogh wished to present to Paul Gauguin, a version of the painting *L'Arlésienne,* based on a sketch made by Gauguin during his stay at Arles. Van Gogh wrote that the painting was a *synthesis* of the female types of Arles, and that it was to be regarded as an epitome of their common efforts during that period. Then the letter continues with the Gachet portrait, which the artist describes in the terminology of symbolism. He compares it to Gauguin's *Christ au Jardin des Oliviers* (Fig. 18), and considers that the two paintings strive to express the same thing—"the agony of the time."

> Haven't you, too, been on the Mount of Olives? I now have a portrait of Dr. Gachet with that agonized expression of our times; if you wish, something like what you would say of your Christ on the Mount of Olives, not meant to be understood. However, up to that point I follow you, and my brother quickly grasped this distinction.*

Never, perhaps, has van Gogh's profound affinity with Gauguin's symbolic world been so clearly formulated as in this draft letter.

WHEN STUDYING THE MATURE WORK of Vincent van Gogh, the portrait of Dr. Gachet, one is really face to face with still another aspect of the problem that both Seurat and Gauguin strove to solve. Van Gogh, too, resorts to a discontinuous composition to illustrate ambivalent feelings and complicated attitudes.

This new structure was evolved in Arles during the autumn of 1888, and may to a great degree be regarded as a consequence of the intensive exchange of ideas with Bernard and Gauguin at that time. But it is also interesting to see how it imbibed nourishment from literary sources that had earlier captivated van Gogh's imagination.

While waiting for Gauguin in October 1888, van Gogh was working intensively on the decoration of his Yellow House. It was

---

* Avez-vous aussi vu les oliviers? Maintenant j'ai un portrait du Dr. Gachet à expression navrée de notre temps. *Si vous voulez,* quelque chose comme vous disiez de votre Christ au jardin des oliviers, pas destiné à être compris, mais enfin là jusque là je vous suis et mon frère saisit bien cette nuance.[10]

then that his sunflower pictures were executed, and then, too, that he painted a picture of his own bedroom. It was a puritanically austere room, the only furniture being a rustic bed, two chairs, a dressing table, a looking glass and a few works of art on the walls. With these ingredients he composed an extremely complex picture, rich in overtones.

With the steeply ascending perspective lines of the floor and bed, he gave a strong suggestion of movement. The focus of the lines seems to be at the right-hand side of the window frame, about level with the lowest crosspiece. This inward motion is caught up and reflected by the contrasting lines of the half open window, which form an angle leading back into the room. This counter movement is repeated and augmented by the obliquely situated table and the chair by the window, and echoed in the ends of the bed.[11]

To define the positions of the objects in the room more exactly is very difficult. The bed occupies a curious position in relation to the right-hand wall, which seems to bend indefinitely near the head of the bed. The bed, too, seems to be at one and the same time both too long and too short. The table and the chairs are unsatisfactorily defined in relation to the walls, besides which they appear to be suspended slightly above the floor. But at the same time the furniture gives a feeling of being firmly fixed to the floor. Furthermore, the floor itself seems to have a fold in the middle, like an open book. The two doors are drawn in such a way as to give the impression of their being both shut and half open. As a kind of compensation for this extremely ambivalent conception of reality, the articles have been given strong tactile values, and are outlined and painted with muscular tangibility. The vermilion bedspread, for example, seems to emerge from the picture and make almost physical contact with the viewer.

One of the most striking features, however, is that the painting has two mutually antagonistic main stresses. The focus of the perspective lines, mentioned above, is not the psychological center of interest. It is the looking glass in its black frame that captivates the imagination of the spectator. Curiously enough, it does not reflect anything, but hangs like an empty canvas. It is difficult to take

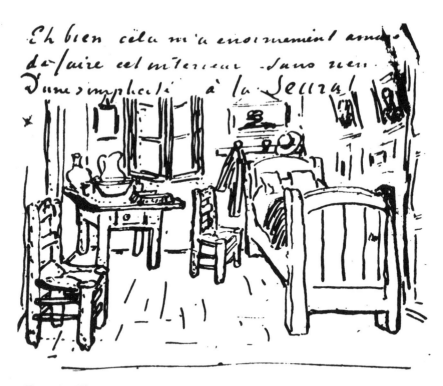

FIG. 23   Vincent van Gogh, Letter to Paul Gauguin with a sketch of van Gogh's bedroom, Arles, Oct. 1888.

one's eyes from it. One becomes more and more aware of how the zigzag pattern of the floor and the oblique position of the table and chair help to lead the eyes to that empty, enigmatic, blind rectangle. It gives the whole room an air of unreality, which is strongly emphasized by the fact that all the other articles are shadowless.

Taken together all these small peculiarities create a curious mood. The calm holiday peace that seemed at first to hover over the scene is changed into a feeling of anxious anticipation. One gets an indefinite feeling of the presence of someone in the empty room. Something must happen—the chairs will be put straight, the window closed, and the looking glass will begin to reflect.

What has happened artistically in the painting is as follows. In his great love of reality van Gogh has ignored the objective distance to the simple familiar objects. They overpower and animate simultaneously. The great aesthetic effect is very largely a function of the

nice equilibrium that has been established between the observed and what is experienced under strong emotional stress. By exploiting the latent conflict between the phenomenal and noumenal worlds he achieved a new and unique vision of art.

In a letter to Théo he hastened to give an account of his work. His description has a rugged beauty. He explained that by simplification he had endeavored to achieve a grand style, by which he desired to suggest a feeling of rest.[12] It is impossible not to observe that he avoided every tendency towards a poetic interpretation of the painting. The sketch of the interior that accompanied the letter is a pattern of realism, and lacks much of the aesthetic tension of the final version.[13]

It was not until a year later that he gave the key to the painting of his bedroom at Arles. He had painted a replica to send to his sister Will at the Hague. He wrote that he was afraid she would think it ugly, but he asked her to think of Felix Holt when she looked at it. Then she would understand. He had striven for similar simplicity, and he had endeavored to achieve it in a new way—by means of glaring colors, not the traditional broken accords of grey, white, black, and brown.[14]

A letter to Théo dated Isleworth, 2 August 1876 shows that during his apprenticship and evangelist period in England Vincent had read George Eliot's *Felix Holt the Radical*.[15] It is perhaps not difficult to understand that he was fascinated by this now practically unreadable book. It had a social outlook that was rooted in religious views. Further it dealt, at least in part, with the problems of the simple people in the period of transition between the old agrarian society and the new age of industry. The hero of the novel, driven by socialism and idealism, risked his freedom for what he considered to be the right of every citizen.[16] It was some years, however, before van Gogh could fully accept Felix Holt, who showed suspicious inclinations towards atheism. But after Vincent had seceded from religious sectarianism, Felix Holt developed in his imagination into an ideal figure. He admired him for his feeling of responsibility, his unity of purpose, and his intellectual gifts; but also because he was "a rough, severe fellow," and for his awkwardness in relation to his surroundings and his obvious clumsiness in his connections with

women.[17] In van Gogh's eyes he became a kind of secular Christ who bore his vicarious suffering with hard-won patience.

In a letter to Théo written in the summer of 1883 he compared his painter colleague, Piet van der Velden, with the hero of George Eliot's novel,[18] and his correspondence with Anthon van Rappard shows that he scrutinized the art of the time from Felix Holt's angle.[19] It is therefore not too far-fetched to assume that the exaggerated, bristling self-portraits of the Paris period 1886–87 are intended to be interpreted as van Gogh in the personality of Felix Holt.

In the picture of the bedroom at Arles this symbolism is more profound and refined, and the composition reflects the artist and his literary alter ego. The content and message of the painting are nevertheless not fully accounted for. It has other dimensions, too. As already mentioned, it was executed while the artist was awaiting Gauguin's arrival at Arles. Van Gogh's enthusiasm over his work was clearly so great that he could not wait till Gauguin's arrival to tell him about it, but described it by means of a sketch and a letter (Fig. 22).

> I have done, still for my decoration, a size 30 canvas of my bedroom with the white deal furniture that you know. Well, I enormously enjoyed doing this interior of nothing at all, of a Seurat-like simplicity; with flat tints, but brushed on roughly, with a thick impasto, the walls pale lilac, the ground a faded broken red, the chairs and the bed chrome yellow, the pillows and the sheet a very pale green-citron, the counterpane blood red, the washstand orange, the washbasin blue, the window green. By means of all these very diverse tones I have wanted to express an *absolute restfulness,* you see, and there is no white in it at all except the little note produced by the mirror with its black frame (in order to get the fourth pair of complementaries into it).
>
> Well, you will see it along with the other things, and we will talk about it, for I often don't know what I am doing when I am working almost like a sleepwalker.*

* J'ai fait, toujours pour ma décoration, une toile de trente de ma chambre à coucher, avec les meubles en bois blanc que vous savez. Eh bien, cela m'a enormément amusé de faire cet intérieur sans rien, d'une simplicité à la Seurat: à teintes plates, mais grossièrement brossées, en pleine pâte, les murs lilas pâle, le sol d'un rouge rompu et fané, les chaises et le lit jaune de chrome, les oreill-

The wording of the letter is the same as the one to Théo, but new interesting information is added. He wished to discuss the painting with his more experienced colleague since the work had been executed in a state bordering upon "somnambulism," that is to say, under the influence of strong emotional stress so typical of van Gogh, and which, according to his own account, was so powerful that he felt ready to faint. There are two points in particular in the description that draw one's attention. He mentions the accent given by the black-framed looking-glass. It is true that he continues his discussion of complementary colors, which he had carried on with Théo from Antwerp as early as the autumn of 1885,[21] but one also gets the impression that for psychological reasons he wished to stress this structurally important detail.

Above all he says that he had desired to execute the work "d'une simplicité à la Seurat." By this he meant, of course, that he had wished to solve a complicated artistic problem with the sure elegance which made the observer of Seurat's paintings accept without question the intricate problems of composition. During his passionate Paris period Vincent van Gogh was an insatiable student of *avant-garde* art, and his interests extended from Manet to Degas, from Anquetin to Seurat. He soon gave up the pointillist technique, but Seurat's conception of space clearly made a deep and lasting impression on him. The last thing he did before leaving Paris was to pay a visit with Théo to the leader of neo-impressionism in his studio. He returned to him repeatedly in his letters, and he maintained that Seurat was the unchallenged "chef du petit Boulevard," that is, of the painters who, during the most recent years, had frequented and exhibited in the Boulevard de Clichy—van Gogh himself, Anquetin, Bernard, Gauguin, and Toulouse-Lautrec.[22]

It is tempting to imagine that Vincent van Gogh executed his picture with Gauguin's *Les Misérables* (Fig. 17) in mind, and that it

ers et le drap citron vert très pâle, la couverture rouge sang, la table à toilette orangée, la cuvette bleue, la fenêtre verte. J'aurais voulu exprimer un repos absolu par tous ces tons très divers, vous voyez, et où il n'y a de blanc que la petite note que donne le miroir à cadre noir (pour peusser encore la quatrième paire de complementaires dedans). Enfin, vous verrez cela avec les autres, et nous en causerons, car je ne sais souvent pas ce que je fais, travaillant presque en somnambule.[20]

was a reply to the Pont-Aven painters' symbolic doctrines. There is reason to revert to van Gogh's letter to Bernard, quoted on page 134. Vincent began by thanking Bernard for the self-portraits he had received. He continued by relating how he had failed to follow Gauguin's and Bernard's intentions in a Gethsemane picture and in a picture of a poet in a starry night.[23] Instead he gave an account of his personal relationship to patterns in nature. Now, in the "Bedroom," he had given a practical demonstration of his theories. The symbolic picture of van Gogh-Felix Holt was a worthy counterpart to the portrait of Gauguin-Jean Valjean. One may also say with justification that van Gogh had created a picture that completely covers Albert Aurier's definition of the new art. With his simple bedroom interior he had produced *"a new being, one may say an absolutely living thing."* *

DURING THE LATTER HALF OF JUNE 1889, Vincent van Gogh finished his visionary painting *La Nuit Etoilée.* He had then been in the hospital at Saint-Rémy barely two months. He had been admitted to recuperate from the crises following the tragic break with Gauguin and the event with the amputated ear, a ritual sacrifice, which in the bullfighting town of Arles had its especial significance.

Even a cursory glance at the picture tells that it was conceived in a state of great agitation. Every tendency towards depth has been stifled and substituted by a contrasting scheme of vertical and horizontal motion. The cypress to the left writhes as if tortured by fire, and the jab-like brushstrokes pursue each other and flock together in electrified streams whirling around the firmament like a maelstrom. The tiny village in the valley cowers to the ground, and the mountains bow down before the majestic spectacle of the skies. The elimination of the foreground causes the viewer to feel enveloped in and overwhelmed by the celestial phenomenon.[24]

Because of the hallucinatory character of the painting and its vi-

---

* *un être nouveau,* on peut dire absolument *vivant.*

FIG. 24   Vincent van Gogh, *La Nuit Etoilée,* Saint-Remy, June 1889,
Museum of Modern Art, New York.

olently expressive form, physicians and psychiatrists have sometimes
designated it "psychopathic art," a symptom of a defective psychotic
condition.[25] Such a conclusion, apart from the fact that it is false, is
an injustice to Vincent van Gogh's intellectually and aesthetically
outstanding composition. Both Dr. Rey at Arles and Dr. Peyron at
Saint-Rémy were convinced that van Gogh was suffering from a
form of epilepsy.[26] Recent research has also diagnosed the illness as
"epileptoid psychosis." This condition was manifested in fits, and
was sharply limited in time. During the seizures the artist was inca-
pable of any form of activity, but between them his feelings and in-
tellect functioned normally, even if at times he felt extremely de-
pressed.[27]

Further, Vincent van Gogh did not paint his *Starry Night*
immediately after an attack of illness. As much as three months
elapsed between a crisis and the execution of the work. An art-his-

torical interpretation of *La Nuit Etoilée* demands an approach quite different from the medical-psychiatric. As a matter of fact, the painting is the final version of an idea that van Gogh had been working on long before his first seizure at Arles on 24 December 1888. In addition it is a contribution to the current debate on art, the implications of which can only be understood by an analysis of the circumstances prevailing when the work was executed.

The subject "starry night" appears first in the correspondence with Bernard and Théo in the spring of 1888. To Bernard Vincent wrote that he would like to paint a starry night, but then he would have to desert his principles of painting from nature, which would naturally gratify his young friend (and, one might add, Albert Aurier).

> A star-spangled sky for example, that's a thing I would like to try and do, just as by daylight I shall attempt to paint a green meadow spangled with dandelions. But how can I manage unless I make up my mind to work at home and from imagination? That's a criticism of me, and a credit to you.*

To his brother he was even briefer, but his reflections appear in a very interesting connection. They were made immediately after he had expressed his regret at the death of his old Dutch teacher, the painter Anton Mauve. Thus Vincent van Gogh's conception was originally connected with the thought of death.

> Mauve's death was a terrible blow to me. You will see that the rose-coloured peach trees were painted with a sort of passion.
> I must also have a starry night with cypresses, or perhaps above all, a field of ripe corn; there are some wonderful nights here. I am in a continual fever of work.**

---

* Un ciel étoilé, par exemple, tiens c'est une chose que je voudrais essayer à faire, de même que le jour j'essayerai à peindre une verte prairie étoilée de pissenlits. Comment, pourtant, y arriver, à moins de me résoudre à travailler chez moi et d'imagination. Ceci donc à ma critique et à ta louange.[28]

** La mort de Mauve a été un rude coup pour moi. Tu le verras bien que les pêchers roses ont été peints avec une certaine passion.

Il me faut aussi une nuit étoilée avec des cyprès ou—peut-être au-dessus d'un champ de blé mûr; il y a des nuits fort belles ici. J'ai une fièvre de travail continuelle.[29]

Painters—to take them only—dead and buried, speak to the next generation or to several succeeding generations in their work.

Is that all, or is there more besides? In a painter's life death is not perhaps the hardest thing there is.

For my own part, I declare I know nothing whatever about it, but to look at the stars always makes me dream, as simply as I dream over the black dots of a map representing towns and villages. Why, I ask myself, should the shining dots of the sky not be as accessible as the black dots on the map of France? If we take the train to get to Tarascon or Rouen, we take death to reach a star.*

In July the artist visited the small fishing village of Saintes-Maries south of Arles, and in a letter to Théo he told about a night walk along the deserted beach. The account is remarkably free of emotion, and mainly describes color relations. All the same one seems even then to be able to discern the outlines of *La Nuit Etoilée*. It was not until September, however, that he applied himself to the practical solution of the problem, and then his idea was realized in two versions painted within a very short time of each other.

At the beginning of December he wrote to his sister that his trip to Saintes-Maries had inspired him to paint a starry night, but in the same letter he mentioned that he was then working on an exterior of the café terrace just around the corner from his Yellow House. It was, he claimed, very reminiscent of Guy de Maupassant's description of a Parisian boulevard café in the opening pages of *Bel Ami*.

I was interrupted these days by my toiling on a new picture representing the outside of a night café. On the terrace there are the tiny figures of people drinking. An enormous yellow lantern sheds its light on the terrace, the house front and the sidewalk, and even casts a cer-

---

* Les peintres—pour ne parler d'eux—étant morts et enterrés, parlent à une génération suivante ou à plusieurs générations suivantes par leurs œuvres. Est-ce là ou y a-t-il même encore plus? Dans la vie du peintre peut-être la mort n'est pas ce qu'il aurait de plus difficile.

Moi je déclare ne pas en savoir quoi que ce soit, mais toujours la vue des étoiles me fait rêver les points noirs représentant sur la carte géographique villes et villages. Pourquoi me dis-je, les points lumineux de firmament nous seraient-elles moins accessibles que les points noirs sur la carte de France?

Si nous prenons le train pour nous rendre à Tarascon ou à Rouen, nous prenons la mort pour aller dans une étoile.[30]

tain brightness on the pavement of the street, which takes a pinkish violet tone. The gable-topped fronts of the houses in a street stretching away under a blue sky spangled with stars are dark blue or violet and there is a green tree. Here you have a night picture without any black in it, done with nothing but beautiful blue and violet and green, and in these surroundings the lighted square acquires a pale sulphur and greenish citron-yellow color. . . .

So far you have not told me whether you have read *Bel Ami* by Guy de Maupassant, and what in general you think of his talent now. I say this because the beginning of *Bel Ami* happens to be a description of a starlit night in Paris with the brightly lighted cafés of the Boulevard, and this is approximately the same subject I just painted.*

This was neither the first nor the last occasion on which van Gogh mentioned Guy de Maupassant in his letters. At a time when Vincent was both attracted and repelled by the seductive symbolic strains from Pont-Aven, he had very strong reasons to follow the development of this author. The draft of Zola's *L'Œuvre* reveals that one of the principal characters, Fagerolles, was to be modeled on Guy de Maupassant. He was to be made evil and traitorous, like one who deserted his friends, a turncoat.[32] Zola really had reason to be dissatisfied with this member of the naturalistic Médan group. He had begun to show tendencies towards *l'art pour l'art* more and more clearly, and was gliding away from the master. In the autumn of 1887, in a preface to *Pierre et Jean,* he showed a very critical attitude towards naturalism.[33] During the same year he had finished the hallucinatory short story, "Le Horla."

As a rule Vincent van Gogh followed events in the literary

* J'ai été interrompu justement par le travail que m'a donné de ces jours-ci un nouveau tableau représentant l'extérieur d'un café le soir. Sur la terrasse il y a de petites figurines de buveurs. Une immense lanterne jaune éclaire la terrasse, la devanture, le trottoir, et projette même une lumière sur les pavés de la rue qui prend une teinte de violet rose. Les pignons des maisons d'une rue qui file sous le ciel bleu constellé d'étoiles, sont bleus foncés, ou violets avec un arbre vert. Voilà un tableau de nuit sans noir, rien qu'avec du beau bleu et du violet et du vert et dans cet entourage la place illuminée se colore de souffre pâle, de citron vert. . . .

Tu ne m'as jamais dit si tu avais lu Bel ami de Guy de Maupassant, et ce que tu penses maintenant en général de son talent. Je dis cela parce que le commencement de Bel ami est justement la description d'une nuit étoilée à Paris avec les cafés illuminés du Boulevard et c'est à peu près ce même sujet que je viens de peindre maintenent.[31]

world very closely. For example, in January 1886 he was reading *L'Œuvre,* which was then appearing in serial form in *Gil Blas,* and commented on it to many of his French artist colleagues.[34] In April 1888 he reported to Théo that he was reading *Pierre et Jean,* and he asked his brother if he had read the introduction, in which the author defended the right of the artist to exaggerate, to create a more beautiful, simpler, and more comforting world.

> I am in the middle of *Pierre et Jean* by Guy de Maupassant. It is good. Have you read the preface where he declares the liberty of the artist to exaggerate, to create in his novel a world more beautiful, more simple, more consoling than ours, and goes on to explain what perhaps Flaubert meant when he said that "Talent is long patience, and originality an effort of will and of intense observation." *

Maupassant's creed gave van Gogh an artistic doctrine which made it possible for him to bridge the chasm between his violent love of natural prototypes and his desire to partake of the aesthetic ideals of his artist colleagues. The painting, *Terrasse de café* (Fig. 25), however, does not contain any tangible symbolic values, but bold and acute compositional features. With its wild perspective and X-like structure, it is far more advanced than the style of the painters of the "Petit Boulevard," with which it has certain points of contact. Coloristically it is divided into a warm, lively zone, and a chilly, dark, and quiet one, between which the starry sky forms a reconciling link.

The other nocturnal picture executed during September is essentially different from *Terrasse de café,* but like it, is painted direct from the subject. It is a painting of a view across the Rhône with a town on the horizon. The work is based coloristically on a triad of purple in the foreground bank, royal blue in the water, and bluish green in the sky. The spit of land and the curved horizon give great depth to the *motif.* The glittering sky with the Great Bear and

---

* Suis en train de lire Pierre et Jean, de Guy de Maupassant, c'est beau— as-tu lu la préface, expliquant la liberté qu'a l'artiste d'exagérer, de créer une nature plus belle, plus simple, plus consolante dans un roman, puis expliquant ce que voulait peut-être bien dire le mot de Flaubert: *le talent est une longue patience,* et l'originalité un effort de volonté et d'observation intense? [Tr. *Further Letters,* p. 20].

FIG. 25 Vincent van Gogh, *Terrasse de café, La nuit,* Arles, Sept. 1888, Rijksmuseum Kröller-Müller, Otterlo.

Orion, and the lights of the town vibrating in the river give the picture a disintegrative, almost impressionist character. In the foreground the artist has included the lovers who had appeared in his earlier pictures of bridges.

Vincent van Gogh called the Rhône picture one of his *sujets poétiques.* As usual he described the picture to Théo with the help of a sketch and notes on the colors, and added that he was in dire need of religion. That was why he always wandered about at night and painted stars. He dreamt all the time of painting a starry sky with a group of his artist friends.

Enclosed a little sketch of a square size 30 canvas, the starry sky actually painted at night under a gas jet. The sky is greenish-blue, the water royal blue, the ground mauve. The town is blue and violet, the gas is yellow and the reflections are russet-gold down to greenish-bronze. On the blue-green expanse of sky the Great Bear sparkles green and pink, its discreet pallor contrasts with the harsh gold of the gas. . . .

That does not prevent me from having a terrible need of—shall I way the word?—of religion. Then I go out at night to paint the stars, and I am always dreaming of a picture like this with a group of living figures of our comrades.*

The passage is an important one, and the contours of van Gogh's literary sources of inspiration become more clear if one studies his correspondence with Will. About the same time he recommended to her the poetry of Walt Whitman, who, wrote Vincent, told of both past and present as a world under the banner of powerful and free love—a world of friendship and work under the mighty, star-spangled sky, that is God and eternity instead of this world.

Have you read the American poems by *Whitman?* I am sure Theo has them, and I strongly advise you to read them, because to begin with they are really fine, and the English speak about them a good deal. He sees in the future, and even in the present, a world of

---

* Ci-inclus petit croquis d'une toile de 30 carrée, enfin le ciel étoilé peint la nuit même sous un bec de gaz. Le ciel est bleu vert, l'eau est bleu de roi, les terrains sont mauves. La ville est bleue et violette, le gaz est jaune et des reflets sont or roux et descendent jusqu'au bronze vert. Sur le champ bleu vert du ciel, la grande ourse a un scintillement vert et rose, dont la pâleur discrète contraste avec l'or brutal du gaz. . . .

J'ai un besoin terrible de—dirai-je le mot—de religion—alors je vais la nuit dehors pour peindre les étoiles, et je rêve toujours un tableau comme cela avec un groupe de figures vivantes des copains.[35]

healthy, carnal love, strong and frank—of friendship—of work —under the great starlit vault of heaven a something which after all one can only call God—and eternity in its place above this world. At first it makes you smile, it is all so candid and pure; but it sets you thinking for the same reason.

The "Prayer of Columbus" is very beautiful.*

This is the only occasion in Vincent van Gogh's extensive correspondence that Whitman's name is mentioned, but the essential features of his poetry are seen through the penetrating eyes of the initiate. If one begins to read Whitman with van Gogh's art in mind, one is struck by the many similarities between the artist at Arles and the "poet of comrades." He was attracted by both the American poet's rugged, inspired conception of nature, and his naive, primitive gospel of love.[37] *Le Rhône. Nuit Etoilée,* with its lyrical overtones, is a pure Whitman illustration.

One may naturally assume that Vincent van Gogh had read Walt Whitman in the original. Nevertheless it is interesting to see that his appreciation of the poet was shared by the literary symbolists of Paris. In spite of the fact that he was personally acquainted with both Kahn and Dujardin he gave no signs of being favorably attracted by symbolic poetry, rather the contrary.

Although Whitman was in a way anticipated by Jules Michelet's poetic, philosophic conception of nature (read avidly by van Gogh), it was not until the 1880's that the American poet began to have significant influence on French literature.[38] In 1886 Jules Laforgue made an excellent translation of *A Woman Waits for Me* for *La Vogue,* and in 1888 Francis Viélé-Griffin published in *La Revue Indépendante* and elsewhere translations from *From Noon to Starry Night.*[39] The *avant-garde* writers were naturally attracted by Whitman's poetic form, free verse, but they also shared von Gogh's

---

* As-tu déjà lu les poésies américaines de *Whitman.* Théo doit les avoir et je t'engage bien à les lire parce que c'est réellement beau d'abord et puis des anglais en parlent beaucoup actuellement. Il voit dans le présent, un monde de santé d'amour charnel large et franc—d'amitié—de travail avec le grand firmament étoilé quelque chose qu'en somme on ne sait appeler que Dieu et l'éternité remis en place au-dessus de ce monde. Cela fait sourire d'abord tellement c'est candide et pur; cela fait réfléchir pour la même raison. La prière de Christophe Colomb est fort belle.[36]

FIG. 26   Vincent van Gogh, Letter to Eugene Bock with a sketch of *Le Rhône. Nuit Etoilée,* Arles, Sept. 1888.

appreciation of his inspired conception of nature, his sexual romanticism, and his idealism. In one case the similarities between von Gogh's later work and literary symbolism is obvious. The works of the Belgian poet Emile Verhaeren have a forced emotional, marked declamatory, and hallucinatory, symbolic language reminiscent of van Gogh.[40] Thus in advanced symbolic circles there was a poetic climate that was comparable to van Gogh's literary inclinations, and this may, in any case, have been significant for Aurier's strong sympathy with his painting.

In the Saint-Rémy painting, *La Nuit Etoilée,* Vincent van Gogh expressed more clearly than ever before the conception of nature and life that was common to him and Whitman. It is a no longer neo-Rousseauian philosophy that is dominant. In the situation in which the artist found himself in June 1889 it was instead only natural that he was attracted by the religiously inclined longing for the beyond, not to say death instinct, that provided the bass accompaniment to the work of the American poet. In his letter to Will he had

already stressed his great admiration for Whitman's *Prayer of Columbus.*

> Is it the prophet's thought I speak, or am I raving?
> What do I know of life? what of myself?
> I know not even my own work past or present,
> Dim ever-shifting guesses of it spread before me,
> Of better worlds, their mighty parturition,
> Mocking, perplexing me.[41]

The feelings of isolation and helplessness in face of the problems of life that took possession of him at that time form the fundamental chord in his interpretation of the view from the hospital window at Saint-Rémy. It has features in common with Whitman's nightly peregrinations in *Specimen Days,*[42] but van Gogh presses more out of the *motif,* and creates an infinitely expressive picture which symbolizes the final absorption of the artist by the cosmos. In this van Gogh is in complete harmony with the deepest chords in Whitman's poems.

> Come lovely and soothing death,
> Undulate round the world, serenely arriving, arriving,
> In the day, in the night, to all, to each,
> Sooner or later delicate death.
>
> Prais'd be the fathomless universe,
> For life and joy, and for objects and knowledge curious,
> And for love, sweet love—but praise! praise! praise!
> For the sure-enwinding arms of cool-enfolding death.
> . . .
> The night in silence under many a star,
> The ocean shore and husky whispering wave whose voice I know,
> And the soul turning to thee O vast and well-veil'd death,
> And the body gratefully nestling to thee.[43]

By exerting his great artistic powers to their fullest, Vincent van Gogh has visualized in *La Nuit Etoilée* this mystic frontier between two worlds. It gives a never-to-be-forgotten sensation of standing on the threshold of eternity.

This interpretation is naturally not the only one that can be made of a picture as complex as *La Nuit Etoilée.* Walt Whitman's

poetry is not the only possible source of inspiration. The marked religious character of the painting stimulates further investigation into its origin. Meyer Schapiro, in an eloquent interpretation, pointed out that the moon in the picture is also a sun. He advances the view that the vision was inspired by an apocalyptic theme in the twelfth chapter of the Book of Revelations.[44]

> And there appeared a great wonder in heaven; a woman clothed with the sun, and the moon under her feet, and upon her head a crown of twelve stars: and she being with child cried, travailing in birth and pained to be delivered. And there appeared another wonder in heaven; and behold a great red dragon, having seven heads and ten horns, and seven crowns upon his heads. And his tail drew the third part of the stars of heaven, and did cast them to the earth: and the dragon stood before the woman which was ready to be delivered, for to devour her child as soon as it was born.
>
> Revelations xii. 1 –4.

Recent van Gogh studies have shown that there was a curious connection between Vincent's attacks and the actions of his brother Théo.[45] Théo's financial help and interest were essential to Vincent's life as an artist. For that reason he regarded every change in Théo's way of life as a threat to his existence. It was certainly no coincidence that Vincent cut off his ear when he heard that Théo had gone to Holland to marry Johanna Bonger. He had a new serious seizure at Saint-Rémy when Jo wrote to tell him that she was expecting a child.

This was possibly in Schapiro's mind when he made his apocalyptic interpretation of *La Nuit Etoilée*. As a matter of fact, the painting was finished in June, but Jo's letter did not arrive until the following month.[46] Further, the biblical account of the red dragon with the seven crowned heads and ten horns has no tangible similarities with van Gogh's picture. All the same, I think the suggestion that inspiration may have come from the Bible is worth following up.

If one makes a careful study of the circumstances around the creation of *La Nuit Etoilée,* it will be found that the artist also made a daylight version of his view from the window. It exists both as a

FIG. 27  Vincent van Gogh, *Champ de blé aux Alpilles,* Saint-Remy, June 1889, Stedelijk Museum, Amsterdam.

drawing (Fig. 27) and as a painting (in Ny Carlsberg Glyptotek, Copenhagen). The profile of the mountain range shows that the subject is the same as that of *La Nuit Etoilée,* but with certain modifications. Both the cypress and the little village with the church are absent. The delineation is certainly very expressive, and in the painting in particular appear the dizzying perspective in the landscape and the heavy clouds rolling towards the viewer, so typical of van Gogh's later work. Nevertheless, both the drawing and the painting are experienced as continuous, that is, a "historic course of events" can be discerned. The viewer can, so to speak, walk across the field, rest at the stone wall, and then go on up the hills.

The spirituality of *La Nuit Etoilée* loosens the artist's naturalistic grasp of the subject. The *motif* expands into a mighty vision, the elements of which are visualized in purely symbolic terms. One remembers that, for example, the cypress is the tree of death in the Mediterranean countries. *La Nuit Etoilée* was also executed in two

FIG. 28   Vincent van Gogh, Drawing for *La Nuit Etoilée,* Saint-Remy, June 1889, formerly Kunsthalle, Bremen.

versions. The drawing (Fig. 28) is by no means a rough sketch of the kind that Vincent used to send to Théo, but a well composed, finished pen-and-ink drawing with an even more exalted form than the painting. In most respects the drawing and the painting are in agreement with each other. In spite of the fact that the fundamental emotional features and the poetic overtones have been retained in the painting, one still has a feeling that van Gogh has tightened up the composition and attempted to curb his pathos in order to proclaim solemnly definite tidings.

A careful comparison of the drawing and the painting reveals that in one respect they are remarkably dissimilar. In the drawing the celestial phenomenon comprises the sun-moon and ten stars. In the painting the point of the cypress has been reduced and rounded off to make room for an *eleventh* star. It is difficult to find good reasons for this compositional change. One must assume, therefore, that it was made to increase the symbolic values of the picture. The

sun, the moon, and eleven stars—the combination leads one's thoughts to the Bible story of Joseph.

And he dreamed yet another dream, and told it to his brethren, and said, Behold, I have dreamed a dream more; and, behold, the sun and the moon and the eleven stars made obeisance to me. And he told it to his father, and to his brethren: and his father rebuked him, and said unto him, What is this dream that thou hast dreamed? Shall I and thy mother and thy brethren indeed come to bow down ourselves to thee to the earth? And his brethren envied him; but his father observed the saying.

<div align="right">Genesis xxxvii. 9–11.</div>

Here we are face to face with a new variant of the individual-symbolic theme, the sufferings and glorification of the servants of the Lord, as expressed in the still life painted in 1885, the secular parallel of which was to be found in the allusion to Felix Holt. Joseph's dreams of glory, which led to debasement but finally to elevation and triumph, is a *motif* that suits Vincent van Gogh's situation at Saint-Rémy in June 1889 remarkably well. Though innocent he was degraded and persecuted by the people around him. A petition signed by eighty-one citizens of Arles was presented to the mayor in order to get "the mad artist" expelled from the town.[47] He was separated from his family, and the brotherhood of artists that he had wished to form under the starry sky had failed him and turned their backs on him.

The correspondence between Vincent and Théo around the middle of June 1889 reveals that *La Nuit Etoilée* was painted at the time that Vincent was informed that he had been excluded from the Café Volpini exhibition. In his letter Théo took upon himself part of the responsibility for this step. Gauguin had included Vincent in his proposal, made in March,[48] and Théo, too, had said that he wished to see Vincent among the exhibitors. However, there had been so much discord among the members of the group that Théo decided to withdraw his brother from their company.

Now he consoled Vincent by saying that his colleagues had made their way into the World's Fair by the "back stairs," and he intimated that everything was for the best and that he was in the good company of Toulouse-Lautrec.[49] Vincent replied by return

post. His letter showed no surprise over the decision. The tone was extremely resigned, but one can read between the lines the great pain and disappointment his exclusion must have caused him. He mentioned, too, that he had made a new study of a starry sky, which he thought was animated by the same spirit as Gauguin's and Bernard's works. With almost exaggerated zeal he emphasized that it was not a return to romantic or religious ideas.

I think you were right not to show any pictures of mine at the exhibition that Gauguin and the others had. My not yet being recovered is reason enough for my keeping out of it without giving them offense.

I think that unquestionably Gauguin and Bernard have great and real merit.

And it remains very understandable that for beings like them— young and very vigorous, who *must* live and try to hack out their way—it would be impossible to turn all their canvases to the wall until it should please the people to admit them into something, into the official stew. You cause a stir by exhibiting in cafés; I do not say it is not bad taste to do it, but I myself have this crime on my conscience twice over, as I exhibited at the Tambourin and at the Avenue de Clichy, without counting the upset caused to 81 worthy anthropophagi of the good town of Arles and their excellent mayor.

So in any case I am worse and more to blame than they, as far as that goes, in causing stir enough, my word, quite involuntarily. Young Bernard—I think—has already done some absolutely astonishing canvases in which there is a sweetness and something essentially French and sincere of rare quality.

After all, neither he nor Gauguin are artists who could ever look as if they were trying to get into a universal exhibition by the back stairs.

Be reassured about this. That they *could not* hold their tongues is very understandable. That the impressionist movement has had no unity proves that they aren't as skilled fighters as other artists such as Delacroix and Courbet.

Finally, I have a landscape with olive trees and also a new study of a starry sky.

Though I have not seen either Gauguin's or Bernard's last canvases, I am pretty well convinced that these two studies I've spoken of are parallel in feeling.

When you have looked at these two studies for some time, and that of the ivy as well, it will perhaps give you some idea, better than words could of the things that Gauguin and Bernard and I sometimes used to talk about, and which we've thought about a good deal; it is not a return to the romantic or to religious ideas, no.*

Although the study of the starry night must have been very near to Vincent's heart, he showed marked reluctance to discuss it. This is understandable after a perusal of the beginning of Théo's letter of 16 June. There he warns his brother to beware of surrendering himself to mystical speculations, and he exhorts him to paint what he sees and to keep to still lifes and flowers.[51] It is not clear from Vincent's reply whether he sent *La Nuit Etoilée* with the letter, but it seems likely that he did so. In his later letters, however, he never mentioned the painting.

---

* Je trouve que tu aies bien fait de ne pas exposer des tableaux de moi à l'exposition de Gauguin et autres, il y a une raison suffisante que je m'en abstienne san les offenser, tant que je ne suis pas moi-même guéri.

Il est indubitable pour moi que Gauguin et Bernard ont du grand et réel mérite. Qu'à des êtres comme eux, bien vivants et jeunes, et qui *doivent* vivre et chercher à se frayer leur sentier, il soit impossible de retourner toutes leurs toiles contre un mur, jusqu'à ce qu'il plaise aux gens de les admettre dans quelque chose dans le vinaigre officiel, demeure pourtant fort compréhensible. En exposant dans les cafés, on est cause de bruit, qu'il est, je ne dis pas non, de mauvais goût de faire, mais moi, et jusqu'à deux fois j'ai ce crime-là sur la conscience, ayant exposé au Tambourin et á l'Avenue de Clichy, sans compter le dérangement causé à 81 vertueux antropophages de la bonne ville d'Arles et à leur excellent maire. Donc dans tous les cas je suis pire et plus blâmable qu'eux, en tant que quant à cela causer du bruit, ma foi, bien involontairement.

Le petit Bernard—pour moi—a déjà fait quelques toiles absolument étonnantes où il y a une douceur et quelque chose d'essentiellement français et candide de qualité rare. Enfin ni lui ni Gauguin sont des artistes qui puissent avoir l'air de chercher à aller à l'exposition universelle par des escaliers de service.

Rassure-toi là-dessus. Qu'eux ils *n'ont pas pu* se taire, c'est compréhensible. Que le mouvement des impressionistes n'a pas eu d'ensemble, c'est ce qui prouve qu'ils savent moins bien batailler que d'autres artistes, tels Delacroix et Courbet.

Enfin j'ai un paysage avec des oliviers et aussi une nouvelle étude de ciel étoilé. Tout en n'ayant pas vu les dernières toiles ni de Gauguin ni de Bernard, je suis assez persuadé que ces deux études, que je te cite, sont dans un sentiment parallèle. Lorsque pendant quelque temps tu auras vu ces deux études, ainsi que celle du lierre, mieux que par des paroles je pourrai peut-être te donner une idée des choses dont Gauguin, Bernard et moi ont quelquefois causé et qui nous ont préoccuppé; ce n'est pas un retour au romantique ou à des idées religieuses, non.[50]

Van Gogh decided to bide his time, hoping that his colleagues would recognize his message. When Théo told him at the beginning of October that Bernard had returned to Paris from Brittany and had studied his latest works, he could wait no longer. He wrote to Bernard, with whom he had not corresponded for a year, and his desire to learn Bernard's opinion can be clearly discerned.[52] When Bernard finally took the trouble to reply he does not seem to have said a word about either *La Nuit Etoilée* or any other of Vincent's paintings. Instead he sent him some photographs of his own religious-symbolic pictures, including a Gethsemane painting where Judas was painted in the likeness of Gauguin. Vincent had also received a letter from Gauguin at Le Pouldu somewhat earlier. It contained a sketch of the self-portrait *Christ au Jardin des Oliviers* (Fig. 18). A few weeks later Théo wrote that he had seen Bernard's Gethsemane picture—a violet Christ with red hair, and a yellow angel.[53]

All this was too much for Vincent van Gogh. To Théo he merely said that he could not tolerate the Bible interpretations of his friends. It was the wrong way to synthetize, and it was a rape of nature.[54] But in his long reply to Bernard he completely lost control of himself and abandoned the Felix Holt pose of hard-won equanimity that he had always sought to achieve in his letters. He began by criticizing a picture of *The Adoration of the Kings*. He likened the figures to fat "priest-frogs" kneeling as if in an epileptic fit (!), "God knows how or why." The whole picture was unwholesome, he thought, for he loved the true, the possible. Vincent begged his colleague to forget the Parisian fancies à la Baudelaire.

The Gethsemane picture was treated no less harshly. It was terrible—a nightmare. Vincent wanted to scream and howl with all his might to make his friend come to his senses. And then followed his reasons. He had not used all these hard words only because he had wrestled with nature for nearly a generation. One might certainly grapple with abstractions of the kind that Bernard presented, but for his part he had no intentions of dashing out his brains on such things. He had spent the past year working from nature without thinking of impressionism or any other fashionable style.

*But once he allowed himself to be beguiled into stretching out*

*his hands for stars far too large, and after his latest failure it was
enough.* He added harshly that for the moment he was working
"dans les oliviers." [55]

With caustic clarity these lines reveal Vincent van Gogh's suffer-
ing and disappointment when neither Théo nor his artist friends had
understood the subtle, symbolic message, the modern religious alle-
gory of his *La Nuit Etoilée.* He underlined his feelings by saying bit-
terly that now he was working on the Mount of Olives, his own
private, eternal Gethsemane.

The letter to Bernard shows admirably that van Gogh had the
courage to struggle onwards and not give up, something that was
common to the pioneers of modernism. After he had poured out his
wrath he pulled himself together and gave his alternative to Ber-
nard's symbolism. He did this by describing two landscapes that he
had recently painted, and he succeeded in an excellent way in ex-
plaining that it was not merely the *motif* itself, but the organization
of color and form that gave the pictures their specific emotional
values. His aesthetic manifesto—one may well call it so—re-
solved itself into the thesis that the artist's most important task
was to interpret the fundamental emotions: joy, sorrow, anger, and
fear. This could only be achieved by an unceasing study of the rela-
tions between planes, lines, and forms. The artist who submitted to
such a program would aspire to a more profound artistic vision; he
would, in other words, create a new reality.

I am telling you about these two canvases, especially about the
first one, to remind you that one can try to give an impression of an-
guish without aiming straight at the historic Garden of Gethsemane;
that it is not necessary to portray the characters of the Sermon on the
Mount in order to produce a consoling and gentle motif.

Oh! undoubtedly it is wise and proper to be moved by the Bible,
but modern reality has got such a hold on us that, even when we at-
tempt to reconstruct the ancient days in our thoughts abstractly, the
minor events of our lives tear us away from our meditations, and our
own adventures thrust us back into our personal sensations—joy,
boredom, suffering, anger, or a smile. . . . Being able to divide a can-
vas into great planes which intermingle, to find lines, forms which
make contrasts, that is technique, tricks if you like, cuisine, but it is a

sign all the same that you are studying your handicraft more deeply, and that is a good thing.*

It was thus that Vincent van Gogh formulated his solution of the artistic problems that were also the foundation of Seurat's and Gauguin's endeavors. However unlike their personalities were, they succeeded, because they worked in the same ideological sphere, in giving three alternative solutions to the aesthetic problems of symbolism—three alternatives that had enough in common to lay the foundations of modern art.

*Je te parle de ces deux toiles, surtout alors de la première, pour te rappeler que pour donner une impression d'angoisse, on peut chercher à le faire sans viser droit au jardin de Gethsemane historique; que pour donner un motif consolant et doux il n'est pas nécessaire de représenter les personnages du sermon sur la montagne.

Ah! il est sans doute sage, juste, d'être ému par la Bible; mais la réalité moderne a tellement prise sur nous que même en cherchant abstraitement à reconstruire les jours anciens dans notre pensée, les petits événements de notre vie nous arrachent à ce même moment à ces méditations, et nos aventures propres nous rejettent de force dans les sensations personnelles—joie, ennui, souffrance, colère, ou sourire. . . .

Savoir diviser une toile ainsi en grands plans enchevêtrés, trouver des lignes, des forme faisant contrastes, c'est de la technique, des trucs, si tu veux, de la cuisine, mais enfin c'est signe que tu approfondis ton métier, et cela c'est bien.[56]

DEAR SIR,

Your letter indeed surprised me, not for what it contained, but rather that you had even thought of writing it. Denmark and the Danes caused me so much suffering that I have always been instinctively suspicious of them. Also, at Pont-Aven, I was friendly with the artist because he was you, and not with the Dane whom I mistrusted. It is different now that I have received your letter, and I take great pleasure in admitting that I was wrong, that there is an exception to my decision to hate all the inhabitants of Denmark. Having established this, let's talk like good friends. You are happy about your trip to Holland, and I don't wish to talk to you about all your appreciations of the Dutch masters, but only about Rembrandt and Hals. Of the two, you prefer Hals. We French know him only slightly: it seems to me, however, that the life in his portraits manifests itself too showily through a skillful (perhaps too skillful) treatment of exterior things. I urge you then to look well at père Ingres' portraits in the Louvre. In the French master you will find interior life; that apparent coldness for which he is reproached hides an intense heat, a violent passion. There is, beyond this, in Ingres a grandiose love of the lines of a composition, and a quest for beauty in her veritable essence, Form. And what can one say about Velázquez? Velázquez, the royal tiger. There's a portrait, with all its royalty written on its face —and by what means—the simplest kind of execution, a few strokes of color.

Rembrandt—him I know through and through. Rembrandt, a redoubtable lion who dared everything. *The Night Watch,* reputed to be a masterpiece, is in fact of a lesser class, and I understand that you might misjudge him because of it. All the great masters have weaknesses, and it's exactly these weaknesses that pass as masterworks, furthermore they do them as homage to the crowd to prove that they know. A sacrifice to knowledge! Emotion suddenly vanishes. At such a moment, when your blood is boiling, you chill it into lava and make a rock. Even if it is a

ruby, throw it far away from you, but the public loves rubies. For me there are no masterpieces but the totality of the artist's work. A rough sketch announces the presence of a master. And this master is of the first or second rank. You will see some tiny Rembrandts at the Louvre— like the *Good Samaritan,* the *Tobit!* Acquaint yourself with Rembrandt's etchings, like the *Saint Jerome*—deliberately unfinished, I am sure—a dream landscape, a lion, a real lion, not stuffed with straw, one that roars and rules. In a white corner an indication of Saint Jerome reading. Rembrandt touched everything with a powerful and personal mark, with a mysticism which attained the summit of human imagination. And I admire his great brain. It seems to me that the inferior artist always falls into the excesses of the so-called silence of execution of a work. That which is noble is simple, and the most accomplished brushwork can only do harm to a work of the imagination by recalling its materials. It is only the great artist who happily applies the most abstract precepts, and does so in the simplest way. Listen to the music of Handel! You're right to say that we are a bit related. In time we will gain the strength to accomplish our work, if we learn to recognize one another and to cluster ourselves like disciples of a new religion, and if we fortify each other in our faith by mutual affection. As for me, my mind is made up. I am going soon to Tahiti, a small island in Oceania, where the material necessities of life can be had without money. I want to forget all the misfortunes of the past, I want to be free to paint without any glory whatsoever in the eyes of the others and I want to die there and to be forgotten here. And if my children are able and wish to come and join me, I would feel completely isolated. A terrible epoch is brewing in Europe for the coming generation: the kingdom of gold. Everything is putrefied, even men, even the arts. There, at least, under an eternally summer sky, on a marvellously fertile soil, the Tahitian has only to lift his hands to gather his food; and in addition he never works. When in Europe men and women survive only after unceasing labor during which they struggle in convulsions of cold and hunger, a prey to misery, the Tahitians, on the contrary, happy inhabitants of the unknown paradise of Oceania, know only sweetness of life. To live, for them, is to sing and to love—(a lecture on Tahiti, Van der Veere)—. Once my material life is well organized, I can there devote myself to great works of art, freed from all artistic jealousies and with no need whatsoever of lowly trade.

In art one is concerned with the condition of the spirit for three quarters of the time; one must therefore care for oneself if he wishes to

make something great and lasting. Before leaving, I must spend some time in Paris and I shall have the pleasure of coming to clasp your hand.

*Cordially,*

PAUL GAUGUIN

CHER MONSIEUR,

*Votre lettre m'a bien surpris, non pas en ce qu'elle renferme, mais par cela même que vous avez pensé à l'écrire. J'ai eu tellement à souffrir du Danemark et des Danois, que j'ai toujours conservé à leur égard une méfiance instinctive. Aussi, à Pont-Aven, j'ai été aimable avec l'artiste parce que vous l'êtes, et non avec le Danois dont je me méfiais. Il en est autrement au reçu de votre lettre, et j'ai grand plaisir à avouer que je me suis trompé, à revenir par exception sur ma décision de haïr les habitants du Danemark. Ceci établi, causons en bons amis. Vous êtes heureux de votre voyage en Hollande, et sur toutes vos appréciations des maîtres hollandais, je ne veux vous parler, si ce n'est sur Rembrandt et Hals. Sur les deux votre préférence est pour Hals. Nous autres Français, nous le connaissons peu: il me semble pourtant que la vie dans ses portraits se manifeste avec trop d'éclat par les choses extérieures traitées habilement (trop habilement peut-être). Je vous conseille alors de bien voir au Louvre les portraits du père Ingres. Chez ce maître français, vous trouverez la vie intérieure; cette froideur apparente, qu'on lui reproche, cache une chaleur intense, une passion violente. Il y a, en outre, chez Ingres, un amour des lignes d'ensemble qui est grandiose, et une recherche de la beauté dans sa véritable essence, la Forme. Et que dirait-on alors de Velázquez? Velázquez, le tigre royal. Voilà du portrait, avec toute la royauté inscrite sur la face—et par quelques moyens—une exécution des plus simples, quelques taches de couleur.*

*Rembrandt, celui-là, je le connais à fond. Rembrandt, un lion redoutable qui a tout osé. La Ronde de nuit, réputée chef-d'œuvre, est en effet d'un ordre inférieur, et je comprends que vous le jugiez mal d'après cela. Tout les maîtres ont des faiblesses et justement ces faiblesses passent pour des chefs-d'œuvre, il les font du rest comme hommage à la foule pour prouver qu'ils savent. Sacrifice à la science! L'émotion disparaît du*

*coup. En pareille occasion d'un sang bouillonnant vous en refroidissez la lave et vous en faites une pierre. Fût-elle un rubis, rejetez-le loin de vous, mais la foule aime les rubis. Pour moi il n'y a pas de chefs-d'œuvre, si ce n'est l'œuvre totale. Une ébauche annonce un maître. Et ce maître est de premier ou deuxième ordre. Vous verrez au Louvre des Rembrandt tous petits. Tel* le Bon Samaritain, Le Tobis! *Connaissez vous des eaux- fortes de Rembrandt, telle* le Saint-Jérôme *inachevé bien exprès, je le crois, un paysage comme on les rêve, un lion, un vrai lion pas empaillé qui rugit et domine. Dans un coin blanc une indication de* Saint-Jérôme lisant. *A toute chose Rembrandt a touché avec une griffe puissante et personnelle, il y a mis un mysticisme qui atteint les plus hauts faits de l'imagination humaine. Et j'admire chez lui ce grand cerveau. J'estime que l'artiste inférieur tombe toujours dans les excès de la prétendue si- lence de la facture. Le noble est simple, et toutes les plus grandes sou- plesses du pinceau ne peuvent que nuire à une œuvre imaginative en rap- pelant la matière. N'est vraiment grand artiste que celui qui applique heureusement ses préceptes les plus abstraits, et cela le plus simplement. Ecoutez la musique de Haendel! Vous avez raison de dire que nous sommes un peu parents. Nous acquerrons la force d'accomplir notre œuvre avec le temps, si nous apprenons à nous reconnaître et à nous grouper comme disciples d'une religion nouvelle, et si nous nous forti- fions en notre foi par une mutuelle affection. Quant à moi, ma résolution est prise, je vais aller dans quelque temps à Tahiti, une petite île de l'Océanie où la vie matérielle peut se passer d'Argent. J'y veux oublier tout le mauvais du passé et mourir là-bas ignoré d'ici, libre de peindre, sans gloire aucune pour les autres. Et si mes enfants peuvent et veulent venir me rejoindre, je me déclare tout à fait isolé. Une terrible époque se prepare en Europe pour la génération qui vient: le royaume de l'or. Tout est pourri, et les hommes, et les arts. Là-bas au-moins, sous un ciel sans hiver, sur une terre d'une fécondité merveilleuse, le Tahitien n'a qu'à lever ses bras pour cueillir sa nourriture; aussi ne travaille-t-il jamais. Pendant que en Europe les hommes et les femmes ne l'obtiennent, qu'après un labeur sans répit pendant qu'ils se débattent dans les convul- sions du froid et de la faim, en proie à la misère, les Tahitiens au con- traire, heureux habitants des paradîs ignorés de l'Océanie, ne connaissent de la vie que les douceurs. Pour eux vivre, c'est chanter et aimer—* (Conférence sur Tahiti, Van der Veere)*—Aussi ma vie matérielle une fois bien organisée, je puis là-bas, me livrer aux grands travaux de l'Art, dégagé de toutes jalousies artistiques, sans aucune nécessité de vils trafics.*

*Dans l'art, l'état d'âme où l'on est entré pour les trois quarts: il faut donc se soigner si on veut faire quelque chose de grand et de durable. Avant de partir, je suis obligé de séjourner quelques temps à Paris et j'aurai le plaisir d'aller vous serrer la main.*

*Cordialement*

PAUL GAUGUIN

*Letter to J. F. Willumsen, Pont-Aven, autumn 1890,* Les Marges, 15 March 1918 [*Tr. McGarrell; Chipp, p.* 79]

Only books and articles mentioned in this work are included in the following list. For a comprehensive bibliography see J. Rewald, *Post-Impressionism. From van Gogh to Gauguin,* 2nd ed. (New York, 1962).

Adam, P. "Peintres impressionnistes." *La Revue contemporaine littéraire, politique et philosophique,*" IV. Paris, 1886.

Adam, A. *Verlaine, l'homme et l'œuvre.* Paris, 1953.

Ajalbert, J. *Mémoires en vrac.* Paris, 1938.

Allen, G. W. *The Solitary Singer.* New York, 1955.

Andry-Bourgeois, Ch. "Le rayonnement universel," *Cahiers de l'Etoile.* Paris, 1930.

Anonymous (O. Maus?). "Les vingtistes parisiens," *L'Art Moderne* (Brussels), 1886.

Antoine, J. "Impressionnistes et synthétistes," *Art et Critique* (Paris), 1889.

Aurier, G.-A. "Camille Pissarro," *La Revue Indépendante* (Paris), 1890.

——— "Concurrence," *Le Moderniste* (Paris), 1889.

——— *Œuvres posthumes.* Paris, 1893.

——— "Le symbolisme en peinture. Paul Gauguin," *Mercure de France* (Paris), 1891.

Baldick, R. *Life of J.-K. Huysmans.* Oxford, 1955.

Barre, A. *Le symbolisme.* Paris, 1911.

Beauclaire, H., and Vicaire, G. *Les déliquescences. Poèmes décadents d'Adoré Floupette, avec sa vie par Marius Tapora. Byzance chez Lion Vanné, 1885.* Paris, 1885.

Benéteau, A. *Etude sur l'inspiration et l'influence de Paul Verlaine.* Washington, D.C., 1930.

Bernard, E. "Lettre ouverte à M. Camille Mauclaire," *Mercure de France* (Paris), 1895.

——— *Lettres à Emile Bernard.* Brussels, 1942.

———— "Louis Anquetin. Artiste peintre," *Mercure de France* (Paris), 1932.

———— "Notes sur l'école dite de 'Pont-Aven'," *Mercure de France* (Paris), 1903.

———— *Souvenirs inédits sur l'artiste peintre Paul Gauguin et ses compagnons lors de leur séjour à Pont-Aven et au Pouldu.* Lorient, n.d. [1939].

———— *Souvenirs sur Paul Cézanne.* Paris, 1912.

Le Blond-Zola, D. *Emile Zola raconté par sa fille.* Paris, 1931.

Bodelsen, M. "An Unpublished Letter by Théo van Gogh," *The Burlington Magazine* (London), 1957.

———— *Gauguin's Ceramics.* London, 1964.

———— *Gauguin og Impressionisterne.* Copenhagen, 1968.

———— *Willumsen i halvfemsernes Paris.* Copenhagen, 1957.

Bohn, G. "Quelques souvenirs sur Charles Henry," *Cahiers de l'Etoile.* Paris, 1930.

Borel, P. *Le vrai Maupassant.* Geneva, 1951.

Bourdeau, J. *Schopenhauer, Pensées, maximes et fragments.* Paris, 1880.

Bowie, Th.R. "The Painter in French Fiction," *University of North Carolina Studies in the Romance Languages and Literatures,* 1950.

Brady, P. *"L'Œuvre" d'Emile Zola.* Geneva, 1967.

Buser, T. "Gauguin's Religion," *Art Journal,* XXVIII (1968).

*Catalogue cinquantenaire du symbolisme.* Bibliothèque Nationale, Paris, 1936.

*Catalogue Eugène Carrière et le symbolisme.* Orangerie des Tuileries, Paris, Dec. 1949–Jan. 1950.

*Catalogue de l'exposition du centenaire Gauguin.* Orangerie des Tuileries, Paris, 1949.

Cézanne, P. *Correspondance,* ed. J. Rewald. Paris, 1937.

Chassé, Ch. "De quand date le synthétisme de Paul Gauguin," *L'Amour de l'Art* (Paris), 1938.

———— *Gauguin et le groupe de Pont-Aven.* Paris, 1921.

———— *Gauguin et son temps.* Paris, 1955.

———— *Le mouvement symboliste dans l'art du XIX^e siècle.* Paris, 1947.

———— *Les clés de Mallarmé.* Paris, 1954.

———— *Le mouvement symboliste dans l'art du XIX^e siècle.* Paris, 1947.

Chastel, A. "Une source oubliée de Seurat," *Études et Documents sur l'Art français* (Paris), 1959.

Chipp, H. B. "Orphism and Color Theory," *The Art Bulletin* (New York), XL (1958).

Christophe, J. "Symbolisme," *La Cravache* (Paris), 16 June 1888.

Clouard, H. *Histoire de la littérature française du symbolisme à nos jours de 1885–1914.* Paris, 1947.

Cooper, D. *Georges Seurat's "Une Baignade, Asnières."* London [1946].

Coquoit, G. *Les Indépendants 1884–1920.* Paris, 1920.

———— *Seurat.* Paris, 1924.

Cornell, K. *The Symbolist Movement.* New Haven, Conn., 1951.

Coulon, M. "Une minute de l'heure symboliste, Albert Aurier," *Mercure de France* (Paris), 1921.

Deffoux, L., and Royère, J. *Dix-neuf lettres de Stéphane Mallarmé à Emile Zola.* Paris, 1929.

Delfel, G. *L'esthétique de Stéphane Mallarmé.* Paris, 1951.

Denis, M. "Définition du néo-traditionnisme," *Art et Critique* (Paris), 1890.

———— "L'époque du Symbolisme," *Gazette des Beaux-Arts* (Paris), 1934.

———— *Théories 1890–1910.* Paris, 1920.

Dinar, A. *La Croisade Symboliste.* Paris, 1943.

Dorival, B. *Les étapes de la peinture française contemporaine.* Paris, 1943.

———— "Sources of the Art of Gauguin from Java, Egypt and Ancient Greece," *The Burlington Magazine* (London), 1951.

Dorra, H. "Emile Bernard and Paul Gauguin," *Gazette des Beaux-Arts* (Paris), 1955.

Dujardin, E. "Aux XX et aux Indépendants: Le Cloisonisme," *La Revue Indépendante* (Paris), 1888.

Durry, M. J. *Jules Laforgue.* Paris, 1952.

Eliot, G. *Felix Holt,* Library Edition. Edinburgh and London, 1901.

Fénéon, F. "Autre groupe impressionniste," *La Cravache* (Paris), 1889.

———— "Aux vitrines des marchands de tableaux," *La Revue Indépendante* (Paris), 1888.

———— "Feu Cros," *La Cravache* (Paris), 1888.

———— *Œuvres.* Paris, 1948.

———— "Une esthétique scientifique," *La Cravache* (Paris), 1889.

Fontainas, A. *Mes souvenirs du symbolisme.* Paris, 1928.

Fosca, F. *Edmond et Jules de Goncourt.* Paris, 1941.

Fowlie, W. *Mallarmé.* Chicago, 1953.

Franzén, N.-O. *Zola et La Joie de Vivre.* Stockholm, 1958.

Gastaut, H. "La maladie de Vincent van Gogh, envisagée à la lumière des conceptions nouvelles sur l'épilepsie psychomotrice," *Annales médico-psychologiques* (Paris), 1956.

Gauguin, P. *Avant et après.* Copenhagen, n.d. [1951].

———"Notes sur l'art à l'Exposition Universelle," *Le Moderniste* (Paris), 1889.

———"Qui trompe-t-on ici?" *Le Moderniste* (Paris), 1889.

Geffroy, G. *Claude Monet, sa vie, son œuvre.* Paris, 1924.

Gengoux, J. *Le symbolisme de Stéphane Mallarmé.* Paris, 1950.

Gilbert, K. E., and Kuhn, H. *A History of Aesthetics.* Bloomington: Indiana University Press, 1953.

Gogh-Bonger, J. van. *Verzamelde brieven van Vincent van Gogh.* Amsterdam and Antwerp, 1952–54.

Goldwater, R. J. "Some Aspects of the Development of Seurat's Style," *The Art Bulletin* (New York), 1941.

Gourmont, R. de. *Le chemin de velours. Nouvelles dissociations d'idées.* Paris, 1901.

——— *Le livre des masques.* Paris, 1900.

Graber, H. *Edgar Degas nach eigenen und fremden Zeugnissen.* Basel, 1942.

Guérin, M. *Lettres de Degas.* Paris, 1931.

Haftmann, W. *Malerei im 20. Jahrhundert.* Munich, 1954.

Hanson, L. and E. *Marian Evans & George Eliot.* London, New York, Toronto, 1952.

Hartrick, A. S. *A Painter's Pilgrimage Through Fifty Years.* Cambridge, 1939.

Hauser, A. *The Social History of Art.* London, 1951.

Hautecœur, L. *Littérature et peinture en France du XVII$^e$ au XX$^e$ siècle.* Paris, 1942.

Hemmings, F. W. J. *Emile Zola.* Oxford, 1953.

Hennequin, E. *La critique scientifique.* Paris, 1888.

——— "Les impressionnistes," *La Vie Moderne* (Paris), 1886.

Herbert, R. L. "Seurat in Chicago and New York," *The Burlington Magazine* (London), 1958.

——— "Seurat and Puvis de Chavannes," *Yale University Art Gallery Bulletin,* Oct. 1959.

Homer, W. I. *Seurat and the Science of Painting.* Cambridge, Mass., 1964.

Hope, H. R. *The Sources of Art Nouveau.* Cambridge: Harvard University Press, 1942.

Humbert, A. *Les Nabis et leur époque 1888–1900.* Geneva, 1954.

Huret, J. "Enquête sur l'évolution littéraire," *Le Figaro* (Paris), 1891.

Huyge, R. *Cézanne.* Paris, 1936.

Huysmans, J.-K. *Certains.* Paris, 1887.

——— *Croquis parisiens.* Paris, 1905.

——— "L'art moderne," *Œuvres complètes,* no. 6. Paris, 1929.

——— *Lettres inédites à Emile Zola,* ed. P. Lambert. Geneva, 1953.

——— *A Rebours avec une préface de l'auteur écrite vingt ans après le roman.* Paris, 1922.

Jansson, H. W. *Apes and Ape Lore in the Middle Ages and the Renaissance.* London, 1952.

Jaulme, A., and Moncel, H. "Le mouvement symboliste," *Catalogue d'une exposition à la Bibliothèque Nationale.* Paris, 1936.

Kahn, G. "Au temps du pointillisme," *Mercure de France* (Paris), 1924.

——— "De l'esthétique du verre polychrome," *La Vogue* (Paris), 1886.

——— *Introduction to Les Dessins de Georges Seurat.* Paris, 1928.

——— "Quelques souvenirs de jeunesse," *Cahiers de l'Etoile.* Paris, 1930.

——— "Paul Gauguin," *L'Art et les Artistes.* Paris, 1925.

——— "Réponse des symbolistes," *L'Evénement* (Paris), 1886.

——— "Seurat," *L'Art Moderne* (Brussels), 1891.

——— *Silhouettes littéraires.* Paris, 1925.

Kraus, G. *The Relationship between Théo & Vincent van Gogh.* Amsterdam, 1954.

——— "Vincent van Gogh en de psychiatrie," *Psychiatrische en Neurologische Bladen* (Amsterdam), 1941.

Laprade, J. de. *Georges Seurat.* Monaco, 1945.

Lecomte, H. *Camille Pissarro.* Paris, 1922.

Lehman, A. G. *The Symbolist Aesthetic in France 1885–1895.* Oxford, 1950.

Malingue, M. *Gauguin. Le peintre et son œuvre.* Paris, 1948.

——— *Lettres de Gauguin à sa femme et ses amis.* Paris, 1946.

Mallarmé, S. *Œuvres complètes,* ed. H. Mondor and G. Jean-Aubry. Paris, 1954.

——— *Correspondance 1861–1871,* ed. H. Mondor. Paris, 1959.

Marks-Vandenbroucke, U. F. "Gauguin—ses origines et sa formation artistique," *Gazette des Beaux-Arts* (Paris), 1956 (1958).

Marois, P. *Le secret de van Gogh.* Paris, 1957.

Martino, P. *Parnasse et symbolisme.* Paris, 1930.

——— *Verlaine.* Paris, 1924.

Maupassant, G. de. *Pierre et Jean*. Paris, 1888.

Mauron, Ch. *Mallarmé l'obscur*. Paris, 1941.

Maus, O. "Le Salon des XX à Bruxelles," *La Cravache* (Paris), 1889.

Maus, M. O. *Trente années de lutte pour l'art 1884–1914*. Brussels, 1926.

Mellerio, A. *Le mouvement idéaliste en peinture*. Paris, 1896.

Meyerson, Å. "Van Gogh and the School of Pont-Aven," *Konsthistorisk Tidskrift* (Stockholm), 1946.

Michaud, G. *Mallarmé, l'homme et l'œuvre*. Paris, 1953.

Mikhaël, E. *Œuvres*. Paris, n.d.

Mirabaud, R. *Charles Henry et l'idéalisme scientifique*. Paris, 1926.

Mirbeau, O. "Chronique-Paul Gauguin," *L'Echo de Paris,* 1891.

Mondor, H. *Mallarmé plus intime*. Paris, 1944.

———— *Propos sur la poésie de Stéphane Mallarmé*. Monaco, 1945.

———— *Vie de Mallarmé*. Paris, 1941.

Moréas, J. "Le symbolisme," *Figaro Littéraire* (Paris), 1886.

———— *Les premières armes du symbolisme*. Paris, 1889.

Morice, Ch. *Paul Gauguin*. Paris, 1919.

Nicolson, B. "Seurat's 'La Baignade'," *The Burlington Magazine* (London), 1946.

Niess, R. J. "Another View of Zola's L'Œuvre," *Romantic Review* (New York), 1948.

———— *Zola, Cézanne and Manet, A Study of L'Œuvre*. Ann Arbor: University of Michigan Press, 1968.

Nordenfalk, C. "Van Gogh and Literature," *The Journal of the Warburg and Courtauld Institutes* (London), 1948.

Noulet, E. *L'œuvre poétique de Stéphane Mallarmé*. Paris, 1940.

*Nouvelle Rive Gauche* (Paris), 9–16 Feb. 1883.

Paulsson, G. *Konstverkets byggnad*. Stockholm, 1942.

Perruchot, H. *La vie de Cézanne*. Paris, 1956.

Petersen, C. V. "Omkring Zola's 'Mesterværket'," *Afhandlinger og Artikler om Kunst*. Copenhagen, 1939.

Pissarro, C. *Lettres à son fils Lucien*. Paris, 1950.

Pissarro, L.-R. and Venturi, L. *Camille Pissarro*. Paris, 1939.

Quillard, P. "Théâtre d'art. Représentation au bénéfice de Paul Verlaine et de Paul Gauguin," *Mercure de France* (Paris), 1891.

Raymond, M. *From Baudelaire to Surrealism*. New York, 1950.

Reneville, A. R. de. "L'élaboration d' 'A Rebours'," *Comœdia* (Paris), 1943.

Reuterswärd, O. Impressionisterna inför publik och kritik. Stockholm, 1952.

Rewald, J. *Cézanne et Zola*. Paris, 1936.

———— *Cézanne, sa vie—son œuvre, son amitié pour Zola*. Paris, 1939.

———— "Extraits du journal inédit de Paul Signac, I, 1894–1895," *Gazette des Beaux-Arts* (Paris), 1949.

———— *Gauguin. Drawings*. New York, London, 1958.

———— *Georges Seurat*. Paris, 1948.

———— *The History of Impressionism*. New York, 1946; 2nd ed., 1961.

———— *Post-Impressionism. From Van Gogh to Gauguin*. New York, 1956; 2nd ed., 1962.

Rey, R. *La renaissance du sentiment classique dans la peinture française à la fin du XIX$^e$ siècle—Degas, Renoir, Gauguin, Cézanne, Seurat*. Paris, 1931.

Rich, D. C. *Edgar-Hilaire-Germain Degas*. New York, 1951.

———— *Seurat and the Evolution of "La Grande Jatte."* Chicago, 1935.

Richard, N. *A l'aube du symbolisme*. . . . Paris, 1961.

Richer, J. *Paul Verlaine*. Paris, 1953.

Robert, G. *Emile Zola, principes et caractères généraux de son œuvre*. Paris, 1952.

Rookmaaker, H. *Synthetist Art Theories*. Amsterdam, 1959.

Roskill, M. *Van Gogh, Gauguin and the Impressionist Circle*. New York: New York Graphic Society, 1970.

Rostrup, H. "Gauguin et le Danemark," *Gazette des Beaux-Arts* (Paris), 1956 (1958).

Rotonchamp, J. de. *Paul Gauguin 1848–1903*. Paris, 1925.

Sandblad, N. G. "Manet," *Three Studies in Artistic Conception*. Lund, 1954.

Sandström, S. "Darwinistisk symbolism," *Symbolister*. Malmö, 1957.

———— *Le monde imaginaire d'Odilon Redon*. Lund, 1955.

Schapiro, M. "Seurat and 'La Grande Jatte'," *Columbia Review* (New York), XVII (1935).

———— *Vincent van Gogh*. New York, 1950.

Schmidt, A.-M. *La littérature symboliste*. Paris, 1955.

Schyberg, F. *Walt Whitman*. New York, 1951.

Sérusier, P. *ABC de la peinture*. Paris, 1942.

Seurat, G. *Les dessins 1859—1891*, I–II. Paris, 1928.

Seznec, J. "Literary Inspiration in Van Gogh," *Magazine of Art,* 1950.

Signac, P. *D'Eugène Delacroix au néo-impressionnisme.* Paris, 1899.

———— "Le néo-impressionnisme, documents," *Gazette des Beaux-Arts* (Paris), XI (1934).

———— "Une trouvaille," *Le Chat Noir* (Paris), 11 Feb. 1882.

Simond, C. *Paris de 1800 à 1900—La vie parisienne au XIX^e siècle,* vol. III, 1870–1900. Paris, 1901.

Soula, C. *Essai sur l'hermétisme mallarméen.* Paris, 1919.

Speaight, R. *George Eliot.* London, 1954.

Sutton, D. "Notes on Paul Gauguin apropos a Recent Exhibition," *The Burlington Magazine* (London), 1956.

Thibaudet, A. *La poésie de Stéphane Mallarmé.* Paris, 1943.

Thirion, Y. "L'influence de l'estampe japonaise dans l'œuvre de Gauguin," *Gazette des Beaux-Arts* (Paris), 1956 (1958).

Venturi, L. *Les archives de l'impressionnisme.* Paris and New York, 1939.

Verhaeren, E. "Le Salons des Vingts à Bruxelles," "Les néo-impressionnistes," *La Vie Moderne* (Paris), 1887.

———— "L'exposition des XX à Bruxelles 1888," *La Revue Indépendante* (Paris), 1888.

Verlaine, P. *Les poètes maudits.* Paris, 1884.

———— *Sagesse.* Paris, 1881.

Vollard, A. *Paul Cézanne.* Paris, 1914.

Wais, K. *Mallarmé. Dichtung. Weisheit. Haltung.* Munich, 1952.

Whitman, W. *Œuvres choisies.* Paris, 1918.

———— "Prayer of Columbus" (*Leaves of Grass*), *The Complete Poetry and Prose of Walt Whitman.* New York, 1948.

Wyzewa, Th. "L'art contemporain," *La Revue Indépendante* (Paris), 1886.

Zervos, C. " 'Un Dimanche à la Grande Jatte' et la technique de Seurat," *Cahiers d'Art.* Paris, 1928.

Zola, E. *Œuvres complètes, I–L.* Paris, 1927–29.

*The following abbreviations given in square brackets indicate the sources of the English translations used in the text:*

Abel *Camille Pissarro, Letters to His Son Lucien,* John Rewald, ed., with the assistance of Lucien Pissarro. Translated from the French manuscript by Lionel Abel (New York: Pantheon Books, 1943).

Baldick J.-K. Huysmans, *Against Nature.* A New Translation of *A Rebours* by Robert Baldick (Baltimore: Penguin Books, 1968).

Chipp Herschel B. Chipp, ed., *Theories of Modern Art. A Source Book of Artistic Concepts by Artists and Critics* (Berkeley: University of California Press, 1969), contributions by Peter Selz and Joshua C. Taylor.

*Complete Letters* *The Complete Letters of Vincent van Gogh,* vol. 3 (Greenwich, Conn.: New York Graphic Society, 1958).

Cook Stéphane Mallarmé, *Selected Prose Poems, Essays and Letters,* translated by Bradford Cook (Baltimore: The Johns Hopkins Press, 1956).

*Further Letters* *Further Letters of Vincent van Gogh to His Brother, 1886–1889* (London: Constable, 1929).

Kay Marcel Guerin, ed., *Degas Letters,* translated by Marguerite Kay (New York: Studio Publications, n.d.).

Lord Douglas Lord, ed., *Vincent van Gogh. Letters to Emile Bernard* (New York: Museum of Modern Art, 1938).

MacIntyre Stéphane Mallarmé, *Selected Poems,* translated by C. F. MacIntyre (Berkeley: University of California Press, 1957).

| McGarrell | Translated by Ann McGarrell for this edition. |
| Nochlin | Linda Nochlin, *Impressionism and Post-Impressionism 1874–1904. Sources and Documents* (Englewood Cliffs, N.J.: Prentice-Hall, 1966). |
| Walton | Emile Zola, *The Masterpiece,* translated by Thomas Walton (London: Paul Elek, 1950). |

### Preface

1. The concept was probably first launched by the Goncourt brothers.

### 1. *In Search of a Style*

1. According to a lecture by Octave Maus at Lausanne in 1918. M. O. Maus, *Trente années de lutte pour l'art 1884–1914* (Brussels, 1826), p. 16.

2. On 29 Dec. 1883 Felicien Rops, who had been invited to participate in a *Les XX* exhibition, wrote to Maus: "What pleases me extraordinarily in the XX is their absence of program. A program is already a rule. A rule means method. Method and doctrine are sisters. You see where it leads!" [Tr. McGarrell]. ("Ce qui me plaît extraordinairement dans les XX, c'est leur absence de programme. Un programme est déjà une règle. La règle est méthodiste. La méthode et la doctrine sont sœurs: voyez ou l'on va!") Maus, p. 24.

3. Ibid., p. 15.

4. Paul Signac, "Le Néo-Impressionnisme, documents," *Gazette des Beaux-Arts,* tom XI (1934), pp. 49 ff. [Tr. McGarrell]. Cf. also Paul Signac, *D'Eugène Delacroix au Néo-Impressionnisme* (Paris, 1899), Ch. IV.

The source material for the earliest manifestations of the independents is remarkably meagre. Cf. Gustave Kahn, "Au temps du pointillisme," *Mercure de France,* 171 (1924), pp. 5 ff.; Gustave Coquiot, *Les Indépendants 1884–1920* (Paris, 1920), p. 9.

5. Quoted after J. Rewald, *Georges Seurat* (Paris, 1948), p. 46 [Tr. McGarrell].

6. G. Kahn, p. 10.

7. P. Signac, "Une Trouvaille," *Le Chat Noir*, 11 Feb. 1882, p. 4.

8. R. L. Herbert, "Seurat in Chicago and New York," *The Burlington Magazine*, May 1958, pp. 146 ff., gives an excellent summary of the development of Seurat's style. Cf. also J. Rewald, *Georges Seurat*, Ch. I.

9. Renoir's famous *Le Déjeuner des Canotiers,* painted at Bougival in 1881 provides excellent comparative material (Fig. 2). The artist's friends and models have gathered for a jolly lunch at the restaurant "Fournaise." The scene is a crowded veranda that sticks into the room like a wedge. The figures are grouped so that they are in contact with one another. The picture is captured in one glance, and the eyes find rest in the background view of the river. The whole painting exhales light and air. In its clear-cut composition and spontaneous execution, it gives a strong feeling of harmony.

10. It is not intended to give a comprehensive analysis of this work here, but only to indicate its position in the aesthetic field dealt with. For studies on the painting see D. Cooper, *Georges Seurat's "Une Baignade, Asnières"* (London, undated [1946]); B. Nicolson, "Seurat's 'La Baignade'," *The Burlington Magazine,* Nov. 1946.

11. For a summary of the tactical situation in the impressionist camp during the years 1882–84 see J. Rewald, *The History of Impressionism* (New York, 1946), pp. 355–87; O. Reutersvärd, *Impressionisterna inför publik och kritik* (Stockholm, 1952), pp. 135–68.

12. Published in H. Graber, *Edgar Degas nach eigenen und fremden Zeugnissen* (Basel, 1942), pp. 80–87.

13. M. Guérin, *Lettres de Degas* (Paris, 1931), pp. 64 f. [Tr. Kay, p. 81].

14. Ibid., p. 64 [Tr. Kay, pp. 80–81].

15. L. Venturi, *Les Archives de l'impressionnisme* (Paris and New York, 1939), I, p. 227 [Tr. McGarrell].

16. Ibid., I, p. 121 [Tr. McGarrell].

17. The Russian philosopher, socialist, and anarchist Petr Lavrovich Lavrov (1823–1900), who had come to Paris from Switzerland, where he had been living as a refugee during the seventies. *Les Archives,* I, p. 122 [Tr. McGarrell].

18. Letter from Renoir, May 1884, *Les Archives,* I, p. 127; letter from Monet, 15 May 1884, *Les Archives,* I, p. 278. Cf. also letter from Pissarro to Monet, 12 June 1883; and G. Geffroy, *Claude Monet, sa vie, son œuvre* (Paris, 1924), II, pp. 10 f.

19. *Les Archives,* I, pp. 127–29.

20. *Les Archives,* I, pp. 265 ff.

21. Camille Pissarro, *Lettres à son fils Lucien* (Paris, 1950), p. 68 [Tr. Abel, p. 47].

22. Ibid., p. 71 [Tr. Abel, p. 49].

23. Cf. A. Adam, *Verlaine* (Paris, 1953), p. 120.

24. Cf. P. Martino, *Verlaine* (Paris, 1924), pp. 50 ff. See also André Benéteau, *Etude sur l'inspiration et l'influence de Paul Verlaine* (Washington, 1930), Ch. II.

25. Quoted from J.-K. Huysmans, *Lettres inédites à Emile Zola* (ed. Pierre Lambert) (Geneva, 1953), p. 97, n. 3 [Tr. McGarrell].

26. J.-K. Huysmans, *A Rebours avec une préface de l'auteur écrite vingt ans après le roman* (Paris, 1922), p. 103 [Tr. McGarrell].

27. Ibid., pp. 107 ff. [Tr. McGarrell].

28. Schopenhauer's train of thought is given after K. E. Gilbert and H. Kuhn, *A History of Aesthetics* (Bloomington: Indiana University Press, 1953), pp. 464 ff.

29. R. Baldick, *Life of J.-K. Huysmans* (Oxford, 1955), pp. 80 f. Cf. also G. Kahn, *Silhouettes littéraires* (Paris, 1925), pp. 7 ff.

30. According to a letter from J.-K. Huysmans to S. Mallarmé, 27 Oct. 1882. See A. Rolland de Reneville, "L'élaboration d' 'A Rebours'," *Comœdia,* Sept. 1943, p. 1.

31. Quoted after H. Mondor, *Vie de Mallarmé* (Paris, 1941), p. 453 [Tr. McGarrell].

32. *A Rebours,* p. 81.

33. F. W. J. Hemmings, *Emile Zola* (Oxford, 1953), p. 171. Cf. also N.-O. Franzén, *Zola et La Joie de Vivre* (Stockholm, 1958).

34. Emile Zola, *Œuvres complètes* (Paris, 1928–29), I-L, tom. 13, p. 368 [Tr. McGarrell].

35. Ibid., p. 369 [Tr. McGarrell].

36. J.-K. Huysmans, *Lettres inédites,* p. 99.

37. Ibid., p. 100.

38. For an excellent study of the aesthetic doctrines of the symbolist periodicals see A. G. Lehmann, *The Symbolist Aesthetic in France 1885–1895* (Oxford, 1950); A. Barre, *Le symbolisme* (Paris, 1911); and K. Cornell, *The Symbolist Movement* (New Haven: Yale University Press, 1951).

39. The account of the milieu summarized here is taken chiefly from J. Christopher, "Symbolisme," *La Cravache,* 16 June 1888; A. Barre, section II; A. Fontainas, *Mes souvenirs du symbolisme* (Paris, 1928), Ch.

I–II; A. Jaulme and H. Moncel, "Le mouvement symboliste," *Catalogue d'une exposition à la Bibliothèque Nationale* (Paris, 1936); J. Ajalbert, *Mémoires en vrac* (Paris, 1938). W. Fowlie, in *Mallarmé* (Chicago, 1953), pp. 256–64, gives a good summary.

40. *Les Déliquescences* is reviewed rather exhaustively in A. Barre, pp. 143–56. Cf. also Noël Richard, *A l'aube du symbolisme, Hydropates, Fumistes et Décadents* (Paris, 1961).

41. *Les Déliquescences,* pp. xxi–xxii [Tr. McGarrell].

42. Tr. McGarrell.

43. *Les Déliquescences,* pp. xliii–xliv [Tr. McGarrell].

44. Tr. McGarrell.

45. Tr. McGarrell.

46. A. Barre, p. 105.

47. *A Rebours,* p. 81.

48. K. E. Gilbert and H. Kuhn, pp. 494 ff.

49. *La Nouvelle Rive Gauche,* 9–16 Feb. 1883. Quoted after P. Martino, p. 189 [Tr. McGarrell].

50. P. Cézanne, *Correspondance,* ed. J. Rewald (Paris, 1937), pp. 169 f.

51. L. Venturi, II, pp. 277–80 [Tr. McGarrell].

52. Quoted from H. Perruchot, *La vie de Cézanne* (Paris, 1956), p. 262 (italics mine) [Tr. McGarrell].

53. Ms dated 12 May 1885–22 Feb. 1886. E. Zola, *Œuvres complètes,* tom. 15 (*L'Œuvre*), p. 401.

54. Ibid., p. 47 [Tr. McGarrell].

55. Ibid., pp. 235 f. [Tr. Walton, p. 266].

56. Ibid., pp. 375 f. [Tr. Walton, p. 423].

57. Tr. Walton, p. 435.

58. H. Perruchot, p. 262.

59. J. Rewald, *Cézanne, sa vie—son œuvre, son amitié pour Zola* (Paris, 1939), pp. 319 ff. [Tr. John Rewald, *Cézanne* (London: Spring Books, n.d.), p. 132].

60. Cf. D. Le Blond-Zola, *Emile Zola raconté par sa fille* (Paris, 1931), p. 141; R. Huyge, *Cézanne* (Paris, 1936); J. Rewald, *Cézanne et Zola* (Paris, 1936), Ch. XVI–XVII; H. Perruchot, *La vie de Cézanne* (Paris, 1936); and others.

61. P. Cézanne to E. Zola, 4 Apr. 1886 (P. Cézanne, *Correspondance,* p. 208) [Tr. John Rewald, *Paul Cézanne Letters* (New York, 1941), p. 183].

MY DEAR EMILE,

I have just received *L'Œuvre* which you were kind enough to send me. I thank the author of the "Rougun-Macquart" for this kind token of remembrance and ask him to allow me to clasp his hand whilst thinking of bygone days.

Ever yours under the impulse of past times.

PAUL CEZANNE

(MON CHER EMILE,

Je viens de recevoir *L'Œuvre* que tu as bien voulu m'adresser. Je remercie l'auteur des *Rougon-Macquart* de ce bon témoignage de souvenir, et je lui demande de me permettre de lui serrer la main en songeant aux anciennes années.

Tout à toi sous l'impulsion des temps écoulés

PAUL CEZANNE)

62. "Zola was a mediocre intelligence and a detestable friend. He saw nothing but himself. *L'Œuvre,* in which he allegedly depicted me, is nothing but a horrible deformation, a lie entirely for his own glory." [Tr. McGarrell]. ("Zola était une intelligence médiocre, et un ami détestable. Il ne voyait que lui. C'est ainsi que *L'Œuvre* où il a prétendu me peindre, n'est qu'une épouvantable déformation, un mensonge tout à sa gloire.") E. Bernard, *Souvenirs sur Paul Cézanne* (Paris, 1912), pp. 19 f.

63. A. Vollard, *Paul Cézanne* (Paris, 1914), Ch. X. Cf. M. Le Blond's comments in E. Zola, *Œuvres complètes,* tom. 15, pp. 404 ff. and Zola's "Ebauche de *L'Œuvre,*" ibid., pp. 409 ff.

64. Cf., e.g., F. W. J. Hemmings, loc. cit.; R. J. Niess, "Another View of Zola's L'Œuvre," *Romantic Review,* vol. XXXIX (New York, 1948), pp. 282–300.

65. C. Pissarro, pp. 99 f. [Tr. Abel, p. 73].

66. *L'Œuvre,* p. 50 [Tr. Walton, p. 63].

67. "As he used to say at Bennecourt, he had 'got' his open-air, meaning the painting with the harmonious liveliness of colour which so surprised his friends when they came to see him. They all admired it, and were all convinced that with works so personal in their expression, showing as they did, for the first time, nature bathed in real light, with its interplay of reflections and the continuous decomposition of colours,

all he had to do was to show himself to take his place, and a very high place too, in contemporary art." [Tr. Walton, p. 251.] ("Comme il le disait à Bennecourt, il tenait son plein air, cette peinture d'une gaîté de tons chantants, qui étonnait les camarades, quand ils venaient le voir. Tous admiraient, convaincus qu'il n'aurait qu'à se produire pour prendre sa place, très haut, avec des œuvres, d'une notation si personnelle, ou pour la première fois la nature baignait dans la vraie lumière, sous le jeu des reflets et la continuelle décomposition des couleurs.") *L'Œuvre,* p. 223.

68. "Besides, he acknowledged the usefulness of the Salon as the only battlefield on which an artist could assert himself at one blow." "Every picture rejected he pronounced bad, or rather incomplete, since it failed, he said, to convey his intentions. It was this feeling of impotence that exasperated him even more than the Committee's repeated rejections." [Tr. Walton, pp. 252, 254.] (". . . il reconnaissait du reste l'utilité du Salon, le seul terrain de bataille où un artiste pouvait se révéler d'un coup.") *L'Œuvre,* p. 224. ("Toute toile qui revenait, lui semblait mauvaise, incomplète surtout, ne réalisant pas l'effort tenté. C'était cette impuissance qui l'exaspérait, plus encore que les refus du jury.") *L'Œuvre,* p. 225.

69. *L'Œuvre,* pp. 281 f. [Tr. Walton, p. 319]. The point of departure for Zola was probably Antoine Guillemet's *Vue de la Seine vue du quai des Tuileries,* which had been exhibited in 1875 and reviewed by Zola. A photograph of the painting is still among Zola's drafts for *L'Œuvre.* See Patrick Brady, *"L'Œuvre" d'Emile Zola* (Geneva, 1967), pp. 110, 252.

70. J.-K. Huysmans, *Lettres inédites à Emile Zola,* p. 106.

71. "At the same time [1884] [Dubois-Pillet] exhibited *The Dead Child,* which corresponds exactly in title, subject, and conception to the painting which Zola has since attributed to his Claude Lantier." [Tr. McGarrell]. ("En même temps il exposait *L'Enfant Mort,* qui correspond exactement comme titre, sujet et conception au tableau que M. Zola attribua depuis à son Claude Lantier.") *L'Art Moderne,* 19 Sept. 1886, p. 301.

72. L. Deffoux and J. Royère, *Dix-neuf lettres de Stéphane Mallarmé à Emile Zola* (Paris, 1929). The letters for the period 1878–87 were, unfortunately, not found among Zola's papers.

73. E. Zola, "Ebauche de L'Œuvre," *Œuvres complètes,* tom. 13, p. 414.

74. E. Bernard, "Louis Anquetin. Artiste peintre," *Mercure de*

*France,* 1932, pp. 590 ff. See also E. Bernard, "Notes sur l'école dite de Pont-Aven," *Mercure de France,* Dec. 1903, p. 676.

75. The term *béjoité* is something of a linguistic problem. Prof. Charles Bruneau of the Sorbonne has, at my request, been kind enough to give the following explanation: "Béjoité is not to be found in dictionaries and is unknown to my nephew who works at the Ecole des Beaux-Arts.—'Béjoité' is probably a printer's error for 'béjointé.' The word 'bévue' [blunder], for 'besvue,' has existed for a long time. It is perfectly clear and it has given a pejorative value to this form of the Latin prefix. Two technical words that date from the nineteenth century and that are applied to horses, 'court-jointé' [short-jointed] and 'long-jointé' [long-jointed], explain the creation of this 'béjointé.'—That this word is unknown today should present no problem; it is a studio word. The studio that created it has doubtless changed vocabulary many times since that date.—'Béjointé' obviously means that the strokes of color do not touch one another." [Tr. McGarrell.] ("Béjoité est ignoré des dictionnaires et inconnu de mon neveu qui travaille à l'Ecole des Beaux-Arts. —Il est vraisemblable que 'béjoité' est une faute d'impression pour 'béjointé.'—Il existe depuis longtemps un mot 'bévué' (pour 'besvue') qui est bien clair et qui a donné à cette forme du préfixe latin une valeur péjorative. Deux mots techniques, qui datent du XVII° siècle, et qui s'appliquent au cheval: 'court-jointé,' 'long-jointé,' expliquent la création de ce 'béjointé.'—Que ce mot soit ignoré aujourd'hui ne présente aucune difficulté; c'est un mot d'atelier; l'atelier qui l'avait créé a dû depuis cette date changer plusieurs fois de vocabulaire.— 'Béjointé' signifie évidemment que les touches de couleur ne se rejoignent pas.") Cf. also p. 5, above (Signac on Seurat).

76. *L'Œuvre,* p. 270 [Tr. Walton, p. 305].

77. For summaries of Signac's and Seurat's color-theoretical development during the first half of the 1880's, see P. Signac, *D'Eugène Delacroix au Néo-impressionnisme;* J. Rewald, *Georges Seurat;* J. Rewald, *Post-Impressionism* (New York, 1956), Ch. II; O. Reutersvärd, pp. 171–72; H. B. Chipp, "Orphism and Color Theory," *The Art Bulletin,* vol. XL (March 1958), pp. 57–58. See also C. V. Petersen, "Omkring Zola's 'Mestervaerket' " (*Tilskueren,* 1913), *Afhandlinger og Artikler om Kunst* (Copenhagen, 1939), pp. 69–86.

78. Shown at *Les XX,* Feb. 1888, under the title of *Bateau, soleil couchant.*

79. E. Bernard, pp. 594 ff.

80. Cf. *L'Œuvre,* p. 435.

81. *Lutèce,* 17–24 April 1886 [Tr. McGarrell]. Léo Trézenick was a pseudonym for Léon Epinette (1855–1902). He also contributed to *L'Art Moderne.*

82. M. O. Maus, pp. 31–37.

83. The regulations of the Société des Artistes Indépendants, quoted in G. Coquiot, pp. 221–29.

84. G. Geffroy, II, p. 13.

85. C. Pissarro, p. 91.

86. Monet to Durand, Etrétat, 10 Dec. 1885. *Les Archives,* I, p. 301.

87. C. Pissarro, p. 101 [Tr. Abel, p. 74].

88. Cf. O. Reuterswärd, p. 177.

89. Anonymous, "Les vingtistes parisiens," *L'Art Moderne,* 27 June 1886 (*L'Art Moderne,* 1886, pp. 201 ff.).

90. Letter to Lucien, 5 Apr., 1886. C. Pissarro, p. 102.

91. P. Adam, "Peintres impressionnistes," *La Revue contemporaine littéraire, politique et philosophique,* tom. IV, n° 4 (1886), pp. 541–51; E. Hennequin, "Les impressionnistes," *La Vie Moderne,* 19 June 1886, pp. 389–90; G. Kahn, "Réponse des symbolistes," *L'Evènement,* 28 Sept. 1886; E. Verhaeren, "Le Salon des Vingts à Bruxelles, les neo-impressionnistes," *La Vie Moderne,* 27 Feb. 1887, pp. 135–39; Th. Wyzewa, "L'Art contemporain," *La Revue Indépendante,* Nov.–Dec. 1886, pp. 68–78.

92. F. Fénéon, *Œuvres* (Paris, 1948), p. 72 [Tr. Albert Read].

93. J. Ajalbert, p. 238.

94. Cf. Ch. Chassé, *Les clés de Mallarmé* (Paris, 1954), Ch. III.

## 2. *L'Ile des Iridées*

1. G. Coquiot, *Seurat* (Paris, 1924), pp. 65–72.

2. For a study of the sketches for *La Grande Jatte* see in particular C. Zervos, " 'Un Dimanche à la Grand Jatte' et la technique de Seurat," *Cahiers d'Art,* no. 9 (1928); D. C. Rich, *Seurat and the Evolution of "La Grande Jatte"* (Chicago, 1935).

3. See above all Rewald's comprehensive studies in this sphere.

4. The categorical dating that appears regarding the sketches reproduced in J. Rewald, *Georges Seurat* (Paris, 1948), has been modified in the same writer's *Post-Impressionism* (New York, 1956).

5. It is known that Seurat's friend, the philologist, poet, philosopher,

and physicist, Charles Cros, was fascinated by the technique of photography. As early as 1869 he published *Solution générale du problème de la photographie des couleurs,* which marks the invention of color photography. See F. Fénéon, "Feu Cros," *La Cravache,* 18 Aug. 1888. (F. Fénéon, *Œuvres* [Paris, 1948], pp. 246–53.)

6. The problems of this and similar elements of the picture have been discussed in a number of special studies. See, e.g., D. C. Rich, loc. cit.; M. Schapiro, "Seurat and 'La Grande Jatte'," *Columbia Review,* XVII (1935); R. J. Goldwater, "Some Aspects of the Development of Seurat's Style," *The Art Bulletin,* 1941, pp. 117 ff.; G. Paulson gives a short but important interpretation of the emotional structure of *La Grande Jatte* in *Konstverkets byggnad* (Stockholm, 1942), Ch. "Diskontinuerlig verklighet."

7. See H. W. Janson, *Apes and Ape Lore in the Middle Ages and the Renaissance* (London, 1952).

8. *L'Art Moderne,* 1886, p. 204 [Tr. McGarrell].

9. F. Fénéon, *Œuvres,* p. 80 [Tr. Nochlin, p. 109].

10. F. Fénéon, *Œuvres,* p. 80 [Tr. Nochlin, p. 109].

11. The German physicist Heinrich Wilhelm Dove formulated his theories on the mixture of colored light in *Darstellung der Farbenlehre und optische Studien* (Berlin, 1853). Dove is cited in Rood's *Text Book of Colour* (1879). W. I. Homer believes (see his important study *Seurat and the Science of Painting* [Cambridge, Mass., 1964]) that Seurat knew Dove only via Rood. It does not appear that Dove had been translated into French at that time.

12. Ibid., pp. 80–81 [Tr. Nochlin, p. 110].

13. It is possible that Fénéon was also acquainted with Seurat's small copy of Puvis de Chavannes's *Le Pauvre Pêcheur* made in 1882. By small changes—alterations of sizes, the principal figure facing the onlooker more, the beach diagonal steeper—Seurat completely changed the emotional strain in Puvis's classical painting, which is borne up by devout confidence. Instead he has created a mysteriously agitating sketch, full of touching melancholy. See R. L. Herbert, "Seurat and Puvis de Chavannes," *Yale University Art Gallery Bulletin,* Oct. 1959, pp. 22–29. Cf. also p. 6f. regarding Paul Alexis.

14. *L'Art Moderne,* 1886, p. 301 [Tr. McGarrell].

15. Ibid., p. 302 [Tr. McGarrell].

16. M. O. Maus; *Trente années de lutte pour l'art 1884–1914* (Brussels, 1926), pp. 51–60.

17. La Recherche de la lumière dans la peinture, *Catalogue Les XX,* 1888.

18. See in particular *La Wallonie,* April 1890.

19. *L'Art Moderne,* 1887, p. 139 [Tr. Nochlin, pp. 111–12].

20. Tr. McGarrell.

21. That is to say Seurat, Signac, etc.

22. G. Kahn, "Réponse des Symbolistes," *L'Evénément,* 28 Sept. 1886 [Tr. McGarrell].

23. G. Kahn, "Introduction" to *Les Dessins de Georges Seurat* (Paris, 1928), p. xx.

24. A. Barre, *Le symbolisme* (Paris, 1911), pp. 344 ff.; M. J. Durry, *Jules Laforgue* (Paris, 1952), pp. 89 f.; cf. also G. Lehmann, *The Symbolist Aesthetic in France 1885–1895* (Oxford, 1950), pp. 115 ff.

25. R. Mirabaud, *Charles Henry et l'idéalisme scientifique* (Paris, 1926), passim.

26. S. Sandström, *Le monde imaginaire d'Odilon Redon* (Lund, 1955), Ch. III; Sandström, "Darwinistisk symbolism," in *Symbolister* (Malmö, 1957), III, pp. 53–87.

27. G. Bohn, "Quelques souvenirs sur Charles Henry," in *Cahiers de l'Etoile* (Paris, 1930), pp. 74 ff.

28. Ch. Andry-Bourgeois, "Le rayonnement universel," in *Cahiers de l'Etoile* (Paris, 1930), pp. 79 ff.

29. G. Kahn, "Quelques souvenirs de jeunesse," in *Cahiers de l'Etoile* (Paris, 1930), pp. 57 ff.

30. The best survey of those scientific works in the field of optics and perception with which Seurat was well acquainted is in W. I. Homer, loc. cit. Although Homer dates Henry's influence on Seurat as beginning in 1887, the *Introduction à une esthétique scientifique,* which contained the germ of all of his later theories, was published as early as 1885 in *La Révué contemporaine,* pp. 441–69. It is improbable that Seurat would not have been familiar with this article while he was struggling with *La Grande Jatte.*

31. Tr. McGarrell.

32. Tr. McGarrell.

33. Tr. McGarrell.

34. F. Fénéon, "Une esthétique scientifique," *La Cravache,* 18 May 1889. (F. Fénéon, *Œuvres,* pp. 167–72).

35. J. Rewald, *Post-Impressionism,* p. 141.

36. *La Vogue,* 18 April 1886, pp. 54–65.

37. Later, however, Gustave Kahn himself, by an ambiguous formulation, contributed towards the confusion regarding the genesis of the neo-impressionist theories. See G. Kahn, "Seurat," *L'Art Moderne*, 5 Apr. 1891, p. 108.

38. G. Lecomte, *Camille Pissarro* (Paris, 1922), p. 75.

39.

*Eragny, November 6, 1886*

MY DEAR M. DURAND-RUEL,

I send you herewith the note which you asked me to make on my new artistic doctrines.

You may complete it by consulting the brochure by M. Félix Fénéon, which appeared recently under the title, "The Impressionists in 1886," on sale at Soiret in Montmartre and at the principal booksellers.

If your son publishes something on this subject, I should like him to make it quite clear that it is M. Seurat, an artist of great worth, who was the first to have the idea and to apply the scientific theories after studying them completely. All I did was follow—as did my other colleagues, Signac, Dubois-Pillet—the example given by Seurat. I hope that your son will be willing to render me this service for which I shall indeed be grateful.

### THEORY

We seek modern synthesis by scientific means, based on the theory of colors discovered by M. Chevreul, and following the experiments of Maxwell and the measurements of O. N. Rood.

We substitute an optical mixture for a mixture of pigments. To put it differently: the decomposition of tones into their constituent elements. Because the optical mixture creates luminosities much more intense than the mixture of pigments.

As for the execution, we consider it of no account; it has only the slightest importance: art has nothing to do with it. According to us, the sole originality consists in the character of the design and the vision peculiar to each artist . . .

[Tr. McGarrell]

*(Eragny, 6 novembre 1886*

MON CHER M. DURAND-RUEL,

Je vous envoie ci-inclus la notice que vous m'avez prié de faire sur mes doctrines artistiques nouvelles.

Vous pourriez la compléter en consultant la brochure de M. Félix Fénéon parue dernièrement sous le titre: "Les Impressionnistes en 1886," en vente chez Soiret à Montmartre et chez les principaux libraires.

Si votre fils fait une publications à ce sujet je désirerais qu'il fît bien comprendre que c'est M. Seurat, artiste de grande valeur, qui a été le premier à avoir l'idée et à appliquer la théorie scientifique après les avoir étudiées à fond. Je n'ai fait que suivre, comme mes autres confrères, Signac, Dubois-Pillet, l'exemple donné par Seurat. J'espère que votre fils voudra bien me rendre ce service pour lequel je lui serais vraiment reconnaissant.

### THÉORIE

Rechercher la synthèse moderne par des moyens basés sur la science, lesquels sont basés sur la Théorie des couleurs découverte par M. Chevreul, et d'après les expériences de Maxwell et les mensurations de O. N. Rood.

Substituer le melánge optique au mélange des pigments. Autrement dit: la décomposition des tons en leurs éléments constitutifs. Parce que le mélange optique suscite des luminosités beaucoup plus intenses que le mélange des pigments.

Quant à l'exécution, nous la regardons comme nulle, ce n'est du reste que peu important: l'art n'ayant rien à y voir, selon nous: la seule originalité consistant dans le caractère du dessin et la vision particulière à chaque artiste. . . .)

Cf. also L.-R. Pissarro and L. Venturi, *Camille Pissarro* (Paris, 1939), pp. 5 1 –5 3.

40. Concerning Sutter's dependence on the Dutch aesthetician Humbert de Superville's *Essai sur les signes inconditionnels dans l'art* (*1827–1832*) see Andre Chastel, "Une Source oubliée de Seurat," *Etudes et Documents sur l'art français,* XXII (1950–1957) (Paris, 1959), pp. 400–407.

41. J. Rewald, however, seems inclined to date the color wheel around the year 1885. *Post-Impressionism,* pp. 82 f.

42. *L'Art Moderne,* 1887, p. 140 [Tr. McGarrell].

43. M. O. Maus, p. 61 *passim.*

44. Mr. Lars Olsén has been kind enough to draw my attention to the following prose-poem written in 1885 by the then nineteen-year-old poet and librarian at the Bibliothèque Nationale, Ephraïm Mikhaël, later a contributor to *La Pléiade.* The work shows astonishing similari-

ties, in both iconography and emotional content, to Seurat's *La Grande Jatte,* particularly by the fluctuation between dream and reality. Its formal construction is, however, much less complex than Seurat's painting.

## THE TOY SHOP

I no longer remember the time, or the place, or if it was a dream. . . . Men and women were coming and going along a long sad promenade; I came and went in the crowd, a rich crowd, from which rose the perfumes of women. And despite the soft splendor of furs and velvets that brushed me, despite the red smiles of cool lips seen through fine veils, a vague worry took hold of me at seeing the monotonous strollers pass by on my right, on my left.

On a bench a man was looking at the crowd with strange eyes, and as I approached him I heard him sob. I asked him what distressed him so, and lifting great fevered eyes towards me, the weeper said: "I am sad, you see, because for days I have been shut up here in this toy shop. For days and for years, I've seen nothing but Puppets, and I'm sick of being the only one alive. They are made of wood, but so marvellously fashioned that they move and speak like me. Yet I know, they can only make the same movements, utter the same words, always.

"These beautiful Dolls, dressed in velvet and furs, who leave an adorable odor of iris drifting in the air behind them, they are even more exquisitely articulated. Their springs are much more delicate than the others, and when you know how to work them, they give the illusion of life. . . ."

## LE MAGASIN DE JOUETS

(Je ne me rapelle plus à présent ni le temps, ni le lieu, ni si c'était en rêve. . . . Des hommes et des femmes allaient et venaient sur une longue promenade trist; j'allais et je venais dans la foule, une foule riche, d'où montaient des parfums de femmes. Et, malgré la splendeur douce des fourrures et des velours qui me frôlaient, malgré les rouges sourires des lèvres fraîches, entrevus sous les fines voilettes, un ennui vague me prit de voir ainsi, à ma droite, à ma gauche, défiler lentement les promeneurs monotones.

Or, sur un banc, un homme regardait la foule avec d'étranges yeux, et, comme je m'approchais de lui, je l'entendis sangloter. Alors je lui demandais ce qu'il avait à se plaindre ainsi, et, levant vers moi ses grands yeux enfiévrés, celui qui pleurait me dit: "Je suis triste, voyez-vous, parce que depuis bien des jours je suis enfermé ici dans ce Magasin de jouets. Depuis bien des jours et bien des années, je n'ai vu

que des Fantoches, et je m'ennuie d'être tout seul vivant. Il sont en bois, mais si merveilleusement façonnés qu'ils se meuvent et parlent comme moi. Pourtant, je le sais, ils ne peuvent que faire toujours les mêmes mouvements et que dire les mêmes paroles.

"Ces belles Poupées, vêtues de velours et de fourrures, et qui laissent traîner dans l'air, derrière elles, une enamourante odeur d'iris, celles-là sont bien mieux articulées encore. Leurs ressorts sont bien plus délicats que les autres, et, quand on sait les faire jouer, on a l'illusion de la Vie. . . .") *Œuvres de Ephraïm Mikhaël* (Paris, Lemerre, n.d.), pp. 131–33 [Tr. McGarrell].

45. H. Mondor, *Vie de Mallarmé* (Paris, 1941), pp. 408 ff.

46. This is implied by, *inter alia,* Huysmans' cautious letter of 11 Jan. 1885 to Mallarmé regarding *Prose:*

DEAR FRIEND,

Let me send you at least a warm handclasp for that delicious and fictitious voyage which is missing from "A Rebours," but which you have so terrifically ornamented in "La Revue Indépendante," for des Esseintes.

I wanted to come to see you—which explains my delay in writing—but, but, I've been in a painful state of nerves or taken up with mediocre occupations which have absolutely worn away my time.

Hennequin, who gives me news, tells me that you are going to bring out four books. Ah, it will certainly not be too soon for des Esseintes to be invigorated by a few suggestive readings in these times of democratic prose.

Do it quickly, quickly, dear Mallarmé. I hope to see you very soon, both literarily and personally.

Your very devoted,

J.-K. HUYSMANS

(MON CHER AMI,

Que je vous envoie au moins une bonne poignée de main pour ce délicieux et artificiel voyage qui manque dans "A Rebours," mais que vous avez si terriblement guilloché dans "La Revue Indépendante," pour des Esseintes.

Je voulais vous aller voir—ce qui vous explique le retard de cette epistole—puis, puis, j'ai été souffrant des nerfs ou pris par de médiocres occupations qui m'ont absolument limé mon temps.

Hennequin, par qui j'ai des nouvelles, me dit que vous allez faire paraître quatre livres. Ah, ce ne serait pas trop tôt vraiment que des Esseintes pût se tonifier par quelques suggestives lectures dans ce temps de démocratique prose!

Faites vite paraître, mon cher Mallarmé, vite. Et à bientôt, littérairement et personellement, j'espère.

Votre bien dévoué

J.-K. HUYSMANS)

(Quoted after A. Rolland de Reneville, "L'elaboration d' 'A Rebours'," *Comœdia,* Sept. 1943, p. 1.) [Tr. McGarrell.]

The friendship between Huysmans and Mallarmé was soon broken, however, possibly as a consequence of the intrigues of the symbolist critic, Emile Hennequin. Félix Fénéon seems to have taken the side of Mallarmé. In any case, his criticism of Huysmans' essays on art, *Certains,* published in 1887, was very adverse. F. Fénéon, *Œuvres,* pp. 265–68.

47. J.-K. Huysmans, *A Rebours avec une préface de l'auteur écrite vingt ans après le roman* (Paris, 1922), pp. 256 f. [Tr. Baldick, p. 196].

48. See *inter alia* C. Soula, *Essai sur l'hermétisme mallarméen* (Paris, 1919); E. Noulet, *L'Œuvre poétique de Stéphane Mallarmé* (Paris, 1940); Ch. Mauron, *Mallarmé l'obscur* (Paris, 1941); A. Thibaudet, *La poésie de Stéphane Mallarmé,* 4th ed. (Paris, 1943); H. Mondor, *Propos sur la poésie de Stéphane Mallarmé* (Monaco, 1945); J. Gengoux, *Le symbolisme de Stéphane Mallarmé* (Paris, 1950); K. Wais, *Mallarmé, Dichtung. Weisheit. Haltung.* (Munich, 1952); W. Fowlie, *Mallarmé* (Chicago, 1953); Guy Michaud, *Mallarmé, l'homme et l'œuvre* (Paris, 1953); Ch. Chassé, *Les clés de Mallarmé* (Paris, 1954).

49. H. Mondor and G. Jean-Aubry, *Œuvres complètes de Stéphane Mallarmé* (Paris, 1954), pp. 284–86.

50. Tr. Cook, pp. 4–5.

51. Tr. Cook, p. 5.

52. Tr. Cook, p. 6.

53. For further views on Mallarmé's aesthetics, see A. G. Lehmann, pp. 60–67, 88–92 *passim.*

54. *La Vogue,* 1886, pp. 70 f. [Tr. McGarrell].

55. G. Delfel, *L'Esthétique de Stéphane Mallarmé* (Paris, 1951), pp. 34 ff.

56. The poem is presented here in the same way as it was printed in

*La Revue Indépendante,* i.e., with a dividing line between the second and third stanzas.

57. Tr. MacIntyre, pp. 62–67.

58. Ch. Chassé, Ch. XVI, "Un poème occultiste." The author points out that such words as *sœur* and *trouble* in Mallarmé, as in Baudelaire, Villiers, and Banville, often have an erotic connotation (p. 180). See also Ch. Mauron, p. 122.

59. Cf. Ch. Chassé, p. 180 and Ch. XX, "Les poèmes érotiques," pp. 201–209.

60. Fanatical admirers of Mallarmé have tried to interpret the association as a Platonic romance. The true character of the acquaintance-ship is evident in H. Mondor, *Mallarmé plus intime,* 13th ed. (Paris, 1944), Ch. "Ce qu'on nomme de l'amour . . ." See in particular Mallarmé's letter to Méry Laurent, pp. 247–49. See also K. Wais, pp. 285–96 (Méry).

61. Mallarmé in J. Huret, *Enquête sur l'évolution littéraire* (Paris, 1891), pp. 62 f. [Tr. McGarrell].

62. Ibid., p. 60 [Tr. McGarrell].

63. Cf. E. Noulet's interpretation, op. cit., pp. 420 ff.

64. Letter to Cazalis regarding *L'Après-midi d'un Faune,* July 1865. *Correspondance 1861–1871,* ed. Henri Mondor, 8th ed. (Paris, 1959), p. 168.

65. The discussion of the relationship between the sexes appears like a persistently recurring problem in symbolic literature. Lofty infatuation blended with contempt for women and feelings of impotence is a cherished theme, and the conception of woman is void of nuances. She was either a madonna or a servant of the Devil, preferably a little of each.

Marius Tapora's account of the coterie at "Le Panier Fleuri" gives an apposite description of the tone of the companionship in the Bohemian circles of Paris around Nina Callias and Mme. Rachilde. One of the most brilliant examples of Adoré Floupette's ability to reproduce this side of the poetic inspiration of the symbolists is the sonnet *Avant d'entrer,* which in its fluctuation between different erotic effects could well have been written by Mallarmé and dedicated to Méry Laurent.

| | |
|---|---|
| I feel a taste of syrup | Je sens un goût de sirop |
| In the Paradise of your mouth | Au Paradis de ta bouche |
| The head wobbles, the eye rolls. | La tête branle et l'œil louche |
| Eight and five, total zero. | Huit et cinq, total zéro. |

| How moist in its sheath | Quelle est moite en son fourreau |
| The tender soul which sleeps, | L'âme tendre qui se couche |
| A dragonfly affrighted | Libellule qu'effarouche |
| By the coarseness of the show! | La grosseur du numéro! |

| And we go on, doing nothing | Et nous allons sans rien faire |
| After all, Sirius will tell | Après tout, la grande affaire |
| You of the grand affair, | Sirius te la dira, |

| And my song, all pink and gray, | Et ma chanson rose et grise |
| In your little Opera | De ton petit Opéra |
| Curls and uncurls the frieze. | Frise et défrise la frise. |
| [Tr. McGarrell.] | |

66. *Les Taches d'Encre,* 5 Dec. 1884, p. 25 [Tr. McGarrell].

67. E. Hennequin, *La critique scientifique* (Paris, 1888), Résumé, pp. 219–25.

68. Ibid., p. 139 [Tr. McGarrell].

### 3. *La Lutte et le Rêve*

1. The following oral tradition is probably worthy of consideration as an explanation of Gauguin's devoting himself to art: "My father knew Gauguin well. Within the milieu of the Bank, he remained his only friend, for the painter, by the bizarreness of his nature, had lost everyone's sympathy.

"At a certain period, Gauguin, who was earning a very good living, was swollen with pride. He would come to the Bourse in a smart carriage, which waited for him until the end of the meeting. This was hardly common practice for a bank employee! A little later, he began to speculate for himself and lost heavily. It was in these circumstances that he had to abandon the world of finance."

("Mon père connaissait bien Gauguin. Il était resté dans le milieu de la Banque son seul ami, car le peintre, par les bizarreries de son caractère, avait écarté de lui toutes les sympathies.

"A un certain moment, Gauguin qui gagnait très largement sa vie était plein d'orgueil. Il venait à la Bourse dans un coupé qui l'attendait jusqu'à la fin de la séance. Cela n'était point la pratique courante des employés de banque! Dans la suite, il se mit à spéculer pour son propre compte et perdit. C'est dans ces conditions qu'il dut abandonner la Fi-

nance.") An interview with M. Marcel Mirtil, *Gazette des Beaux-Arts,* Jan.–Apr., 1956 (1958), p. 86 [Tr. McGarrell].

See also U. F. Marks-Vandenbroucke, "Gauguin—ses origines et sa formation artistique," *Gazette des Beaux-Arts,* Jan.–Apr. 1956 (1958), pp. 51 ff.; and Ch. Chassé, *Gauguin et son temps* (Paris, 1955), p. 42. A thorough analysis of Gauguin's activities in Paris during the 1870's and early 1880's is also given in M. Bodelsen, *Gauguin og Impressionisterne* (Copenhagen, 1968).

2. Pissarro himself, however, was far from happy about his influence on Gauguin: "Yesterday I received a letter from Gauguin, who probably had heard from Durand that I did some good work here. He is going to look me up and study the place's possibilities from the point of view of art and practicality. He is naive enough to think that since the people in Rouen are very wealthy, they can easily be induced to buy some paintings. . . . Gauguin disturbs me very much, he is so deeply commercial, at least he gives that impression. I haven't the heart to point out to him how false and unpromising is his attitude; true, his needs are great, his family being used to luxury, just the same his attitude can only hurt him. Not that I think we ought not try to sell, but I regard it a waste of time to think *only* of selling, one forgets one's art and exaggerates one's value. It is better to get low prices for a while, and even easier, particularly when your work is strong and original, and to go ahead bit by bit, as we do."

("J'ai reçu hier une lettre de Gauguin, sachant probablement chez Durand que j'avais (fait) de bonnes études ici. Il vient me retrouver pour étudier la place, me dit-il, au point de vue pratique et artistique. Il ajoute naïvement que les Rouennais sont très riches, il serait peut-être facile de les faire acheter à un moment donné.—Décidément, Gauguin m'inquiète; lui aussi est un terrible marchand, du moins en préoccupations. Je n'ose lui dire combien c'est faux et ne l'avance guère. Il a des besoins très grands, sa famille est habituée au luxe, c'est vrai, mais cela lui fera un grand tort. Non pas que je pense que l'on ne doive pas chercher à vendre, mais je crois que c'est du temps perdu que de penser à cela uniquement; vous perdez de vue votre art, vous exagérer votre valeur. Il vaut mieux vendre à des petits prix pendant un certain temps, et c'est du reste plus facile, surtout quand c'est bien et original, et avancer peu à peu, comme cela arrive à nous tous.") (Rouen, 31 October 1883.) C. Pissarro, *Lettres à son fils Lucien* (Paris, 1950), p. 65 [Tr. Abel, p. 44].

3. This account is based on H. Rostrup, "Gauguin et le Danemark," *Gazette des Beaux-Arts,* Jan.–Apr. 1956 (1958), pp. 63–82. The article contains the hitherto most detailed and most reliable studies of Gauguin's relations with Denmark. See also D. Sutton, "Notes on Paul Gauguin apropos a Recent Exhibition," *The Burlington Magazine,* 1956, pp. 84–88.

4. M. Malingue; *Lettres de Gauguin à sa femme et ses amis* (Paris, 1946), p. 63.

5. P. Gauguin, *Avant et Après,* facsimile edition (Copenhagen, n.d.), pp. 145 f.

6. Gauguin's letters to Pissarro have not yet been published, but have been touched on by H. Rostrup, op. cit., passim.

7. M. Malingue, *Lettres de Gauguin,* p. 47 [Tr. Chipp, p. 59].

8. Included in Gauguin's MS *Avant et Après,* ed. cit., pp. 36 f. Further details on the mysterious text are given in M. Roskill, *Van Gogh, Gauguin and the Impressionist Circle* (New York, 1970), pp. 267 f.

9. Quoted here with Seurat's own italics in the copy he took. Signac Archives, Paris [Tr. Chipp, p. 167]. See R. L. Herbert, "Seurat in Chicago and New York," *The Burlington Magazine,* May 1958, p. 151.

10. G. Kahn; "Au temps du pointillisme," *Mercure de France,* 1924, pp. 16 f.

11. F. Fénéon, *Œuvres* (Paris, 1948), pp. 75 f. [Tr. McGarrell].

12. Similar ideas seem to have been at the back of the mind of the Paris correspondent of *L'Art Moderne,* but with a negative conclusion: "M. Paul Gauguin, a newcomer, we believe, among the Impressionists, follows the path of the preceding painter (Guillaumin). Look closely at his *Church,* the *Park,* the *Chateau,* painted with strength. But those *Resting Cows!* But that *Cow in the Water!*" ("M. Paul Gauguin, un nouveau venu, croyons-nous, parmi les *Impressionnistes,* marche dans la voie du précédent (Guillaumin). A examiner l'*Eglise,* le *Parc,* le *Château,* peints avec fermeté. Mais les *Vaches au repos!* Mais la *Vache dans l'eau!*") Anonymous, "Les Vingtistes Parisiens," *L'Art Moderne,* 27 July 1886, p. 203 [Tr. McGarrell].

13. "I forgot to tell you that Seurat, Signac, Gauguin, Guillaumin, are supposed to exhibit at the Independents and urge you to campaign with them." ("J'oubliais de te dire que Seurat, Signac, Gauguin, Guillaumin doivent exposer au *Indépendants* et te conseillent de faire campagne avec eux.") C. Pissarro, p. 104, June 1886 [Tr. McGarrell].

14. "I was with Signac, Seurat, and Dubois-Pillet at the Noivelle-Athènes recently. Coming home, Guillaumin, Gauguin, and Zando (me-

neghi) were there.—Both Guillaumin and Gauguin refused to shake hands with Signac. There was some incomprehensible explanation, seemingly about the affair of Signac's studio, a misunderstanding. Despite this, Gauguin left abruptly without speaking to me or to Signac, etc."

("Je me suis trouvé avec Signac, Seurat et Dubois-Pillet à la Nouvelle-Athènes dernièrement. En rentrant, Guillaumin, Gauguin et Zando (meneghi) s'y trouvaient.—Guillaumin a refusé de donner la main à Signac, ainsi que Gauguin. Il y a eu explication, impossible d'y rien comprendre, il paraît que c'est pour l'affaire de l'atelier de Signac, un malentendu. Malgré cela, Gauguin est sorti brusquement sans saluer ni moi, ni Signac, etc.") Ibid., p. 112, 3 Dec. 1886 [Tr. McGarrell].

15. "The hostility of the romantic impressionists is more and more marked. They meet regularly, Degas himself comes to the café, Gauguin has become intimate with Degas once more, and goes to see him all the time—isn't this seesaw of interests strange? Forgotten are the difficulties of last year at the seashore, forgotten the sarcasms the Master hurled at the sectarian, forgotten all that he [Gauguin] told me about the egotism and common side of Guillaumin. I was naive, I defended him [Gauguin] to the limit, and I argued against everybody. It is all so human and so sad."

("Les hostilités continuent de plus en plus parmi les impressionnistes romantiques. Il se réunissent très régulièrement; Degas lui-même vient au Café, Gauguin est redevenu très intime de Degas et va le voir souvent—curieux, n'est-ce pas, cette bascule des intérêts! Oubliées, les avanies de l'année passée aux bords de la mer, oubliés les sarcasmes du Maître contre le sectaire, oublié ce qu'il m'a assez dit sur l'égoïsme et le côté commun de Guillaumin. Moi, naïf je le défendais (Gauguin) à cor et à cri contre les uns et les autres. C'est bien humain et bien triste.") Ibid., p. 111, Nov. 1886 [Tr. Abel, p. 81]. See also letter to Lucien, 20 May 1887, pp. 151 f.

16. J. de Rotonchamp, *Paul Gauguin* (Paris, 1925), p. 41. The author, whose real name was Brouillon, is identical with the "marsouin" mentioned by Gauguin in letters from Martinique. Malingue, *Lettres,* p. 117.

17. A short time earlier, unfortunately, the potter Chaplet had retired, which left Gauguin without a workshop in which to realize his ideas. Letter to Mette, 20 Nov. 1887. Malingue, p. 119.

18. Pissarro, p. 163, letter of 24 Sept. 1887.

19. Malingue, p. 121 [Tr. McGarrell].

20. For an excellent account of Gauguin's exhibition work during

1888 see M. Bodelsen, "An Unpublished Letter by Théo van Gogh," *The Burlington Magazine,* 1957, pp. 199–202.

21. G. Kahn, "Paul Gauguin," *L'Art et les Artistes,* Nov. 1925.

22. F. Fénéon, "Aux vitrines des marchands de tableaux," *La Revue Indépendante,* 15 Jan. 1888 (F. Fénéon, *Œuvres,* pp. 116 f.) [Tr. McGarrell].

23. Malingue, p. 128.

24. For a discussion of Gauguin's religious outlook see T. Buser, S. J., "Gauguin's Religion," *Art Journal,* XXVII (Summer 1968), pp. 375–80.

25. Malingue, p. 140 [Tr. McGarrell].

26. Octave Maus, "Le Salon des XX à Bruxelles," *La Cravache,* 2 March 1889.

27. "My latest works are coming along well and I think you will find a special note in them or rather the affirmation of my former studies, or the *synthesis* of a form or a color in only considering what is *dominant.*"

("Mes derniers travaux sont en bonne marche et je crois que vous trouverez une note particulière ou plutôt l'affirmation de mes recherches antérieures ou *synthèse* d'une forme et d'une couleur en ne considérant que la dominante.") Letter to Schuffenecker, 14 Aug. 1888. Malingue, p. 135 [Tr. McGarrell]. (Italics mine.)

28. Ch. Chassé, *Gauguin et le groupe de Pont-Aven* (Paris, 1921); Chassé, "De quand date le Synthétisme de Paul Gauguin," *L'Amour de l'Art,* April 1938; M. Roskill, Ch. 4.

29. See E. Bernard, "Lettre ouverte à M. Camille Mauclaire," *Mercure de France,* June 1895; Bernard, "Notes sur l'école dite de 'Pont-Aven'," *Mercure de France,* Dec. 1903; Bernard, *Souvenirs inédits sur l'artiste peintre Paul Gauguin et ses compagnons lors de leur séjour à Pont-Aven et au Pouldu* (Lorient, n.d. [1939]); Bernard, "Note relative au symbolisme pictural de 1888–90," appendix to *Lettres de Vincent van Gogh, Paul Gauguin etc.* (Brussels, 1942).

30. Cf. Merete Bodelsen's interpretation of *La Lutte* in *Gauguin's Ceramics* (London, 1964), pp. 182–86.

31. See Y. Thirion, "L'influence de l'estampe japonaise dans l'œuvre de Gauguin," *Gazette des Beaux-Arts,* Jan.–Apr. 1956 (1958), p. 101.

32. Cf. F. Fosca, *Edmond et Jules de Goncourt* (Paris, 1941), pp. 342 ff.; and N. G. Sandblad's analysis of Manet's portrait of Zola in *Manet. Three Studies in Artistic Conception* (Lund, 1954), pp. 106 f.

33. B. Dorival, "Sources of the Art of Gauguin from Java, Egypt and Ancient Greece," *The Burlington Magazine,* Apr. 1951, pp. 118–22.

34. Mallarmé, "Hommage à Puvis de Chavannes," *La Plume,* 1895.

35. Malingue, p. 300.

36. For a comprehensive study of "Japonaiserie" and "Japonism" among the impressionists and their successors see M. Roskill, Ch. 2.

37. E. Dujardin, "Aux XX et aux Indépendants: Le cloisonisme," *La Revue Indépendante,* Mar. 1888, pp. 489 f.

38. E. Verhaeren, "L'exposition des XX à Bruxelles 1888," *La Revue Indépendante,* Mar. 1888, p. 456 [Tr. McGarrell].

39. Tr. McGarrell.

40. Albert Aurier: "The pine forests seem like cathedrals / Which crosshatch immense mournings. / Infinite, without hope." ("Les forêts de sapins semblent des cathédrales / Qu'ombrent d'immenses deuils. / Infinis, sans espoir.") Beginning of a sonnet printed in *Le Décadent,* 4 Sept. 1886.

Emile Bernard:"Under the sleeping domes of gigantic trees." ("Sous les dômes dormeurs des arbres gigantesques.") Beginning of a sonnet sent to Vincent van Gogh [April 1888]). J. van Gogh-Bonger, *Verzamelde brieven van Vincent van Gogh* (Amsterdam and Antwerp, 1952–54), IV, p. 194. (Quotations from this work will be given under the abbreviation *Verz. brieven,* I–IV.)

41. *Verz. brieven,* IV, pp. 196 f. [Tr. Lord, p. 30].

42. Letter from Vincent van Gogh to Bernard (Arles, Oct. 1888), ibid., IV, p. 229 [Tr. Lord, p. 89].

43. Unpublished letter from Gauguin to Vincent van Gogh (Pont-Aven, Sept. 1888). See J. Rewald, *Post-impressionism,* Ch. IV, notes 22 and 30.

44. The first three stanzas of "O mon Dieu, vous m'avez blessé d'amour" from Paul Verlaine, *Sagesse* (Paris, 1881) [Tr. McGarrell].

45. For information about Albert Aurier see R. de Gourmont in G.-A. Aurier, *Œuvres Posthumes* (Paris, 1893), pp. i–xxii; M. Coulon, "Une minute de l'heure symboliste, Albert Aurier," *Mercure de France,* 1 Feb. 1921, pp. 599–640.

46. *Œuvres Posthumes,* pp. xiv–xv.

47. Quoted after M. Coulon, p. 608 [Tr. McGarrell].

48. For a good account of this exchange see particularly Å. Meyerson, "Van Gogh and the School of Pont-Aven," *Konsthistorisk Tidskrift* (Stockholm), Dec. 1946.

49. Malingue, *Lettres*, pp. 140 f. [Tr. McGarrell]. Cf. also Bodelsen, p. 112.

50. Unpublished letter from Gauguin to Vincent van Gogh (Pont-Aven, Sept.–Oct. 1888). See J. Rewald, Ch. IV, note 34.

51. Vincent van Gogh to Anthon van Rappard (May 1883). *Verz. brieven*, IV, p. 100.

52. Letter from Quimperlé (16 Oct. 1888). Malingue, *Lettres*, p. 147 [Tr. McGarrell].

53. Cf. annotation on one of Gauguin's visiting cards, found among the papers of Aurier:

| | |
|---|---|
| Christ special Pain of betrayal<br>    applies to Jesus today<br>              and tomorrow<br>    little explanatory group<br>    the whole sober harmony<br>    somber color and<br>    red—supernatural | Christ Douleur spéciale de trahi-<br>    son<br>    s'appliquant à Jésus au-<br>    jourd'hui et demain<br>    petit groupe explicatif<br>    le tout sobre harmonie<br>    couleur sombre et<br>    rouge—surnaturelle |

—Malingue, *Lettres*, p. 323 [Tr. McGarrell].

54. J. Antoine, "Impressionnistes et Synthétistes," *Art et Critique*, 9 Nov. 1889; G.-A., Aurier; "Concurrence," *Le Moderniste*, no. 10, 27 June 1889.

55. F. Fénéon, "Autre Groupe Impressioniste," *La Cravache*, 6 July 1889. Reprinted in Fénéon, *Œuvres*, pp. 178 ff. [Tr. McGarrell]. (Italics mine.)

56. "Fénéon really wrote that I imitated *Anquetin*, whom I don't know." ("Fénéon a bien écrit que j'imitais *Anquetin* que je ne connais pas.") Gauguin to Bernard (Nov. 1889), Malingue, *Lettres*, p. 172 [Tr. McGarrell].

57. See Malingue, *Lettres*, pp. 323 f.

58. P. Gauguin, "Notes sur l'art à l'Exposition Universelle," *Le Moderniste*, 4 and 13 June 1889; Gauguin, "Qui trompe-t-on ici?" *Le Moderniste*, 21 Sept. 1889.

59. G.-A. Aurier, "Camille Pissarro," *La Revue Indépendante*, Mar. 1890. Reprinted in Aurier, *Œuvres Posthumes*, pp. 235–44. The article is fundamentally negative concerning neo-impressionism.

60. Malingue, *Lettres*, p. 194 [Tr. McGarrell].

61. Cf. n. 53.

62. The best summing up, built on primary research on the milieu of Le Pouldu, is given by Ch. Chassé, *Gauguin et son temps* (Paris, 1955), Ch. VI.

63. P. Sérusier, *ABC de la peinture* (Paris, 1942), pp. 50 ff.

64. M. Denis, "Définition du Néo-traditionnisme," *Art et Critique*, 23 and 30 Aug., 1890. Reprinted in Denis, *Théories 1890–1910* (Paris, 1920), pp. 1–13.

65. Bernard to Aurier (Oct. 1890). Malingue, *Lettres*, pp. 322 f.

66. Camille Pissarro's letter to Lucien, 13 May 1891, gives an explanation of this somewhat unexpected support. C. Pissarro, pp. 246–48.

67. O. Mirbeau, "Chronique—Paul Gauguin," *L'Echo de Paris*, 16 Feb. 1891 [Tr. McGarrell]. Reprinted in *L'Art Moderne*, 22 March 1891.

68. Ms posthumously published in *Mercure de France*, Dec. 1892.

69. G.-A. Aurier, *Œuvres Posthumes*, p. 303 [Tr. McGarrell]. For an important discussion of Aurier, see H. R. Rookmaaker, *Synthetist Art Theories* (Amsterdam, 1959).

70. Gauguin to his wife (Tahiti, May 1892). Malingue, *Lettres*, p. 226 [Tr. McGarrell].

#### 4. La Nuit Etoilée

1. G. Kahn, "Seurat," *L'Art Moderne*, 5 April, 1891 [Tr. McGarrell].

2. See P. Quillard, "Théâtre d'Art. Représentation au bénéfice de Paul Verlaine et de Paul Gauguin," *Mercure de France*, July 1891, pp. 45–49.

3. "But I who read a book to seek out the artist who created it, would I be wrong to love French novelists so much?" ("Mais moi qui lis les livres pour y chercher l'artiste qui l'a fait, aurais-je tort de tant aimer les romanciers français?") Vincent to Will, *Verz. brieven*, IV, p. 172 [Tr. McGarrell].

4. Vincent to van Rappard, *Verz. brieven*, IV, p. 100.

5. C. Nordenfalk, "Van Gogh and Literature," *The Journal of the Warburg and Courtauld Institutes*, vol. 10 (1948), pp. 132–47. Cf. also J. Seznec, "Literary Inspiration in Van Gogh, *Magazine of Art*, Dec. 1950, pp. 282–88, 306.

6. *Verz brieven*, III, p. 207.

7. Cf. above, Ch. I, pp. 21 ff. Here my interpretation deviates from Nordenfalk, p. 142.

8. *Verz. brieven,* III, p. 207; IV, p. 210: "L'amour de l'art fait perdre l'amour vrai". Cf. also Zola, *L'Œuvre* (1886).

9. Vincent to Will (Auvers, first half of June 1890), *Verz. brieven* IV, p. 183 [Tr. *Complete Letters,* p. 470].

10. Vincent to Gauguin, *Verz. brieven,* III, p. 528.

11. Cf. Meyer Schapiro's comments to Pl. 23 in M. Schapiro, *Vincent van Gogh* (New York, 1950).

12. Vincent to Théo (Arles, Oct. 1888), *Verz. brieven,* III, pp. 345–46.

13. About Théo's possibilities of understanding Vincent's art see G. Kraus, *The relationship between Théo & Vincent van Gogh* (Amsterdam, 1954).

14. "You will probably think the interior of the empty bedroom with a wooden bedstead and two chairs the most unbeautiful thing of all—and notwithstanding this I have painted it twice, on a large scale.

"I wanted to achieve an effect of simplicity of the sort one finds described in *Felix Holt.* After being told this you may quickly understand this picture, but it will probably remain ridiculous in the eyes of others who have not been warned. Doing a simple thing with bright colors is not at all easy, and I for my part think it is perhaps useful to show that it is possible to be simple by using something other than gray, white, black or brown. Here you have the justification for this study's existence."

("Tu trouveras le plus laid probablement l'intérieur d'une chambre à coucher vide avec un lit en bois et deux chaises—et pourtant je l'ai peint deux fois en grand. J'ai voulu arriver à un effet de simplicité comme on le trouve décrit dans Felix Holt. En te disant cela tu comprendras peut-être vite le tableau, mais il est probable que non prévenus cela reste ridicule pour d'autres. Faire de la simplicité avec des couleurs voyantes cela n'est pourtant pas commode et moi je trouve qu'il peut être utile de montrer qu'on puisse être simple avec autre chose que du gris, blanc, noir et brun. Voilà la raison d'être de cette étude-là.") Vincent to Will (Saint-Rémy, Oct. 1889), *Verz. brieven,* IV, p. 174 [Tr. *Complete Letters,* p. 460].

15. *Verz. brieven,* I, p. 68.

16. Concerning the authorship of George Eliot see R. Speaight,

*George Eliot* (London, 1954); A. Hauser, *The Social History of Art* (London, 1951), II, pp. 835 f.

17. G. Eliot, *Felix Holt,* Library Edition (Edinburgh and London, 1901). See especially Ch. V, LI.

18. "Van der Weele came to see me again. Perhaps he will bring me in contact with Piet Van der Velden, whom I think you will know from his peasant and fisherman's figures.

"I once met Van der Velden, and he then made a very good impression, he reminded me of the figure of Felix Holt, the radical, by Eliot. There is something broad and rough in him that appeals to me very much—something of the roughness of *torchon.* A man who apparently doesn't seek culture in outer things, but who is inwardly much, very much farther than most."

("V. de Weele was weer eens bij me. Misschien kom ik door hem in kennis met Piet v. d. Velden, dien ge zeker wel kent uit zijn boeren en visschersfiguren. Ik heb v. d. Velden eens ontmoet, en hij maakte toen een goede impressie op mij, ik dacht aan't figuur van Felix Holt de radicaal van Eliot. Er is iets breeds en ruw in hem dat mij zeer bevalt— iets van het ruwe van torchon. Een man, die de beschaving blijkbaar niet zoekt in uiterlijke dingen, doch inwendig veel verder is, veel, veel, veel verder dan de meesten.") Vincent to Théo (The Hague, Summer 1883), *Verz. brieven,* II, pp. 159–60 [Tr. *The Letters of Vincent van Gogh to His Brother, 1872–1886* (London: Constable, 1927), vol. II, p. 138].

19. "And what I want to say, among other things, is this—that Eliot is masterly in her execution, but quite apart from this there is a genius-like quality about which I should like to say, Perhaps one improves when one reads those books—or, These books possess an awakening power. . . .

"The other day I reread *Felix Holt, the Radical* by Eliot. This book has been very well translated into Dutch. I hope you know it; but if you don't, try to get it somewhere. There are certain conceptions of life in it that I think are excellent—deep things, said in a guilelessly humorous way; the book is written with great vigor, and various scenes are described in the same way Frank Hol or someone like him would draw them. The conception and the outlook are similar. There aren't many writers who are as thoroughly sincere and good as Eliot."

("En wilde ik er op komen o. a. dat Eliot meesterlijk is voor executie ook doch buiten en behalve dat nog iets eigenaardig geniaals waarvan ik

zou willen zeggen: men wordt er misschien beter door als men die boeken leest, of die boeken hebben een wakkermakende kracht. . . .

"Ik herlas dezer dagen Felix Holt the radical van Eliott. Dit boek is zeer goed vertaald in 't Hollandsch. Ik hoop dat gij het kent—indien gij het niet kent zie eens of gij het niet ergens te lezen krijgen kunt.

"Er komen zekere levensbeschouwingen in voor die ik uitmuntend vind—diepe dingen op lejke wijs gezegd—'t is een boek dat geschreven is met groot pit en verschillende scènes zijn beschreven zóó als Frank Hol of een dergelijke ze zou teekenen. 't Is een dergelijke opvatting en zienswijs. Er zijn niet veel schriejvers die zoo door en door opregt en goed zijn als Eliott.") Vincent to Rappard (April 1884), *Verz. brieven,* IV, pp. 113 f. [Tr. *Complete Letters,* p. 400].

20. Vincent to Gauguin (Arles, Oct. 1888), *Verz. brieven,* IV, pp. 237–38 [Tr. Chipp, p. 42].

21. Vincent to Théo (Antwerp 1885), *Verz. brieven,* III, pp. 72–75.

22. See *Verz. brieven,* III, pp. 238 and 183.

23. In July 1888 he had written to Théo: "I have scraped out a big painted study, an olive garden, with a figure of Christ in blue and orange, and an angel in yellow. Red earth, hills green and blue, olive trees with violet and carmine trunks, and green-grey and blue foliage. A lemon-yellow sky.

"I scraped it out because I tell myself that I must not do figures of that order without models. Certainly it would be better to my thinking for Gauguin to come here, with the winter coming on."

("J'en ai gratté une grande étude peinte, un jardin des oliviers, avec une figure de Christ bleue et orangé, un ange jaune. Un terrain rouge, collines vertes et bleues. Oliviers aux troncs violets et carminés à feuillage vert, gris et bleu. Ciel citron.

"Je l'ai grattée parce que je me dis qu'il ne faut pas faire des figures de cette portée sans modèle. Certes il vaudrait aussi selon moi mieux que Gauguin vienne ici, pour cette raison de l'hiver à venir.") *Verz. brieven,* III, p. 248 [Tr. *Further Letters,* p. 99].

24. Cf. the interesting discussion of the space organization in van Gogh's late paintings by Gregor Paulsson, *Konstverkets byggnad* (Stockholm, 1942), pp. 261 f.

25. A summary of this debate is given in G. Kraus, "Vincent van Gogh en de psychiatrie," *Psychiatrische en Neurologische Bladen,* Sept.–Oct. 1941.

26. *Verz. brieven,* III, p. 425.

27. H. Gastaut, "La maladie de Vincent van Gogh, envisagée à la lumière des conceptions nouvelles sur l'épilepsie psychomotrice," *Annales médicopsychologiques,* 1956, I, pp. 196–238.

28. Vincent to Bernard (Arles, Apr. 1888), *Verz. brieven,* IV, p. 193 [Tr. Lord, p. 24].

29. Vincent to Théo (Arles, Apr. 1888), *Verz brieven,* III, p. 192 [Tr. *Further Letters,* p. 29].

30. Vincent to Théo (Arles, July 1888), *Verz. brieven,* III, p. 252 [Tr. *Further Letters,* p. 104].

31. Vincent to Will (Arles, about 8 Sept. 1888), *Verz. brieven,* IV, pp. 159 f. [Tr. *Complete Letters,* p. 444].

32. E. Zola, *L'Œuvre,* ed. cit., p. 419.

33. G. de Maupassant, *Pierre et Jean* (Paris, 1888) (ed. 1897, p. x).

34. Vincent to Théo (Antwerp, Jan. 1886), *Verz. brieven,* III, p. 186.

35. (Arles, Sept. 1888), *Verz. brieven,* III, p. 321 (Cf. III, p. 328) [Tr. *Complete Letters,* p. 56].

36. Vincent to Will (Arles, Sept.–Oct. 1888), *Verz. brieven,* IV, p. 161 [Tr. *Complete Letters,* p. 445].

37. Cf. G. W. Allen, *The Solitary Singer* (New York, 1955).

38. Cf. F. Schyberg, *Walt Whitman* (New York, 1951), p. 292.

39. J. Laforgue, "Une Femme m'attend," *La Vogue,* No. 2, 9 Aug. 1886. F. Viélé-Griffin, "De Midi à la Nuit étoilée," *La Revue Indépendante,* Nov. 1888.

40. Cf. A. Barre, *Le Symbolisme* (Paris, 1911), pp. 327 f.

41. W. Whitman, "Prayer of Columbus" (*Leaves of Grass*), *The Complete Poetry and Prose of Walt Whitman* (New York, 1948), I, p. 371.

42. "Again commencing one of those unusually transparent, full-starr'd, blue-black nights, as if to show that however lush and pompous the day may be, there is something left in the not-day that can outvie it."
. . .

"Venus like blazing silver well up in the west. The large pale thin crescent of the new moon, half an hour high, sinking languidly under a bar-sinister of cloud, and then emerging. Arcturus right overhead. A faint fragrant sea-odor wafted up from the south. The gloaming, the temper'd coolness, with every feature of the scene, indescribably soothing and tonic—one of those hours that give hints to the soul, impossible to put in a statement. (Ah, where would be any food for spirituality

without night and the stars?) The vacant spaciousness of the air, and the veil'd blue of the heavens, seem'd miracles enough." "Full-starr'd Nights," *Specimen Days,* ibid., II, pp. 97–98.

43. From the gray-brown bird's song in *Memories of President Lincoln,* ibid., I, pp. 303–304.

44. M. Schapiro, *Vincent van Gogh,* pp. 30 f.

45. Cf. P. Marois, *Le secret de van Gogh* (Paris, 1957).

46. Jo to Vincent (Paris, 5 July 1889), *Verz. brieven,* IV, pp. 268–69.

47. *Verz. brieven,* III, p. 432.

48. Gauguin to Schuffenecker (Pont-Aven, Mar. 1889), M. Malingues, *Lettres de Gauguin à sa femme et ses amis* (Paris, 1946), pp. 152–53 (given erroneously as written in Arles, Dec. 1888, corrected in J. Rewald, *Post-impressionism* [New York, 1956], Ch. VI, n. 10).

49. "As you know, there is an exhibition at a café à l'exposition where Gauguin and some others (Schuffenecker) are exhibiting pictures. At first I had said you would exhibit some things too, but they assumed an air of being such tremendous fellows that it made one sick. Yet Schuffenecker claims that this manifestation will eclipse all the other painters, and if they had let him have his way, he would have paraded all over Paris adorned with flags of all manner of colors to show he was the great conqueror. It gave one somewhat the impression of going to the Universal Exhibition by the back stairs. As always, there were exclusions. Lautrec, who had exhibited with a Center, was not allowed to be in it, and so on."

("Comme tu sais il y a une exposition dans un café à l'exposition où exposent Gauguin et quelques autres. J'avais d'abord dit que tu y exposerais aussi, mais on s'y donnait un tel air de casseurs d'assiettes qu'il devenait vraiment mauvais d'en être. Cependant Schuffen- prétend que cette manifestation enfoncera tous les autres peintres et si on l'avait laissé faire je crois qu'il se serait promené à travers Paris avec les drapeaux de toutes les couleurs pour montrer qu'il était le grand vainqueur. Cela avait un peu l'air d'aller à l'exposition universelle par l'escalier de service. Comme toujours il y avait des exclusions. Lautrec ayant exposé à un cercle ne devait pas en être, etc.") Théo to Vincent (Paris, 16 June 1889), *Verz. brieven,* IV, p. 268 [Tr. *Complete Letters,* p. 544].

50. Vincent to Théo (19 June 1889), *Verz. brieven,* III, pp. 431–32 [Tr. *Complete Letters,* pp. 182–83].

51. "For this reason, my dear brother, when you tell me that you are working again, in which from one point of view I rejoice, for by this you

avoid lapsing into the state of mind which many of the poor wretches who are taken care of in the establishment where you are staying succumb to, it worries me a little to think about it, for you ought not to venture into the mysterious regions which it seems one may skim cautiously but not penetrate with impunity before you recover completely. Don't take more trouble than necessary, for if you do nothing more than simply tell the story of what you see, there will be enough qualities in it to make your pictures last. Think of the still lifes and the flowers which Delacroix painted when he went into the country to stay with George Sand."

("Pour cela mon cher frère, quand tu me dis que tu travailles de nouveau, ce qui me réjouit d'un côté parce que tu y trouves de quoi éviter l'état où tombent beaucoup des malheureux qui sont soignés dans la maison où tu es, j'y pense avec un peu d'inquiétude, car avant la guérison complète il ne faut pas te risquer dans ces régions mystérieuses, qu'il paraît que l'on peut effleurer mais non pénétrer impunément. Ne te donnes pas plus de mal qu'il ne le faut car si tu ne fais qu'un simple récit de ce que tu vois, il y a des qualités suffisantes pour que tes toiles restent. Penses aux natures mortes et aux fleurs que faisait Delacroix quand il allait à la campagne chez G. Sand.") Théo to Vincent (Paris, 16 June 1889), *Verz. brieven*, IV, pp. 267 f. [Tr. *Complete Letters*, p. 544].

52. *Verz. brieven*, IV, p. 231.

53. Théo to Vincent (Paris, 16 Nov. 1889), *Verz. brieven*, IV, pp. 278 f.

54. Vincent to Théo (Saint-Rémy, Nov. 1889), *Verz. brieven*, III, p. 475.

55. "I won't say that one might not venture on it after a virile lifetime of research, of a hand-to-hand struggle with nature, but I personally don't want to bother my head with such things. I have been slaving away on nature the whole year, hardly thinking of impressionism or of this, that and the other. And yet, once again I let myself go reaching for stars that are too big—a new failure—and I have had enough of it.

"So I am working at present among the olive trees, seeking after the various effects of a gray sky against a yellow soil, with a green-black note in the foliage; another time the soil and the foliage all of a violet hue against a yellow sky; then again a red-ocher soil and a pinkish green sky. Yes, certainly, this interests me far more than the above-mentioned abstractions."

("Je ne dis pas, après toute une vie mâle de recherches, de lutte avec

la nature corps à corps, on peut s'y risquer; mais quant à moi, je ne veux pas me creuser la tête avec ces choses-là. Toute l'année j'ai tripoté d'après nature, ne songeant guère à l'impressionisme, ni à ceci, ni à cela. Cependant encore une fois je me laisse aller à saisir des étoiles trop grandes et—nouvel échec—j'en ai assez. Donc actuellement je travaille dans les oliviers, cherchant les effets variés d'un ciel gris contre terrain jaune, avec note vert-noir du feuillage; une autre fois le terrain et le feuillage tout violacés contre ciel jaune; terrain ocre rouge et ciel rose-vert. Va, ça m'intéresse davantage que les abstractions ci-dessus nommées.") Vincent to Bernard (Saint-Rémy, end of Nov.—beginning of Dec. 1889), *Verz. brieven,* IV, p. 234 [Tr. *Complete Letters,* pp. 522–23].

56. Vincent to Bernard (Saint-Rémy, end of Nov.—beginning of Dec. 1889), *Verz. brieven,* IV, pp. 235–36 [Tr. *Complete Letters,* pp. 524–25].